LUKAS & STERNBERG, NEW YORK

TRANSLATOR'S NOTE

CONSIDERING THE TONE AND STYLE OF A BOOK THAT HAS NO PRETENSIONS TO ACADEMIC RIGOR OR EX-
HAUSTIVENESS, THE DECISION WAS MADE EARLY IN THE TRANSLATION WORK TO AVOID TRANSLATOR'S
NOTES, AT FIRST INSOFAR AS POSSIBLE AND FINALLY ALTOGETHER. SUCH NOTES WOULD HAVE CONSTITUTED
AN UNNECESSARY INTRUSION ONTO THE SCENE OF THE TEXT, INTERRUPTING WITH EXPLANATIONS OR
COMMENTS THE RHYTHM THAT SUSTAINS IT AND THE VOICE THAT RUNS THROUGH IT. THE GOOD NUMBER OF
ALREADY EXISTING BIBLIOGRAPHICAL NOTES REQUIRED BY THE AUTHOR'S EXTENSIVE USE OF QUOTATIONS
WOULD HAVE EASILY BEEN INCREASED TWOFOLD TO NOTE EVERY WORD, EXPRESSION OR ADVERTISING SLO-
GAN THAT APPEARS "IN ENGLISH IN THE ORIGINAL" (AND THE AUTHOR MAKES FREE USE OF THEM), TO COM-
MENT PEDANTICALLY ON LEXICAL DIFFICULTIES WITH NO ENGLISH EQUIVALENT (INCLUDING THE USUAL SHARE
OF "UNTRANSLATABLE" PUNS), AND TO EXPLAIN EACH CULTURALLY-SPECIFIC REFERENCE. THERE MAY IN-
DEED BE A CERTAIN FRENCH FOCUS TO *AMOUR, GLOIRE ET CAC 40* BUT MOST OF THE REFERENCES THAT
ARE SPECIFIC TO FRENCH CULTURE ARE NOT LIMITED TO IT AND ARE EASILY COMPREHENSIBLE IN THE CON-
TEXT. WHEN THEY ARE NOT, THEY HAVE BEEN ADAPTED TO AN ENGLISH-LANGUAGE, AND EVEN AN AMERICAN,
READER (E.G. THE SNAP, CRACKLE AND POP OF RICE CRISPIES SOUNDS CLEARER TO AN AMERICAN EAR
THAN CRISPY CRACOTTE CRACKERS).
MY THANKS GO TO JEAN-CHARLES MASSERA FOR HIS UNFAILING GENEROSITY AND TO CAROLINE SCHNEIDER
FOR PROVIDING ME NOT ONLY WITH ALL THE REFERENCE MATERIAL I NEEDED BUT ALSO WITH HER CONSTANT,
QUIET SUPPORT AND TRUST.

SEX ART AND THE DOW JONES

JEAN-CHARLES MASSERA
TRANSLATED FROM THE FRENCH BY GILA WALKER

FOR JENNIFER

JEAN-CHARLES MASSERA

SEX, ART, AND THE DOW JONES

© LUKAS & STERNBERG, 2003

ISBN 0-9671802-9-5

EDITOR: CAROLINE SCHNEIDER

TRANSLATION: © GILA WALKER, 2003

COPY EDITORS: WILL BRADLEY, RADHIKA JONES

DESIGN: SURFACE, FRANKFURT AM MAIN / BERLIN

PRINTING AND BINDING: DRUCKEREI LEMBECK

FIRST PUBLISHED AS *AMOUR, GLOIRE ET CAC 40 – ESTHÉTIQUE, SEXE, ENTREPRISE, CROISSANCE, MONDIAL-
ISATION ET MÉDIAS* © P.O.L, ÉDITEUR, 1999

THIS PUBLICATION HAS BEEN SUPPORTED BY THE FRENCH MINISTRY OF CULTURE – CENTRE NATIONAL DU
LIVRE / OUVRAGE PUBLIÉ AVEC LE CONCOURS DU MINISTÈRE FRANÇAIS CHARGÉ DE LA CULTURE – CENTRE
NATIONAL DU LIVRE

SPECIAL THANKS TO EMMELENE LANDON AND GILA WALKER

LUKAS & STERNBERG 1182 BROADWAY #1602 NEW YORK, NY 10001

LINIENSTRASSE 159 D-10115 BERLIN

MAIL@LUKAS-STERNBERG.COM WWW.LUKAS-STERNBERG.COM

CONTENTS

REPRESENTATIONS OF WORK IN THE CULTURAL LANDSCAPE) -
WHAT CAN I DO 'BOUT IT? DUNNO WHAT TO DO! (EXCLUSION FROM
ECONOMIC GROWTH)

HISTORY'S GENDER
(AGAINST THE STREAM OF HETEROSEXUAL REPRESENTATIONS)
UNITED CLICHÉS OF STRAIGHT SOCIETY - MEANWHILE, UNTIL
THINGS GET BETTER

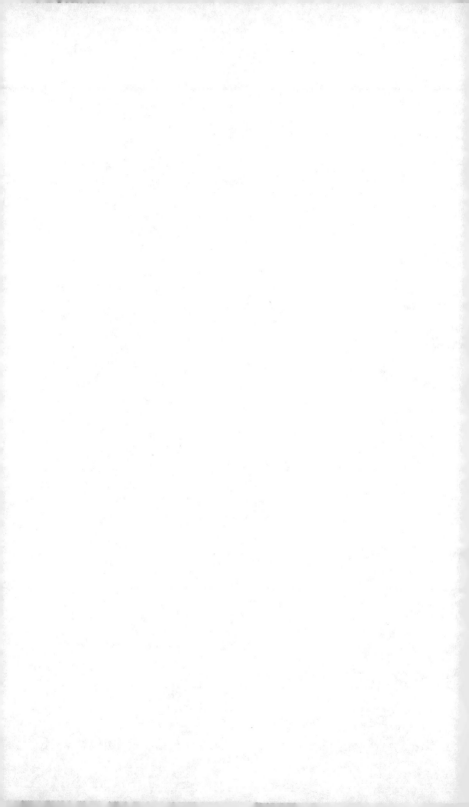

FOREWORD

What follows does not constitute a history, anthology, or theory of art and film. It is rather an essay on the way in which certain recent approaches in contemporary art and film have tackled the culture, economic system, myths, and beliefs around which we organize our lives.

Why contemporary art (from the seventies to 1999)? For its freedom in formulating questions when all other forms of expression are dependent on specific codes and characteristics. Why film? For the role it plays in collective projections and representations. Why a particular artist or filmmaker and not another? Why Bruce Nauman and not Mike Kelley? Why Sadie Benning and not Chantal Akerman? Because it is difficult to see everything. This book does not pretend to be an exhaustive catalogue or a "best of" the last three decades. It is simply an assemblage of exemplary and significant practices. An assemblage that sometimes works in the manner of an exhibition…An exhibition in which the interaction between the pieces proposed would generate a statement.

Why performances, activities, acts, and interventions in the public sphere, constructions, diversions, and misappropriations of objects, textual propositions posited as art and not literature, or sound pieces defined in the field of visual arts and not in that of music? Why sound installations, video installations, film, photography, and slide projections and not painting and sculpture? Because it is difficult to apprehend the present with forms conceived for yesterday.

1999. If art has left the Duchampian paradigm (the importing and subverting of the world in the field of art) and the white cube (the suppression of History and the construction of a timeless space), if it has definitively distanced itself from formal specificity (the self-legitimation of an autonomous form) and from the site-specific (the dissolution of the autonomous form), as it has from the protest form (the challenge to the world and its models) and from questions of identity (the challenge to norms), then where is it? In which space(s) and in which history? What is its object? Does art still assign itself a function? Or, at the very least, does it still have the desire and the capacity to do so? If since the second half of the nineteenth century art has seen itself progressively dispossessed of its fields of competence by other forms of knowledge (social sciences) and representation (film, television, radio, etc.), if it has been replaced by other modes of expressing the imagination and satisfying the need for emotion (sports, spectacles, tourism, etc.), and, finally, if its attempt to build an autonomous field of experience has come up against competition from the many forms of sensorial

and intellectual experiences offered by the entertainment and communications sectors (from role-playing games to interactive systems of wired conviviality via theme parks and fitness centers), how is it possible to get out of a logic that consists in formulating one's own disappearance or one's own incapacity to produce meaning? By ceasing to ask questions conceived for yesterday.

Displace the questions. Overturn the logic that places form at the center of aesthetic preoccupations. Take a look at the context of enunciation. If an art proposition only makes sense in the context of enunciation that it gives itself, then apprehend what it is querying, producing, and building in this same context. And when it comes to formulating these questions: prefer the plural to the singular. If the functions and issues that art takes up are as numerous and heterogeneous as the paradigms in which it operates, then it can no longer be apprehended as a homogenous, monolithic object. The proliferation of forms, questions, and manifestations proposed in the field of art attests to the disappearance of art as a monolithic, homogenous object, constant in its forms and everlasting in its legibility.

Sex, Art, and the Dow Jones? An attempt to bracket a certain number of aesthetic issues together with the historical context in which they are embedded, to take contemporary art propositions out of their specific history (art and film history) and articulate them with the questions being raised by certain recent mutations in our societies. A number of the questions that haunted the eighties seem to constitute a vital issue today, as much on the anthropological, political, and social planes as on the aesthetic plane: How can other modes of symbolic inscription and other forms of representation be conceived? How can the events in which we are supposed to participate be translated into experience? How can we represent ourselves in a History that is being written in terms of the economy and the stock market? How can the distance be reduced between the History that is being transmitted to us (economic growth and the Dow Jones) and the events that punctuate our daily lives (our timetables)? How can we represent ourselves here and now? How can we project ourselves?

*Some sections in this book present integral or reworked versions of articles, or excerpts thereof, already published in journals (*La Lettre du cinéma*, art press, Parachute, La Revue de littérature générale), joint publications or exhibition catalogues (*L'Intime, École nationale supérieure des Beaux-Arts, Paris; *Bruce Nauman, Centre Georges-Pompidou, Paris; *Transit, Centre national des arts*

plastiques / École nationale supérieure des Beaux-Arts, Paris; À quoi rêvent les années 90? *[le catalogue], Maison populaire, Centre d'art moderne Mira Phalaina, Montreuil;* Life / Forms [vita / formae], *Musée Fesch, Ajaccio;* Passage New French Art, *Setagaya Art Museum, Tokyo).*

I. WINTER OF CURIOSITY

MY SEXUAL LIFE
(OR HOW I'VE CUT MYSELF OFF FROM HISTORY)

I ZAP AND I EYE (WHEREIN WE SEE PEOPLE SHUTTING THEMSELVES UP)
1992. *Oh! Charley, Charley, Charley*: Charles Ray casts his own form in eight different positions, multiplying (cloning) himself eight times, in eight standard models. Naked mannequins, true to his own scale, frozen in a variety of rigid positions. Mannequins as smooth and as rigid as those displayed in shop windows...But here, they are set in the middle of a room. Mannequins masturbating and penetrating one another. Representations of self-loving selves replicating before our eyes. Representations of the self that impose their physical presence upon exhibition visitors reduced to the role of spectators to an archetypal representation of lovemaking positions in which erotic self-sufficiency and the love of one's own image negate the possibility of another person's body appearing. A mirror stage at an adult age...A multiplication of me, myself, and I versus the community...Or rather, a self dissolved in the multiplication of its own image...A self formatted to the aesthetic canons of a society of standardized bodies and narcissism. A self with smooth skin and an advertising build. A skin and a build that belong at once to ourselves and to others. A mass-produced self. A sitcom self.

By force of reproducing advertising gestures and poses that heighten sensations and moods, by force of putting on sweaters and easy-wear pants for that relaxed fit, by force of running my hand through my hair so that it stays soft, supple, and full of shine all day long, models of generic attitudes (the supply) were bound to replace the bodies of individuals (the demand). *Oh! Charley, Charley, Charley*: exhibition of a body getting off on the images – gestures and positions – it has built of itself. A body lost in self-worship. A self-worship in which the model (the projection) eclipses the self. Step out of your own body to reproduce a standardized self compatible with current norms in the world's most technologically advanced countries. "Masculinity at its best. A line of innovative, high-performance male grooming products that combine a refreshing, adventurous fragrance with improved skin care benefits for a clean, fresh, modern, sophisticated, and masculine look." A reproduction and projection of the self with no wrinkles, no hair, no excess weight, and especially no traits. Step out of the self to become one more projection of the generic white male of Western type. Mass-produced bodies for a growing demand (the sophisticated masculine look). A magazine body or else I can't come! A body like everyone else's or I'm gonna get depressed. A global face as the aim of the globalized society of supply and demand. "Our face smoothing gel treats the texture of the skin with elastomer technology. It fills in pores and wrinkles and creates a glass-like surface to skin: it's like paving a road." Giorgio Agamben: "The planetary petty bourgeoisie [...]

has taken over the aptitude of the proletariat to refuse any recognizable social identity. The petty bourgeois nullify all that exists with the same gesture in which they seem obstinately to adhere to it: They know only the improper and the inauthentic and even refuse the idea of a discourse that could be proper to them. That which constituted the truth and falsity of the peoples and generations that have followed one another on the earth – differences of language, of dialect, of character, of custom, and even the physical particularities of each person – has lost any meaning for them and any capacity for expression and communication…"[01] Paradox of a planetary petty bourgeoisie that has never, through the course of its history, taken such an interest in its own image and in its own body. Never has it worked so hard on building and adapting its body to conform to Western standards. Measurements as the dimensions of existence and a flat stomach as a project in life. A representation of the self that can be wrapped up in a couple of lines: "Good-looking man, 30, green eyes, 5'9", 140 lbs. looking for thin woman for lasting relationship." So much for the man of the nineties. 1997. If women's bodies were precursors in the commodification of standardized bodies, the world of masculine beauty is now expanding its horizons: "Improving the face you show to the world is no longer the exclusive province of women. Men-specific personal-care products work to help protect, repair, moisturize, and strengthen men's skin to meet everyday challenges. The better you look and feel, the bolder and more confident you will appear." There's no end to alienation. As if, outside working hours, the planetary petty bourgeoisie were now spending more time with the little trifles that make all the difference and tips for looking young and staying fit – from hours in front of the mirror to hours working out at the gym, without forgetting the weekly beautician appointments or the years of depression before finally opting for plastic surgery – than with other people's bodies…Never throughout the course of our History has the appearance of the self mobilized as much time and energy – from getting rid of hair of all shades (black, brown, red, and blond) to laser treatments for stretch marks and tinted contact lenses. Soon beauty will hold no secret for us. Watch your figure, your dress, and your looks until your body looks like someone else's more than your own…Repress differences and others. Repress alterity in order to live with oneself. A subject with no Other. In the event, Ray's gangbanging bodies seem to be recreating an ersatz community. A clone gangbang from which anyone who does not resemble us is excluded. Allegory of a mode of being entirely

01 GIORGIO AGAMBEN, *THE COMING COMMUNITY*, TRANS. MICHAEL HARDT (UNIVERSITY OF MINNESOTA PRESS, 1993), P. 63.

withdrawn into one's own image…A gangbang of sameness in a community in which cloning the human species may be definitively replacing reproduction, a community in which our attention has been diverted from others to focus and stay definitively fixed on ourselves.

Worse still…1993. *C'est mignon tout ça* (Ain't that sweet, Pierrick Sorin)…a black and white video intercut with color scenes: In a black-and-white sequence, stripped to the waist, a man in a miniskirt and stockings climbs up on a kitchen table and gets down on his hands and knees. In the background, a clutter of pots, cans, and a gas heater over the sink. In front of him, a television screen. Behind him, a video camera hooked up to the TV. Offscreen voice: "I really gotta change…I really gotta do something…gotta stop being so withdrawn…gotta be less shut off from the world…gotta be more open…more receptive to the outside…to exchanges…gotta be more capable of giving…" A string of hackneyed self-critical remarks about giving and taking intercut now and again with shots in color of the same man offering flowers to the camera. Back to close-up of his face looking confused: "But I don't know if it would really be better…" Cut to the kitchen…: On the answering machine, messages accumulate, but our man on the table does not want to be bothered by the woman next door offering him geranium cuttings or anyone else while he gets off on watching himself gently spanking his own ass. A two-way relationship (with one hand behind him between his thighs and the other hand in front on the screen), and a soliloquy with no feedback: "Ooooh. You like that don't you…you like playing with yourself… you little bitch you…I can see you do." A caricature of new technological approaches to sexual practices? A deactivation of the erotic charge of new solo lovemaking positions? A way of satirizing a brand new form of sexual deprivation or of deriding some of the most significant features of contemporary erotic culture? A videotape in which the burlesque overrides the erotic…A burlesque erotic staging in which new technology plays the part of the new partner…A new sexual partner, complex but available, and a man who gets into the position of a man (or woman) who is about to be taken from behind without there being anybody around to take him (or her). The video device as fetish. A high-tech fetish for a single man. A device detached from a given person and turned into a sexual object in its own right. The position of voyeur embodied by Sorin as an allegorical position for a technologized society in which access to communication techniques has often worked to the detriment of access to the addressee. Caricature of a culture of erotic conviviality in which the minimal space on Web pages compels us to express ourselves in a minimal number of words…Enter

the gist and send now. Here, a man who turns himself on by repeating bits of archetypal dialogues from porn culture…Elsewhere, surfers who content themselves with "my prick up your ass," for want of being able to get in touch with the alias they're bashing. If Sorin's position is inventive (the burlesque yet singular appropriation of technique), the verbalization of his desires is less so (the repetition of stereotypical dialogues). A man who lets his body be alienated by technique and his capacity of enunciation by a pornographic culture that voices our desires in our name and on our behalf. The absence of a partner as grounds for splitting the person into a figure combining the subject of desire (the voyeur) and its object (the exhibitionist). An organic body projecting itself into a caricature of cathodic or electronic bodies. In the event, when our man climbs onto the table, his body assumes the form of a synthesized body: a man's torso and a woman's legs…Eroticism gives way to self-eroticism. The split of a body without a partner. A desire that has to content itself with what it has. The eroticization of one's own solitude as a last resort. Substitute yourself for the object of desire. A male body that, lacking a partner, projects itself into a part of the female body. A sort of She-Male lover. (If you want something done right, better do it yourself!) A She-Male without breasts and with big black underpants that hide h/er sex. A synthesized projection without organs that touches (itself?) dress accessories and images (fetishes). Critical Art Ensemble: "Voice 2: For too long we have been caught in the circle of the organism, between the goat's anus and the mouth of God, between the logic of the cock and the cunt, the One and the Zero, the cause and the effect – let nothing flow – let nothing pass – BwO now."[02] Between camcorder and monitor, between his ass and the picture of his ass, Sorin leaves no room for organs. A BwO that has nothing left besides words. But these words do not belong to it. Our She-Male is simply mouthing the words that usually go with the kind of close-up he's getting all excited about. An expression of the hackneyed (downloaded) libido for an alienated imagination with a cathodic or electronic body. To wit, a video setup, which is as grotesque as it is convoluted, and in which our actor-voyeur is integrated. A She-Male who talks while making self-love and who plays with h/erself without conviction. A technical setup designed to fill in for a deficit of experiences. Exacerbation of a private use of video…A use that duplicates our sexual behaviors in pictures to boost emotions that our bodies seem incapable of experiencing without the mediation of these pictures. Illustration and proof by contradiction of a desire that has been losing itself in the escalation of techniques of access to its object.

02 CRITICAL ART ENSEMBLE, *THE ELECTRONIC DISTURBANCE* (AUTONOMEDIA, 1994).

The democratization of the Webcam as a sublimation of the need to stay at home. The proliferation of virtual encounters between exhibitionists (the site of Tina on her toilet) and voyeurs surfing the net in search of sites like Tina's. Techniques legitimated by the deficit of experiences...Techniques that repress the emergence of the other's body. Another's body that is staying at home more and more...The keyboard and the mouse as extensions of a body typing in the electronic address of its lacks...A use that, here, reflects a wretched experience of the self, or rather, a disparaging self-image. Sorin's She-Male is more akin to Benny Hill's characters than to the siliconed bodies of pornographic aesthetics. To wit, the staging of an ever-growing gap between the disseminated models and the spectators who identify with these same models. A staging and a use of video symptomatic of an era in which our relationship to the other's body is being undermined by the fear of HIV contamination. The culture of ersatz.

If others "are driving me out of my mind with their fucking motorbikes," if the neighbor can keep her geranium cuttings to herself, if organic bodies can stay outside and if we would rather shut ourselves up inside our kitchens for a good session of self-eroticism hostile to any form of exchange, then the atomization of the community to the profit of practices of the self is as good as done. The self (the body) has nothing left to do but turn inward. Lock yourself up inside and live with your self. But before sinking into an exhaustive catalogue of the different celibate statements made in art in recent years, a question: Are we doomed never to see any more formulations of exchange, and, especially, have we definitively entered a stage in History in which consciousnesses have turned away from the political and social sphere and withdrawn into the sole sphere of intimacy? As for this culture of intimacy, do celibate behaviors herald erotic and affective practices informed only by advertising culture and technology? Does the rise in the divorce rate and in single-parent family cells necessarily imply ersatz practices? Is there some way of using media culture that can lead to more open behaviors than those of Charles Ray or Pierrick Sorin?

1995. *If 6 Was 9* (Eija-Liisa Ahtila): Between documentary and fiction, on three screens side by side and simultaneously over the whole exhibition wall, five teenagers talk about their awakening sexuality. The girls take turns talking while their friends are seen going about their activities or listening to the story on the other two screens. Sexuality as a fundament in the construction of the self. Looking back at a period of initiation, from their first discoveries as children to their first experiences. Memories of a time when one of the girls, not yet school age, used

to pretend-play by herself that she was sick and surrounded by a doctor, a nurse, and some other people. Memories of letting the doctor examine her bottom with his gentle hands in front of several people. Memories that did not assume a conscious sexual form until much later, after she had dwelt on a scene from a pornographic film: "Then the picture showed only the guy's ass and the old man's hand and all that he stacked into it." The memory comes before the understanding and the picture makes it possible to read the memory. An interrelating of two periods (childhood and adolescence) and two forms (dreaming and observation) that makes it possible to construct her first representations of sexuality. A construction that hinges less on personal experience than on culture – and the way culture works on us inside. A construction whose fundaments hark back to a period in childhood when attention was easily focused on minor details in the narrative development of a tale – an attention carried beyond the narrative. On two screens, the alternating projection of two pictures from a Viewmaster slide show telling the story of the Pied Piper (the third screen remains black). Characters appear on a mountainside: "...I kept running the pictures back and forth...First there was an opening, then there was no more." On the third screen, a porn picture appears: "It was equally amazing to see in a porn magazine that men had no hole behind the testicles." The feeling came before its formulation, but now this feeling seems to be connected more often to the use of pictures than to the experience of one's own body. Experience has given way to the investigation of culture (watching and consuming disseminated images). The Viewmaster as a forerunner of the television remote. Its manipulation as a mode of questioning and learning. Decoding the image (consciousness) requires mastering the techniques put at our disposal. Constructing the self requires managing and reappropriating images produced by our culture. Michel de Certeau: "Thus, once the images broadcast by television and the time spent in front of the TV set have been analyzed, it remains to be asked what the consumer *makes* of these images and during these hours. The thousands of people who buy a health magazine, the customers in a supermarket, the practitioners of urban space, the consumers of newspaper stories and legends – what do they make of what they 'absorb,' receive, and pay for? What do they do with it?"[03] In the event, what the teenagers depicted by Ahtila are making is their own representation of sexuality. One girl does it with a children's tale, another with an article about a cannibal eating the women he's just killed (the media demonization of

03 MICHEL DE CERTEAU, *THE PRACTICE OF EVERYDAY LIFE*, TRANS. STEVEN RENDALL (UNIVERSITY OF CALIFORNIA PRESS, 1984), P. 31.

living conditions in cities). To wit, the creation of a tension between collective representations (the supply), striking events in the news (stories that make the news) and personal experiences (the questions). Life is a montage.

If the younger generations draw their information from magazines, films, TV and radio shows, must we conclude that they pattern all their behaviors and desires on advertising or fictional models (the parental fear)? In the words of a teenager with a look visibly inspired by women's magazines: "A gray day...no point going out...It's too wet. Hair gets curled up in a stupid fashion...I wish I was taller and more photogenic." Elsewhere, an offscreen voice and a shot of two of the girls meeting outside a supermarket: "It would be nice if somebody wrote a book about me." As if existence simply had to be written on the spectacular model. As if life had to be dreamed rather than lived. Is it possible to imagine teenagers projecting themselves otherwise? How can the effects of an identification with spectacular models be attenuated? How can we escape from the imperative of figuration (the alienation of teenage consciousness in looks copied from sitcoms and glossy magazines)? A room full of posters and photos of girlfriends: A young girl with an overly suggested look (I'm looking for myself) is spending her time cutting out pictures from magazines and making a series of photomontages. Collages made up of bodies from a porn magazine and faces of models from a fashion magazine. Articulate dream looks with vague impulses. A child's game that turns into a mode of appropriating adult fantasies even as it deactivates the still somewhat traumatic violence of sex. To overcome your fear, make friends with sex. Appropriating images as a way of appropriating our fears. Cut up spectacular representations and piece them back together in an imaginary space on our own scale. Move from compulsory figures (pornographic positions and figures of fashion) to the nutty things I do with my girlfriends. The move from posters (contemplation and identification) to cutouts (appropriation) as a key stage in growing up. Cutouts, collages, and play as metaphors for emancipation (detaching oneself from the model) and self-construction. Here, the extension of the sphere of play prepares the adolescents to confront a still hostile city outside, demonized by the media: "In every picture a couple showed how to do it in public places. We cut out the pictures and each of us picked one. My picture showed a car next to the Parliament building."

Here, the initiation and appropriation are not accomplished by each girl on her own. Images from the world of grown-ups are watched, discussed, and subverted among girlfriends. To wit, a structural attenuation of the spectacular

communication of behaviors, thought to unilaterally address passive spectators (who don't participate), isolated from one another (the impossible community). Here, the girls are sharing and exchanging. At times, they talk to each other (getting ready to enter the world of grown-ups and their sexuality), at others, they address the spectator – be it on a documentary mode (frontal shot) or on a provocative mode (extreme low-angle shot of one of the girls with her legs spread widely apart, but who stresses in her attitude and her voice her innocent girly side). The film's overall economy usually enables the spectators to choose the screen where they direct their attention, but here only the screen offering us this low-angle shot has anything on it (the peeping-tom point of view). To wit, a confrontation with the spectator who is invited to bring his or her senses and imagination to bear: "In fact, I am thirty-eight years old. I have woman's breasts and labia which open beautifully." To wit, the result of a whole history of self-education.

Fiction. Parental fear: Isn't there a danger that our children will lose the reference points that once distinguished fiction from reality (the demon of the virtual)? Isn't there a danger of confusing and blurring reality and projections, culture and self culture? At some point around two-thirds of the way into the film: "He was about a year older than me. He looked like a friend of mine whom I had fallen for in spring." The girl, as the spectator soon realizes, is talking not about someone she met but about a scene from a porn film: "That's why I checked out the story." The boundaries between reality and fiction are blurred. Television as a mode of questioning one's own biography. Projection as transference.

1987. *Family Viewing* (Atom Egoyan): High-angle shot of Van sitting on a couch in the living room, a teenager seemingly absorbed in a TV program, a remote in his hand. Zoom in on his face. The camera does not show us the TV set or what's on the screen. But we can hear from the tone of the dialogues and the canned laughter that it's a comedy show. Van's stepmother enters the room: "Was that our phone?" Van: "I didn't hear anything." Sandra: "Of course you didn't, with the TV so loud." Canned laughter. Van turns down the sound. Sandra: "Why do you always turn off the lights?" Van: "It helps me to concentrate." Canned laughter. She joins him on the couch, takes his arm, shrugs with an affectionate smile: "Why would you want to do that?" Laughter…"How was school?" Van: "Fine." Sandra: "What did you learn?" Van: "Not much." TV: canned laughter. Sandra: "Miss me?" Van: "Yep!" Sandra: "I missed you. I was thinking about you all day." TV: canned laughter. The lines on the TV program are covered by the dialogue

between Van and Sandra. Close-up of their faces drawing together. Silence. Hesitations. Van's grinning, punctuated by canned laughter. Lips about to touch. Freeze frame. Applause. Suddenly: Rewind. The sequence we have just watched flashes backward as if the stepmother were returning to where she was before she came in to disturb Van. Normal speed: Back to the picture at the start of the scene, the one of a teenager seemingly absorbed in a TV program, a remote in his hand. Image of an adolescent playing with pictures and feelings (reminder of the Viewmaster). So he must have been watching a videotaped scene. Was the scene a fantasy or a way of getting rid of an overbearing stepmother? Was it the tape or Egoyan's film that was wound back? Repression or an impasse in the story pictured by the director? Life is a blurring of planes. A blurring of images played and replayed. A blurring of dream pictures. A blurring of fiction, reality, and representation. The boundaries between the people and the characters are blurred. *If 6 Was 9*: Who's the young girl talking about? An old boyfriend or the actor? *Family Viewing*: What film is it about? Is the boy playing in the comedy he's watching on TV or in Egoyan's film? Did the stepmother actually go sit down on the couch? How did she get from the film to the video? Who's the viewer…the teenager or us? A projection or a confusion of planes of reality inherited from childhood? Experience gives way to its distancing. A distance that takes the form of a culture. A culture between life and the technologization of life. But this tech-nologization is not the prerogative of the zapping generation. When Van enters his father's bedroom, he comes across a video camera hooked up to a televi-sion and discovers that his father has been recording his lovemaking sessions with the stepmother over old family films, in particular films of Van as a child with his parents. Fantasies erase memories. Sandra's image erases his mother's. Van then sets out to look for the last films of his childhood. Leave the present behind to plunge into pictures of the past (the son) or project yourself into pic-tures of your fantasies (the father). In praise of distancing.

Does focusing attention on fiction (fantasy) necessarily work to the detriment of lived time? Doesn't the experience of images constitute a time that is lived just as much as a time unmediated by images? Does transference necessarily express a deficit of experience? Isn't the transference of the other and the self onto images simply a form of experience in its own right? A form of experience that involves appropriating technology (the private use of video) and images from pornographic culture. A disalienated appropriation of technology situated some-where between a remake of scenes that arouse fantasies and a sublimation of the spectator's position (voyeurism). Leave your place as a voyeur excluded from

the picture and make your own pictures of your own voyeurism. Take part in the process of constructing the voyeurist image, and choose the place in the production line that suits us best (rather than staying at the receiving end and letting others impose pictures that arouse our fantasies by playing on our incapacities of being)...Michel Foucault: "Sexuality is something we ourselves create – it is our own creation and much more than a discovery of a secret side of our desire. We have to understand that with our desires, through our desires, go new forms of relationships, new forms of love, new forms of creation. Sex is not a fatality: it's a possibility for creative life."[04] A look at new forms of relationships. Faced with an upsurge of impulses: make your own film. *Family Viewing*: On the edge of the bed, the father in a robe...On the bed, Sandra in a negligee. Wait. Telephone ring. Father answers...puts down receiver, presses loudspeaker button and continues conversation: On the other end of the line, a female voice...Zoom in on the TV screen hooked into a video camera next to the bed. Enact a scene, record it, and watch it, live or in playback, so as to reenact it. Sandra stares absentmindedly. Voice on the phone: "I dream of being with a man like you...I'd run my tongue on your chest." Sandra starts licking his chest (separation of functions). Father: "That'd feel good. And what would you be doing to yourself while you would be running your tongue over my chest?" Voice: "I'd be playing with my breast." Father: "Which one?" Voice: "The right one." Sandra complies...raises her right hand to her left breast...disapproving look...: Sandra drops her hand, and raises the other to her right breast. In the event, Sandra is neither the subject nor the object of desire. In the almost grotesque complexity of this setup, she is assigned only a function (playing with her right breast). Desire breaks down in the separation of functions and disintegrates in the absence of rhythm. The setup takes time to get going because the subjects of desire (the couple) are replaced by agents (the components of the setup). The father not only uses Sandra's body, he also dispossesses her of her voice (the telephone) and her gaze (the camera). To wit, a sequence of shots shifting between the room's drab colors (the lack of desire) and the tape's poor picture resolution (the fantasy). A shot of the possibilities and a reverse shot of the results.

More at ease and in tune with the new technologies of representation, *Trainspotting* (Danny Boyle): The eighties in Scotland, teenage curiosity, Renton steals a videotape from his friend Tommy on which Tommy and Lizzy have filmed

04 "SEX, POWER, AND THE POLITICS OF IDENTITY," REPRINTED IN SYLVÈRE LOTRINGER ED. *FOUCAULT LIVE: COLLECTED INTERVIEWS, 1961-1984* (SEMIOTEXT[E], 1996), P. 382.

themselves making love. Watching it, he realizes that something important is missing from his life. Rise of libido. Good reason to go nightclubbing. *Temptation* as an opener. Couples forming to the sound of disco music. Renton thinking about "the haste with which the successful in the sexual field, as in all others, segregate themselves from the failures." Blondie on the turntable...*Atomic*...: A beauty walks by the dance floor...Exit. Classy stuff! That's it...Renton's hooked...He drops his blasé beer pose and his thoughts about the ambient state of stupidity, and runs after her. She turns round just as he catches up to her...Brief exchange...Renton listens as she reels off the hackneyed line he was about to give her...What class! She hails a cab (Blondie still), climbs in and leaves the door open...Classy and astonishing to boot! A stunned guy and a stunning girl wondering what he's waiting for...(Blondie blasting)...long, deep kissing in the back-seat. A rock beat for bodies getting worked up...Cut: Tommy and Lizzy can't wait a second longer...Dying to screw...fall in through the door to their apartment, tearing each other's clothes off, tongues digging into mouths, gasping, on the verge of suffocation (Blondie more than ever)...Cut: Renton can't believe his eyes...the precision and confidence of her gestures...She tosses a condom on the bed, drops her dress, no underwear...: nothing left for Renton to do but take off his underpants...Cut: Tommy and Lizzy, burning with desire, bodies pressing hard against one another as they finish undressing: "Tommy, let's put on the video. I want to watch ourselves while we're screwing..." Grabs the remote (Blondie all worked up). Presses ON...: "and he's picking up the ball from the outside...and I think he's gonna go...yes, he's gonna go all the way... he's gooooone...What a magnificent goal!": Tommy's eyes are popping out of his face: Their tape is gone...Tommy and Lizzy stop dead in their tracks (maybe he returned it by mistake to the video shop). Cut: She's riding Renton like crazy... (Blondie on the verge of exploding)...Rocking him hard...Bodies stiffen: orgasm in the chorus...Renton dripping in sweat. Cut: Lizzy throwing a fit at the idea that every fucker in Edinburgh is jerking off to their video. Tommy going berserk looking through all his tapes...Cut to Renton being thrown out of the room. A heap of clothes in his arms. Life is a mise-en-scène (the use of rock and video). The bass as a libidinal particle accelerator. Impulses that beat to the rhythm of pop culture and pictures borrowed from porn culture (the remake) to heighten pleasure. To wit, an appropriation of music and pornography. Home porn.

If Tommy and Lizzy manage to enjoy the mediatization of their relationship, it is because they have turned sex into the object of their desire. Sandra desires Van (the position of subject) but puts up with his father's obsessions (the instrumental

position). Her relations have no object. The technologization of the relationship to the other fails because the projection of the fantasy onto the image is voiceless. When she tries to seduce Van, her gaze and her voice match the forms of her desire, but when her partner calls on the voice of another (be functional and shut up), he deprives her of her capacity to desire. Voiceless bodies, speechless pictures. Speak bodies when images fail.

Back to If 6 Was 9. The protagonists in Eija-Liisa Ahtila's film recount different experiences, but none of these experiences are pictured on the screen. In the event, the pictures seem to be subjected to the words. Pictures that show the girls doing some of their favorite activities (playing piano, flipping through magazines, daydreaming, playing basketball, etc.)…Pictures that situate them in a social sphere (middle- to lower middle-class) and age group (teenagers). Pictures as a mode of representing the group. Speech as a mode of representing the self. Introduction. Blank screen to let us listen to a few clichés: "Oh…Ah…Yeah… No more!…I can't now!…Don't touch me, please!…It was incredible…I have never…My head is spinning and my legs are shaking…How many times did we do it?" Intimacy is given to hear more than it is given to see.

The proliferation of radio talk shows for teenagers providing them with an arena for relating their affective and sexual experiences as testimony to the growing importance of talking in the construction of subjectivities. The body is spoken more than it is shown. The radio as a social bond. The exchange of experiences on live broadcasts or in chat forums as the mode of exchange (cafés and city parks in the past). Theorists of the breakdown in social bonds may not realize it, but the younger generations converse more than their elders may imagine in their nostalgic yearning for a form of being-together founded on outdated modes and contents. If social bonds are asleep during the day, they are wide awake at night (when grown-ups are asleep). From the first rave parties in Detroit warehouses to chat groups on the Net via hot discussions on the radio, young people continue to communicate with their words and their bodies. A far cry from the "embarrassment all around when the wish to hear a story is expressed" that Walter Benjamin saw as a sign of an end to "the ability to exchange experiences,"[05] experiences which now seem to be developing in other forms and on other networks. Forms and networks where representations are built out of

05 WALTER BENJAMIN, "THE STORYTELLER" IN ILLUMINATIONS, TRANS. HARRY ZOHN (SCHOCKEN BOOKS, 1968), P. 83.

material drawn from the field of images, but where experiences are translated into words. If, to borrow Giorgio Agamben's terms (in the lineage of Benjamin), "just as modern man has been deprived of his biography, his experience has likewise been expropriated," and if "his incapacity to have and communicate experiences is […] one of the few self-certainties to which he can lay claim,"[06] then are we to conclude that there is no transmission of experience anymore? Just imagine that the transmission is now taking place via the media (retransmission). If images mediatize experiences and ways of being in the world: Use it.

ALL I WANT IS REGRESSION (THE CD IS MAN'S BEST FRIEND)

A question before continuing: Is the function and relevance of pictures overrated in relation to sound tracks? Sound tracks that dramatize the news (the repetitive, haunting music accompanying pictures of and comments on the Vietnam War). Sound tracks that heighten the emotional content of fiction films and neutralize and standardize our behaviors in public places (Muzak). What have we retained, for example, from the Gulf War? Not a single image. On the other hand, our representation of military operations was informed by a media metrics, a refrain, a scansion of events and facts (Now over to our special correspondent): "According to the Pentagon…" (the validity of the statement versus the truth of the picture) "…twenty-three civilians were killed" (numbers versus visual impact). The event is an inflection. The binary beat (the origin or place of the news / the description of the news) as the structure of our representations. What do we retain from a TV commercial? Pictures or sounds? If your Rice Crispies snap, crackle, and pop, it's thanks to sound designers who've amplified those nice crispy sounds. What do we retain from a TV program on corporate life? French network TV program…*Capital*: hand-held shot…tracking through an office…the pace of the camera moving from room to room synchronized with the rhythm of employees working. On the other hand, only the brevity of the descriptions and the dry tone of the commentary can translate the energy inherent in the corporate form and the pressure on the employees (orders, reports, criticism). The rhythmic cutting as reproducing the rhythm of corporate life (stress, efficiency, time-saving). If film, and the (visual?) arts in general, give pride of place to the visual dimension, this may be because the history of painting was long linked to the representation of space, and to landscape in particular…But what do we see of landscapes today? What do we retain from a drive through the

06 GIORGIO AGAMBEN, *INFANCY & HISTORY, ESSAYS OF THE DESTRUCTION OF EXPERIENCE*, TRANS. LIZ HERON (VERSO, 1993), P. 13.

residential outskirts of Chicago or a 1,153-mile trip on the highway from Barcelona to Berlin? A quality of asphalt that ensures perfect road contact, an increasing scarcity of bends in the road, an ever-growing uniformity of service stations, and a succession of signs signaling cities we never see...To wit, the repetition of sameness and the monotony of driving. If landscape is practiced (the user) more than it is seen (the tourist), if landscape sends no more signs: Turn up your car radio and give depth to your soundscape with an autosound system that offers the full-range quality of home-theater Dolby surround. The surround effect and the power of the bass guitar in *Fascination Street* (Cure) so you can feel the accelerations on the fast lane while you're overtaking on Michigan Avenue. Khaled's Rai (*Didi*) to match the form of Nanni Moretti's zigzagging through Rome on his Vespa (*Dear Diary*)...A swaying ride cruising through a decor of facades that don't retain our attention or send us signs anymore. Car radios and walkmans as mediating between the environment and the user. Sound tracks as a key form of representation of the self in the landscape. Work the soundscape.

For the younger generations, sound tracks seem to have more significance than pictures in the construction of the self: The world is listened to more than it is seen. Sound tracks and music as the main modes of representation of the world and of access to others. Sound tracks speak to us more than pictures do because they transmit a personal and affective memory (the time when she didn't take her hand away). Pictures transmit collective memories with which we rarely identify: How can you identify with pictures of the Berlin Wall falling when you've had no experience of the Cold War? How can you identify with Hollywood blockbusters when the characters and situations they propose are so excessive and inhuman that it is impossible to recognize yourself in them? How can you identify with sitcoms and movies that do nothing but caricature the specificities of the social groups to which we belong? Over the past few decades, music culture – from its underground or alternative expressions to its most commercial forms – has participated in the construction of the History of contemporary society through the production of a number of models, references, and individual or collective ways of being that are no doubt more significant for the younger generations than visual culture. 1996. *Amsterdam Global Village* (Johan van der Keuken): The lyrics of a song by a young rock group transmit a political stand on the former Yugoslavia, and the refrain gives rhythm to the movement of the camera as it follows the passes and dribbles of some soccer fans playing in a yard. Just feel it. *Trainspotting* (Danny Boyle)...A movie filmed in 1996 about a bunch of friends in Scotland in the eighties...A movie that starts with a chase

scene played to the rhythm of a typical eighties song, a song that sets off a series of hits that teenagers, like the ones portrayed in Boyle's film, listened to while they were living their love lives and taking their trips...hits that gave rhythm and shape to their imaginary world...an imaginary grounded in a rejection of the community...Desert the street and the community and get into Lou Reed, Blur, Iggy Pop, Pulp and Blondie. Be the music that moves in you. Move to the rhythm of the bass guitars (the trance). Turn up the music and tune out the din of the world. Dolby as a reducing agent for the sound and fury that clashes with our desires, for an optimal self-to-environment balance. Sound tracks as the territory of a self bruised and battered by what's outside.

1997. *Happy Together* (Wong Kar-wai): Between work in the kitchen of a restaurant and the four walls of a squalid room, an uprooted couple is unable to build a relationship. The lack of air, sunlight, and space for atmosphere. The nagging pain of not reaching the other as the sole sensation of being in the world. Outside the room, a few shots of a scale-model city with cars whizzing through it in fast motion. Two incompatible speeds: The slow pace, intercut with wild jerks (impulses), characteristic of a desire that can't seem to take shape (a story for two), and the velocity of city activities. To wit, a feeling of discontinuity. The last shot in the film as a sign of the incapacity to escape fantasies (the affect) structured by musical forms: One of the two lovers steps out into the city night, filled with garish, fluorescent signs (the pop video), his head bobbing up and down to the rhythm of "Happy Together" (the song). To wit, an illustration of the projection of the self onto an outside that cannot be experienced without the help of a surrogate rhythm. Sound tracks as prostheses for coping with the outside...An outside with which the individual reduced to h/er sole desire to love has nothing to share. Sound tracks of the self (the desire) versus pictures of the outside (the social). Internalize the feelings disseminated in clips and get into a headtrip. Live to the rhythm of guitars.

1997. *The Same Old Song* (Alain Resnais): Dispossessed of their ability to experience a situation directly and to feel the presence of others without mediation, the characters in Resnais's film interrelate through a series of affective postures dictated by social scores and atmospheres conducive to bringing together bodies and needs...scores and atmospheres that have been played (programmed) for more than twenty years on radios, walkmans, record players, television, in night clubs and in supermarkets. Move to the rhythm of the dullest, most widely shared refrains and guitar riffs in the repertoire of French song (Arditi and the others do

not so much experience life as they embody attitudes suggested by the hits they listen to). Whenever the emotional dimension enters the parameters of a situation – be it in the form of a need to make a declaration of love, a feeling of being fed-up or a desire to feel alive again –, the characters stop talking and burst into a song that perfectly sums up this same situation. If songs run through us, if they move inside us, if they speak to us (and for us), if they speak our minds, they can never do more than project bodies against one another (*Take Me Higher*). The body as an echo chamber for refrains and rhythms that modulate our emotions and shape our feelings. Stick a U2 song (a sound) onto a memory or a desire to meet someone (a picture) and believe in it for three minutes and thirty seconds. To wit, an intimacy organized and structured by free time, the ability to temporarily get rid of stress, the geographic and climatic environment (a lovely view, a setting sun) and the desire to tell you that "I still haven't found what I'm looking for." To wit, an aggregate of attitudes sampled from the sociocultural landscape. Julien Husson: "In Resnais's work, bodies are all presented, and perhaps conceived, as *toons* of sorts, mechanical objects oddly incarnated, the last avatar in a process of dehumanization. This is why the issue of 'what a body can do' – find a voice – seems to be so sharply *granted* in his films. There is something decidedly *frozen* (cryogenized?) that will never find its rhythm on its own. [...] Can bodies belong to another 'region' of time besides the inhuman?"[07]

1876. *L'Inconnue* (The Unknown Woman, Villiers de L'Isle-Adam): Having fallen abruptly and passionately in love with a very beautiful young woman, the naive young Félicien de la Vierge declares his feelings to her. Apparently quite consumed by emotion, he spouts off a series of clichés: "In one moment you have become my very heartbeat! How can I live without you? The only air I want to breathe is yours!" Irritated, she replies: "Monsieur, the feeling responsible for your pallor and your bearing must indeed go deep [...]. Alas, the trouble is that you think that what you are saying is peculiar to you, my dear friend. You are sincere, but your words are new only for you." And delivering a final blow to her poor lovestruck admirer, she tells him that she's deaf...that she doesn't hear him but that she knows what he's saying because it's always the same old song...that we are spoken (cliché-ridden): "For me you are reciting a dialogue of which I have learnt all the answers in advance. For years now, it has always been the same for me. It is a part in which all the phrases are dictated and enforced with truly

07 "DOUBLE MESSIEURS," *LA LETTRE DU CINÉMA* 5, SPRING, 1998, P. 3.

dreadful precision."[08] Today? The young man's declaration would make it to the top of the hit parade. What is the difference between Félicien de la Vierge and Pierre Arditi wondering "How can I tell her"? The commodification and technologization of emotion. An emotion that's on sale@music.com and the hope that she won't take her hand away available for playback on four channels and two sound speakers with Dolby Surround Prologic. But doesn't this mode of letting ourselves be carried by songs that we reappropriate lead us to definitively cut ourselves off from the outside in the sense that it individualizes us and removes us from the crowd (the walkman versus the community)?

Close shot of a clientele barely out of adolescence. 1994. *Alexia* (Ange Leccia): In a sweater…alone in her room…a young melancholic looking girl singing an Elton John song. In another video-projection she'll be singing to Daniel Balavoine, David Bowie, or Claude François. Three to four minutes worth of sentimental fiction that she knows by heart and that she appropriates as her own. Her eyes are lost in nostalgia or desire. Nostalgia (the past) and desire (the eventual future) as enacting the difficulty of conjugating the self in the present. Her voice no longer addresses anyone (the abandonment of the present); it patterns itself on lyrics (mental pictures) that, for want of coming true in lived time, give rhythm and modulation to a surrogate affect. Cultural products are substituted for real presence and for the experience of being-together. The record industry as the locus of emotion production. Listening as emotion consumption. Use as feeling. Technologization as environment. 1967. Guy Debord: "Technology is based on isolation, and the technical process isolates in turn. From the automobile to television, all the goods selected by the spectacular system are also its weapons for a constant reinforcement of the conditions of isolation of 'lonely crowds.'"[09] 1994–97. *Anna* (Ange Leccia): A young woman's stroboscope-lit face to the looped sound of disco music. Consider, a one-hour video-projection. With the tight close-up of her face covering the entire wall, the video image projects us onto a dance floor. Dance all night opposite a girl who has put on too much makeup and who keeps striking poses straight out of *Vogue*. Birth of a sense of discontinuity. If traits and expressions are put on after applying foundation, hiding blemishes and wrinkles with a cover stick (Shiseido, Bourjois, Shu Uemura) or concealing cream (Chanel's Extreme Estompe Cover Up, Clinique's Soft Concealer Corrector) and using a swivel-out brush to apply transparent (certainly

08 IN *CRUEL TALES*, TRANS. ROBERT BALDICK (OXFORD UNIVERSITY PRESS, 1963).
09 GUY DEBORD, *THE SOCIETY OF THE SPECTACLE* (HTML VERSION, BLACK & RED, 1983).

not tinted!) face powder for a flawless finish, then real presence breaks down into images. Discontinuity between the movements of a young woman absorbed in rhythms and figures imposed by advertising aesthetics (the projection) and the contemplative immobility of the spectators (the exhibition room). Discontinuity between Anna's exposure (the incommunicability of the self) and the spectator's inability to get through to the body of the other. The exhibition as spatializing a frustration and picturing a display. At times, the quickening of the stroboscopic rhythm reduces the image impression time (the retinal persistence) to the point that her body and face disappear (gain in abstraction). The visuals break down into rhythms. The desire for bodies is lost in the focusing of the self on its own movements. Move to the rhythm of the sounds that inhabit us. Be the rhythm (the beat) that inhabits us. Keep to the rhythm of the music so as to drive away the body of the other (after-hours nightclubbing to avoid falling asleep in his arms). In the absence of an experience of the other: experience culture and the technologized body movements it offers. The CD is man's best friend.

For Alexia, the appropriation of pop music is built on an absence of bodies – an absence of a sense of self in the present. If Pierre Arditi, with his hair turning gray, simply hasn't the strength left to change the story of his own life – and lets the social fiction suppress any remaining desires so that he can more easily fit into a paradigm of aging-together based on the physical proximity of bodies that cannot arouse each other anymore –, Alexia, with her sightless stare, seems to have already relinquished the thought of starting a story of her own. Words (stories) run through her and touch her without triggering the slightest desire to experience what she is happy to dream about. You're My Heart, You're My Soul. Transitional songs (Digital Transfer). Abnegate your own memories (lived time) and let yourself be carried by collective memories (transferred time). Collective memories reduced to replaying cultural products designed to liven up a party or a walk on the beach and rekindle our hopes that she won't take her hand away. Collective memories made up of intimate moments repeatedly ad-libbed in pop forms and rhythms (the personalized product). The intimate moment is the most common territory that exists. Intimacy as repetition and sum total of the nicest commonplaces. For Alexia's generation, the will to act (to go out) gives way to dreams (the bedroom). Construction gives way to emotion. The project (lived time) is abandoned to the profit of reception (culture). The hit versus the story.

1998. October Love Song (Rebecca Bournigault): Alternately, over an entire wall, two hour-long projections. First video: In the corner of a bedroom, a young

woman in teenage attire insists on making a young man listen to a whole series of hit singles that she grew up to. A series of souvenir singles that supplied rhythm to the emotions and affective events of her teens. She's French, he's English. She sings along to certain refrains, gets carried away to the rhythm of her memories, switches to another song…"Do you know this one?"…He nods his head…Starts listening with half an ear…picks up the CD cover…looks at it at length…he doesn't understand French…gazes off into some distant place with no connection to the music playing. Time stretches out. The first bars of a song have hardly begun and she's already moving onto the next. Stop. Next track. Barely the time to get into the beat…The inability to concentrate for the three to four minutes of the song begins to set the pace of the evening. Mounting excitement. The desire to share turns into childishness. A desire to share that comes up against the hegemony of Anglo-American good taste (culture shock). Too French. When the local tortures the global…Aware of the cultural gap between them, the girl looks for some English-language singles (the attempt to narrow the gap)…Intensification of search and childish excitement. The guy tunes out. His body is still in the frame (politeness), but his mind is elsewhere (What the hell am I doing here?). Impossible meeting between two behaviors and two cultures. Impossible meeting between a childlike behavior resurfacing with enthusiasm (listen to this…and this…and this, it's too much…) and a polite manner of being bored out of his mind (silence and absentminded gaze)…Meeting between a French pop culture shared by all those who wouldn't consider missing a Saturday night music and variety special hosted by Michel Drucker or Guy Lux and an Anglo-Saxon rock culture that can't figure out what all the excitement is about…But the child ends up wearing herself out (time to go to bed) …The bodies curl up to the sounds of wearily repeated notes. She calms down… He falls asleep. The silence of the picture matches the respiration of the sleeping body. Sensual abandonment of the present. If bodies share the same habits, their sensibilities are not informed by the same tunes. Cultural exception as emotional exception.

Second video: The same young woman, this time in the company of a girlfriend who seems to share the same culture (the same memories). Trendy looks: Faded clothes, cool makeup and all the signs of belonging to the latest in hip micro-communities. A hip look, in overexcited teen style. Two chicks singing at the top of their lungs hit singles from their teenage years and jingles from their favorite children TV shows. Two trendy chicks (one with two fake teeth) who have no qualms about listening to tacky music. Two chicks having a blast: "How

about this one? Yeeeeaaah…" Eyes shining, hands clapping…"Chapi Chapo" as "a must." Two chicks closer to their thirties than to the age of reason. Two girl-friends who share memories (the things we used to listen to on our Fisher Price players) rather than a way of being in the moment they are living (the present). Two friends who spend more time remembering than conversing. As if feelings could only be territorialized in a *yesterday* (nostalgia). Teenage dreams and attitudes (you and me against the whole world) – or children's (*Yeeeaaah*) – in grown-up bodies (the deformity of the imagination). A rock 'n' roll generation of kids who have not yet thought of a good reason to leave their rooms. Life is a big chest of toys.

To stay stuck in the corner of your room for two hours. Listening (the passive form) to a culture of entertainment and emotion accompaniment versus movement (the active form). A desire to stop growing up (freeze growth) that comes down to losing all interest in whatever the songs do not say (Please don't bug us with all that dull crap of yours: we're having a blast). The no-complex attitude toward tacky music ("this is so nifty") and the affective immersion in a past regarded as a period to be maintained as long as possible (the thoughtlessness and carelessness of acts) to complete a sense of detachment from a community regarded as a drag. Pretending innocence. To wit, an expropriation of the capacity to project the self onto the outside (building and sharing meaning in the community) orchestrated by the top sales of the week. Filming the self as an exacerbation of the lack of interest in the Other. Fun autism or loss of consciousness? Provocation or abandonment? The bedroom as a space of repression of the world. The bedroom as a locus of withdrawal from History. A History that we don't want to hear about. Run away from History's uncertain, collective time to take refuge in the repetitive, reassuring private time of our own biography (that's me in the photo). The mirror stage as an insurmountable period in the development of the self. Turn the camcorder on *me* (turn it away from the world) and invest the whole of the camera field so as to eliminate all other images of the world. The building of a bubble of intimacy with the man or woman of my choice as sole project. The closed space of the bedroom (the sphere of intimacy) versus the city (the political and the social). Regression versus insertion. The hope that he or she will not take his or her hand away versus all the elections in the world. Idle hours versus working hours. The corner of the bedroom as figuring the shrinking field of the imaginary.

The words of a song versus the words of the world. Run away from the present time (what I could live with others) and let yourself be carried by the time of rock music and popular culture. Headphones on your ears versus the circulation of words. Step out of the world and project yourself into emotions available@music.com. Run away from the experience of the world and take refuge in the experience of its representation. The refrain as existential horizon. The song's playing time as sole lifetime. The exhibition of a self delimited and produced by the lyrics I listen to. A self carried by a tune…Guy Debord: "The alienation of the spectator to the profit of the contemplated object (which is the result of his own unconscious activity) is expressed in the following way: The more he contemplates the less he lives; the more he accepts recognizing himself in the dominant images of need, the less he understands his own existence and his own desires."[10] In the event, my alienation to the profit of my favorite song is expressed in the following way: The more I listen to this really nifty song the less I live; the more I accept recognizing myself in the dominant lyrics and tunes expressing the need for an emotion that makes you cry so much it's awesome, the less I understand my own existence and my own desires. Live no other experiences besides those expressed in my favorite hits. Live emotions by proxy.

If the outside elicits no desire (it's all a drag), if the community is experienced as a space of dissolution of the self and alienation of consciousness to professional activities (nothing but hassles) that don't concern us, then stay in your room with your records (your emotions), your posters (your dreams), and your small TV set (my perception of the outside). 1986. Postulate: *I'm Not the Girl Who Misses Much* (Pipilotti Rist). On a monitor, a blurry picture, slightly masked by a glossy, opaque screen. Music: Bare-breasted, a twenty-four-year-old half-woman half-babe, spinning every which way, waving her arms about hysterically, getting all worked up as she sings a John Lennon refrain ("She's not the girl who misses much"), which she appropriates through identification ("I'm not the girl who misses much…I'm not the girl who misses…I'm not the girl who misses much…" ad lib) and through her disruptive use of the remote. Speeded up: My gesticulations get more and more ridiculous and my voice sounds like a little girl's. Slowed down: My voice deepens…the whole of my body is plunged into red…Back to normal speed for a few seconds…I'm grown up…Very high speed: Shrieks and total disarticulation…I'm turbulent. A body technologized to the hilt for maximal temporal regression. A kid who plays with the remote controller of

10 *IBID.*, PARA. 30.

her own image. 1996. *I've Only Got Eyes for You (Pin down jump up girl)*: Freeze frame of a mature woman jumping for joy, frozen in mid-air, her tongue sticking out, a remote in her hand…Frozen in a photographic representation, Rist is bare-breasted, she has underpants on, and her hair is white. The inability to project yourself outside your own room (outside the self) imposes a necessarily regressive mode of behavior, and the regression is necessarily conjugated in the first person. A first person disconnected from the body. To wit, a widening gap – a split – between an "I" that regresses and a body that ages, and that has more and more difficulty forcing itself into the narrowness of the imaginary world delimited by the TV set. To be incapable of experiencing and seeing your own body from any other point of view than that of your childhood. The body as sole preoccupation and sole object of contemplation (the negation of others and of the world). The body becomes landscape. Explore and rediscover oneself by formally manipulating the body (technical regression). Resize our living environment to fit the scale of our images.

1994. *The Room* (Pipilotti Rist): An oversized lamp, armchair, and sofa opposite a TV set showing videos of the same Pipilotti Rist. Consider an invitation to plunge into a space and time forgotten since childhood: "Sitting in a huge armchair made you remember the time when everything used to be too big and too high, but it was also a time when you knew: it's all mine. For children the whole world belongs to them."[11] If the world does not belong to us anymore, if we experience it with a sense of being expropriated from a space of our own, have we no other choice than to sink into the armchair onto which we used to climb when we were kids (the comfort) and sit back enthralled by the exploration of our own image…an image removed from the world and projected into the magma of harsh fluorescent colors borrowed from a pop video aesthetics (the distancing of History)? How can the desires of a grown-up body be articulated with the urge for regression?

1992. *Pickelporno*: Two bodies caress each other to the sounds of children's voices, New Age vocals, whispering, a heartbeat, and synthesized noise. Extreme close-ups of scalps, phalluses, flowers, plants, eyelids, areolas, pubic hair, orifices, and navels…Tracking through the depths of the sea or beneath the clouds (formal regression). Curl yourself up inside a protective sea or take off into the

11 "LAURIE ANDERSON AND PIPILOTTI RIST MEET UP IN THE LOBBY OF A HOTEL IN BERLIN ON SEPTEMBER 9, 1996," *PARKETT* 48, 1996, P. 114.

sky to get your feet off the ground. The quickening pace of pictures and breathing for final orgasm. A climax in wonderland. Resize our impulses to fit the scale of our regression or reconstruct a body that has no image yet, a body to come. 1994. In the middle of a room, a cylindrical structure, 350 centimeters in height, 240 centimeters in diameter (11.5 by 7.9 feet), with an entrance on either side: *Corps étranger* (Foreign Body, Mona Hatoum). Inside this structure, a circular video image under our feet: the internal organs of a female body explored by camera. Illusion of following a subjective camera…Plunge the eye into the body and follow the progression of an endoscopy and colonoscopy…Immerse oneself in the internal organs of a body that could be our own…Project yourself into a trajectory where cavities and walls follow from and merge into one another…An abstract body. Desa Philippi: "Here we are confronted with a look that fragments and fractures. The completeness of the figure, that is usually suggested by an emphasis on its contours, is substituted for details that can no longer be assembled into a whole. […] To speak about these video images as 'details' or 'close-ups' is misleading in a way because they do not clarify or explicate a larger entity. Precariously balanced in such a way that they still read as close-ups of a female body, we are constantly aware of how fragile that identification is and how easily it slips into a terrain of associations that quickly turn the body into other figures […]"[12] Associations that turn the body into regions of introversion…Feed your eye with yourself…A descent into the body… Abstract yourself from the outside once and for all. An abstraction dramatized by the amplified sound of breathing and a heartbeat recorded by ultrasound scan. A breathing and heartbeat that accompany – and give rhythm to – the speed at which the camera and our eye move through the body. A subjective camera at the core of our inner side. Beyond the voyeurism: The body turned inside out, a public exhibition of what we still have left that is shielded and preserved if not intimate (since nothing is more anonymous than the interior architecture of a body). Enactment in images and trajectory of a proximity to the self… A proximity to the self encouraged by a culture of attention focused on the body (the development of forms of prevention). A culture of attention focused on the self wherein anatomical details and singularities constitute an end around which a good part of our lives revolves. Medical monitoring as a form of self-representation. A form that allows us to identify with the progress of a disease…Recognize a picture representing the ailment from which we're suffering and with which

12 "SOME BODY," PUBLISHED IN FRENCH IN *MONA HATOUM* (CENTRE GEORGES-POMPIDOU, 1994), PP. 28-29; THIS UNPUBLISHED ORIGINAL ENGLISH LANGUAGE VERSION WAS KINDLY MADE AVAILABLE BY DESA PHILIPPI.

we end up identifying…In the event, the progression of Hatoum's camera acts as a radicalization of the appropriation of the sole register of images still capable of circumscribing a part of the self. A register of images, a form of representation, whose only point of view is that of medical treatment. A form of representation that has not yet been instrumentalized…A form devoid of psychology and subjectivity…A form that informs us without prior assumptions and that, for the time of the treatment, builds a narrative of the self that accords with what we are living and feeling.

If, for spectators who are not undergoing a treatment necessitating an endoscopy or a colonoscopy, the pictures in *Corps étranger* may seem abstract, if they seem removed from us in the sense that they do not pertain to an image register that we are accustomed to experiencing, the dramatization of the breathing and heartbeat reduces the distance that we are tempted to keep with the device. A dramatization (amplification) that carries us, picks up our breathing and our heartbeat and makes them its own…duplicating them and drowning them out. A device that grips our senses and ends up inhabiting us totally. Let yourself go to the rhythm of the spectacularized representation of a breathing and a heartbeat that you never hear…The breathing and the beating of the heart as the ultimate signs of the self (our last *own*). Representation of an infinitesimal singularity…A singularity that, in our overattentiveness to it, keeps pushing the bodies of others a bit farther away from us, and us a bit farther away from the community. Stay attentive to the self, listen to your body. Or when the visceral ends up abstracting us from the community…

Before the image was the sound. Flashback to an intrauterine state when our first sensorial contact with the outside was through sound. 1996. *Something Between My Mouth and Your Ear* (Douglas Gordon): In a dimly lit room painted in blue, thirty songs heard between January and September 1966. To wit, the nine months in which the artist's mother was pregnant with him. Carrying music. The spectators leave the visual field to plunge into the choruses and solos that carried the emotions of a mother. In the mother's womb, hearing is the first sense that puts us in contact with the world outside. Birth of my first mode of representation. A mode of representation that accompanies us from early childhood ("Chapi Chapo") to adulthood (*The Same Old Song*) via adolescence (*Go Your Own Way*). A mode of representation without images. A mode of representation that can do without the world and the images it projects of itself.

In praise and need of a clip or refrain form…If, from now on, our modes of belonging to the world have more to do with what's fleeting than with what's lasting, if our relationship to the present is based not so much on saving now and enjoying later as on immediately satisfying our senses and desires, then the experience of today derives from the immediate consumption of the moment. Long narratives (ninety-minute time slots or three volumes of five hundred pages) for savings (with remittance at the final scene) and short narratives (the clip or the song) for immediate satisfaction ("Why Don't We Do It in the Road?"). If our desires and our life stories (adventures) can fit into a song, why stretch them out?

1972. *Memory Box – Performance Spaces*, School of Visual Arts, New York (Vito Acconci). A mattress in a black box and a confessing voice, harping obsessively on the same terms: "I hate myself for hesitating every time I start to touch you…I hate myself for giving in to your terms, to your casualness, to your withdrawal from me…I hate myself for my confusion, for being puzzled by your reasons for seeing me…I hate myself for drawing back, looking down, grinning sheepishly, when you turn quickly to face me."[13] A confession in the form of whispers, moans, groans, wailing, and grumbling. A story of the self that turns into a refrain…A whole stereophony of the body and of reasons searching for release. A voice struggling to get out of the body. But is this "I" speaking to us? Aren't we put into the position of the person confessing? Should we go lie down on the mattress and listen to this voice talking to us, if indeed it is this voice that is doing the confessing?…The spectator-auditor as the artist's psychoanalyst. Or perhaps we are lending our bodies to the voice we are hearing…Isn't this confession our own in a way? If we identify with this voice, if we let it carry us until it says what we are feeling, then the mattress is our couch…A couch that turns the black box into a psychoanalyst's office…A black box that contains enough personal information to constitute an individual memory…Listening to a personal memory (*Memory Box*). Listening to a voice that can't seem to settle anywhere or on anything. Acconci's voice – the deep, husky sound of his voice – evokes drifting and process…Minute variations on a haunting refrain. An unstable "I" talking about itself, drifting around a form that resembles a long solo… An "I" qualified by the intonations and the grain of the voice (information that the words need not convey). An "I" addressed to the other and to the public. An "I" to be adopted by the spectator-auditor. Vito Acconci about Van Morrison and Neil Young: "In the music of the early seventies, what interested me was a kind

13 *AVALANCHE*, FALL 1972, P. 64.

of single voice, long songs, very much this kind of solo performer – almost like early work of mine. In a long song, this single voice has time to find the self. You sort of drift around yourself, you're constantly renewing yourself, developing yourself. But it needs time to do that."[14] The same year, *Anchors* (Vito Acconci): In the middle of the room, a few rocks in the form of a circle (as if to make a campfire), an unusable cot of sorts, a wooden structure polished in a way that suggests a piece of furniture, a blanket lying about, women's underwear and nightwear. Absence of bodies and heavy atmosphere. At either end of the room, a white mat – one placed vertically on the wall, the other on the ground: An invitation to press your ear against a speaker hidden behind the pillow to listen to Acconci's alluring whispers. A "grain of the voice" that allures us…that compels us to step out of our distant – critical – attitude as spectators and go lie down. To be more relaxed and less attentive to the codes of conduct in public. Forget our codes of critical reading and grasp the work sensually. A voice calling not for the representation of bodies but for their presence. When it comes to articulating intimacy, confessions, novels, and poetry hold readers at bay, maintaining them in the position of voyeurs prying into a private experience and space. In the event, Acconci's invitation eliminates the division separating the author's voice from the reader-listener. Shift from voyeurism to embodiment, from reading to listening. The spectator-auditor steps into a real space (a gallery, an arrangement of objects) to embody a voice, to pick up a long solo, for the time it takes to find the self, to enact (play) a piece of fiction. A private space that absorbs public space. An aesthetics of adhering to the intimacy of the other, an intimacy that becomes our own for the time of the experience.

If the search for the self could constitute an issue in the seventies, and if this search could engage the subjectivity of the spectator-auditor, did it have to remain isolated in a space that repressed everything that did not concern intimacy? Was the desire for proximity to the self not, in fact, a way of definitively cutting oneself off from community and History? Vito Acconci: "By 1974, I began to think of the self differently: the self isn't something that you isolate and put into a meditation chamber; rather the self exists only through a historical system, a cultural system, a social system, the self exists only through and by these systems. I began thinking that the self is formed by the situation you are in."[15] A self,

14 INTERVIEW WITH THE AUTHOR IN *ENTRETIEN/INTERVISTA/INTERVIEW* (CENTRE CULTUREL FRANÇAIS DE TURIN, 1999), PP. 136-137.

15 *IBID.*, P. 134.

a desire for self-construction searching for a way to get out of the introspective trip (withdrawal into the self). A self that starts skipping sessions...Get up off the psychoanalyst's couch (the mattress) and put some distance between us and what's suffocating us. Step out of my personal memory (*Memory Box*) and try to articulate the self that obsesses me with a collective memory. Get out of the coming-and-going-between-you-and-me imaginary and find a common imaginary...1975. Leave your home (New York) and do some traveling (Portland)...: *Voice of America*. Over nearly the entire gallery floor, the projection of a map of some part of the United States, and immediately above it, at ankle height, a thin cord stretched from wall to wall, serving as a trap for the visitors and as a grid – a representation of illusory boundaries, delineating states, regions, and places that nothing sets apart. Projected onto the map, photos of landscapes. Crossing this abstract representation of the country with giant steps, the spectators. High over this representation, just below the ceiling, two giant chairs intermittently illuminated by a flashing light ("seats for a mythical Mr. and Mrs. America"[16]). Allegory of a culture of excess, enormity, and control. Scales inverted. Bearings scrambled. Seven-league boots for Lilliput. From out of nowhere comes the barely audible sound of pop and folk music. Intermittently, Acconci's voice interrupts it – "Look, Ma, there's America rising, right at our feet" –, explodes, disguised as a child's voice, attacking the chairs, surrendering, making a fuss. An America too young to take root...States without places of identity...Big kid states in a recess country that invents territories and conquests for itself. States of passage hoping for the West. Cities of waiting. Non-places. Western chairs on the scale of the American imaginary to look back at the journey accomplished from the East Coast. If space breaks down, if there is no end to geography, then "The model for a new public art is pop music. Music is time and not space; music has no place, so it doesn't have to keep its place, it fills the air and doesn't take up space. Its mode of existence is to be in the middle of things; you can do other things while you're in the middle of it. You're not in front of it, and you don't go around it, or through it; the music goes through you, and stays inside you."[17] A culture that spreads through us, stays in us, speaks in us and for us. America speaks to us more than it carries us. In the event, the principle of playing live radio broadcasts, used by Acconci in his installations in the mid-seventies, corresponded to a desire to expose practices of self-construction embedded in a given space and time grounded in seemingly incompatible strata of discourses

16 VITO ACCONCI, "WEST, HE SAID (NOTES ON FRAMING)," UNPUBLISHED TEXT.

17 VITO ACCONCI, "PUBLIC SPACE IN A PRIVATE TIME," UNPUBLISHED TEXT.

and dimensions. To wit, an assemblage and a tangle of psychological, civic, cultural, anthropological, political, economic, and social dimensions. An assemblage and a tangle of historical components that grip and traverse the consciousness of the spectator (the subject) in order to put an end to the myth of a timeless, everlasting self. To put an end to the fantasy of a self removed from the world, the fantasy of a way of being as if the historical dimension did not exist.

As if the specific historical conditions in which the subject develops never affected this same subject, as if the self could protect itself from what shapes it (culture) …As if the self were an aggregate of sentiments, emotions, sensations, moods, and desires, with no content other than themselves…As if the self were a sensitive structure, without material and without objects, a structure without the world…As if the self could be constructed outside the situations with which it has to grapple each day…As if it were possible to ignore the fact that our attitudes and our behaviors – from the most collective to the most personal – are generated by certain characteristics of the places we occupy (the detached house, the apartment building, the supermarket, the conurbation, the remote rural area, the workplace, and so on)…As if it were possible to ignore the fact that our consciousness today is often alienated by fantasies of compatibility, communication, accessibility, speed, and so on – all informed by the latest mutations in the economic landscape…: compatibility of computers, systems, cultures, moods, desires, or countries; communication between individuals, cultures, and political, economic, social, or sexual interests; accessibility of information, products, services, bodies, distant places, the inaccessible, SAT tutoring, and cultural practices censured on one's own territory; speed of access, processing, conducting operations…Such fantasies underpin many of our collective and private behaviors. A network imaginary has unconsciously come to be superimposed on the imaginary of growth rates, competition and performance… As if we had been gradually substituting immaterial myths (information) for material ones (things)…The fantasy of a life totally independent of historical conditions and mutations…As if it were possible to ignore the fact that our sensations and our behaviors are contextualized in specific spaces, conditions, and time schedules that entail increasingly limited, separated, or piecemeal experiences – from open-plan offices that generate feelings of jealousy and bitterness to hours spent in traffic jams that give rise to the desire to return to nature and to some sort of supposed "authenticity," and so on. Probe the way in which certain social situations and professional activities format our modes of representing others…Probe the way in which corporate values and work organization

46

determine relations of friendship or resentment…Probe the way in which stress or environmental design influences our behavior in love relationships, or yet again the way in which the use of certain products generates particular sexual or affective behaviors…But before launching into what could turn out to be a distressingly lengthy inventory of the conditions of alienation with which the subject has to cope, a few questions: Are we then to abandon the goal of finding and circumscribing the self? Are we to abandon the goal of producing a language of our own in the time and space through which we are passing and accept a relationship to the world in which we are permeable to discourses that do nothing but pass through us…? Are we to reconcile ourselves to the idea of a subject who speaks less and less…A subject who is spoken – produced – by culture? Are we condemned to feel and to be what they sell us? Must we give business the right to modulate our affect?

1997. Do all the long drifting vocals in search of forms capable of defining the contours of our sensations and our emotions still belong to their authors and to those who project themselves into them after thirty years of rock culture? After the rock years, here comes the age of the Top of the Pops…*The Same Old Song* (Alain Resnais): Men and women meeting, loving, and breaking up to the tune of popular French songs, or rather embodying desires and emotional needs played (programmed) for thirty years or more (the time it takes to build a generation's imaginary) on radios, walkmans, record players, television, in night clubs, and in supermarkets. Refrains as emotion-intensity boosters. Refrains for losing ourselves in what we desire most in the world. The slow dance as the beginning of a love story. The nightclub as the horizon of a new love story (maybe Saturday night…). A new love story that has nothing extraordinary about it…A new love story like all others…Love stories shared by everyone everywhere. Love stories that always come to an end…Because love is a battlefield…Because I should have known better…Because love is a temple, love is a higher law…Because you ask me to enter and then you make me crawl and, most of all, because love stories can be wrapped up in less than four minutes. In his musical comedy, Resnais does not relate stories of love, he strings them together (a clip parade). If a song or a clip can relate the building up of desire in four minutes (a four-minute slow song to get close and the rest of the night to do it), what can a ninety-minute form build up? Obsessive or serial loves? The same scene over and over again? Ways of repeatedly falling into the same pattern? Years of building and consolidating desire before the fusional act between Fabrice and Clélia on page 568 of Stendhal's *The Charterhouse of Parma*? A father who says no?

An unresolved Oedipus complex? The short form for immediate satisfaction and the long form for pathos. The consumer imperative necessitates reducing commuting time between the subject and the object of desire. Orgasms don't last.

In praise and need of a form that perfectly matches the contours of our affect, that crystallizes our personal stories in a few seconds of happiness...Seconds of happiness that make us gradually forget the hours before and after listening to the song...Hours that don't really interest us, in the sense that they belong to a dimension that eludes emotion...A dimension that does not touch us. The growing importance of personal memory (the nostalgia in *October Love Song*) and the aesthetics of withdrawal (the bedroom) may very well correspond to a will and need to find a unity of and proximity to the self. To recreate a body of experience, a body that is not instrumentalized by business, lost or ignored in public space, technologized or atomized in advertising representations. Turn the exhibition space into a place for suppressing the sound and fury of the city, a place abstracted from the world, a place for refocusing on the self.

1997. *A Woman Left Lonely* (Kristin Oppenheim): In an empty room, four speakers on the floor...Four speakers playing in a continuous loop an appropriation, an internalization of Janis Joplin's "A Woman Left Lonely"...: "A woman left lonely will soon grow tired of waiting. She'll do crazy things, yeah...on lonely occasions..." A voice – Kristin Oppenheim's – singing a song that nurtured her imagination...A voice layered in echoes...Echoing inside us...A mood that is barely sung...almost whispered...a refrain whose repetition picks up the slow, obsessive pace of the experience of loneliness...Let oneself be carried by these echoing words...a voice and a timbre grazing over our bodies...a breath trembling inside us. The emptiness of the room enacting a direct confrontation with loneliness...An emptiness that secludes our body in an experience of absence. Paradox of a voice lamenting loneliness even as it seduces us with its softness...A softness that envelops and carries us until we are totally permeated, until it becomes utterly our own. Take the time to sit down on the floor and internalize this voice, which could be ours, harping on a feeling of loneliness and waiting, or pace up and down the room ("will soon grow tired of waiting")...The circulation of the sound from one speaker to the other (the balance) as a form of accompaniment to our pacing back and forth. Be this waiting and nothing else...The lack of silence between each verse and the continuous looping of this same verse as articulating the total permeation of the self by this single feeling of waiting and

loneliness. A total permeation that could drive us crazy if we don't share it with someone ("she'll do crazy things")…To remove all visuals from the space so that the visitor can concentrate solely on internalizing the voice. The conditions of internalization are substituted for the conditions of exhibition. Intimacy is not exhibited; it is internalized and experienced without pictures. Intimacy is lived not represented. Its representation results from a deficit of intimacy (the lack): We live through projections (fantasy) what we are unable to live in life (frustration). The representation of intimacy requires a distance between subject (desire) and object (lack), or a delay (nostalgia). The experience of intimacy requires abolishing the distance (language) between the subject and the feeling. Its representation is an afterthought. When I come, I come (proximity to the self). Intimacy is felt in an immediacy without mediation (no medium). Between living and representing: You have to choose.

As to the old fantasy of returning to and focusing entirely on the self, a radical statement to conclude: 1992. *Solitary* (James Turrell). Consider a sensory deprivation chamber. When I sit down in the chamber, the light goes out, leaving me in total darkness. Not a sound reaches me from the outside…The insulating materials throw me back onto myself. After a while (minimum twenty minutes, maximum four hours), I lose touch with the outside (memory) and hear only the internal functioning of my own body (proximity to the self). In the event, the experience of the self is associated with a radical – and dramatized – break between the subject and the outside. The museum sheds its specificity as a public place and becomes a private place. The desire for representation (what is outside myself) gives way to the sole desire to find myself – not alone with myself but alone within myself, just to see, as Turrell seems to imagine, if I am able "…to investigate the seeing that comes from within." To wit, the old fantasy of interiority and depth (artistic regression). A fantasy that brings up a question: Am I really all that interesting?

The emergence on the contemporary art scene of works centered entirely on the question of intimacy seems to correspond to this need to define a space of our own, a space that we can immediately recognize as ours. Élisabeth Lebovici: "In order for the representation of intimacy to exist, or rather to be expressed, it must fix the inner movement from which it proceeds and which is constantly eluding it. […] Joan W. Scott […] demonstrated how women, in order to acquire rights declared 'universal' but understood exclusively in the masculine modality […], had to manifest themselves as women and thereby exclude themselves

from the universality that they themselves had posited as a prerequisite. This is the implacable logic of *Only Paradoxes to Offer*: Intimacy necessarily engages minority thoughts, or rather thoughts of minorities, in the sense that at some point in our lives, in our work, or in our relationships, we have to define ourselves by what we are not and so exclude ourselves in the same contradictory movement."[18] If the representation of intimacy can constitute an issue insofar as it allows us to gain recognition as being different in a society that imposes a certain number of paradigms of being-together and being in relation to others from which we are excluded, in many other cases it seems to express a resistance to the world and the community. The growing number of video works defining an intimate space in order to protect ourselves from whatever doesn't enter our mental space as a sign of an aesthetics of withdrawal. An aesthetics of withdrawal that is constructed without contextualizing the attitudes to which it gives shape in their historical conditions of emergence, without knowing the way in which the imaginary of the bubble and introversion is articulated with the political, social, and cultural realities that determine it.

THE FRUSTRATIONARY AGE (FROM EXHIBITION CONDITIONS TO LIVING CONDITIONS)

"1997 statistics showed a drop in the number of conversations that employees have per week as compared to 1983, a 10% drop in non-professional conversations with colleagues (from 82% to 72%) and a 12% drop in conversations with friends (from 78% to 66%). The reduction of idle time in offices has contracted the amount of time available for establishing contacts. The unemployed lose about two interlocutors per week."[19] If we are to believe this poll, it would seem that the giving of the self to business life, community action, and household chores is gradually reducing the moments of proximity to the self or to others (moments of intimacy). If the corporate spirit mobilizes and channels our physical and emotional energy to keep us on the growth track (stress), if business culture categorizes unemployed time as a time of exclusion and self-devaluation during which we are meant to do all we can to find a job, then the culture of intimacy (being present to oneself and to others) is in danger. Does this mean that all those who work more hours than the full-time working week – shop-keepers, doctors,

[18] "L'INTIME ET SES REPRÉSENTATIONS," *L'INTIME* (ENSBA, 1998) PP. 14-15. CF. JOAN W. SCOTT, *ONLY PARADOXES TO OFFER, FRENCH FEMINISTS AND THE RIGHTS OF MAN* (HARVARD UNIVERSITY PRESS, 1996).
[19] *LIBÉRATION*, THURSDAY, MARCH 26, 1998, P. 20 (BASED ON A POLL CONDUCTED BY THE FRENCH NATIONAL INSTITUTE OF STATISTICS).

farmers, restaurant workers, business owners, and so on – are doomed to see their intimate moments reduced to a strict minimum until retirement? Are people working standard shifts, those with part-time jobs, the unemployed, the retired, children, teenagers, and artists the only ones entitled to some intimacy? Must we accept the idea that intimacy necessarily belongs to leisure time? Paradoxically, while time for intimacy is becoming increasingly rare, the intimacy market is a booming business. In the game of supply (the lack) and demand (the turnover of desires), professionals in the field of seduction (from lingerie to plastic surgery), conviviality (from the cozy atmosphere package to finding true love@datingfaces.com), and emotion distribution (from the slow hit of the summer to the scene in which she finally says yes) are continually expanding their services and updating their products. Is intimacy still a feeling and a state of mind or merely a good niche in the market, a form of entertainment, a leisure activity? Does intimacy have to do with practices of being-together, of the self, of culture, or of entertainment? Who is responsible for my smile? L'Oréal or my good mood? And what about my desires? How can I keep some time for intimacy in a culture that keeps on reminding me that I can get good head@b-intense.com and that a horny housewife is waiting for you, so call now before her husband gets home from work? And what about emotion? What emotion can there be after the rush on thrills at Disneyland and the latest craze for paragliding and bungee jumping?

In the meantime, in the field of computer technology and telecommunications, the building of information highways continues. Companies such as 3Coms, Ascend Communication, and Lucent Technologies pursue their major acquisition policies in order to complete their product range and be in a position to process and transport affects and desires. In France, such conviviality manufacturers as Bouygues or SFR – whose sales (exclusively by cellular phone or Internet) rocketed sixty percent after France Telecom lost its monopoly – have revamped their policy of love calls and are offering packages designed to satisfy customer needs in the field of calling him after 6 P.M. and talking to her on weekends. In the movie industry, major companies and small production houses alike are releasing pictures in which the time lived individually at work and hours spent in traffic jams or supermarkets are eliminated to the profit of time packed with action and emotional thrills…This elimination of a certain type of lived time corresponds to a desire to abstract individuals from the social sphere and project them into the construction of a private territory. Time for love versus commodity-time. The cinema as a product of distraction. Distract the subject's mind from the

History in which he or she is embedded…Isolate employees from the community when they leave the office (the framing) and project them into intimist situations (the dream world). The twosome versus the community. Being with you versus being in common. To wit, a reduction of being to the sole dimension of desire. Meanwhile, while spectators prolong their adolescence in city settings (I love Judy, but I'm living with Carol who has no respect for what I do), men and women organize their lives in the lived time of circulating goods and services. This circulation of goods and services not only occupies the better part of our timetable – from producing them (work) to consuming them (leisure) –, it also structures and conditions a good part of our imaginary. An imaginary on sea level in the summer (*Beach Party*), on growth level during the week (success) and on an easy-payment plan on weekends (salary). If cinematographic time is at odds with work time, if it is occupied by entertaining feelings and stories, if it is embedded in a time of relaxation, then is the point to replicate this relaxation (*Beach Party*)? To take its place (*Beach Party*)? To refuse it (*Every Man for Himself / Slow Motion*)? To project the spectator elsewhere (*Jurassic Park*)? If cinema participates in the construction of our imaginary, then this imaginary is to be contained exclusively outside working hours. Working fewer hours as a social project and the dinner-for-two as a film project. Hollywood versus the Trade Unions. But apart from emotions, what do we have to share with others?

At this stage in the reduction of the dimensions of being and the imaginary, a question: Why do movies still exert such a strong appeal? The testimony of a motorist driving across France at the end of the summer of 1997 by way of an embryonic answer: Saturday, September 20, 4 P.M. You have ten days off and are on your way to the Pyrénées. You left Paris early this morning and have just passed Limoges when you feel weird vibrations coming from the front of your car. You pull over. Warning light…A look under your gas guzzler: The universal joint's broken. A call to Peugeot Repair Service's toll-free number. They'd be glad to take a look at the joint but you'll have to wait till Monday for a new one to be delivered anyway. Back behind the wheel of the car, you drive to the nearest town at twenty miles an hour. Limoges, 6 P.M., the Limousin Peugeot Service Station: You'll have to wait till Monday morning (the mechanics start work at 7:30). Downtown. Find a hotel (7:30 P.M.). Pizzeria (9 P.M.). Television (10:30 P.M. to 1 A.M.). Sunday after breakfast: Impossible to rent a car or bike for a ride in the country (everything's closed on Sunday). Stroll in the city…Nothing much of architectural interest…Deserted streets…Couples pushing strollers through parks…Table outside a café opposite the train station…Walk through streets void

of possibilities (I dunno what to do…) and find yourself in front of a movie theater…Get on one of the lines waiting for the event, sink into a cozy armchair and dream of meeting the woman in *La Femme défendue* (The Forbidden Woman), filmed by Philippe Harel with a subjective camera…A camera that is substituted for the eyes of a man whose voice we hear but whose body we never see…A camera harping obsessively on the face of the only character in the film (the forbidden woman)…A voice that tries to seduce a woman who resists…Identification guaranteed. Step out of the time you have trouble living outside the movie theater and wait for film events to happen (the meeting, the break, the news, the results…). Compensate for a lack of professional or affective activities by the emotion sublimated on the screen. Stop thinking and let yourself be swept along by characters who live much better than we do. The actor as an emotion booster. The difficulty in feeling your own being, the boredom, and the depression – intensified by three hours of wandering around the city center – to justify the building of a cinematographic imaginary (the multiplex concept). Fifteen screens playing *Cyrano*, James Bond, Lelouch, and *Jurassic Park* to forget. Move to the rhythm of Dolby or have a beer across the street from the train station.

If the means of communicating (Bouygues, France Telecom, Cegetel) and representing intimacy (Canal+, Générale des Eaux, Warner Bros., etc.) have proliferated, so have talk shows and documentaries focused on the investigation and public display of issues that were considered taboo not so long ago. Indeed, the accounts of our number two preoccupation (unemployment is still number one) bear the stamp of the program of restructuring affective and sexual behaviors that was initiated in the seventies ("When I was seventeen, the idea of finding myself with my nose pressed against the carpet would have seemed preposterous. Now I find it erotic."[20]) Faced with such an abundance of talk about our intimacy: Query whether art is still apt to circumscribe intimacy. And if so, in what forms? Finally, if representations of intimacy exist, if there is a need for such representations, what sort of intimacy are we talking about?

If the exhibition of the self remains at the center of preoccupations in most of the places consecrated to culture, the enactment of intimacy in an exhibition space has often failed because the conception of aesthetic experiences underpinning the conditions of exhibition and reception is far removed from the principles of emancipation that have informed the work of artists over the past thirty years.

20 SANDRINE, 32, RECENTLY DIVORCED, IN *VITAL*, A FRENCH WOMAN'S MAGAZINE, OCTOBER 1994, P. 32.

1972. *Anchors*...How many people stepped out of their stiff, distant stance and went to lie down on the mat to listen to Vito Acconci whispering confessions about his sister (a whisper that calls for the presence of bodies not their representation)? Don't go mistaking an exhibition room for a shrink's couch (and the spectator for a confidant). What if the story coming from the loudspeakers hidden under the bolster cannot be heard if I stay where I am? You don't really think I'm gonna lie down, just like that, in front of everyone? And it's not because Vito Acconci masturbated under the floor of the Sonnabend gallery (*Seedbed*, 1972) while listening to our footsteps on top of him and building up fantasies that he addressed back to us over two speakers ("you're pushing your cunt down on my mouth...you're pressing your tits down on my cock...you're ramming your cock down into my ass...") that we should transgress the basic exhibition rule of keeping a tacit distance from an aesthetic proposal.

1973. *Feed Me* (Barbara T. Smith): A line of people waiting in front of a door. Behind the door, hidden from sight, in a candlelit room with incense burning, a naked woman (Barbara Smith) lying on a mattress invites visitors to enter the room one at a time. A looped sound track makes the proposal explicit: "Feed me...Feed me." On a table, flowers, books, body oil, food, tea, wine, and grass. Consider a proposal that includes different forms of exchange: offering flowers, talking with one another, looking at each other, smoking, reading, spreading oil over the body, getting drunk, dining together, making love...staying silent. In the event, the construction of an intimacy (sharing) was made possible by a total appropriation of the gallery space (the creation of an environment) and a complete break with the traditional mode of representation based on the predominance of sight. Indeed, visitors to the exhibition could not see this performance. On the other hand, they were invited to participate in it. The visual gave way to a practice. The performance lasted all night. The construction of an intimate space requires time – time to immerse oneself in a situation and get used to it. The time of reception intrinsic to exhibition conditions is a short time based on moving from one piece or activity to the next. Intimacy is an experience of duration. Building an intimate space requires environments that contrast sharply with the coldness of the white cube. Intimacy is hidden from sight in a warm, comfortable setting; it is not exhibited in public. The public gives way to a partner.

If most of the conditions necessary to the experience of intimacy are incompatible with exhibition conditions, some find a more suitable form of expression in film or literature. But books and dark theaters preclude exchange. Certain artists in

the sixties and seventies worked on this dimension of exchange within the speci-
ficity of the exhibition form. Jean-Christophe Royoux: "Representation no longer
guarantees the stable presence of the world; it involves, to the contrary, an
activity dissolving any prior definition and position of the subject. [...] The artwork
becomes an expanded stage on which the relationship between the work and
the spectator is acted out. It is tantamount to an enunciation setup in which the
'speaker' and the 'listener' keep switching positions."[21] One of the distinctive
features of art in the sixties and seventies was not only to have developed certain
procedures of reciprocity but also to have placed the building of a body of
experience at the center of its preoccupations: "Just as minimalism reified the
pictorial object by stripping it of all subjective traces, the objectification of the
body in American dance in the sixties was to serve as a model for the presenta-
tion of *activities* that artists such as Bruce Nauman, Vito Acconci, and Richard
Serra began proposing in the sixties. [...] The interest in artwork as process log-
ically led to the use of the artist's own body as the enunciator of the work. [...]
It was no longer simply a matter of including the spectator in the making of
the work, but rather of engaging in a series of investigations concerning the physi-
cal and psychological limits of representing the 'self.'"[22] At the beginning of the
seventies, the use of the body as the artwork's site of enunciation sometimes
coincided with a determination to devise strategies of resistance. Resistance
to the spectacularization of the body and to its commodification. Resistance to
losing a sense of one's own body – notably, in the workplace where robotics
and computers were progressively being substituted for the last specific func-
tions of this same body (dispossession). Or yet again, resistance to the reduc-
tion of feminine identity to a projection of masculine desire. These strategies
often involved enacting presence here and now. An enactment that could act as
a mode of reappropriating the sense of one's own body. Chris Burden: "I wanted
them to really be there, as opposed to making an illusion about them. It's nice
that they're there, in a sense, because it gives society a broader range."[23] Turn
images (clichés) into experiences. 1975. *Role Exchange*: Marina Abramovic
asks a prostitute to stand in for the artist throughout the entire opening of her
exhibition and, in exchange, she would take the prostitute's place in a window in

21 "EXPOSITIONS(S) DU RÉCIT APRÈS LA LITTÉRATURE," *OMNIBUS* 16, APRIL 1996, P. 11.

22 JEAN-CHRISTOPHE ROYOUX, "POUR UN CINÉMA D'EXPOSITION. 1. RETOUR SUR QUELQUES JALONS
HISTORIQUES," *OMNIBUS* 20, APRIL 1997, PP. 11-12.

23 "BORDER CROSSING: CHRIS BURDEN QUESTIONED BY JIM MOISAN," *HIGH PERFORMANCE* 5, MARCH 1979,
P. 8.

Amsterdam's Red Light District – both were to assume their roles to the end, regardless of the circumstances. Get beyond the stage of social representation (the distant gaze) to construct a representation based on intimacy. Appropriate the intimacy of another for the time it takes to break through the generalities of our collective representations of others. Incarnate our images. Feeling (experience) is substituted for images *of* and discourses *about* (distance). Knowledge of others derives from experience, recognition from exchange. Here again, the effectiveness of the exchange was based on the relative exclusion of the public (the role exchange only makes sense for the two "actors"). The experience of intimacy and the building of a representation out of this intimacy necessitate a privatization of experience. Furthermore, the body that the "expanded stage" integrates is often inhibited, caught between phenomenological experience on one side and recognition of the principle and the possibility of exchange on the other.

1970, at San Jose College in California, *Corridor Installation with Mirror* (Bruce Nauman). Consider two corridors in the form of a V with floor-to-ceiling walls. Two corridors, with the only source of light coming from the two entrances, and a mirror in the corner where they meet. A mirror slightly smaller than the average height of a spectator so that when you are right in front of it, you see only part of your body reflected...Walk slowly into a corridor that narrows as we proceed. The progressive adaptation of our movements to this narrowing as the gradual heightening in our awareness of our body and of these same movements. Pay more and more attention...Move with less and less amplitude as we edge between the two walls...The progression through space as an intensification of attention focused on the self...Become aware of the growing pressure exerted on the body. An awareness activated by the physical and sensorial experience of space... The initial reflection of the second corridor seen from the entrance in the mirror at the other end followed by the sudden impossibility of seeing ourselves fully once we've reached this end as an experience in a loss of visual bearings. To see no more...To be forced to apprehend space through other senses. Physical experience is substituted for visual experience...The body as a mode of reading space. Bruce Nauman: "So going into it is easy, because there is enough space around you for you not to be aware of the walls too much until you start to walk down the corridor. Then the walls are closer and force you to be aware of your body."[24] Become the subject of an aesthetic experience. Get in touch with your own body (the sense of self), activate certain sensations

24 INTERVIEW WITH WILLOUGHBY SHARP, *AVALANCHE* 2, WINTER 1971.

(claustrophobia), work with your own body…Work with yourself and only with yourself. An aesthetics of refocusing.

The effectiveness of Bruce Nauman's installations in the early seventies was derived from the way in which they worked the phenomenological dimension; the effectiveness of Vito Acconci's pieces – which were often perceived as proposing complex, allegorical figures because museums inhibit and incite spectators to repress a good part of their impulses (when they do not reduce the spectator's field of experience to some fancy voyeuristic footwork) – derived from the way they dealt with the liberation of viewers at the time. Twenty years later, the proliferation of peepholes (from Ann Hamilton's intimacy concealed in a wall to Marie-Ange Guilleminot's small rooms to be seen through a tiny hole pierced in a wall) offer a different kind of experience, one closer to an early-twentieth-century posture (the position of the spectator leaning over) than were the experiences involved in the apprehension of Nauman's or Acconci's work. The keyhole as frame. Voyeurism as an old condition of experience. Curiosity as a sign of frustration. In short, the sites of construction of the body today are somewhere else: in the country (wheat fields), in the city (gyms, private screening rooms, aqua fitness complexes, pavements designed for smooth, easy rollerblading), in the mountains (trails for hiking, slopes for skiing, canyons, and cliffs for paragliding), and so on. If the eighties and nineties reinvented emotional thrills (paragliding, bungee jumping, surfing, close-ups of mock bodies being blown to pieces in the latest Spielberg films, etc.), they also encouraged a return to relatively unadventurous behaviors (the revival of the couple as the paradigm of togetherness, the need for integration into reassuring models of life, the desire for comfort and "authenticity," etc.). Between the need to be reassured and the need to have a blast, has art carved out a lukewarm place for itself? An art whose force and whose freedom of experimentation have been deactivated by culture? Or maybe desire has burnt itself out and died.

1994. "L'Hiver de l'amour" (Winter of Love): In the middle of the exhibition a see-through plastic bubble mounted on a base, and on a mattress inside the bubble, with supplies to help make it through the day (a walkman, a sweater, books, medicine, tissues, tangerines), a young woman (Vidya) spends most of her time sleeping – *Untitled*. The exhibition of a retreat and a withdrawal. Exhibit our inertia to a world that seems hostile to us. Take time off from your daily activities and curl up in a fetal position. A position (living in a bubble) dramatized by the material and shape (the signs) of the bubble in which she takes refuge. In the

thin membrane that cuts her off from the space for the public (the community), an opening for the visitor to slip h/er hand into a glove and enter into contact with this body. A body exposed to sight and touch. How many people took her up on the invitation? How many managed to disregard the gaze of other visitors and venture a hand onto this body? Don't go mistaking the white cube for a sexodrome (and the spectator for a partner).

But leaving aside exhibition (inhibition) conditions, is such an aesthetic relationship desirable? This proposal, made by an artist who was twenty at the time – as were a number of the other artists whose works punctuated our stroll through the "Winter of Love" exhibition – could be seen both as a form produced by a "today" lived on the mode of disenchantment, fear, and the incapacity to project the self into the near future (the symptom), and also as a mode of escaping into a culture of merry apocalypse (here, the walkman as a principal activity, elsewhere, partying as an aim in life). What could be seen in this exhibition? Or rather how could it be seen (felt)? Allegorized or directly designated, many of the works seem to have been conscious or unconscious metaphors for the fear of AIDS and the behaviors that go with it. And when neither this fear nor these behaviors were in question, we were inclined to project our own. Vidya's sleeping body figured a certain resignation, a flight into a passive and regressive position. Cut yourself off from other bodies and the threat that they present to your body's integrity (the sleep mode versus exchange, latex versus transmission). Abandon the possibility of actively working on today (the consciousness), let it work on you (the atmosphere of our times) and deprive your body of any possibility of projecting yourself outside (the meaning). Sleep to escape from the community. The exhibition of a sleeping body as a reduction of oneself to the state of an object. An access to the other now subjected to certain conditions (latex) and the inertia of the other (what's the point?) that undermines any possibility of exchange, and consequently of sharing (the winter of meaning). We have entered the frustrationary age.

1987–90. *Untitled (Perfect Lovers)* (Felix Gonzalez-Torres): Isolated on a white wall, two clocks side by side, set to the time of the city where they are exhibited. Two identical clocks, reduced to their simplest form…The picture of two perfect lovers in accord with one another. Then the batteries begin to wear down…one clock falls behind the other…ineluctably slowing down and ultimately stopping altogether. The literal exhibition of a gradual, ineluctable decline in intensity, of an implacable weakening, of a way of living with AIDS. Beat to the rhythm of

its progression. The isolation of the clock hands and numbers on a space devoid of all other signs as an insistence of the conscientization of time and its flow. A conscientization of time and its flow that ends up constituting our conscientization of the world and our relationship to it. 1991. *Untitled (March 5th) #2*: Enlaced in the wire that energizes them, a couple of bulbs keep each other lit… Allegory of a fragile togetherness…with each bulb apt to burn out abruptly and definitively at any moment…leaving the other alone. Exhibition of a togetherness stripped of a story (of any other embodiment of the intensity of love besides the frailty of the bond). Duration as form. Felix Gonzalez-Torres about his work on the whole: "[…] This refusal to make a static form, a monolithic sculpture, in favor of a disappearing, changing, unstable, and fragile form was an attempt on my part to rehearse my fears of having Ross disappear day by day right in front of my eyes."[25] To wit, the aestheticization of a form of sharing dictated by the development of the disease and by fear of the other's disappearance. Felix Gonzalez-Torres died on January 9, 1996.

The bodies that Vito Acconci and Barbara T. Smith desired were living in a social context of experimenting with possibilities (the search for and culture of forms of pleasure) and exchange. Bodies in the nineties are under stress from having given too much (the instrumentalization of skills by business), and suffering from having been exposed too much (AIDS) and separated again (solitude and exclusion).

An overexposed body…An overexposed body that has probably contributed to the emergence of new forms of being in the present. First (when you hear the news of your seropositivity), the sudden sense of no longer belonging to a world that continues to project itself in a duration from which we are abruptly excluded. Consider a feeling of discontinuity coupled with the difficulty of picturing yourself in a different – uncertain – duration that cannot be shared, a duration that requires a reconstruction of the self dictated by conditions that often seem to be exactly the opposite of the conditions of existence that we had imagined until then. Live with the feeling that time is forsaking us and that others continue to belong to a story in which we will no longer take part. Live with a sense of seclusion defined by this feeling of separation from the time of others. Live with our time. A time that loses in abstraction and gains in reality as the ineluctable

25 TIM ROLLINS, "INTERVIEW WITH FELIX GONZALEZ-TORRES," *ART RESOURCES TRANSFER*, LOS ANGELES, 1993, P. 11.

process of cell destruction invades the body. Live to the rhythm of its progression. Live by representing yourself on an implacable curve. 1987. Felix Gonzalez-Torres started a series of acrylics on canvas, a series in which he charted the evolution of a curve on a grid: *Bloodworks. 7 Days of Bloodworks*...A series of canvases traversed by a downcurving diagonal line...With, here and there, the rare rising curve. 1992...: *Untitled (False Hope – Bloodworks)*...1993...: *7 Days of Bloodworks – Steady Decline*...The rigor and repetition of the representation as reflecting the rhythm of medical monitoring. The regularity as a constraint. The monitoring as a calendar. The news of results as the rhythm of existence. A representation in which the curve's precision is substituted for any form of pathos...A clinical report (representation) that precludes the representation of all other dimensions of existence and suffering connected to the disease. A decline in the state of health that does not modify the form of monitoring...A representation with no point of view other than that of a medical checkup. A representation that puts my own body at a distance, that views my own body as the medical body views it – and from the same distance...*9 Days of Bloodworks – Steady Decline and False Hope*...1994...: *19 Days of Bloodworks – Steady Decline...21 Days of Bloodworks – Steady Decline*...A monitoring that intensifies...An existence that sticks more and more closely to the progression of the disease. A projection of the self (the curve) that is implacably stuck to the results (the grid). A curve (a life) that corresponds to the monitoring of blood tests. The steady decline of the curve representing a drop in T4 cells. But at no time does the series directly mention AIDS. We are free to interpret these curves as we wish.

Densify the moment. Stop resigning oneself to self-denial or to a sense of duration that cannot be shared. Georges Bataille on three forms of erotism – the erotism of bodies, the erotism of hearts, and sacred erotism: "What is always in question is replacing the isolation of being and its discontinuity by a sense of profound continuity."[26] The sense of continuity involves a different way of being in the moment. Rarefy the intervals of stepping out of the moment (the sense of being versus absentmindedness) and of putting off till tomorrow (the luxury). Construct a different consciousness of time. The conjugation of the self in the present as the unique form of projection. Immediacy versus saving and building. Desiring and consuming the moment versus projects. Invent forms of consuming the moment. The short form as the unique form of being in the world and in relation to others. Invent and build ways of being and sharing dictated by the

26 *L'EROTISME* IN *ŒUVRES COMPLÈTES*, VOL. X, GALLIMARD, P. 21.

fear of the other disappearing or cut oneself off from the building of long-term relationships. Surrender to the urgent need of being with the other right now. Be only this sense of the self in the present moment and nothing more. Be only this surge of pleasure and its consumption without restraint. Keep moving from adventure to adventure so as not to have to cope with long-term prospects. 1995. *Rome désolée* (Desolate Rome, Vincent Dieutre). Offscreen confessions of a man who goes from one lover and love experience to another: "Gian Maria came without waiting for me. He's already up and I'm still lying like a spot on an overly lush carpet and I don't dare speak. He tells me it's time for me to leave. I'm feeling broken and hurt, like I've been had. We won't be sleeping together, we won't have coffee together in the morning. I try to get hold of myself, to recover a sense of healthy indifference but the pain must be written all over my face. He looks ashamed for a moment but then his defenses spring right up again. I'll understand, when I'm his age, he explains. At his age, I know I'll be dead already." Keep moving from adventure to adventure to avoid having to experience anything but pleasure. Keep moving from adventure to adventure to avoid having to deal with other people's time. Prefer projecting yourself into pleasure (a time on our scale) to projecting yourself into a time that will outlive us. Project ourselves into a future conceived in terms of our awareness of a time when everything will stop.

HOOKY FROM HISTORY
(IS THERE LIFE AFTER THE TEENS?)

JANUARY 17, 1991, 2:40 A.M. (NO MORE REALITY)

1991. In the West, round-the-clock media coverage of military operations in the Gulf War substantiates the state of derealization into which the Western outlook on distant realities had fallen. A derealization coupled with a degree of apathy and contempt for the Other as never before attained by the world's most technologically advanced societies. Never had the negation and destruction of the Other been trivialized to such a pitch. Viewed from the United States and Europe (the continents of righteousness), the Desert Storm operation, with its "surgical" missions, was the first modern war without pictures of wounded and maimed bodies, the first *clean* war for the victors. Clean because virtualized by mediatization. Clean because journalists were far from the field of the operations they were covering. A mediatization under close supervision, a mediatization that was curbed and deprived of its power of spectacularization for the first time in its history. A few images of fighters taking off...A few images from the archives... Dispossessed of their usual powers by political and military authorities (the Pentagon), the television stations sought other modes of representing the conflict...What pictures could be shown – invented – in the context of an absence of pictures from the field of operations? Why not forget the field of operations, forget the civilians, and shift audience attention to the use of new technologies. A logic of distraction...Distract Western viewers from their position as passive spectators of a distant war and place them in the role of protagonists acting directly on the conflict. A conflict abruptly reduced to its technological dimension...A dimension that screens out the human, political, and economic dimensions. Distract the consciousness of viewers from a tragedy they ignore (absence of information) and sit them down at the controls of a game in which you are the hero...Substitute the pictures displayed on the fighter pilot's control screen for the pictures recorded by television cameras...Rivet their gaze to this screen so that they can watch a laser-guided bomb heading for a military target "replayed in slow motion" (seen and heard on one of France's major TV networks). A bomb that heads in one direction before it abruptly changes direction...A change that occurs just as two hands appear to the left and right of the control screen, two hands that manipulate a command that apparently changes the missile's path... The joystick is substituted for analysis...The reference to video games as a culture of erasing History. A war remote-controlled from the West for abstract effects that don't concern us. The commentator proposing to view the action "replayed in slow motion" as an emotional thrill booster...Apply sports broadcasting techniques to History. A History packed with superb action and abruptly devoid of implications...A war with no one left to experience it (the myth of

progress)…Action with no subject and no object…Actions that mean something by themselves…A History that takes place on an exclusively technological plane…A History without men. Media coverage of the Gulf War seems to have symbolically completed the process of expelling man from History. A process inaugurated in the first half of the twentieth century…Robert Musil: "Today responsibility's center of gravity is not in people but in circumstances. Have we not noticed that experiences have made themselves independent of people? They have gone on the stage, into books, into the reports of research institutes and explorers, into ideological or religious communities, which foster certain kinds of experience at the expense of others as if they were conducting a kind of social experiment. […] A world of qualities without a man has arisen, of experiences without the person who experiences them."[27]

Nowadays, even when civilians fall victim to bombs, the ideology informing the media seems to be telling us that a world of technological feats without a man has arisen, of experiences put into practice without the person who experiences them…The representation of the Gulf War looked very much like simulations of conflict available@video-game.com…A History suitable for all members of the family and a confusion between planes of reality. In TV-viewer consciousness, the Gulf War really did take place; it was not virtual…simply high-tech. Meanwhile, men and women were dying out of camera sight. Meanwhile, millions of Muslim men and women, humiliated and powerless, bore the brunt of ally violence, cynicism, apathy, and contempt. The culture of the spectacle and of derealization had done its work. The Gulf War enabled Western viewers to appreciate the latest technological developments, to assess the progress made since the war in Vietnam – when pictures of wounded and maimed bodies had left a lasting impact on viewer consciousness – and to learn that military power in the world's most technologically advanced countries had definitively put them out of danger of war on their own territory. War is their business, not ours. As if the world and its History had definitively moved to the other side of the screen (the other side of the globe), and at the same time to another, more abstract dimension…a low definition dimension of the world…A world that we're not so sure we can situate on a map…A world that we are no longer capable of representing (picturing). We have long relied on media images to construct our relationship to current events with which we are now purportedly saturated…But the Gulf War was

27 ROBERT MUSIL, *THE MAN WITHOUT QUALITIES*, VOL. 1 (VINTAGE INTERNATIONAL, REPRINT EDITION 1996), P. 158.

marked by a deficit if not an absence of images...A lack of images that contributed to deactivating historical consciousness. The lack of potential representations of a war of this type and the pronounced interest in its simulation raise issues with far-reaching consequences. The lack of representation seems to coincide with a lack of awareness as to their real impact on the targeted populations and the ensuing geopolitical upheavals (the deactivation of historical consciousness), but it also goes together with an incapacity to conceive of the Other. An Other who simply does not exist in our news-informed consciousness. What weight and what meaning did Western consciousness grant to the reactions of the Iraqi population – of which we had only patchy representations dictated by the propaganda needs of the two belligerent parties – or of the population in other Arab countries? How could we have eliminated men from History to the profit of technology to such an extent? In the event, the lack of representations was tantamount to no longer granting a status to the Other, and even denying the Other's existence altogether. When the culture of simulation and derealization leaves its field (entertainment) and extends its reach into History, we may consider that its users (TV viewers fascinated by technological feats and unaware of the existence of the Other) have embarked upon a new form of barbarity.

This new form of absence of representations of the Other has also diminished the space in which we recognize and inscribe ourselves. Where can we take place? And with whom? Where does the Other appear? If we are apathetic to distant places in times of war, if our relationship to these same distant places functions in the tourist mode in times of peace – a mode that consists in objectifying the people and cultures we encounter –, if all you have to do is "go for a ride in a 4x4 vehicle to discover Peulh [sic] villages and women gathering salt,"[28] to whom do we still feel close? Are we still capable of having relations with people who do not resemble us, people who resist cloning, other than in an economic, tourist, and military mode? Have we definitively entered an age in which we can no longer communicate with anyone who does not directly address us and show an interest in us? Paroxysm of a process of constructing Western subjectivities...Western subjectivities founded on the individualization of references. Subjectivities that have made their choice, that have opted for references that concern them directly in their private, practical, professional, and social lives (all references that do not directly concern them being irremediably ignored).

28 *AFRICATOURS/ACCOR TOUR*, WINTER 1998–99, P. 127.

Subjectivities that have grown accustomed to being personally and individually addressed by their culture twenty-four hours a day, seven days a week, by mail order, exclusively for me, Because I'm Worth It...A culture adapted to my needs and especially to what's left in my bank account. If banks, dealers, TV shows, guidebooks, singers, insurance brokers, or politicians have grown accustomed to addressing me personally with exclusive offers and customized contracts, are we to conclude that I am no longer capable of hearing any other form of address and of cultivating any other form of relationship? If culture is a shared form, what can I share with people whom I can't recognize? Have I reached such a pitch of individualization of references that I can only relate to those who speak to me about me (advertisers, singers, friends, relatives, my shrink, and my sexual partners)? Have those who do not address me directly disappeared from my mindscape for good? Is my space of inscription to be limited henceforth to what I experience on a daily basis. A space that would be confined to the places I occupy during the day (my workplace, my district, my house, my room)? Is the rest doomed to remain nothing more than a huge fiction? A fiction about which I know next to nothing and which doesn't interest me anyway...

WHATEVER...
1993. *J'ai même gardé mes chaussons pour aller à la boulangerie* (I even kept my slippers on to go to the boulangerie, Pierrick Sorin). At the rear of the room, a video installation comprising six monitors on three levels. In fragments on the six screens, the mishaps of a man struck by a paranormal phenomenon in the middle of his kitchen. Six moments in a single story. A brief, fragmented story, accompanied by a linear sound track. The pictures are in black and white, the scene takes place in front of an oven and a sink...The confessions of our man: "Umm...this mornin' didn't go so bad...got up early to go to the boulangerie... uhmm...Even kept my slippers on to go to the boulangerie..." To wit, the start of a confession about a somewhat maladjusted form of behavior. A confession that could only aspire to meet an amused or sympathetic ear...A confession in which the planes of reality are confused. To be more precise, what relationship is there between his morning not going "so bad" and keeping his slippers on to go to the boulangerie? What is the meaning of this "even" intensifying the "didn't go so bad" statement? A confirmation of his difficulties of expression comes a few seconds later: "Before, when I was little, I used to read a lot but...lately, over the past few years...it's hard for me...it's hard now...[...] And what's worse, sometimes I watch TV...and what's worse, I tell myself I should be reading a book but...it's hard for me..." Broken French, hesitant speech. Bits of sentences

he can't seem to finish about a personal biography he can't piece together… Stages in life (a childhood when he used to read, a period of working in a printing house when he lost his ability to read, etc.) that do not follow from one another and that lead nowhere, save perhaps to an admission of failure. Instead of getting up and doing something that lends itself to a more worthwhile construction of the self than watching TV because he can't read, our man emphasizes – with unusual authenticity – some of the least flattering features of what has been called the "whatever generation," a generation purported to have given up: absence of desire, impossibility of defining, expressing, or formulating the slightest project, the faintest idea, of finishing the least sentence. An impossibility that is not indicated or named but spoken. In the event, the tone, inflections, and mistakes in French that underpin the acting of the protagonist (played by Sorin himself) define the point of view and the place from which such words can originate. A point of view that stays shut up inside the narrow confines of his home and a knowledge of what's outside his private space brought to him exclusively by the media. His confession functions as a criticism through acts of what it designates. It doesn't speak *about* the impossibility of expressing and constructing, it speaks *from* this impossibility in the sense that it originates in the very site of inscription of its language.

As a result, everything that our man undertakes fails in the early hours of the morning and he rapidly sinks into a state of depression. Tightly framed close-up: thoroughly confused, uncertain look, three-day beard. A man slumped in his chair, a man who is tired, who seems to have a cold, and who's sniffing a bit. "After, uhmm…after that…it wasn't so great…I had problems…I dunno…dunno exactly why…but don't really feel like talkin' bout it." At this point: slow motion scene…A pile of paperback books falls on top of our man, who is standing now and looking at a loss. A man at a loss, overwhelmed by a paranormal event, a man who ends up collapsing (under the weight of knowledge). Where are the books coming from? We haven't a clue. Does this bombardment have anything to do with the "problems" that he doesn't "feel like talkin' bout"? We can only guess. What we do know is that we are dealing with a ridiculous, absurd event in a domestic context. And since it is the only event that happens to this man who stays home all day – a man who apparently can't venture any farther from his home than to his local boulangerie (the slippers as evidencing the desire not to venture too far out into the social sphere) –, the little there is to say can be summed up in a few minutes. And since thought, even afflicted by inertia and a lack of curiosity, is necessarily articulated in the space and time that it traverses,

the same film of the day is replayed again and again even though the day was totally uneventful. The looped montage as formulating this train of brief, obsessive thoughts. A train of thoughts that, once it gets going, precludes in turn any possibility of snapping out of the inertia. Disjointed visuals and sounds.

Meanwhile, as our man withdraws and suffers this absurd bombardment of books, some barely perceptible snatches of news about the war in Bosnia can be heard behind the amplified sound of the sum total of knowledge (the weight of culture) crashing on his head...: "Clashes continue throughout the country between troops that are theoretically allies...Negotiators in Geneva have not even reached an agreement on the state of the peace talks." Assaulted and overwhelmed by fragments of information and facts that have little to do with his immediate conditions of life, our man lives in proximity to a world that he ignores. The mishaps of a man who can't seem to find his place in a History that is flashing by without him. A man-symptom of the nineties who just cannot adapt to the speed, the simultaneity, the heterogeneity, and the mode of transmitting data that make up his social and geopolitical environment. The overdose of data that cannot be assimilated acts as an anesthetic that confines him within house limits. The slapstick portrayal of the way in which the victim tries to protect himself from being bombarded by knowledge and hears nothing from the outside world that doesn't concern him directly seems to reveal the process of withdrawal that strikes all those who feel less and less capable of coping with anything beyond their front door. *I even kept my slippers on to go to the boulangerie* as the staging of a loss of adhesion to the world coupled with the impossibility of developing a narrative, of maintaining a grip on (a belief in) the political, social, and ideological narratives that structured the experiences of earlier generations. In the event, the non-adhesion is offset by a sublimation of micro-events (withdrawal into the self). Indeed, while war and History continue, our figure of apathy and lack of curiosity vainly goes on building up his biography ("I'm a dynamic sort of guy...but a bit nervous...[sniff] and being nervous does me no good.")... A biography that is definitively cut off from the crucial social and political changes that – from the perspective of the world's most technologically advanced countries – seem to be taking place far away from our centers of interest. Are we to conclude then that the generation of TV kids has definitively entered an age of tuning out History? Is the absence of desire to put your shoes on and go out a significant characteristic of people living in the world's most technologically advanced countries?

In the sixties, Martha Rosler imported pictures of the Vietnam War into the plush, aseptic interiors of middle-class North American homes to activate Western consciousness of present-day History, a consciousness in danger of falling to sleep. In the seventies, Vito Acconci's installations in Europe revealed the expansionist thrust behind U.S. economic and cultural policies. In the eighties, the obsessive, symbolic recurrence of unoccupied chairs suspended in Bruce Nauman's installations served as a constant reminder of the widespread use of interrogations and torture in certain South American countries...Many other examples could be cited. But this historical and political dimension present in some of the most significant art practices of the sixties, seventies, and eighties, seems to have disappeared in the nineties. Instead of raising historical consciousness, the emerging art scene has often substantiated the state of historical derealization and self-withdrawal into which Western culture has sunk. Nowhere has it been a question of the Palestinian cause, the Rwandan genocide, the Gulf War, or the conflicts that decimated the former Yugoslavia. Only a few rare artists in the last decade, among them Willie Doherty, Thomas Hirschhorn, and Johan Grimonprez, have tried to conscientize our relationship to History by working from images that mediatize our relationship to the news. Have two decades of privatization of experience and self-worship definitively cut us off from a part of History? A History about which we couldn't give a fuck?...

1992. *Girl Power* (Sadie Benning). Consider a nineteen-minute black-and-white videotape: On the screen, cut-out letters recombined to form a sentence – "Sometimes I played hooky." Music: A little girl running on a road...Offscreen voice: "I went down to the river. Nobody could find me there. Not even the cops. Sometimes they'd catch me, wandering around. They tried to take me back, 'to where you belong,' they said. But they didn't know nothin' about where I belonged. So I did it every day...Went on journeys [...] I knew that's where I belonged 'cause that's where I wanted to be...In my world, in my head I was never alone...It was at school, with my father and in my own culture, that I felt most alone." Alone amid pictures of policemen manhandling demonstrators; alone amid the racist and homophobic declarations of an American Nazi party member who asserts that whites are in fact "supermen" compared to blacks and who advocates the extermination of homosexuals; alone amid pictures reflecting a culture of force and domination; alone amid a history that is his-story and that is the only story broadcast on TV (the world we receive). Nineteen minutes of highly pixelated black-and-white video images, filmed with a Fisher Price PXL 2000 camera. Watch family films taken with a super 8 camera, use a toy to

68

make your own films all by yourself, just like daddy does, and then splice scenes from your childhood (the super 8) into pictures of current political and social events (the evening news) to measure the divide (the vacuum of representation) separating the history of the self from collective History. Stay in your room and reread this divide through the eyes and projections of a child (the Fisher Price camera). Here, the refusal to project the self into the outer world corresponds to a refusal to belong to a collective History underpinned by relationships of force that standardize behaviors, desires, and beliefs: "The world outside my bed-room window was brutal and needy" (the explosion of a missile, the desperate flight of a man and a woman being chased in a film, or the cold, hard look of a political figure). Refuse to empower broadcast images to make us and to make us comply. Cut the media sound and turn up the sound of your own voice (speak for yourself). The offscreen voice of a nineteen-year-old film director: "I wondered how I would survive, how I would escape and where would I go." If leaving adolescence is tantamount to joining the world broadcast on the evening news, then lock yourself up in your room (the territory of childhood and adolescence) and stay put. If growing up means leaving home and constructing the self in the social field, then refuse to grow up. Desert the field of grown-ups and make your own film: "I survived because I created my own heroes." Heroes who, in the event, take consciousness into an imaginary realm that is decidedly cut off from political, public, and collective affairs. The hypercathexis of affect and of the self and the loss of interest in social affairs seem to correspond to an incapacity to articulate one's own subjectivity with present-day History…A History increasingly experienced as something exterior and hostile to the development of the self. Certain works, notably Sadie Benning's, manage to conscientize this issue and articulate our desire for intimacy in the cultural space and History that are given to us. Her films never cease to generate a tension between images – or rather, projections – of the self and images taken from the TV news, documentaries, or collective representations (the ideology) transmitted by the media. This tension produces a contact point…a contact point between History and the Self.

A look at some of Sadie's compensating heroes…1992. *It Wasn't Love*: Shots of a tender, loving dance, with Sadie Benning and her girlfriend cuddling in each other's arms, and a series of tight close-ups of the face and the mouth (the site of words that the exterior does not want to hear). Tell (yourself) the story of a fling – a fling written in the manner of a Hollywood script: "Yesterday night I drove to Hollywood with this chick." But the car that crosses the screen to the sound

of stereotypical film music and that carries their love adventures is a toy car...
A miniature car pushed across the table by a young woman's hand. Fit your
grown-up desires into an imaginary structured by pretty tales from your child-
hood and by the blues, rock, and movies from your teenage years. Might as
well stay childish, seeing what the grown-ups are doing. Let teenage rebellious-
ness explode for the time of a shot of a clenched fist. A clenched fist that reap-
propriates the ambivalent figure played by Robert Mitchum in *The Night of the
Hunter*, but instead of "love" and "hate" on the knuckles, here's a well put FUCK
(rejection versus construction and destruction). "She had an attitude"...The atti-
tude of a biker coming right up to the camera to give the viewer the eye, the
attitude of a cock-teaser, with her blond wig and a cigarette dangling from her lips,
or yet again the I've-been-around attitude of a woman offering the camera
some nicotine...Play at being, but don't be (the outfit but not the job). The cas-
ual, carefree attitude of actors playing a part ("Get in the car. We're going to
Hollywood [...] I stole this car") versus the seriousness of working life. Someone
to love as sole project: "Go ahead. Fall in love with me. What else do you have
to do?" Emotion versus community. But doesn't the coming-and-going-between-
you-and-me preclude any production of meaning – any circulation of meaning –
outside the space governed by emotions? In praise of an attitude: Appease your
desires (consume) and invent (produce) no more. Satisfaction.

Here, deserting the political and social sphere, elsewhere, rejecting the world of
work and consumption...The eighties. *Trainspotting* (Danny Boyle). Opening
credits, chase scene, camera tracking a group of young guys running away,
hyper music, offscreen voice: "Choose life, choose a job, choose a career,
choose a family, choose a fucking big television, choose washing machines,
cars, compact disc players, and electrical tin openers." Obsessive, hyper refrain
describing the narrow dimensions of existence. Dimensions (the supply) that we
don't appropriate and desires (the demand) that the market economy grants us
(leeway for initiatives and free time). A teenager's obsessive, hyper refrain about
a way of burying yourself in an activity (a niche) that offers you subsistence
conditions of existence (but I can't complain) and preestablished modes of life:
"Choose good health, low cholesterol, and dental insurance. Choose fixed-inter-
est mortgage payments, choose a starter home, choose your friends, choose
leisurewear and matching luggage, choose a three-piece suit on hire-purchase in
a range of fucking fabrics...Choose DIY and wonder who you are on a fucking
Sunday morning. Choose sitting on the couch and watching mind-numbing,
spirit-crushing game shows, stuffing fucking junk food into your mouth. Choose

rotting away at the end of it all, pissing your last in a miserable home, nothing more than an embarrassment to the selfish fucked-up brats that you spawned to replace yourselves. Choose your future, choose life." Hell on earth. A life that resembles a mail-order catalogue. Choice as a mode of articulating the self in the world. Choice as the reduction of freedom to fit the scale of the planetary petty bourgeoisie. Possession as an existential aim. Mortgage payments as the rhythm of life.

1999. *My Catalogue* (Claude Closky): Two hundred and eighty pages of mail-order product descriptions, classified by category, and definitively reappropriated by the potential customer-reader. The shirt in Mayenne cloth becomes "My shirt in Mayenne cloth," the relaxation compact discs become "My relaxation compact discs," the antiburglary security door becomes "My antiburglary security door." Two hundred and eighty pages of descriptions without pictures in which the replacement of the definitive article by the possessive pronoun acts as an illustration of our relationship to the product – from desiring it to using it. The full description as an illustration of our alienation by the product (the item): "My couch. A masterpiece of contemporary design, made with tender, loving care for each and every detail, my couch is meant for all those who seek perfection as I do and who attach great value to creating a personal lifestyle. Hand crafted, piece by piece, by tanning, upholstering and leather craftsmen, my model is an original; it is a unique piece of outstanding craftsmanship made in exceptional-quality natural leather. What I own reveals who I am and although I am a practical person, I want my furniture to have soul." A fucking couch in which our subjectivity engages a good part of its values…The rewriting in the first-person singular (a mass-produced singular) as formulating a fusion of identities (me, myself, and I) and objects (the couch). A rewriting that turns the potential customer into a happy owner…A happy owner who appropriates the world in the manner of a child (my first record-player, my Chatty Cathy, my stove, and so on). I am what I buy and what I buy reveals and modifies who I am: "My dog repellent. Ever since I brought my dog repellent home, I'm not afraid of dogs anymore. I simply press the button and the biggest, most ferocious dogs calm down immediately and run away. My clever device uses ultrasounds that have a dissuasive effect on the eardrums of dogs of all breeds." Demonstration of the ultimate stage in consumption…A stage in which I am my product's person more than my own. A product use that speaks on my behalf and turns whatever is left of my personality into a mindless, alienated user. A couch and a dog repellent that reveal who I am in a society that limits my capacity to express myself to

my capacity to choose. Ordering (by mail) as the expression of desire. Life is a catalogue, and personality a matter of using.

Critique of a relationship to objects announced in the fifties. Roland Barthes: "French toys *always mean something*, and this something is always entirely socialized, constituted by the myths or techniques of modern adult life: the Army, [...] medicine, [...] school, hair-styling, [...] transportation, [...] science [...]. In this world of faithful, complicated objects children can be owners and users but never creators. They don't invent the world, they use it. There is no adventure, wonderment, or joy in what we are preparing them to do. We are turning them into small-minded owners and homebodies who do not even need to invent the mechanisms of adult causality."[29] To wit, the announcement of a new era, an era of happy owners of couches and dog repellents. An era of old homebodies, slumped in their couches in front of their fucking TVs (the imaginary of acceptance)...The exaggerated infantilization of customers informing Claude Closky's work of reappropriation reflects the childish dimension that occupies a growing part of our imaginary, so that when we've reached an adult age, we don't invent, we simply use...A world designed to fit the scale of the imaginary that we built up for ourselves in childhood...A dimension found in the design of shopping areas where Ronald McDonald, the blue elephant washing our cars, or the kitsch store architecture – resembling a Smurf village more than a human one – imperceptibly turn us into Smurfs or garden gnomes. A way of taming urban space and making it "our friend." As if the point was to deactivate the violence associated with city life and the social sphere...A world filled with good guys, unlike the world of bad guys we see on TV. A trend that is affecting more and more areas and products. The design of cars as an indicator of this trend...Handy, compact cars (the Smart car) with a fun look (the Twingo)...Little cars...Round, fun-looking, comfy cars. The fetal shape as the shape of the nineties. The accent in car design – from the family station wagon to the sedan, without forgetting the space cruiser – is on protective, reassuring interiors. Cuddly carriers...Safe Drive and High Fidelity Comfort...Five-seaters for toddlers. Tomorrow's car? A fun, easy-to-park, compact vehicle that will take the driver by the hand (computer-assisted driving) and hug him tightly against its airbag...Speeding and macho driving are out; the maternal school of safe driving is in...Line up in twos, and off we go for a nice ride in the country. The fear of the social sphere as

29 ROLAND BARTHES; *MYTHOLOGIES*, TRANS. ANNETTE LAVERS (HILL & WANG, 1972), PP. 53-54 [REVISED TRANSLATION].

grounds for taking refuge in regressive forms and behaviors. Turn our environment into a huge chest of toys, that way it won't scare us anymore. Make your own cocoon and curl up inside. "My pouf-bed. During the day, my pouf-bed is a table or a seat. It has twelve side pockets for my magazines, my newspapers, and my remote. At night, all I have to do is slip off the cotton cover to turn it into a comfortable bed in no time at all." Yippee. If we have reached such a pitch of infantilization and of accepting this same infantilization in the nineties, the teenage revolt of the eighties deserved a different sort of attention.

Back to the young guys who refuse to identify with a fucking couch, not to mention a dog repellent. From the adolescent perspective, the imaginary in store for youngsters when they get out of school looks like it's conditioned (normalized) by an equation whose factors are a job (and the consequent alienation) and the annual net income per household (the buying power). A job assimilated to a logic of alienation and negation of subjectivity (the instrumental management of skills). An annual income that defines our living space and determines the way we occupy it. A job and an annual income that imperceptibly reduce a good part of our imaginary to the way we spend our free time. A way of spending our free time that imperceptibly turns us into customers, consumers, and users of this same free time. Indeed, if this free time is a period that we slot between working hours, if this same free time is spent consuming what we produce during working hours (weekends for using what we produce during the week), then our relationship to free time is a user relationship. A free time taken up by offers (My pool mat, My barbecue, a holiday package adapted to My budget, My transport + hotel package, etc.), by name-brand types of conduct (a way of being in Nike or in Hugo Boss), by spectacularized emotions (from a Gouffre de Padirac cavern tour complete with special lighting and sound effects to bungee jumping in the Vercors, without forgetting slow motion ejaculations in X-rated films), by ritualized activities (jogging, shopping, nightclubbing), by guided activities (from tour-operators to get-back-in-shape fitness programs), and so on. Free time as a product. The supply as free-time budgeting. At this stage in the enumeration of modes of spending free time, a few questions: Once the shopping has been done, the bills paid and the paperwork finished, what type of time is left for living? Can a flat stomach really constitute a project in life? Is postponing the aging process the sine qua non condition of belonging to our times? Can patch pockets on the front of my poplin shirt definitively change the course of my life? Isn't my adventure travel club actually stifling me? Does the supply offered by our society of continual growth and leisure product renewal still meet my demands? Is there

any genuinely personalized way of living the free time I have left (the appropriation), or am I doomed to choose from a selection of modes of spending free time (the supply). Is free time totally imposed upon me? Has it been definitively turned into a time of alienation of consciousnesses whose only aims are to relax, get loose, and think about something else? Is this time nothing more than the negative of work time? A time that is solely destined to distract consciousnesses from the hardships imposed by work time? Free time or alienated time? Am I doomed to leave it up to L'Oréal, Nike, or tour-operators to occupy my free time for me (alienation), or do I still have the possibility of constructing for myself a time free from the figures imposed by the market economy (the emancipation)?

Trainspotting: Unable to see themselves in a parental lifestyle and equally incapable of inventing other ways of being in the world, the teenagers depicted by Danny Boyle shut themselves up in a squat (their own territory) and shoot up…Shoot up to forget that they can't find, or rather can't make, a place for themselves in a community that makes them puke. If the lifestyle and imaginary being offered today no longer meet the desires of the generation that is supposed to enter "working life," in what history can this same generation embed itself? In what projects can it invest and construct itself?

Dan Graham: "In teenage heaven, adolescence is an eternal state."[30] Driven out of this heaven (the start of working life), teenagers lack the reference points (the imaginary) that would allow them to find a place for themselves in the history of their parents (the investment of certain values in a professional activity to construct a subjectivity through work). "In the 1950s a new class emerged, a generation whose task was not to produce but to consume; this was the 'teenager.' Freed from the work ethic […] their philosophy was fun. Their religion was rock 'n' roll. […] To rock 'n' roll meant to have sex…NOW."[31] If the work ethic is no longer a major issue today, if fewer values are invested in professional activities, if the image projected by boy bands (real cool) provides more inspiration than the image projected by Bill Gates (the success story), the need to find a job and its economic utility are just as crucial as they always were. A job that still occupies the major part of a time that they were promising us would be freer and freer. To wit, the incompatibility between the philosophy of fun and economic reasoning.

30 *ROCK MY RELIGION, WRITINGS AND ART PROJECTS 1965-1990* (MASSACHUSETTS INSTITUTE OF TECHNOLOGY, 1993), P. 89.

31 *IBID.*, P. 85.

Out of this incompatibility arises a relationship of discontinuity between our pro-
jections (ways of being in the world that we are dreaming of) and our experi-
ence of work time. The sense of discontinuity as the impossibility of representing
the self at work. As a result, the need to practice a professional activity can
only be experienced in the mode of a crisis. The growth rate (the time of History)
is achieved at the expense of pleasure (the time of the self). *Trainspotting*:
Unable to identify with their parents' values, the gang forms a community of
withdrawal (the passive population). If access to consumption and to fun is en-
couraged (advertising), if time for fun and for consumption is programmed (free
time), they require means – in the event, work – which imply ways of being that
are in complete contradiction with the fictional and advertising representations
with which we identify. How can high standards and relaxation be reconciled?
How can we concentrate on corporate objectives while dreaming of refocusing
on the self? How can I believe in work when hit singles and sitcoms project me
to a faraway place, remote from corporate culture?

If movies and TV series project us into representations that accord with our
aspirations, if the aim of filmed time is to build a future that suits us, are these
same movies and TV series doomed to deny the time lived in leisurewear, at
work or on this fucking couch? How can I represent myself at work when my
only aim is to get him or her to say yes to a date? How can I represent myself
in leisurewear or at work when all I want to do is have a blast? What picture can
I have of corporate life when the sole images culture offers me are those I watch
every night when I get home from high school or college? *Dawson's Creek* and
Beverly Hills 90210 (breaking up, going out, and quarreling). Come home from
school and see yourself in the school cafeteria drinking an orange juice and
trying to forget that she's going out with him…If college rhymes with the desire
to screw him or her, if being-in-common comes down to confining ourselves
to our plans for tonight or for this weekend, then university libraries can shut their
doors and companies will have to bide their time waiting for the next generation
to take over. The Britney Spears versus OECD forecasts. Sitcom interiors as
replicating the walls of your bedroom. The exterior as a hostile space (hell on
earth). Preserve an interior designed for love, desire, and fun…because outside…
well, outside, it sucks…To wit, an absence of projects, a fear of exclusion, and
a refusal of the violent forms of social and business relationships at work. The
escape mode as a mode of life. A desire not to see and not to become part of
a History that seems to be constructed without us. A way of refusing the myth
of participation in a History made by and for businesses – at the expense of

the self. Keep sipping your orange juice in face of the growing rift between the aims set by actors in the economy (productivity, growth) and the aims that make us feel like getting up in the morning (*Dawson's Creek*), or else shoot up to cushion the shocks produced by a History from which we feel left out (*Trainspotting*). As if business History had not managed to produce the actors it really needed. To wit, a growing gap between representations of the self offered to us in movies, on television, in concerts, on CDs, or on vacation (I'm twenty and I'm having a hell of a blast), and the lived time of having to deal with all this paperwork by the end of the week (stress). If the model of being at work (success, subjectification, identification of the self with a social and professional community) no longer functions for the community of withdrawal in *Trainspotting*, how can the self be represented outside business time and still remain embedded in present-day History? A crisis of representation. The prolongation of adolescence in cities as a (cultural) mode of repressing lived time. The capacity to invent other ways of being in the world as an aesthetic issue.

Find a way out of the logic of withdrawal...1997. "How to re-establish contact with the outside?" Consider a question raised by Dominique Cabrera in her film *Demain et encore demain* (Tomorrow and again tomorrow). A film in the form of a filmic diary...A film that revolves around herself and her immediate environment. Interior of a suburban home...open window...noise from outside...camera scanning another humdrum day...Close-up of a bowl filled with oil...How to gain a grip on my immediate environment (the aspirations and occupations of our close relatives and friends)?...How to become actors again in a social and political construction (share a common history)?...How to deal with existence in another way than through suffering and depression?...How to find a way out when I keep on looking insistently and obsessively (the tight framing) at the clock, the pile of dirty dishes, the bowl of oil where I soak bread when I'm going through one of my bulimic periods, or the bike chain that I haven't the strength to fix and which reminds me that I'm not even a good mother to my own boy? Start by going out. Take my camera...Shoot a woman asleep opposite me in the metro. Subjective camera: Close-up shot around the relaxed hand of the young woman...follow the contours of her body leaning on the window... espouse the rhythm of her breathing. Without imposing an attitude, or impressing the other with your style (Sadie Benning), let yourself go...let yourself be impressed by others. Let the body impress the image...The hand-held camera, the lightweight Hi8 camcorder and the city motion (the metro) as elements in the formulation of a happy, ephemeral proximity to the social body. Dissolve into

the swaying of the train, sink into drowsiness. Let yourself be swept outside the self. Surrender to the moment and let the camera keep shooting. Delay consciousness of the filmed moment until the editing. In the event, the projection of the self outside a state of depression seems to follow the passage from the tightly framed shot (the eye and the mind totally absorbed by the objects that arrest my attention) to the editing (the movement of the mind). A movement of the mind that makes it possible to articulate images of yourself with those of others, to articulate the feelings of malaise when the eye and mind are arrested by an object with moments of activity...Editing as a way of getting yourself back in motion by bracketing images together. A bracketing of long private sequences together with briefer images filmed outside...Edit back together the moments (fragments) that I experience as separated from myself when I'm depressed. Editing as converting a fragment into a moment...The moment as a passage to an otherwise...An otherwise recreated from images experienced and shot too directly, without any distance...Editing as a way of gaining distance from the self...Move from a sense of discontinuity (having no grip on the world) to a sense of continuity (being in accord with the movement outside).

And when the outside takes on hostile, brutal forms, refuse to retreat into an aesthetics of compartmentalization and repression of History (Sadie Benning's room). Refuse to let this History be built up without me (resignation) and against me (negation or exclusion of the subject). Mingle, for instance, with your camera in hand among supporters of the extreme right-wing party who've come to listen to Front National leader Jean-Marie Le Pen and try to understand what it is in the nationalist discourse that reaches a growing number of voters. Leave it to the image to seize the moment when the words of their leader developing the idea that they're being "humiliated" moves these men and women who "are smiling at me as if I were one of them." Stop letting ourselves be subjected to History. Stop letting ourselves be subjected to media images (television). Go out and make different ones. Instead of struggling against present-day History on political grounds, anticipate it so as to grasp some of its motives. Grasp (show) one of the motives behind people's engagement in the Front National. Filming as a first step in deconstructing the nationalist discourse. An overturning of the process of distancing the subject and History formalized by the use of video. Record one's experience of the outside with the qualities of proximity and intimacy inherent in the Hi8 format and restore this experience to the collective experience format (35 mm). But are we to be satisfied with recording? A recording that is not followed by a critical montage...An absence of articulating these

pictures shot among the Front National electorate (the passiveness of the camera) with other pictures – pictures that would reflect the historical conditions of emergence of this type of discourse –, that reflects our difficulty in stepping outside ourselves. A self that remains at the center of our cinematographic preoccupations. An overattentiveness to the self that continues to abstract us from History.

Find a way out of the self...Get out of the logic that consists in letting ourselves be absorbed by the object of our obsessions...Stop taking my immediate environment for the horizon. Get away from intimacy and emotions to recreate a bond with the community from which we've retreated...Strive to articulate our autobiographies with the collective biography. Get out of the self and the anecdotal. An anecdote in which the "I" gets lost (hundreds of stories for an absence of History)...Strive to grasp the historical dimension of our experience – a dimension from which we have been separated (the spectacle, the privatization of experience, the hypercathexis of the self) or which is only delivered to us in the form of fragmented or reconstituted experiences (technology). If the subject has been cut off from History: Produce forms of experiencing this History. Get back in touch with History starting with what we are capable of grasping in reality. Piece back together the sequence of signs that link us to what we perceive of History. Vincent Labaume on the fifty-two photographic images that made up Jean-Luc Moulène's exhibition *Déposition* in 1997: "For him, a photographic image is above all a temporal cross-section of a flux of vague, chaotic, pre-existing images (the world, outside): this cutaway view slices into a segment of the real in keeping with the angle of its selective purpose and [...] relates both a moment at which the visible passes into light and a moment when the social passes into History. [...] If he picks out what seem like the most anecdotic aspects of information, this is because information is always a tissue of forces, law, and History which are never proclaimed as such. And yet, this is one thing that photography really can render: simple anecdotes that configure a play of forces, a state of the world [...]."[32] Devise modes of cross-cutting, of coming and going between fragments, anecdotes in History and our ways of life.

32 "THE PARADISE OF SUSPICION," TRANS. CHARLES PENWARDEN IN *DÉPOSITION* (MUSÉE D'ART MODERNE DE LA VILLE DE PARIS, 1997).

WE WERE SO VERY MUCH ENGAGED
(THE HAMMER AND THE EMOTION)

STATEMENTS THAT GO NOWHERE IN A WORLD THAT COULDN'T GIVE A DAMN

1989. *Palombella Rossa* (Red Wood Pigeon, Nanni Moretti): Michele has lost his memory, and with it his identity, after a car accident…In a hotel room, reading an article signed by him tells him something about his identity…An article that strings together a series of clichés: "It's my article on a dead man. A comrade. I'm a communist! That's what I am. What was that speech? Our project to change society…" The start of a statement that can't seem to find where it's going…Cut to close-up of Michele in a bathing cap, sitting lost in thought in the middle of a water polo team. A communist who ends up on the edge of a pool listening to last-minute advice from his coach right before a critical return match for his team. Out of the pool, two of his former comrades approach him…They're inhabited by passion, he's in his bathing trunks: "They all sold themselves. The more you sell yourself, the more they pay you…" A string of statements without subjects…Who are "they"? Who's been "sold"? The memory of a vocabulary that is now deprived of its historical conditions of emergence. "The more" this and "the more" that, as forming a rhetoric that is no longer informed by meaning…A rhetoric that runs on all by itself…Michele's fed up, he doesn't understand his comrades anymore. Another one comes along: "We must reflect together on this decade. We must construct OUR identity. A strong one! The alternative is a conflictual movement. The strength of the opposition is in the struggle. I'm a union man. Fiumicino, we lost, the school and the housing struggle we lost." To wit, the acknowledgment of an incapacity to influence history. A history that "we lost" and a political will that comes up against conspicuous evidence of indifference…The indifference of contemporary society, here symbolized by the small world of water polo (the world of sports and leisure). An offscreen question: If we lost Fiumicino, the school, and the housing struggle, not to mention the capacity to influence History, to whom did we lose these areas constituent of political and social History? Are they in the hands of local representatives, members of Parliament, the government, business, or the Milan Stock Exchange? The film does not say. On the other hand, it exposes a way of being pushed onto the sidelines of History. The film's perpetual insistence on scenes of discussions concerning the best tactics to win the match intercut with scenes of discussions concerning the decline of political engagement and belief in political action, reveals the more and more pronounced divide between a History that is following its course and men and women who couldn't give a damn. Men and women who seem to have definitively diverted their attention from a History that has offered them enough leisure activities and material wealth to occupy their

free time. Water polo as Michele's contemporary opium...His engagement in the match as a response to the failure of his former comrades. Critical fiction: Michele's misery is at once the expression of real misery and of a protest against real misery. Sports as relief for the troubled mind, as the soul of a world without projects, as the spirit of situations devoid of spirit. It is the opium of the people. Abolishing sports as an illusory happiness makes real happiness a requirement... Back to the reality of Michele, his partners on the edge of the pool and the audience watching...Men and women who also happen to be network news viewers, instrumentalized by History during working hours and indifferent to this same History during their free time (the evening news and the morning paper figuring among modes of occupying free time). History has been turned into news and time liberated for the self into time for standing on the sidelines of public affairs. Water polo as an instance of channeling all of one's energy into free time – a time that is no longer occupied by any type of civic activity whatsoever. The prolixity of tactical discussions as bearing out the total absorption of consciousness in the society of leisure activities. Concentrate on sports and imperceptibly detach yourself from History. Water polo as a fun form of detachment. The loss of Historical consciousness as the result.

The exasperation of Michele's comrades and their impotence to do anything as signs of an incapacity to construct a discourse that accords with the specific characteristics of contemporary society (the articulation of the self with contemporary historical conditions). But his former comrades are not the only ones to come up against a lack of comprehension from their contemporaries. Irritated by a journalist whose language is ridden with trendy words and Americanisms ("kitsch," "cheap"), Michele loses his temper...Slow motion shot of Michele who can't take this byproduct of American imperialism anymore, a slow motion shot that resembles sports replays showing slowed-down action to amplify its effects and to better grasp what has happened: "How do you speak? How do you speak? Words are important." Despairing gestures...painful look on his face at hearing "kitsch" and "cheap." But whereas the journalist's words reflect a certain reality in contemporary Italy – the Americanization of culture, for instance –, those employed by Michele's comrades no longer have any referents whatsoever. In fact, what language are they speaking? And what are they speaking about? The terms they use do not reflect any reality. At a time when contemporary society conceives of itself in economic terms (experts, journalists, companies, and banks represent History in terms of curves, ratings, graphs, indexes, rates, classifications, and so on), Michele's former comrades continue to position

themselves in a language conceived in the context of a struggle against the bourgeoisie as the dominating class governing world affairs. They seem to be addressing a bygone History and fighting the wrong enemy. If the proletariat still exists, if the instrumentalization of the workforce employed for ends that are not their own is still a significant fact of our political and economic condition, the decision makers and centers that Michele's comrades continue to attack are no longer at the origin of recent developments in this society. If Michele once believed they were, perhaps this was because it was still possible in the sixties to locate power (government, employers, and so on) and name the enemy (capitalism). The market economy and globalization have replaced the faces of power by conjunctures and supplanted decision-making centers by a dissemination of these same centers. Michele's awkwardness on a television debate show, where he has been invited to speak as a Communist member of parliament, substantiates his incapacity to connect his discourse to new developments in contemporary economy and politics: "Today, what does it mean to be Communist?…What does it mean to think back…" Michele never seems to be able to finish a statement about his reasons for joining the communist party. Statements without complements…Speaking up without any proposition to make…The expression of a desire with no object besides this selfsame desire to be communist. Or rather a desire devoid of its original object (building socialism). Cut. Just as Michele is getting bogged down in the political jargon intrinsic to television interviews, zap to the pool in the middle of the match. The jump cut acts here to duplicate the flux of images on which TV-viewer consciousness surfs. Zapping as formulating the growing lack of interest in politics as it is still conceived by members of parliament and militants, and especially as it is represented by the media. To wit, the staging of a social and political history that is not only desperately in need of critical actors (other than the possessed comrades) but also, and more importantly, totally lacking in visibility. The characters in *Palombella Rossa* talk a lot about political activity, but this same activity never appears on the screen. What they are saying can never be pictured by others because their words are strung together in an exclusively rhetorical fashion (political jargon). If militant discourse has lost its referent, how is it possible to get back in touch with present-day History?

Back to the reasons that could motivate a new form of engagement in history. Can the idea of changing society still galvanize people when all we need is a few good passes, a bit of concentration, and some self-control to beat them like we did in the first leg? And anyway, what identity are Michele's former comrades

talking about? An identity founded on the capacity to accept responsibility for one's own destiny? An identity founded on the construction of a shared social project? A glimpse at the way in which his former comrades let themselves be possessed by their discourse (a passion inappropriate in a time and place like this)…Speechless, Michele acquiesces, shrinks back, and dives into the pool to escape. Music (calm at last): When his head pops back out of the water…the entire pool is invaded by floating advertisements. Advertisements for cream pies, cup cakes, and chocolate…With childlike pictures and inscriptions…Advertising for sweets (the culture of childish desires) as a strategy for deactivating political consciousness (the conflictual movement, the struggle). The flashbacks in the first sequence of the film to Michele's childhood and his mother encouraging him to practice water polo as querying the reasons behind his engagement. Private or political reasons? Personal or historical aims?

Here, as throughout Europe, the struggle has given way to competition, comrades to teammates, a plan for action to an offensive strategy, changing society to winning the return match. Crosscut montage: On the substitutes' benches, tips from the two teams' coaches on strategies to adopt and the outcome of the match as a measure of those strategies' efficiency; on the spectators' benches (the sidelines), the two comrades launch into electoral strategies, strategies that only concern the positioning of forces in relation to one other, without any regard for the way in which these same strategies could be articulated with the social or political reality. An opposition between a strategy that is articulated on observable situations and a strategy that is articulated on nothing but clichés. Water polo as undermining politics (the efficiency thereof). In this crosscutting between the comrades shouting their heads off and the team members giving their all, between the shouts of encouragement addressed to the teams and the slogans addressed to Michele's very recent incomprehension (amnesia), are we to see the staging of a transference of energy? Is physical engagement being substituted for political engagement? Are Michele's prospects going to be reduced from now on? Reduced to the scale of a weekend, instead of the decade to which his comrades suggest that he "give some thought"? Has the class struggle ended in a definitive victory for the middle classes?

Flashback to the reasons behind his engagement. Insert in the form of super 8 movie that takes us fifteen years back to a conversation that Michele had with a friend who asks him why he became a communist. Michele: "Because I think it's right. You don't feel isolated. Because you're with other people who, like you,

believe in the same things, feel the same things. You are part of a growing world movement. You try to transform reality. You love true humanity, and try to bring it out." Cut. Back to a more reduced perimeter, a perimeter in which the rules never change, that of the pool where the water polo match is following its course. Michele is on the substitutes' bench, unable to concentrate. Has this team in bathing caps really replaced the company of his former comrades? How can you sit there on the side of a pool waiting for the coach to call you in to destabilize the opponent's defense, when you used to be part of a growing world movement? Can maintaining a good position in the regional championship motivate me as much as the desire to change reality? What can come of such a match? Certainly not a new humanity. While the reasons behind his political engagement remain obscure, those behind his engagement in water polo become clearer. Consider a series of obsessive flashbacks to a crucial moment in childhood: While his mother looks on and a sinister monitor threatens him, the little Michele refuses to dive into the deep end of the pool, screaming that he wants to change sports, that he's made a mistake…To wit, a shift in attention from the political to the psychological, from collective History to private history. Right after one of these flashbacks, Michele interrupts a discussion about game strategy (he's just gone into the water) to complain to his coach: "You never talk to me about yourself. I know nothing about you, about your memories." Does beingtogether, does getting a number of individuals together around a common objective (beating the opponent) condemn the individuals to forgetting themselves for the benefit of the common cause? And if we extend the metaphor: Are the community and the ends ascribed to it overemphasized at the expense of the self? Michele suddenly gets nervous and jumps out of the water to apply eye drops…the militant is falling apart…The boo-boos, the small traumas from childhood are gaining the upper hand on the philosophy of engagement and its principle of self-effacement for the benefit of the common cause. A question at this stage in the match: Was this man ever really a militant? *Palombella Rossa* stages two ways of being in the world: one firmly focused on me, myself, and I, and another purportedly directed at the in-common. Certain scenes refer to two ways of reading and constructing the self (two forms of existence) that seem mutually exclusive: psychoanalysis (the self) and communism (the community). If political engagement has repressed the psychological territory, hasn't this same psychology (with its often excessive attentiveness to the self) contaminated politics? In the pool, right after losing a ball while dribbling, Michele explains: "I want to be clear. It's not that in the Communist Party some are anguished and some are not. We are all very worried." Cut. But what are all the militants

worried about? A look outside the pool. Michele's standing in front of a television, watching as a man accuses a woman of being "the kind of woman who sleeps around." Indignant, he and his daughter cry out in unison: "Pig!" But what part of him was offended? The militant-communist part that feels close to feminist concerns in their struggle against macho authority, or the TV audience part necessarily involved in the process of emotional integration inherent in cinema? Can emotional reactions be an ally to political consciousness? Is there such a thing as TV audience conscientization? Unless it is a matter here of staging the alienation of viewer consciousness by private matters. An alienation that becomes the objective ally of those who have an interest in keeping this consciousness out of public matters. In front of the TV, still in a bathing cap but this time on the brink of tears, Michele lets himself be hypnotized by a scene from Doctor Zhivago...Woman: "We should have met sooner. Even one day sooner. We would have married, had children. What would you have preferred. A boy or a girl?" Man: "We'll go mad if we think of this." Woman: "I'll always think of it." Identification guaranteed. The interchange between the man and the woman who are about to part against their will as putting into words the choice that has faced all men – hence all militants – since the Greek tragedies: Civic duty or Helen's eyes? The good of the community or family life? In the event, the classical scene of an impossible choice between love and a nobler aim (the sacrifice of the self for the community) goes together with the bourgeois ideology associating happiness with the acquisition of property. The detached house as a form of living outside of public affairs. The TV screen as a medium for attracting the self outside the public sphere (affect versus the community). Guy Debord: "The economic system founded on isolation is a circular production of isolation. The technology is based on isolation, and the technical process isolates in turn. From the automobile to the television, all the goods selected by the spectacular system are also its weapons for a constant reinforcement of the conditions of isolation of 'lonely crowds.' The spectacle constantly rediscovers its own assumptions more concretely."[33] The television constantly reinforces Michele's conditions of isolation. This isolation does not deactivate his consciousness, but the activation of TV audience consciousness works on the principle of empathy, a principle inherent in the audiovisual form that precludes the possibility of action (leaving the television for the street). If the reaction to a televised injustice is instantaneous ("Pig"), its translation into concrete action is a good deal less so. Worse still, Michele is so infuriated by the journalist's use of Americanized language when

33 OP. CIT., SOCIETY OF THE SPECTACLE.

she questions him about his former engagement and about feminism that he slaps her. The spontaneous reproduction of a gesture inherited from a macho authoritarian culture, which he has condemned just a few minutes before while watching TV. Could his TV-viewer consciousness be more politically active than his consciousness as a former militant? Are acts in constant contradiction with political intent and with the consciousness we construct for ourselves while watching TV? Do we always lag behind our political projections and cultural representations?

POPULAR SONGS WILL SAVE HUMANKIND

If the isolation founded on spectacular goods condemns the possibility of bringing people together (common action), if cultural heritage (the slap) overpowers progressive views, how can Michele's militant potential be recovered? By depriving him of television or by harassing him around the pool to get him to participate again in redefining an identity of his own? A few minutes before the end of the match, Michele's former comrades, exasperated by his refusal to listen, grab the sportscaster's microphone and start screaming that they want to be heard, that they are not fools, that they have important things to tell the contemporary world. At the same time, tension is rising in the losing team...: How can it catch up on a seven-goal lead when there's so little time left?...If the community refuses to hear the last militant's call to an improvement in their lives even though things are going so badly, and if surrogate communities, such as those constituted around sports pursuits, produce nothing but tension, then where can anyone find peace? If politics (the days of an engagement that clearly belong to the past) and sports (the society of leisure activities) are no longer bonds, if card-bearing party membership and membership in sports federations no longer serve as common pursuits, then what is left? What community and what bonds in the years to come (in this case, the nineties)?

Right in the midst of the cacophony produced by the dismembered communities and the divided public (taking sides), just as Michele asks to rejoin the game in the final minutes of the match, the sound of a portable CD player...The first notes of a Bruce Springsteen ballad...Notes whose immediate effect is to suspend all talk among athletes and politicians. In the silence of the stands, the Boss's voice booms...: "Oh, oh, oh, I'm on fire...Oh, oh, oh, I'm on fire..." The coach and a number of supporters and players begin singing along. The others listen. The passion is transformed into adhesion to the song. A song that begins to make the people in the pool and on the stands swing...A song to make you

cry with emotion…A swinging to halt gut reactions and the urge to oppose the other side. It takes two to dance cheek-to-cheek but many more can swing together to the music…A mode of togetherness that doesn't work on the principle of opposition between two classes (the bourgeoisie and the proletariat) or two teams (the reds and the blues)…a mode of togetherness based on sharing the rhythm and the super-duper fun…a mode of being-together that soothes the nerves and deactivates the urge to humiliate the other team. To the last measures, the game picks up at a smooth, easy pace. But as soon as the music stops, the screams and passion resume…The losing team starts to lob, the winning team begins to lose its composure…The public takes sides. Culture as a truce. Make music not sports. Unless we take each goal as a form of self-fulfillment…In the uproar, and to the sound of relatively soothing music, a Catholic speaks to Michele: "We're Catholic. Sports religion, not good against bad. Good against good. The good score goals. Each goal is a silence [the temporary peace of the Springsteen song]. Each silence is a goal. What is Communism? A total sentiment. What is this totality? A field, a playing field." The Communist: "A pool." The Catholic: "A pool with angels around. Spectators looking at you. They yell, see you…but you…silence. One hundred and sixty-three points in your life. Today three or four are enough." The goal as self-fulfillment. The goal as an existential goal. To each his purpose. The dismembered community (individualists) and the breakdown of its activities as grounds for a multiplication of purposes. Purposes on the scale of the individualism with which we have to come to terms. Purposes definitively turned away from the community cause and from the construction of a humanity of another type, but which would nonetheless transcend the law of the jungle and the market economy. Momentary silence of the crowd… music…The allegory-match turns to the advantage of self-fulfillment. In the meantime, possessed by communist passion and infuriated by their inability to win back Michele, the comrades blow their tops: "We need new wisdom for a new era…You've lost all emotions because your egoism devours you…You don't care about world atrocities. You only think of yourself." Thus spoke the men at the edge of the pool. But Michele couldn't give a shit. There's a minute left in the game, his team is only one goal (the fulfillment) behind, and the referee has just awarded them a penalty. Michele beseeches his coach: "Mario. I want to shoot. I can do it. I can do it." After two discounted throws (one before the whistle, the other because it wasn't the referee who whistled), as Michele is about to throw again (the moment of fulfillment), the audience and the players suddenly lose all interest in the action…The audience stands up silently… Michele drops the ball and joins in what becomes a procession. A procession

to the television. On the screen, *Doctor Zhivago*. If sports is no response when it comes to recreating a form of being-together of a different type, what about the spectacular solution? A solution that rallies everyone together in an attempt to tell Omar Sharif that the woman who is walking alongside the tramway is the one he loved eight years ago? So this is where all the emotion has gone. Into the vicarious fulfillment of others. If the audience has long since lost interest in the match, their way of encouraging Sharif in his desperate attempt to attract the attention of the woman he's always loved looks a lot like the way they had of encouraging the players to score a goal just a few minutes before. To wit, the staging of a transference. A transference in which we are deported behind those who are acting and living on our behalf (society of the spectacle): "Turn around! Knock, knock, knock! Run! Run!" And when Sharif, after descending from the tram and trying in vain to catch up with her, collapses dead in the middle of the street – the supporters-cum-television viewers let out a despairing cry: "Noooooo!!!" Expressions of distress in the crowd. A crowd that goes home disappointed. The society of entertainment supplies nothing but temporary solutions. The crowd breaks ranks once more.

On the TV debate show, pushed into the corner by his political opponents, Michele ends up spouting more and more clichés about the goals of the PCI before finally losing control: He drops the political tone and breaks into song…A song that sparks unanimous adhesion ("I should change the object of my desires, No longer be satisfied with daily joys…"). Variety show self-criticism for a repented individualist. Cut. Far from the "Internationale", Michele and then the supporters, put the world and their desires into lyrics…: "I've come searching for you just to talk to you, I like what you say and think. In you, I see my roots. This century which is ending is full of parasites with no dignity, urges me to be better, with more willpower." A drum solo and the swelling sound of the synthesizer to underscore the surge in collective emotion…Music as a body conductor. The memory of the "Internationale" is effaced by popular international music. A refrain and an appealing theme as a fun form of alienating audience consciousness… "Search for ONE above good and evil. Be a divine image of this reality." Michele's head thrown back in joy. The coach's face beaming with emotion…The public singing in unison…A community created for the emotional occasion, brought together by a song. But man is selfish. Forgetting the music, Michele concentrates on *his* goal, wonders which way he should throw the ball, and misses the goal. To end: Unable to find a solution, Michele paces back and forth along the edge of the pool, delirious: "I'm thirty-five. My childhood snacks will never

come back…Bread and chocolate. Mommy, my mommy." The nostalgia for bygone struggles vanishes – the nostalgia for childhood gains the upper hand… Communism never managed to resolve the sense of discontinuity and to compensate for the lack of affection (the hammer and the pacifier). The need to take care of oneself first of all finds expression at last. The culture of overattentiveness to the self (the perfected form of individualism) to the detriment of engagement in the common good (the dreamed form of politics) burst through at last. Music… Gentle notes…Nostalgic, fantasy-like overhead shot of dozens of mothers towel-drying their boys' hair…Cut. Out of breath, unable to find happiness and a sense of continuity as a Communist or a water polo player, Michele gets into his car, steps on the gas, screams "Mommy, come get me," and drives off the road. Driving off the road and a few somersaults to bring to an end what will never change anyhow. A political question to conclude: Is there anything that could still make me feel an attachment to the community?

MEANWHILE...
(AESTHETICS AND HISTORY)

FORMALISM AND SOCIETY (HISTORY AS THE DISREGARDED FACTOR IN
MODERNISM)
Of course, the narcissism, of course, the individualization of references, of course,
the reinforcement of conditions of isolation of lonely crowds, of course, the
eternally prolonged adolescence, the emotion cultivated versus the community,
the need to have a blast...But in a certain way, didn't art history, as it was for-
mulated in the course of the twentieth century, also cut itself off from History?
Didn't it relinquish its capacity to have a critical impact on recent mutations in
contemporary society? Didn't modernism contribute to cutting the subject off
from History?...

Back to a key moment in the history of modernism. Rosalind Krauss on Robert
Morris's *Passageway* in 1961: "a fifty-foot-long curving corridor that narrowed to
a point, so that visitors to the loft-space where it was installed as the only element
of Morris's 'exhibition' would enter only to find themselves progressively squeezed
into an impassible cul-de-sac. The work was thus an exchange between the
single motion of the viewer – 'transit' – and the shaping of that motion by the
increasing pressure of the walls. *Passageway*, one might say, was nothing but
a bodily gesture caught in the act of surfacing into the world."[34] Consider the
start of a decade during which sculpture challenged the boundaries delimiting
its exhibition space and its representation space, and conflated the two in order
to integrate the spectator into the process of making the work. A process that
entailed the experience of real space in real time. The activity of the body put
into a real-life position in space as an affirmation of a mode of self-production.
The motion of the body in space as a mode of self-inscription. Birth of a subjec-
tivity enacted here and now. A subjectivity that did not precede the aesthetic
experience any more than it surpassed it. A subjectivity reduced to the motion
of the body "in the act of surfacing into the world." A neutral transhistorical sub-
jectivity, cut off (emancipated) from psychological, economic, social, political,
and historical determinism. A universal, timeless subjectivity reduced to its sole
appearance. When Robert Morris danced alongside Yvonne Rainer, his body
was a neutral body. Neutral by being naked (stripped of outward signs of belong-
ing to a specific historical period or social group). Neutral by holding the emo-
tional or psychological charge at bay. The radical staging of the body divorced
from affect, individuality, society, and History. The position of the artist's naked
body in the *I Box* as the death of identity. Rosalind Krauss: "Part of the meaning

34 "ROBERT MORRIS AROUND THE MIND/BODY PROBLEM," *ART PRESS* 193, JULY-AUGUST 1994, P. 26.

of much of minimal sculpture issues from the way in which it becomes a meta-phorical statement of the self understood only in experience. Morris's three *L-Beams* from 1965, for example [...]."[35] But the self in question here is neutral and transhistorical. 1965. Whitney Museum of American Art, New York: In an exhibition space, three plain, smooth polyhedrons in fiberglass, one placed on its side, one upright, and one poised on its edges. After the viewer has moved around them and shifted positions a few times, it becomes clear that the poly-hedrons are identical in shape and size (eight by eight by two feet): *Untitled L-Beams*. In the event, the viewer becomes the agent in the articulation of the three beams. To wit, the exhibition of a passage, a shift in the history of art and sculpture. By proposing three absolutely identical structures (the absence of dif-ference), Morris reduces these same structures to simple terms in a set of rela-tionships that the visitor is responsible for establishing: "The better new work takes relationships out of the work and makes them a function of space, light, and the viewer's field of vision. The object is but one of the terms in the newer aesthetics."[36] Shift from an approach to sculpture founded on the apprehension of a three-dimensional object to the articulation of several objects. Shift from a form of sculpture to a form of language. By turning the viewer's attention away from the objects themselves to the relationships between these same objects, Morris disinvents a genre – sculpture – and proposes a syntax in which the spectator is invited to perform a task, a task that consists in assembling three separate elements in an exhibition space henceforth constitutive of the repre-sentation space. The act of relating as a new form. An aesthetic proposal that functions in the manner of a language (the L recalling the first letter in Language), a language extended and materialized in an exhibition space where the task is to connect several terms to form a sentence. The experience of this articulation of polyhedrons as a sentence. The exhibition of a generic syntax. A generic syntax that does without the History that is taking place outside the museum walls.

Indeed, at the end of the sixties, much of what was regarded as Minimal art was marked by the will to lay the groundwork for an aesthetic experience aimed at producing a transhistorical subject and transhistorical forms...A subject and forms outside the sound and fury of the world in the abstract space of the loft

35 "SENSE AND SENSIBILITY," *ARTFORUM* (NOVEMBER 1973), P. 49.

36 "NOTES ON SCULPTURE," *ARTFORUM*, FEBRUARY 1966 AND OCTOBER 1966, REPRINTED IN GREGORY BATTCOCK, *MINIMAL ART*, A CRITICAL ANTHOLOGY (UNIVERSITY OF CALIFORNIA PRESS, 1995), P. 232.

or the white cube. Both symbolic space and the historical dimension of experience were suppressed. The emancipation of the subject was conceived as a release from and a distancing of History. And when art sought to constitute, or rather produce, a collective subject opposed to the notion of authorship and the idea of a work signed by an individual – when Niele Toroni, for instance, noted that "this work can be produced by anybody using a No. 50 brush to apply paint on a white ground (plastic, paper, wall, canvas…) at intervals of thirty centimeters…"[37] – this same subject, released from any form of determinism, was doomed never to be able to articulate itself with a social reality. Jeff Wall on Benjamin Buchloh's functionalism: "When a work by an artist like Buren ventures forth into the city, it does so as a purified and neutralized cipher, dragging with it a residue of simple exhibitability. […] André Breton wrote, 'Revolt is just a spark in the wind, but it is the spark which seeks the powder.' Buchloh's functionalism appears to wish to rekindle this spark – the conscious monad of negativity, revolt and exposure, which trembles toward the social force it sees itself as destined to ignite. But in the self-imposed blankness of its own character, the cipher erases the identity of those forces in the city which can transform society. The consequence of this erasure is that the *impulse* of negativity negates itself in the very gesture in which it appears before 'the public'. The abstract concept of 'the public' though, is also the product of the historical loss of memory embodied by the erasure."[38] On the other hand, certain works at the beginning of the seventies relied on a syntax inherited from Minimalist sculpture, but instead of probing a transhistorical, generic self, they explored a specific self, embedded in a historical dimension. Vito Acconci's early installations count among the most significant proposals in what could be called the – postmodernist – period of reconstruction of the subject. Proposals in which it was no longer a matter of integrating the subject-spectator into the process of making the artwork but rather of constructing a subject integrating psychological, social, anthropological, cultural, or political dimensions (*Voice of America* versus *Memory Box*). This movement of reconstructing the subject apparently came to an end in the eighties and nineties. Acconci on the artists of his generation: "We wondered why museums had no windows […] why is a museum so closed off from the outside world. […] My generation was involved with a kind of everyday space, and once you deal with an everyday space, you're a citizen and not a contemplator of art. […] In my generation there seemed to be such an urge to melt the museum

37 *TORONI*, EXHIBITION CATALOGUE, BRUSSELS, 1970.

38 *DAN GRAHAM'S KAMMERSPIEL* (ART METROPOLE, TORONTO, 1991), P. 110.

walls. And as soon as you do that and you're out into the world, you apply your-self to dealing with the world. I think my generation wanted to think of art history as part of an overall history, and not as a segmented, isolated part."[39]

WHEN ATTITUDES BECOME DISCRIMINATORY (WE HAVE RECEIVED ORDERS NOT TO MOVE)[40]

But this construction of a neutral, transhistorical subjectivity – cut off (emanci-pated) from psychological, economic, social, political, and historical determinism – is possible only insofar as this same subjectivity already enjoys freedom of movement in the social sphere. If in this social sphere the masculine body can assume almost all the positions (functions) necessary to the political, economic, and symbolic functioning of the society in which it is embedded, what postures are offered to the feminine body? What projections and representations of the self are possible in the feminine gender? What are the spaces and modes of symbolic inscription of the self in the feminine gender? What leeway do I have and how far can I allow myself to deviate from the patterns of being in relation to the world and to others (the patterns of being in relation to men) that are proposed to me?

For him. Find a different space of inscription. Choose the space…A loft, a street, a park…A space that will generate certain behaviors and certain activities. 1969. *Level* (Central Park, New York): Lying on his side, Acconci takes five photos – one with the camera at foot level, one at knee level, one at stomach level, one at chest level, and one at head level: "Ways to be in space (ways to consider that): 'I'm here' – 'I' is different from 'here' – 'I' has to go 'here' – 'I' have to go 'here' – I have to keep going to where I am (directing myself to where I am – where I am is directed to my body). Where I am (my position when I take the photographs) – where I might be (the landscape photographed: where I am when I point in that direction) – my body as a system of possible movements trans-mitted from my body to the environment (the environment as a system of pos-sible movements transmitted from the environment to my body)." Action as the relationship and the mediatization (the medium) between body and space. To wit, a work with two dimensions (two spaces): action and representation. A work with (in) two stages: The present in the action and the past represented in the photographs. An "I" placed in a site and in an action – via the body. The medium

39 *OP. CIT., ENTRETIEN/INTERVISTA/INTERVIEW…, P.* 135.

40 TITLE OF A PIECE BY BARBARA KRUGER.

gives it its position – during the shooting and after the printing. The action has only one stage. The positioning, two. Their representation is developed in the printing.

For her. Stay in the space of inscription given by the culture in which I am inscribed. Have no choice...The house, the street, the shops...A space that will generate certain behaviors and certain activities. *Jeanne Dielman, 23, quai du commerce, 1080 Bruxelles* (Chantal Akerman): Get up every morning at the same time; do your shopping at one store on one day and another on another; do the dusting from this time to that; sleep with occasional clients at specific times in the afternoon to pay for your son's studies; make the vegetable soup; eat supper with your son who's absorbed in a book, and go to sleep. Ways to be in space (ways to consider that): "I'm a widow." I'm a mother. I'm at home. I'm a housekeeper. I have to go "do the shopping." I have to find money. I have to keep raising my son (live where I am – where I am conditions my activities). Where I am (my position as housekeeper and mother) – where I might be (the places where I never picture myself: where I might be if I weren't overdetermined by my condition) – my condition as a system of obligatory movements transmitted from my environment to my body (my existence as a system of movements governed and ritualized by the vital needs of the organism and education). Housework as the relationship and the mediatization (the medium) between my body and space. To wit, the inability to appropriate a single moment for myself – a moment (to myself) when I could construct a subjectivity other than the one that engages me totally in peeling potatoes. A functionalized mindscape: I am thinking about the fact that I am peeling potatoes. A mindscape in which the time of the imagination is erased by the real time of potato peeling. Recording in real time as articulating the total absorption of consciousness in the practical dimension of existence. A repetitive existence precluding the possibility of deviating or of behaving unconventionally...as if the absence of idle time in one's timetable meant an absence of time consecrated to desire, to tending toward something other than the potatoes which have to be ready in a few minutes. An existence set in a house and regulated by *things to do* (the ritual) – via the programmed gestures of the body.

Formalism (*Level*) and society (*Jeanne Dielman, 23, quai du commerce, 1080 Bruxelles*). The "I" emancipated from finalized activities, from social, cultural, psychological, and economic determinism, and the condition of the housekeeper whose agency is limited to a sequence of finalized activities. An "I" free to move,

free to project itself into a relationship to space of its own making, and a condition in which movements through space are determined by a position assigned by cultural and economic conditions. An "I" that produces and a behavior that is produced. If the construction of the self may constitute an aesthetic issue, then risk this issue in space and historical time. The construction of the self outside the historical conditions that shape us (the atopia of art) cannot act as a model outside the paradigm of aesthetic experience. By operating solely in the supposedly autonomous and separate sphere of aesthetic experience, this same experience precluded any chance of emancipation from conditions of alienation, from forms of determinism that fix individuals in the very set, limited identities that it was implicitly denouncing. Benjamin Buchloh on James Coleman's work: "Within the general project of reconstituting a historically specific body to the universalist abstraction of phenomenology, Coleman insists on a sociopolitically specific body, structured by the discourse on national identity. [...] It is only in the extreme emphasis on the particularity of historical experience that the last vestige or the first index of unalienated subjectivity is to be found."[41] Indeed, by refusing to operate in the parameters of an experience of time lived outside the separate sphere of art, universalist abstraction became the objective ally of strategies for confining subjectivity. In addition, when the aim of the aesthetic experience, separated from historical space and its contingencies, was the construction of a subjectivity, the projection it reflected was an ambiguous one: that of a subjectivity exempt from contingencies and above belonging, a subjectivity shared by the spectator alone, a subjectivity enacted in a "purified" space...As if the time lived outside the paradigm of the aesthetic experience were "impure"...As if the aesthetic experience had entered a period when the focus was on finding fulfillment as a "Superspectator"...To wit, a projection which, taken out of its context of enunciation (modernism), recalls the ideological fantasies that produced a few of the most tragic events in twentieth-century history ...Michel Foucault: "In fact we know from experience that the claim to escape from the system of contemporary reality so as to produce the overall programs of another society, of another way of thinking, another culture, another vision of the world, has led only to the return of the most dangerous traditions. [...] I prefer even [...] partial transformations that have been made in the correlation of historical analysis and the practical attitude, to the programs for a new man that the worst political systems have repeated throughout the twentieth century."[42]

41 "MEMORY LESSONS AND HISTORY TABLEAUX: JAMES COLEMAN'S ARCHAEOLOGY OF SPECTACLE," IN *JAMES COLEMAN – PROJECTED IMAGES: 1972-1994* (DIA CENTER FOR THE ARTS, 1995), PP. 61-62.

A universalist abstraction that assimilated any experience of specificity existing outside the field of art to an experience of restriction...To be here and now in the process of making an aesthetic work, or not to be. To work on a consciousness of duration (process), forms, and volumes (space) that refer to nothing but themselves...A duration, forms, and volumes that do not refer to any recognizable form existing in the world and in the time lived outside the aesthetic experience, detached from any signifying charge other than that of their neutrality and their appearance (the suppression of the world's forms). The use of exclusively geometric forms, and in some cases, of nude bodies in performances as an affirmation of transhistoricity. As if History, the social, the political, and the psychological were too definite, too defined, too particular, too restrictive, too dirty for a cube that's a bit too white...To wit, a discriminatory conception of the aesthetic experience. Laura Cottingham: "Feminism asserted that art, like 'the personal,' is political. The movement refused a formalist imperative, insisted on the importance of content, contested the absoluteness of history, [...] asserted a place for the autobiographical, reclaimed craft, emphasized process and performance, and, perhaps, most radically, refuted the idea that art is neutral, universal, or the property of men only."[43] In the masculine gender, the modality of the relationship to space is invented. In the feminine gender, the relationship to space is conditioned. *Passageway*: A curving corridor that acts as a pronominal space. A space where we become the subjects of the action during the time of the activity, of the aesthetic experience. Here, the active form, elsewhere, the passive form...Back to History...Emancipation as the point at issue.

Diametrically opposed to the utopia of a de facto emancipated subjectivity (the transhistorical becoming-subject of the spectator), work in (on) the parameters of alienation. Take overdetermined identities based on age, social, and cultural categories as a starting point. 1972. *Vital Statistics of a Citizen Simply Obtained* (Martha Rosler)...Consider a forty-minute color videotape. In a windowless room, two men in white coats: "Next." A young woman enters and sits down: "Your sex?" "Female." "Age?" "Thirty-three." "Race?" "Caucasian." "Ethnic background?" "Austrian and Russian." Back to determinist reality. The aesthetic

42 "WHAT IS ENLIGHTENMENT?," TRANS. CATHERINE PORTER IN P. RABINOW, *THE FOUCAULT READER* (PANTHEON, 1984), PP. 46-47.

43 "THE FEMINIST CONTINUUM: ART AFTER 1970," NORMA BROUDE AND MARY D. GARRARD, *THE POWER OF FEMINIST ART. THE AMERICAN MOVEMENT OF THE 1970S, HISTORY AND IMPACT* (HARRY N. ABRAMS, 1994), P. 276.

fantasy of a neutral subject conflicts with the reality of a society that defines, classifies, labels, categorizes, controls, instrumentalizes, and excludes. The list of identificatory terms as undermining the fantasy of an emancipated, nondetermined subject. In the event, all the criteria of belonging enumerated are unrelated to a national identity or to an identity based on a nation-state. Social and professional criteria are also left out…The exclusive listing of distinctive signs of sexual, ethnic, and racial identity as an elimination of names (de-individualization) and political forms of identity (the negation of citizenship and professional activity as forms of subjectification and modes of representation and symbolic inscription). The exhibition of a woman reduced to her anthropological identity alone. Then a detailed examination of the woman's physical features begins. One of the two men measures all the parts of her body and writes the results down in a notebook, specifying each time whether they are standard or above or below standard; the other man notes them on a true-to-scale drawing of the woman on the wall. After answering the questions about her sex, age, race and ethnic background, she is invited to present herself physically not verbally: "Spread your arms please…Remove your socks please…Spread your legs apart…" Shut up and lend yourself to a detailed examination of your body… Become an unidentified form that is manipulated. Offscreen, Martha Rosler's monologue: "This is a work about how she is supposed to think about herself. How she learns to scrutinize herself, to see herself as a map, a terrain, a product, constantly recreating itself inch by inch, groomed, manufactured, programmed, reprogrammed, controlled." The staging of a scientific, administrative negation of singularity and individuality (the young woman's radical objectification and her lack of expressiveness). Measurements as the sole and ultimate elements of representation (the becoming-statistic of man).

Enter three young women in white jackets. Three young women who remain standing and who punctuate each measurement announcement with a musical comment: bells to congratulate her for standard measurements, three quacks of a horn to mock below-standard measurements, a whistle to greet above-standard measurements…The musical comments as metaphors for normative discourse: whistling as a warning signal (understand: you'll have to lose weight); horn blowing as a sarcastic reaction to measurements you should be ashamed of; and bells to signal the passage of a real beauty. Three women who have totally integrated the criteria (who know the score). Gradually, to facilitate the measuring, the woman has to remove her clothes. Fully dressed when she walked in, she will finish the examination completely naked, following the instructions of the

man in a white shirt. Instructions which, by their matter-of-fact simplicity and crudeness ("Spread your legs apart...Move the bottom of your body forward... Relax"), reduce the woman to a mere object of scrutiny, a body deprived of speech and free will. If Rosler's voice opposes the violence being done to the woman (the consciousness), the citizen who's being done to does nothing to oppose the instructions. The silence of the woman/object of scrutiny as revealing a dispossession of her own capacity of representation to the profit of a representation formulated by the powers-that-be. A representation that calls for the social and economic use of female bodies. Offscreen voice: "Her mind learns to think of her body as something different from herself. [...] She sees herself from outside with the anxious eyes of the judge who holds within her mind the critical standards of the ones who judge. She knows the boundaries of her body, she does not know the boundaries of herself. She's been carefully trained in a mechanical narcissism that it is a sign of madness or deviance to be without. Her body grows accustomed to certain prescribed poses, certain characteristic gestures, certain constraints and pressures of clothing." The representation of the self in the feminine gender as the point at issue.

In the masculine gender, movement through space had no purpose but itself (formalism). In the feminine gender, it had to give itself a critical finality. If, in the masculine, the body can choose its attitudes, gestures, and movements (impress space), in the feminine, it reproduces the figures imposed by the tools of body control and representation that our societies give themselves – namely, advertising, fashion, rules of etiquette, and so on. The ability to impress (mark) the environment is a condition reserved to those empowered to produce and modify space: governments, armies, businesses, banks, architects, artists...In the feminine gender, the body cannot impress space. Erection and invisibility. The condition of being impressed by pressure from the environment – by the gaze of others, by behavioral codes, and so on – is the condition reserved to those who are modified by governments, businesses, advertising companies, and artists...Michel de Certeau: "Clothes themselves can be regarded as instruments through which a social law maintains its hold on bodies and its members, regulates them and exercises them through changes in fashion as well as through military maneuvers. The automobile, like a corset, also shapes them and makes them conform to a model of correct posture; it is an orthopedic and orthopraxic instrument. The foods [...] also shape bodies at the same time that they nourish them; they impose on bodies a form and a muscle tone that function like an identity card. Glasses, cigarettes, shoes, etc., reshape the physical

'portrait.'"[44]…When the examination is over and the woman is dressing, the offscreen voice lists different methods of showing off one's body or conducting oneself in public…The measurement session began with her dressed in loose slacks and a shirt – clothes that didn't hug the contours of her body; it ends with her trying on bras, pantyhose, dresses, and hairstyles in front of a mirror… Choose your image (the reduction of the self to an object of scrutiny as the sine qua non condition of integration). A construction of a self-image that masks other forms of alienation and other forms of instrumentalization…Measurements that call to mind criteria and norms that have already been used in the course of History for purposes of enslavement (slavery) or destruction (genocide). Voice-over: "Scientific human measurements have been used to keep people away from education, to keep certain races and nationalities out of America, to keep women subordinate, to keep women in their place." In the event, the body exhibited by Rosler is arrested…Arrested because it's deprived of free will …Give up the illusion (the dance) of a body with a potential freedom of expression and impression. Imprisoned in representations that do not belong to it, the female body can only produce its own movement by transgressing the criteria of self-presentation that are imposed on it.

Meanwhile, until we are able to create an image of a disalienated body, leave the body's control to judges and construct a critical discourse. A discourse firmly divorced from the body. Since the female body is the property of a power that does not belong to women, it cannot be the place whence a critical discourse originates. The offscreen voice as the conscientization of a condition. A conscientization that opposes the will to abstraction inherent in formalist propositions. In the event, Rosler recontextualizes the female body in historical space and time. Transhistoricity as an absence of historical consciousness (when formalist attitudes become a party to alienation…). When the examination is over, the citizen whose vital statistics have been simply obtained (the woman/object of scrutiny) leaves the screen and comes back naked. She squats and breaks six eggs into a bowl which she presents to the camera. The lesson has been learnt. The citizen knows her proper place. Cut.

44 *OP. CIT., THE PRACTICE OF EVERYDAY LIFE*, P. 147.

MODERNISM AS THE DISREGARDED FACTOR IN CINEMA (HOLLYWOOD PRESENTS LA VIE D'ARTISTE)

Another form, another way of cutting ourselves off from History…A riddle: What do Jacques Rivette, Jean-Luc Godard, Luchino Visconti, Andrei Tarkovsky, Peter Greenaway and the soft porn films shown on late-night TV have in common? A nostalgia for Great Art and a longing to paint a picture of life's great *themes* – in the high-school textbook sense of the term. A nostalgia and a longing patterned on premodern models and aesthetic criteria: the period of wandering (leading to the transition between *the sound and the fury* and the *creative* moment), the *revelation* of *beauty* (large stretches of desert, the sun in his eyes, visions, fainting), the retreat from the world to *create* (the meeting with a stunningly beautiful model, whole days spent in the studio), the artist at home and related behaviors (asociality, rivalry between the painted woman and the painter's wife, eyes lost in thought, disheveled hair, metaphysical doubts, anxiety faced with the blank canvas), the suspension of time and the muscular tension as the hand applies the last layer of *truth* to the painting (a Van Gogh), the belated or posthumous recognition (Musée d'Orsay). Hollywood-sur-Oise. *La Belle Noiseuse* (a blunder by Jacques Rivette) as the perfect, grotesque illustration of this archaeological representation of the artist. A twentieth-century form of representation for a nineteenth-century *cinema d'auteur*.

This naive, archaic view of the artist, which goes from the parallel between the body and the painting to a revival of the supposedly eternal "themes" of Great Art (Goya's black paintings fading into documentary scenes from World War II in *Histoire(s) du cinéma* by Jean-Luc Godard), has nothing to do with any of the major filiations in the history of art over the last eighty years. Is this ignorance of the most significant twentieth-century practices in the field of visual arts due to a lack of curiosity? Is it due to an incapacity to understand the representational issues specific to certain periods in the twentieth century? To a blind, unconscious submission to codes posited at the beginning of the history of cinema and accepted once and for all? It is striking to examine the extent to which cinema has remained faithful (submissive) to its codes of representation, especially if we compare its history to that of the other visual arts. In the fifties and sixties, the work of many artists challenged the traditional forms of representation of painting and sculpture (the exploration and use of their sole constituent elements), and then went on to challenge the boundaries delimiting the exhibition space and the representation space to the point of conflating the two (the abolition of the frame and the base). A brief reminder: At the end of the sixties and the

beginning of the seventies, museums, galleries, cityscapes, and landscapes became the settings in which spectators were called on to participate in the making of the work by articulating its material and its signs – by enacting (realizing) a proposition. This led to a widening of strata of intervention: The formal problematics of modernism (the aesthetic experience) gave way to investigations integrating the historical dimension of experience. In fact, a great number of artists at the beginning of the seventies began working on the social, political, and anthropological dimensions of History, and did so combining an array of media that included the performing arts, music, film, video, photography, text, objects, and/or their own bodies. This work on history sometimes assumed dematerialized forms ("attitude" art, Conceptual art). The abandonment of traditional forms of representation (painting and sculpture) for what is commonly called "installations" was also related to an awareness of the dramatic changes that were taking place in the contemporary "landscape." City life and the collisions and clashes among a wide array of heterogeneous objects, events, images, sounds, and data that occupy us, require other modes of reading (that call on senses other than sight), other relationships to time and speed, other modes of articulating signs (fragmentation, discontinuity, juxtaposition, simultaneity). But who of Jacques Rivette, Jean-Luc Godard, Luchino Visconti, Andrei Tarkovsky, and Peter Greenaway realized the implications of works by Vito Acconci, Allan Kaprow, Chris Burden, Valie Export, Gina Pane, Robert Filliou, Martha Rosler, Robert Smithson, Marina Abramovic, Barbara Kruger, Bruce Nauman, James Coleman, Cindy Sherman, Dan Graham, Mike Kelley, and Felix Gonzalez-Torres?

Eighty-three years after the invention of the readymade (Duchamp's *Portebouteilles* dates 1914 and his *Urinoir* 1917), Great Art and the painting form still stand as models and references in the very closed circle of auteur films. As if the history of art had come to an end with Baudelaire's statement on *beauty* in "The Painter of Modern Life": "Beauty is made up of an eternal, invariable element, whose quantity it is excessively difficult to determine, and of a relative, circumstantial element, which will be, if you like, whether severally or all at once, the age, its fashions, its morals, its emotions. Without this second element, which might be described as the amusing, enticing, appetizing icing on the divine cake, the first element would be beyond our powers of digestion or appreciation, neither adapted nor suitable to human nature."[45] As if the artist still acted as the

45 CHARLES HARRISON ET AL., *ART IN THEORY, 1815–1900: AN ANTHOLOGY OF CHANGING IDEAS* (OXFORD: BLACKWELL PUBLISHERS, 1998), P. 493.

Maker's right hand, transmitting and translating a text written and signed beyond the confines of ordinary experience here and now (Truth) and that our task was to decipher it. What is the meaning of this Truth when the existence of individuals and societies is organized, structured, and developed around a relationship to the world founded on its work, its transformation, its use? If industrial and post-industrial societies have enabled individuals to break free from their status as spectators to a world given to them once and for all (the contemplation) with its procession of immutable, written truths about existence (the Holy Scriptures) and to use scientific and technological tools to become subjects (actors) in historical mutations, how can artists stay on the sidelines of a history that would henceforth be constructed without them? As if artists had to be *innocent*, not to say *dumb* ("Thou may eat from all the trees in the garden, but from the tree of knowledge of good and evil thou shalt not eat"), and leave historical mutations to journalists, experts, scientists, and producers of entertaining lowbrow films, while they give themselves over entirely to what purportedly does not change: the innermost recesses of the human soul, the beauty of nature, love, hate, death...and other Truths (commonplaces) acquired between the age of reason and adolescence. The sorrow of a conception that refuses knowledge. Turn a deaf ear to History and frolic in the Garden of Eden. An aesthetic time deprived of tears, laughter, and emotion versus the collective human time of production, accumulation, development, and searching. The return to nature versus Black Thursday on the Hong Kong stock exchange. And when collective human time is overwhelming (the torments of History): proclaim love against the tragedy of History. To wit, an aesthetics of heartbreak, with, at its two poles, *Hiroshima mon amour* (Alain Resnais and Marguerite Duras) and any of the prime-time TV movies catering to the right-minded, politically correct feelings of its viewers. And style as the sole differential. Michel de Certeau: "One could say that before the 'modern' period, that is, until the sixteenth or seventeenth century, this writing (Holy Scripture) speaks. The sacred text is a voice, it teaches (the original sense of *documentum*), it is the advent of a 'meaning' (*un 'vouloir-dire'*) on the part of a God who expects the reader (in reality, the listener) to have a 'desire to hear and understand' (*un 'vouloir-entendre'*) on which access to truth depends. [...] the modern age is formed by discovering little by little that this Spoken Word is no longer heard, that it has been altered by textual corruptions and the avatars of history. One can no longer hear it. 'Truth' no longer depends on the attention of a receiver who assimilates himself to the great identifying message. It is the result of work – historical, critical, economic work. It depends on a 'will to do' (*un vouloir-faire*). The voice that today we consider altered or extinguished

is above all that great cosmological Spoken Word that we notice no longer reaches us: it does not cross the centuries separating us from it. [...] Henceforth, identity depends on the production, on the endless moving on (or detachment and cutting loose) that this loss makes necessary. Being is measured by doing."[46]

While human sciences, technologies, geopolitics, economy, finance, and ways of being and thinking are going through dramatic changes (History), Tarkovsky's protagonists go back through history – across the centuries – to reach Truth. The swim across the spring in *Nostalghia* or Stalker's journey as figures of anti-modernity.

This somewhat reactionary obsession with the "eternal, invariable element," whose quantity it is obviously excessively difficult to find nowadays and which is founded on a premodern conception of art, is coupled with a more literary model. From Roberto Rossellini (*Stromboli*) to Wim Wenders (*The Wings of Desire*) without forgetting Tarkovsky (*Stalker*), Luchino Visconti (*Death in Venice*), and Pier Paolo Pasolini (*Theoreme*), a whole tradition in film history could be traced that revolves around the journey of initiation (the quest as diegesis). It remains to be seen why we had to wait for the second half of the twentieth century to make our way back to hackneyed truths. *Death in Venice*: Why return to the Lido and watch the agony of a musician as he discovers that beauty may be contained in the spontaneous wrestling and rolling of a young man in the sand rather than in a work produced by the mind? Why is a film a masterpiece (a questionable if not obsolete notion in its own right) when it uses commonplace themes to play on affects? Does filming commonplaces mask a lack of thought (of projects)? The aim of the masterpiece: Eternal Truth (preferably unnamable Meaning). Eternal Truth = Discovery of the Absence of Meaning. A formula that we obtain by carrying out the following operation: Obscurity + Journey of Initiation = Revelation of the Void.

One of the advantages of the quest is that it can be adapted to more modest truths that are always good for the taking. Thus the desert (*Theoreme*) can be reset by the seaside (*The Green Ray*, Éric Rohmer). More suited to the contemporary socioeconomic context (insecurity, emotional, and professional instability, etc.) – 1997: *Western* (Manuel Poirier). Must you lose your job as a rep and have your car stolen in order to discover how good it is just to be in love in a stone

46 *OP. CIT., THE PRACTICE OF EVERYDAY LIFE*, P. 137.

cottage somewhere in the French backcountry? The loss of a steady job and the wandering that goes with it as evidencing the stress of city life and the vacuity of a function. A smile and a nice warm fire versus the market economy. The veneration in which such literary and artistic models incapable of grasping present-day History are held may also account for the isolation of certain artists (filmmakers?) who at some point in their career abandoned imposed (inherited) figures and turned to making subjects in tune with present-day History: Dziga Vertov (*Man with the Movie Camera*), Luis Buñuel (*L'Âge d'Or*), Germain Dulac (*La Coquille et le Clergyman*), Fernand Léger (*Le Ballet Mécanique*), Stan Brakhage (*Reflections on Black*), Jean-Luc Godard (*Two or Three Things I Know About Her*), Orson Welles (*The Trial*), Michael Snow (*La Région Centrale*), Paul Sharits (*T,O,U,C,H,I,N,G*), Chantal Akerman (*Je, tu, il, elle*), Jonas Mekas (*Reminiscences of a Journey to Lithuania*), Guy Debord (*Society of the Spectacle*), Jean Eustache (*La Maman et la Putain*), Ingmar Bergman (*Persona*), Vito Acconci (*The Red Tapes*), Jacques Tati (*Playtime*), Marguerite Duras (*India Song*), Chris Marker (*Le fond de l'air est rouge*), Robert Bresson (*L'Argent*), Johan van der Keuken (*Amsterdam Global Village*), Eija-Liisa Ahtila (*Me/We*), and Sadie Benning (*Girl Power*).

II. LOOKS LIKE HARMONIZING GROWTH AND DESIRE IS GOING TO BE TRICKY BUSINESS

WHEN THE CONDITIONS OF EXPERIENCE BECOME FORMS
(FOR AN AESTHETICS OF MAKING DO)

AND WHAT ABOUT NOW...? (THAT OBSCURE OBJECT OF THE ART APPROACH)

The early-twentieth-century avant-gardes were characterized and motivated by utopias; those at the end of the sixties and beginning of the seventies by movements of protest, by ideas of different ways of living and acting, or by an attempt to create alternative spaces. Compared with these two periods in the History of twentieth-century art, the last two decades seem marked by disillusion, disenchantment, resignation, acceptance, and even adhesion to mainstream social models. Unless what we are dealing with is a phase in History during which artists are working on the principle of *how to make do...How to make do* with this History that is given to us and that escapes our control...

1999. If art has left the Duchampian paradigm (the importing and subverting of the world in the field of art) and the white cube (the suppression of History and the construction of a timeless space), if it has definitively distanced itself from formal specificity (the self-legitimation of an autonomous form) and from the site-specific (the dissolution of the autonomous form), as it has from the protest form (the challenge to the world and its models) and from questions of identity (the challenge to norms), then where is it? In which space(s) and in which history? What is its object? Does art still assign itself a function? Or, at the very least, does it still have the desire and the capacity to do so? If since the second half of the nineteenth century art has seen itself progressively dispossessed of its fields of competence by other forms of knowledge (social sciences) and representation (film, television, radio, etc.), if it has been replaced by other modes of expressing the imagination and satisfying the need for emotion (sports, spectacles, tourism, etc.), and, finally, if its attempt to build an autonomous field of experience has come up against competition from the many forms of sensorial and intellectual experiences offered by the entertainment and communications sectors (from role-playing games to interactive systems of wired conviviality via theme parks and fitness centers), how is it possible to get out of a logic that consists in formulating one's own disappearance or one's own incapacity to produce meaning? By ceasing to ask questions conceived for yesterday.

Displace the questions. Overturn the logic that consists in placing form at the center of aesthetic preoccupations. Take a look at the context of enunciation. If an art proposition only makes sense in the context of enunciation that it gives itself, then apprehend what it is querying, producing, and building in this same context. And when it comes to formulating these questions: prefer the plural to

the singular. If the functions and issues that art takes up are as numerous and heterogeneous as the paradigms in which it operates, then it can no longer be apprehended as a homogenous, monolithic object. The proliferation of forms, questions, and manifestations proposed in the field of art attests to the disappearance of art as a monolithic, homogenous object, constant in its forms and everlasting in its legibility. Nicolas Bourriaud: "Art is an activity that consists in producing relationships to the world with the help of signs, forms, gestures, or objects."[47] If art is an activity, if its form of exhibition often acts as a process, if it operates within the paradigms that it adopts, perhaps we should prefer the English notion of *work* to the French *œuvre*. The work in progress. The process dimension of a work of art is embedded in a conception that was mainly formulated in the United States in the sixties and seventies. Without embarking onto what could turn out to be a dubious, determinist analysis, it may be worth noting that the French term *œuvre* reflects a conception of art that gives priority to the finished form – object or image –, a conception far removed from the notions of work and process that characterized many of the works in the sixties and seventies. Work is to be understood here in the sense that Roland Barthes uses it in his definition of text: "The text is a productivity. This does not mean that it is a product of work (the type required by narrative techniques and stylistic control), but that it is the very theater where the text's producer and its readers meet: the text 'works,' in each moment and no matter which way we take it; even after it has been written (fixed), it never ceases to work, and to keep the production process going. What does the text work? Language."[48] A number of works in the field of art – such as Bruce Nauman's *Corridors*, Suzanne Lafont's *Correspondances* on a railroad line running from Bilbao's center to its port, or Felix Gonzalez-Torres's *Candy Pieces* – likewise act as "the very theater where the text's producer and its readers meet." These works do not fix an image, an object, a form, or an experience; they lend themselves to different receptions, readings and perceptions, and behaviors and manners of being. The spectator's participation as the sine qua non condition of activating meaning. As for the relationship that an artwork maintains with its context of enunciation... Benjamin Buchloh: "With and since Buren, art in Europe not only had to *formally be* but also had to *functionally do*, which means, it had to be obviously effective within the historical and cultural context within which it defined itself and by which it was determined. This definition of *historicity* is therefore exactly

47 *ESTHÉTIQUE RELATIONNELLE* (LES PRESSES DU RÉEL, 1998), P. 111.

48 "THÉORIE DU TEXTE," *ENCYCLOPEDIA UNIVERSALIS*, VOL. 15, 1975 EDITION, P. 1015.

in opposition to *historicalness*, which one could define as the degree of (art) historical learnedness and knowledge that has entered and modelled a work of art."[49] Work the world. Make a proposition effective within the historical and cultural context within which it defines itself.

If a work of art is an activity, or rather if a work is an arrangement of forms, signs, and elements that constitute the paradigm it adopts, a work freed from its specific forms and questions, in touch with today: What today are we talking about? Is a work in touch with today simply the product of this today? Can it, to the contrary, work on this today? Or should it not give a damn? Is it a singular manifestation of mainstream culture or of developing cultural trends (the symptom)? Can it produce other forms of knowing and representing today? What is our relationship to recent mutations in social, economic, and political History? Can an artwork construct a critical form? A form addressed to today and conceived on the scale of our subjectivity. If spectacular and mediatized forms speak on our behalf, if they are continually addressing us as a generic, synthetic subjectivity founded on statistics and the market economy, then think up forms that escape the control of instrumental reasoning while enabling us to reverse the communication trajectory that fixes us in the position of passive recipients. Find forms in which our subjectivity can be lodged to construct a discourse of our own – a discourse of which we have been dispossessed by the mediatized, spectacular culture. A critical form of speech or rather the ability to produce speech.

Meanwhile, in the field of art, look for what is really at stake in aesthetic as well as political and social terms: If the traditional symbolic modes of representation and inscription are no longer effective, what other modes of symbolic inscription and other forms of self-representation can be devised? In what terms can we think of the here and now? How and where can we project ourselves? How can we *make do with* the today that is given to us without continually reverting to the utopias and surrogate forms of being in the world proposed by modernity?

Define the context of enunciation, the place from which we are speaking. Specify the places where aesthetic questions and issues of representation can arise. If the conditions of experience have changed considerably over the past ten years,

49 "FORMALISM AND HISTORICITY – CHANGING CONCEPTS IN AMERICAN AND EUROPEAN ART SINCE 1945," IN ANNE RORIMER, ED., *EUROPE IN THE SEVENTIES: ASPECTS OF RECENT ART* (ART INSTITUTE OF CHICAGO, 1977), P. 100.

if living today requires representations that are more in accord with these new conditions than with the ones left to us in earlier decades, if the spiritual, political, and cultural utopias are not effective anymore, then maybe it is time for art to cut the umbilical cord with what is called art history – or at least to cease defining itself in a game of references, oppositions, and filiations to past art approaches.

Until very recently in art history, most artworks could be read as subsets of prevailing representations of the world – be they founded on religious and political precepts, as they were up to the nineteenth century, or on Marxist, psychoanalytical, structuralist, or deconstructionist approaches, as was the case in the twentieth. They dealt with a world that tended to have stable contours and reference points and that changed at a relatively slow pace compared to our world today. If today is marked by a proliferation of fields of knowledge and experience, an exponential growth in the number of communities with common interests and attitudes, a rapid turnover in models and reference points, and accelerated breaks in habits, then what can forms conceived for yesterday tell us about our increasingly complex, protean today? In disorder: One cannot expect to apprehend imaginaries and representations structured or informed by corporate culture, economic competition, intensified exchanges, unemployment, social conflict, the Dow Jones, job insecurity, advertising, journalism, blockbuster movies, sports performances, leisure activities, logos, globalization, pop culture, raves, name-brand clothing, social and racial exclusion, the end of traditional models of identity, minority demands, the telecommunications boom, the fall of the Soviet empire, the North-South opposition, the rise of religious fundamentalism, identity-related tensions, monoparental family cells, surges of solidarity, interethnic conflict, poverty, and AIDS *with paintbrushes*. Think of using forms that are more in step with certain developments in contemporary society, notably as far as our modes of experience and being in the world are concerned.

Without entirely calling into question the importance of the visual in the arts so named, one may wonder about its primacy in contemporary artworks. Is this visual primacy still legitimate? Does it still correspond to our modes of experiencing the world? In painting and sculpture, visual primacy corresponded to a representation of the world based on what was visible to the naked eye. But today our knowledge of the world is founded on phenomena that are imperceptible to the naked eye. Michel Paty concerning Maxwell's electromagnetism, Clausius, Kelvin, and von Helmholtz's thermodynamics, and Boltzmann and Gibbs's statistical mechanics: "This abstract, indirect, approach to phenomena

led to [...] a certain number of quite surprising observations in respect to the inability of our senses and our imagination to gain direct access to phenomena taking place there. [...] Today, physicists speak of quarks, the tiniest of particles postulated to make up the material world: Nobody has ever set eyes on them [...]. The observation of their indirect effects, relayed in cascade to our senses, is what justifies us in concluding that quarks unquestionably exist in nature."[50] And when a real experiment cannot be conducted, physicists perform what are called "thought experiments." Michel Paty on Einstein, Podolski, and Rosen's thought experiment, or rather about the issue of whether every element in reality has a counterpart in theory: "The aim of such an experiment is to draw all the consequences of a theoretical formulation [...]. It is a 'logical experiment' of sorts whose function is eventually to bring out unsuspected properties that were implicitly contained in the theoretical representation."[51]

On a different level of experience, how can we think in visual terms of the space in which we live and through which we move when we spend our days in air-conditioned buildings or hopping from place to place in planes, high-speed trains, and subways without seeing an iota of the landscape?...Is our sense of self in the spaces we move through and in the situations and activities that occupy our time still based on the eye? When we don't have the time to notice Fujiyama whizzing by between Tokyo and Nagoya, then substitute the feeling of being suspended above the track characteristic of the Shinkansen for the picture art form that we don't have the time to grasp. To wit, the formulation of a relationship of the self to motion that would replace a sense of self in relation to place. A way of being in circulation versus a way of being in a place. Forget the visual (the nostalgia for landscapes and for the paintings related to it) and feel the motion.

American art in the mid-sixties and early seventies inaugurated a period of challenging the primacy of the visual in the aesthetic experience: This was one of its most significant contributions. Certain approaches to sculpture – notably evidenced in Robert Morris's *L-Beams* in 1965, Bruce Nauman's *Corridors* in 1969 and Robert Smithson's *Spiral Jetty* at the Great Salt Lake in 1970 – not only conflated exhibition space and representation space, and called on spectators to participate in the making of the work but demanded that we experience the works in which we were included with our bodies, not our eyes.

50 BANESH HOFFMAN, MICHEL PATY, *L'ÉTRANGE HISTOIRE DES QUANTAS*, SEUIL, P. 200.

51 *IBID.*, P. 219.

If for many centuries our knowledge of the world was essentially derived from texts and images, over the past few decades our modes of access to the world include not only reading and seeing but also hearing: Radio reports provide us with information about events, places, and practices that we can represent visually only by means of association with TV images and photos in the press; our affects are increasingly informed by the hit singles of the week; our behaviors as users, consumers, and drivers increasingly rely on Muzak, and so on. Use media in step with our modes of reading and reception of the world.

The point is not to wallow in the possibilities and effects of manipulating new modes of reading and reception. The appeal of media possibilities and effects could lead us back to the formal explorations that characterized modernism. It could drive us to revive in CD-ROM, radio, or Web form (or in the form of any other new technology) the project that Clement Greenberg already ascribed to modernist painting: "The essence of Modernism lies [...] in the use of characteristic methods of a discipline to criticize the discipline itself, not in order to subvert it but in order to entrench it more firmly in its area of competence. [...] It quickly emerged that the unique and proper area of competence of each art coincided with all that was unique in the nature of its medium."[52] Here, Greenberg's definition of modernism belongs to a period of art history when artists were probing their respective medium's capacity to still produce meaning, a meaning specific to the medium in question and shared by no other art form. The recent infatuation with new audiovisual technologies in the field of art all too often conceals a deficit of issues conceived on the scale of present-day History to the profit of extravagant formal effects, or rather an unwitting revival of the modernist aesthetic decontextualized from its historical conditions of emergence. The rare artists who manage to find a specific use for these new technologies are often those who also make use of other media and who see these new means of information processing and communication as tools for bringing out an issue or making a point beyond questions of mere formal exploration. In 1927, Bertolt Brecht noted, concerning the advent of radio, what was to become a truism in the field of art: "We usually let ourselves be led around by the nose for the sake of *possibilities*. [...] The bourgeoisie judges them only according to the opportunities it naturally can derive from them. Thus the enormous overrating of all

52 *FORUM LECTURES* (WASHINGTON D.C.: VOICE OF AMERICA, 1960), REPRINTED IN CLEMENT GREENBERG, *THE COLLECTED ESSAYS AND CRITICISM, MODERNISM WITH A VENGEANCE, 1957-1969* (THE UNIVERSITY OF CHICAGO PRESS, 1993), PP. 85-86.

things and systems which promise 'possibilities.' No one bothers with results. They just stick to the possibilities. The results of the radio are shameful, its possibilities are 'boundless.' Hence, the radio is a 'good thing.' [...] Every kind of artistic production begins when a man comes to the artist and says he has a hall. At this point the artist interrupts his work, which he has undertaken for another man who has told him that he has a megaphone. For the artist's calling is to find something which later can be used as an excuse from having created the hall and the megaphone without thinking."[53] Substitute "new technology" for "hall" and "video" for "megaphone."

However, to stick to traditional forms of representation without taking into consideration the dramatic changes in our contemporary "landscape" amounts to missing out on an ever greater part of this landscape. Resisting changes in our forms of perceiving the world is tantamount to gradually relinquishing our ability to read our period. A period that increasingly escapes our control as we lose our ability to make sense of it and translate it into experience. 1978. Giorgio Agamben: "For modern man's average day contains virtually nothing that can still be translated into experience. Neither reading the newspaper, with its abundance of news that is irretrievably remote from his life, nor sitting for minutes on end at the wheel of his car in a traffic jam. Neither the journey through the nether world of the subway, nor the demonstration that suddenly blocks the street. [...] nor queuing up at a business counter, nor visiting [...] the supermarket, nor those eternal moments of dumb promiscuity among strangers in lifts and buses. Modern man makes his way home in the evening wearied by a jumble of events, but however entertaining or tedious, unusual or commonplace, harrowing or pleasurable they are, none of them will have become experience. It is this nontranslatability into experience that now makes everyday existence intolerable."[54] Find forms of experience. Try to translate the time spent at the office and in the street into experience...Use forms of representation apt to assimilate the simultaneity of experiences or their accelerated concatenation in a short span of time. Use forms apt to convey the nonlinearity of our modes of spending time. Use forms apt to convey modes of self-construction in lives punctuated by short-term models, sentimental and professional experiences, projects and contracts.

53 "RADIO – AN ANTEDILUVIAN INVENTION?," IN *BERTOLT BRECHT ON FILM & RADIO*, ED. AND TRANS. MARC SILBERMAN (LONDON: METHUEN, 2000), P. 37.
54 *INFANCY & HISTORY, ESSAYS ON THE DESTRUCTION OF EXPERIENCE*, TRANS. LIZ HERON (VERSO, 1993), PP. 13-14.

Paris–Moscow is no longer a narrative odyssey; it's just a few-hour trip. And being faithful to another person, to your business, or to your native country is not on the agenda. Use forms in step with a relationship to the world that has more to do with immediate consumption than with long-term practices. Find means of representing our conditions of minimal adhesion and entrenchment. If we are used to constantly projecting ourselves elsewhere (thinking about the appointment on Tuesday in Milan or the business we have to handle next week), to breaking habits before we have time to get used to them (new logos, new shops, new districts, another fixed-term contract, another encounter, another adventure, and the new types of situations that ensue), then appropriate the zapping form, or wallow in the frustration of not being able to pursue a particular experience (frustration as punctuating contemporary existence and favoring the development of depression). Give priority to ways of moving from one moment or situation to another. Stop considering this way of moving indifferently from one situation to another as something dramatic. Appropriate these new ways of being. The accelerated concatenation and the tempo (the zapping) versus nostalgia for a time that stood still (the stasis).

If we cannot cope with long stories anymore, if the representations that society gives us of ourselves are condensed into flashes and clips, if we can no longer project ourselves into long-term projects, if we are bombarded by events which, by their simultaneity and brevity – in contrast with their supposedly vast scale –, are impossible to assimilate, then drop the linear, evolving axis. Shift gears. Adapt the speed of the subject's reception and experience to the rhythm in which new situations and representations arise. Find a common rhythm (a rhythm of approach) and specific forms (be at one with the forms of the world). Speak our environment. Stop speaking about it. Hubert Lucot: "A book 'that stands on its style'? (stand, houses stand). That beats to the rhythm of the syntax of the world: stages, flashes of consciousness."[55] Without mimicking this syntax, strive to set up forms that afford better access to what surrounds us. Forms-tools that enable us to grasp what is given to us and to translate what we encounter into experience. Devise forms corresponding to ways of being in relation to a particular experience for the time the experience lasts (an evening, a trip, or a meeting as the space-time of representations), and not forms corresponding to a specific being determined by fixed representations embedded in a continuous linear process. 1999. All figures, all styles are in the environment.

55 *LANGST* (P.O.L, 1984), P. 37.

There's no point in reproducing them: Just use them. 1999. An age of slippages in meaning ("Just call her Bob"), of round-the-clock continuous news updates, of collages and montages – clashes – of different registers, heterogeneous images, and lexical fields (global village, Jesus Christ Superstar, econoglobal, glocality, monetary space). The point is not to analyze these figures or "reveal" them, neither is it to launch into gratuitous, punctual associations of signifying possibilities, joining against culture two residues of sentences that everything separates, but rather to use them as a syntactic anchor. A syntax to enrich with issues other than those related to form.

In the sixties, many art approaches developed in an autonomous field. Some were embedded in a logic of one-upmanship, which consisted in adding a little something to the history of a genre or a medium. Others endeavored to construct an aesthetic space or an autonomous form. Without constituting an end in itself, expanding the field of aesthetic experience – in relation to its historical grounding – seems necessary insofar as it corresponds to a number of issues bound up with recent developments in society. 1940. Walter Benjamin: "During long periods of history, the mode of human sense perception changes with humanity's entire mode of existence. The manner in which human sense perception is organized, the medium in which it is accomplished, is determined not only by nature but by historical circumstances as well."[56] Can art today set itself an object – a (necessary and legitimate) project – other than itself? Painting, sculpture, photography, video, installations, and performances, removed from their aesthetic context, are only "modes of human sense perception." 1999: Use forms required by human sense perception today.

The abandonment of traditional forms of representation in the seventies in favor of what were commonly called "installations," conceptual works, or performances corresponded to the realization that the possibilities of painting and sculpture had been exhausted, but also to a growing awareness of the widening gap between our representational modes and the dramatic changes that our contemporary societies were undergoing. Cutting the umbilical cord to the history of past art does not necessarily mean abandoning all of the formal propositions inherited from modernity. If a tried syntax works when it comes to decoding or representing today: Use it. One certainty: Form should no longer be the question,

56 "THE WORK OF ART IN THE AGE OF MECHANICAL REPRODUCTION," IN *ILLUMINATIONS*, TRANS. HARRY ZOHN (SCHOCKEN BOOKS, 1968), P. 222.

in the sense that it must not be an end in itself…simply a means. Instead of the principle that consists in entrenching an art approach in a historical filiation, substitute the idea of proposing assemblages hooked into our day. Take a cross section of today, its social constituents, the recent historical mutations, and work on the necessary relations in this context.

City life, and the collisions and clashes among a wide array of heterogeneous objects, events, images, sounds, and data that occupy us presuppose other modes of reading (that call on senses other than sight), other relationships to time and speed, other modes of relating signs (fragmentation, discontinuity, juxtaposition, simultaneity). In general, devices using different modes of disseminating images, texts, and sounds in a single place and time correspond to the multichanneled reception of our environment today. A real or virtual environment in which the individual is solicited simultaneously by an often heterogeneous array of different data and different injunctions – clashing information and buzzwords –, an environment where s/he is compelled to juxtapose several activities, several situations, several speeds, etc. These new conditions of experience call for fragmented, juxtaposed modes of visual and aural reception (reading channels) interrelating different speeds and intensities…

A comment in passing: A fragment is not a splinter or a remainder of a whole. It indicates a nonrelationship between different elements, different fields of knowledge and experience, different rhythms of existence that never intersect, different cultural reference points or models that are more or less mixable…And there is nothing problematic about this. Yet, many artworks, even those that have integrated the idea of a world that can only be experienced in a fragmentary way, are still informed by a nostalgic longing for some lost unity. A lost unity that has gradually come to replace the lost paradise. A unity that reflects a global view of the world. A necessarily naive view inherited from a time when artists and sages embraced the whole of the world, interpreted it, and gave it meaning by subsuming all its phenomena and properties into a single syncretic conception. As if artists could not stand living in the same world as scientists or experts. As if the idea of different, necessarily separate complexes were unbearable. Jean-Luc Nancy: "A dread of greatness, of monumentality, of art with a cosmological and cosmogonical dimension […] underlies all of art history since Romanticism […]. This dread leads in one way or another to disaster […]. Smallness was meant to be an answer to this disaster, the meteorite splinter torn from the sidereal fall. […] But smallness forms a couple with greatness. It never ceases to

refer to it."[57] Prefer the expression "fields of experience" to the term "fragment" – indissociable from the idea of the greater complex of which it is a part. The complexity of the phenomena, fields of experience, and knowledge that make up our environment requires a multiplicity of approaches, concepts, theories, and formulations. Can an artist's mode of existence change without changing h/er modes of human sense perception? One last, silly question to bring this subject to an end: What possible use could we have for cave paintings today? Put forms back into their historical context of emergence, leave their management to tourist professionals (the becoming-curiosity of art). Look for what could constitute a real issue in representation today, instead of assuming that a medium is pertinent and then looking for applications for it. The conscientization of our position in History as the point at issue.

TELL ME, MOMMY, WHAT'S HISTORY? (CATASTROPHES AND PERSPECTIVES)
But can we still speak of "History"? Is the term still appropriate when our relationship to the political, economic, and social changes happening in different regions of the world is created on the spot, live? If History necessitates a delay (time to analyze, put into perspective, and relate information), if our perception of this same History is limited to live recordings (the mediatization) of whatever is thought to be significant, then this History has long been erased by the "news." News in the form of headlines (unemployment, conflicts, AIDS, crime, communications, summits, negotiations, agreements, strikes, declarations, and so on), curbs, rates, and indexes (domestic consumption is down, the dollar up, growth down, number of people infected by the virus up, unemployment down, etc.). News that brings to life fragments of History…Fragments with low-meaning content because they come to us isolated, decontextualized, and presented as straightforward facts. News formulated in a way that resembles myth as defined by Roland Barthes: "Myth does not deny things, on the contrary, its function is to talk about them; simply, it purifies them, it makes them innocent, it gives them a natural and eternal justification, it gives them a clarity which is not that of an explanation but that of a statement of fact. If I state the fact of French imperiality without explaining it, I am very near to finding that it is natural and *goes without saying* […]. In passing from history to nature, myth acts economically: it abolishes the complexity of human acts […] it does away with all dialectics, with any going back beyond what is immediately visible, it organizes a world which is without contradictions because it is without depth, a world wide open and

57 *LE SENS DU MONDE* (GALILÉE, 1994), PP. 191-192.

wallowing in the evident [...]: things appear to mean something by themselves."[58] How can we position ourselves in relation to the masses of information that appear to mean something by themselves? What type of relationship can I build with all these figures, facts, statements, data, and events? How is it possible to articulate all this heterogeneous news – all the more abstract since it is often converted into statistical data or succinct commentaries – with my own existence? The point here is not to evince art's resignation, its lack of engagement, or inadvertent complicity with contemporary barbarism, but rather to explore the effects of a loss of historical conscientization in the field of aesthetics. If art operates in the field of representation of today, is it conceivable to work on these same representations without being aware of what constitutes *today*? What elements of this *today* inform my ways of being and thinking? In what collective imagination are my representations territorialized? How can *here and now* be represented without knowing what *here* and *now* we are dealing with? Where are we? Etc. To wit, an aggregate of questions that need to be asked prior to any art practice...Simple questions in terms of their formulation but nonetheless essential in their aesthetic implications since they underpin the enunciation context of any art approach.

In relation to some of the aesthetic and political stances taken by earlier generations, the desertion of the social sphere and the refusal of historical conscientization may seem puzzling. What remains of our desire for elsewhere and otherwise? Has the imaginary of subscribing to mainstream models and ideology gradually replaced the imaginary of opposition? In preceding decades, the relationship to historical context was not something that was taken as such; it was conflictual. Self-construction involved the expression of an opposition to the father, to models, to economic and political forces, and so on. The construction of the subject, the subjectification mode, entailed finding or defining modes of resistance to a particular force or to a combination of forces. This aesthetics of resistance was conceivable because it was still possible to attach a name or a face to the representatives of power (heads of state, governments, employers...) and enemy systems (totalitarianism, fascism, capitalism, communism...). Today, if we are capable of naming the problems of our times (stress, unemployment, exclusion, racism, etc.), it is not so easy to designate the origin of these same problems. Who is responsible for the breakdown of social bonds? Who can be blamed? The market economy? Speculation? Globalization? The European Union?

58 *OP. CIT., MYTHOLOGIES*, P. 143.

Low labor costs in Southeast Asia and delocalization? Whom can we oppose? The Dow Jones or the Aérospatiale-Matra merger? Critical Art Ensemble: "The location of power – and the site of resistance – rest in an ambiguous zone without borders. How could it be otherwise, when the traces of power flow in transition between nomadic dynamics and sedentary structures – between hyperspeed and hyperinertia? [...] Treading water in the pool of liquid power need not be an image of acquiescence and complicity. In spite of their awkward situation, the political activist and the cultural activist (anachronistically known as the artist) can still produce disturbances. [...] Knowing what to subvert assumes that forces of oppression are stable and can be identified and separated – an assumption that is just too fantastic in an age of dialectics in ruins."[59] If revolt can still stir people, it seems to have no object anymore. Is an aesthetics of resistance with no object conceivable?

If we cannot position ourselves in relation to "stable," "identified," and "separated" "forces of oppression," try to identify the contexts and conditions of contemporary experience. In what paradigm can an artistic proposition operate? Before trying to position ourselves in a historical relationship, as a continuation of or challenge to significant approaches to art in the past, attempt to identify where we are and what are our current modes of being and thinking. Where are our subjectivities constructed? How is our collective consciousness structured? Around what imaginary, what models, and what reference points do we organize our lives? What are the objects of our aspirations? Where do we territorialize our modes of being? If identities can no longer be built on relations to a specific land, where are they territorialized? Around what projects do we build up communities of attitudes, interests, or beliefs? Anchored in a field of questioning that is too specific to the evolution of the history of forms – forms that, in the last stages of high modernism, turned in on themselves and suppressed anything exterior to their material and conceptual components –, works legitimated by the sole paradigm of art history seem to have lost their capacity to answer these questions. The emergence of new conditions and new territories of experience – as a result of the progressive disappearance of political and cultural borders, the increasing globalization of behaviors in the world's most technologically advanced countries, the development of means of communication and networking, or changes in our relationships to work – has produced a brand new historical situation. A situation that calls for the formulation of specific questions.

59 OP. CIT., THE ELECTRONIC DISTURBANCE.

To leave the exclusively aesthetic field and take a look around in other directions. Benjamin Buchloh on James Coleman's 1977 video piece, *Box (ahhareturnabout)*: "To the same degree that *Box* reiterates the experience of the perceptual pulse in the spectator [...], this pulse alternates with an iconic sign of two fighters exchanging actual punches. [...] *Box (ahhareturnabout)* signals a major departure from American post-Minimalist aesthetics, since the bodies of Coleman's performers no longer appear as neutral and naturalized transhistorical givens, as a universally valid field of potential phenomenological inscriptions – the manner in which the body had been presented in the work of Graham or Nauman in order to oppose the techno-scientific orthodoxy and morphology of Minimalist literalism while ultimately still participating in its very logic. [...] Within the general project of reconstituting a historically specific body to the universalist abstraction of phenomenology, Coleman insists on a sociopolitically specific body, structured by the discourse on national identity (in this case by the presentation of the Irish fighter Gene Tunney as the struggling protagonist who tries to save not only his boxing championship but his sociopolitical identity as an Irishman)."[60] Extend the overturning. Articulate form with History. Use forms inherited from art to invest the cultural, social, and political fields. The context of life versus the context of an aesthetic experience. Work in the field where conditions of experience are structured. Specific historical conditions that must be located.

The point is not to evidence different ways out of the white cube or the museum – this type of approach is still embedded in the separate, independent field of postmodern art history – but rather to explore the specific historical conditions of our experience. An exploration that cannot stop at locating these conditions. In the event, locating them is a preliminary to the art work (a precondition to the exploration). Nor is the point to record or to describe them – an aesthetics based on statements of fact only replicates what other forms of investigation, such as journalism or sociology, are capable of doing, and usually in a more pertinent way. This does not mean that an art approach must assume the task of undermining or modifying these conditions of experience. The many manifestos with their projected utopias have taught us modesty. Many contemporary approaches now seem to be embedded in a proximate relationship to history. Nicolas Bourriaud: "The aim of artworks is no longer to create imaginary or utopic realities, but to constitute modes of existence or models of action within existing

60 OP. CIT., JAMES COLEMAN, PP. 60-61.

realities, regardless of the scale chosen by the artist."[61] Forget the utopias of elsewhere and otherwise. Have a go at today, at here and now.

Among the new facts and new conditions of contemporary experience: the mutations engendered by new communications technologies. In a culture where the communication imperative has taken hold of most levels of society, where are the artworks that deal with the communications dimension? How are we to understand the increasing number of works staging forms of exchange? Are they to be seen as a duplication of configurations and contexts of experience available on the leisure and professional communications market? Can they act as critical devices when it comes to our habitual ways of using and appropriating new communications technologies? Can they work to establish (and network) new sites for words? Words that would no longer be the property of commercial or ideological interest groups…Singular words proper to Internet users? And if this is the case, in what way do proposals in the field of art differ from those circulating and being exchanged on other sites? If this circulation and these exchanges act as new modes of subjectification, aren't they also generating a new form of exclusion, a gap between those who have access to surfing, to participating in the collective production of hypertexts, and so on, and those who have no access, who do not participate, who do not produce?…Pierre Lévy: "Every time a new communications system emerges, it produces a new form of exclusion – all the more so when the system is universal. Illiteracy appeared with writing. […] The case of the new communications technologies is somewhat different. The new forms of exclusion may be economic, of course, but they also have to do with the capacity to be active agents. There are those who participate in the collective intelligence and the others. Physical or material access does not suffice; anyone whose use is limited to consuming data, is not participating in the dynamic process of this new space. A struggle for democratization will involve getting people to use this space in order to gain in autonomy and become more active as agents so as to participate in creating communities of thought or even simply in helping one another in a practical way. Education must contribute to this democratization."[62] Back to art approaches. How are we to understand convivial works that use more traditional modes of conviviality? How are we to take Rirkrit Tiravanija's proposal to share a bowl of

61 OP. CIT., ESTHÉTIQUE RELATIONNELLE, P. 13.

62 "TO BE OR NOT TO BE ON LINE," INTERVIEW WITH PIERRE LÉVY BY JEAN-CHARLES MASSERA IN PARACHUTE 85 (JANUARY, FEBRUARY, MARCH 1997), P. 17.

soup outside the time and space of the exhibition? If we leave aside the exhibition context, in what field does the proposal operate and to which field does it belong? Does this form of staging an exchange serve to designate and compensate for the lack of time and space for this same exchange in the social sphere? Is it a matter of calling attention to the breakdown of certain forms of being-together? Forms of being-together that are being undermined by the emergence of new identity-related tensions, by fears of the Other (cultural differences deemed incompatible with the culture we belong to) or of h/er body (AIDS), by the growing individualization of social and professional practices or by the manifest absence of projects conceived on the scale of social groups and apt to consolidate a community of common desires (the boom in micro-interest communities, particularly on the Net, has only accelerated the breakdown of the community). Are such communications proposals intended to act as substitutes, as ersatz?

Other artworks that do not rely on this logic seem to transpose into codes intrinsic to the field of art the recent incapacity to share meaning other than in terms of particularities (a particular form of sexual, cultural, or athletic practice), a meaning that circulates in a restricted community of practices. Some such works are territorialized in codes intrinsic to the exhibition context. From the mailing of invitations to the reception of the works by the public and by collectors, without forgetting the exhibition preview and mediatization, many artworks seem to have unconsciously turned their backs on History outside the field of art. If they have expanded their conditions of experience in comparison with Conceptual or Minimal art, they still consider art as their sole object. They relate to one another but not to the world. It may be argued that these situations are as meaningful as any others, that they are realities with as much meaning as any other reality. But isn't this just another form of micro-reality? In the field of cultural practices, the hypercathexis of the self in role-playing games or in online discussion forums focused on interests shared by a limited number of Internet users, the proliferation of leisure products and activities and the myth of personalized practices, services, and products only reinforce the dynamics of separation that farther undermines being-together. In the separate sphere of art, the work on codes specific to one social group and shared only by members of that same social group cannot affect what's left of the community or what we still have in common. In this sense, low-tech convivial devices that can be shared by everyone (if role-playing games rally specialists, sharing soup is a form of being-together that is not based on a specialization) seem to undermine the exponential process

of diversification in the supply of cultural practices and activities – from digital television transmission to Internet sites. Expand the field of experience. Substitute world codes for art codes.

Here the breakdown of the community, elsewhere the problems generated by recent developments in our industrial societies. In the past decade, many art approaches have acted as signs pointing to political, social, or economic deficiencies and as symbolic palliatives. From Krzysztof Wodiczko's vehicle for the homeless to Fabrice Hybert's teddy-bear suit (*Ted Hybert*) that protects its potential user from pollution, art seems to be working directly on certain urgent issues dictated by current events. But doesn't Wodiczko's vehicle contribute to permanently identifying people without homes to their homeless condition? And isn't Hybert's P.O.F. (*Prototype des objets en fonctionnement*, or Prototype of Functioning Objects) embedded in a logic of resignation, a logic that consists in giving visual form to the merry apocalypse? And when representations of being in contemporary society reduce the distance separating the formulation of their questions and the object that they set for themselves, when they make statements of fact without imagining alternative forms to symbolically find a way out, then contemporary man seems condemned to watching the process of his own instrumentalization or that of his own negation as a subject. Must we reconcile ourselves with the self-image reflected in Thomas Ruff's photographic portraits, which seem to expose the way in which housing complexes "rub off" on the people who live in them? Is the lack of expressiveness on the faces of the people he portrays related to living in standardized housing units (I am where I live)? Ruff's subjects do not act, they are simply there. As if the multiplication of sameness (housing units) goes together with a devitalization of being (housing complexes that seem to house devitalized subjects). Are we to conclude that "vitalized" subjects live in one-of-a-kind homes? Is the lack of vitality related to a lack of financial means? The lack of means to go somewhere else, to move around? Show how our attitudes and behaviors – from the most collective to the most intimate – are generated by certain features of the places we occupy (the detached house, the apartment building, the supermarket, the conurbation, the remote rural area, the workplace, and so on) without aesthetically accepting these conditions of being in the world. In the event, to what extent can a housing unit be appropriated and truly personalized? Can I live my detached house differently or am I condemned to use its space in accordance with advertising models of comfort and the IKEA do-it-yourself guide to interiors. Make do with the environment, or rather negotiate ways of being with the environment in which

we find ourselves. Michel de Certeau: "Thus a North African living in Paris or Roubaix (France) insinuates *into* the system imposed on him by the construction of a low-income housing development or of the French language the ways of 'dwelling' (in a house or a language) peculiar to his native Kabylia. He superimposes them and, by that combination, creates for himself a space in which he can find a *way of using* the constraining order of the place or of the language. Without leaving the place where he has no choice but to live and which lays down its law for him, he establishes within it a degree of *plurality* and creativity. By an art of being in between, he draws unexpected results from his situation."[63] The relationship to the environment is not a given; it's to be invented. The relationship between place and subject is not a given because the subject has no roots in this place, because the place's complexity, its many layers and characteristics are never wholly practiced by the subject who spends time in one part of the city or another, exercises one type of activity or another. A subject dispersed in a variety of moments and ways of being in the environment. Moments and ways of being a consumer, a user, a citizen, a passerby, a resident, and so on. Negotiate ways of being one by one.

Try working in ways that escape the logic of opposition or support. Start from the cultural practices that structure our imagination (tourism, zapping, fashion, variety shows, games, etc.), from the places that generate and structure our collective behaviors (the bedroom, school, public sphere, shopping mall, workplace, etc.), from the models with which we try to identify, etc. Then strive to reappropriate time and space for ourselves – a time and a space from which we have been dispossessed.

63 *OP. CIT., THE PRACTICE OF EVERYDAY LIFE*, P. 30.

THE BECOMING DETACHED-HOUSE OF MAN
(FOR AN AESTHETICS OF RELEASE FROM ALIENATION)

GREENERY AND GUARD DOGS (ABOUT THE HOMEBODY IMAGINARY)
If getting outside the self and accessing History may constitute an issue on the
aesthetic plane, start by probing some of the places in which our subjectivities
have been confined...Back to the planetary petty bourgeoisie sitting on their
fucking couches with the mortgage to pay. 1993. *Dear Diary* (Nanni Moretti):
Rome in the middle of the summer...A good-looking man in his forties free-
wheeling through the old capital on his Vespa...Wearing a T-shirt, he sways
casually through the streets...He's happy. His zigzagging gets in nobody's way...
He is free to admire the city without being disturbed by honking, without bump-
ing into anybody or anything. He's alone...Rome...Deserted city. Where are all
the Romans? Leave the city center...Take a look at the residential areas...to the
sound of one of the hit Rai singles of the year (Khaled's *Didi*)...Moving to the
rhythm of the music...swaying to the tempo, waving his arms to the rhythm of
the refrain...his head in the wind...Return to a bit of calm...: The music and the
touring pleasure give way to a few questions: "Casalpalocco...Just passing these
houses, I can smell the scent of leisurewear, video cassettes, guard dogs in
gardens, pizzas in cardboard boxes. Why did they move here thirty years ago?"
Response from a concerned party as he's about to walk through the gate to
one of these houses, carrying two videotapes: because it's "green," because
it's "quiet." The forty-year-old: "Thirty years ago Rome was a wonderful city."
The concerned party: "It's different here." The forty-year-old: "That's just what
frightens me: the guard dogs, the videotapes, the slippers..." Turn up the volume
of the Rai again to forget...When Southern Europe catches up with Northern
Europe's living standards...when Southern Europe catches up with the standards
of isolation of lonely crowds...when the fear of seeing the community forever
atomized (the nostalgia of the forty-year-old for togetherness) joins the hate for
grown-ups who have "chosen" their "leisurewear and matching luggage," their
"fucking couch" and their "mind-numbing, spirit-crushing game shows"...(*Train-
spotting*). A Roman imaginary in compliance with European standards, a retreat
into a homeowner imaginary linked to the disappearance of cities and social
bonds. From the perspective of the street, the homebody imaginary is seen as
a retreat from togetherness (the fenced-in self). With greenery for horizon and
slippers for rhythm. From the perspective of teenagers, the home-of-your-own
mortgage-plan imaginary is seen as a lack of projects (settle in and settle down).
With resignation for address and savings for life plan.

1994. *Untitled* (Claude Lévêque): On a color photo of a fenced-in house of the
type available for purchase@homestore.com – where "whether you're looking

for a manufactured mansion or the ultimate ranch house, chances are you can find a factory-built home that will fit your dreams" –, a question scribbled with a marker...A question scribbled across the blue sky above the home of your dreams: "Ready to croak?" The graffiti form to contrast with the glossy smoothness of the detached-home ideal...An ideal of whitewashed houses and blue skies...Where your "dream come true" is nicely isolated between a field of sunflowers and neatly trimmed lawns...An ideal of no noise and no neighbors...An ideal with high fences to keep troublemakers out...An ideal of peace and quiet ...A dream of neatly trimmed gardens. A dream come true in which our subjectivities are locked up...1999. Deauville. In the context of an exhibition titled *Le temps libre : son imaginaire, son aménagement, ses trucs pour s'en sortir* (Leisure Time: Tricks of the Trade), this photo was blown up to billboard format to be displayed in a building lot...An image and a question addressed to promoters of dreams that reduce the scale of our imaginary to the size of our homes... An image of a residential dream and a question about a project in life which – given their thrust – were ultimately moved to a more suitable location...on the edge of a road on the outskirts of the city...Graffiti as a form of deactivating the advertising message. Identify the nature of the product proposed and banish the urge to borrow one hundred thousand dollars at 6.2 percent with monthly payments over the next twenty-five years. The passage from photo to billboard format as a way of putting into question supply and demand.

And when the customers of this detached-house ideal finally go out, they do so to bring back what they need to stay in (pizzas, videotapes, etc.). To wit, a choice of domesticated flavors and pictures of the world reduced to the scale of our interiors and meant to reinforce a logic of retreat from the community inherent in the homebody lifestyle. Instead of projecting themselves into the world (the street), the residents receive the world in their homes (via digital television transmission). *Dear Diary*...And when they venture out again, in cars or in couples, they do so with the firm intention of not being disturbed (the transference of the homeowner's desire for tranquility onto the street). So that Nanni Moretti's attempt to speak to people on the street (get back in touch with the outside), be it a young man driving a Mercedes convertible or Jennifer Beals from *Flashdance*, always makes them feel uneasy and embarrassed. The unknown, Baudelaire's "stranger as he passes," gives way to the intruder. Relational places (parks, cafés, shops) disintegrate in the urban sprawl. The garden and the refusal to be disturbed by the neighbors as social progress. A loss of interest in the public sphere that turns any attempt to meet others into an act of aggression, and a

fear of this aggression that is translated by a reinforcement of the private sphere. Emptied of its potential for encounters, the public sphere becomes an arena for traffic. Nanni Moretti spends more time riding on his Vespa than stopping. The building fronts constructed in the sixties and eighties become the setting for an outing, for a use of space.

GREENERY AND SEPARATION OF AFFECTS (ABOUT FAMILY LIFE)
1993. *Today* (Eija-Liisa Ahtila): In an exhibition space, one screen in front, one to the right and one to the left. Consider a video-projection composed of three distinct monologues. Three stories generated by a single event: One night, somewhere in Finland, a man is hit by a car and dies instantly. One after another, his granddaughter, a woman named Vera (his son's companion?), and his son appear on the screen. Outside the house, the granddaughter, a teenager in a red tennis shirt and a blue skirt, bounces a ball off a wall. Close-ups of her staring at the camera. Her grandfather's death does not affect her. She describes her father's despondency, dwelling on the physical signs of a pain she doesn't feel. ("Today my dad's crying [...] His shirt and pants are all soaked. [...] Two vertebrae were sticking out of his back"). The over-the-shoulder shots adopting the girl's viewpoint standing at some distance from her father and looking at his back as articulating a distance that cannot be overcome. A distance between the girl and her father that he puts into words when he says, "When I ask her 'How do I look?' she says, 'You look like a dad.'" Whereupon we see an over-the-shoulder shot of the girl watching her father standing on a bridge below, his back turned to us, looking out on the water…"Standing at the quay, I felt in my back a feeling as if my braces would have snapped and my pants dropped to my ankles." And when the teenager talks about herself, she adopts again an exclusively external, factual point of view ("I'm in an armchair, I have a boyfriend. I have something on my lap.") A point of view stated in a tone and rhythm that makes everything she says sound like a statement of fact emptied of content and that places everything on the same plane of reality. Boredom, absence of intensity, and lack of connection between three pieces of information that don't belong to the same reality. What is the relationship between sitting in an armchair and having a boyfriend? Why does the information about the girl's affective situation come between – and interrupt the continuity of – two pieces of information of the same type? To wit, an incapacity to tell a story, to build up the story of her own biography. Step out of the self and picture yourself in fragmentary representations. Factualness versus inwardness. Whereas the girl does not internalize the event, her father seems to be physically immersed in the pain of his loss.

Shots of his tear-drenched shirt and long painful cries punctuate the girl's story. A physical internalization of pain intensified by mental pictures of the grandfather: On a road, at night, in the middle of the forest, an old man walks toward us. When he reaches the camera (the surface of consciousness), his features become clear. It's the grandfather…For a few seconds, he stares at the camera (etching an impression on the surface of consciousness), then walks away and lies down across the road. To wit, a sequence of mental pictures that initiate the son's monologue and stand in for a lack of words. In fact, if the son feels the pain of his loss, he is unable to formulate it in words. The mental picture of the grandfather meeting his death and the lack of verbalization as signs of his incapacity to translate this death into experience. Is this incapacity due to the nature of the event (the unnamable)? To the father's personality? To a defect in language that Ahtila's montage would remunerate? Does the focus on the exclusively visible signs of pain and behavior (deprivatized interiorization) that characterizes the teenager's monologue also stem from an incapacity to translate time and events into experience? Can my subjectivity be reduced to the fact that I'm in an armchair, that I have a boyfriend, and that there is something on my lap?

If contemporary man "has been deprived of his biography," if "his experience has likewise been expropriated" and henceforth he finds himself incapable of "translating into experience" the "jumble of events" that he confronts every day (Giorgio Agamben), then find modes of translation and representation on the scale of our days. On the everyday surroundings: a few shots of the family home and garden, some pictures of a forest and a lake in the vicinity. A peaceful family environment (a chair in the shade of a tree, an empty plate on a branch, a green lawn…a close-up of three insects…): Events are rare, activities repetitive (doing the dishes, resting in an armchair, bouncing a ball off a wall, sitting in front of the television, etc.)…A modest living environment hardly affected by the consumer imaginary – hardly penetrated by the market (shots of the garden tools against the wall of the house, a few flowers, secondhand furniture at the back of the garden, some clothes drying on the line). If the identities depicted in *Today* seem reduced to the functional dimensions of the rooms or places they occupy (washing up in the kitchen, sitting in the living room, playing in the garden…), they do not seem to have integrated the imaginary of the planetary petty bourgeoisie – an imaginary founded on the turnover of consumer goods and services. In the event, *Today* displays the signs of a permanence (a ritual) and durability situated at the periphery of the supply turnover and the desires it elicits (the novelty). The girl about her father: "If he starts doing something that he likes, his back

128

starts aching so much that he has to stop everything. Then he can't do anything else than sit and watch TV. [...] Granddad lived to be old. He had long ago retired from working life. My dad retired from life." Here, the absence of activities (the possibility of building up the self through an activity), elsewhere, in Vera's monologue, the absence of desire: "The streets are swarming with people who look alike, and boast about having done precisely what's undone. [...] People make love at least twice a week only because nobody wants to feel shame." A verbal inflation that hides a deficit of experience. A good average that stands in for feeling. To be conform to arbitrarily and consensually fixed norms ("twice a week") or not to be ("to feel shame"). The good average as the sine qua non condition less of belonging to a homogenous community ("people who look alike") than of being presentable to this same community. A social determinism that stands in for desire. Cease being the subject of your desires and let norms organize our timetable and govern our affects (the becoming-statistic of man). Vera's monologue as evidencing a process of expropriation of desire.

If the girl seems able to see herself and the people around her only from an external, factual point of view, maybe it is because the models of being in the world and in relation to others available to her have annihilated any possibility of having experiences of her own (deprivatized interiorization). Vera's soliloquy (the isolation) as an example (the paradigm): "I preserved the fear inside my body and made myself it." The internalization of feeling as self-negation. Can self-compliance with standards (the disabling of the self) be translated into experience? If this compliance with standards entails a loss of desire, then existences cannot strive toward any goal. Existences exclusively moved by the necessities of keeping the household going and losing awareness of time passing by...The permanence of this same necessity as the rhythm of life. Inertia as the mode. The norm as the setting. The negation of one's *ownness* as the model...Being there as the condition. If the teenager cannot internalize the events she is describing, if the father's lived time is characterized by an absence of activity (the passive form) and if Vera's existence comes down to keeping the household spick-and-span (the active form) while denying anything that could be her own (self-compliance with standards), then *Today* shows different forms of one and the same dispossession: that of the possibility of building up a biography. The protagonists give us a biography of their relatives ("My dad normally doesn't cry, he normally don't do nothin'. Except he used to work" "At home in the morning he made coffee and held a newspaper so that he couldn't touch anybody") and neighbors ("In this city adults have become failed teenagers"), but they tell us

nothing of themselves and repress anything intimate ("I preserved the fear inside my body and made myself it"). The ability to say *I* – and to tell about yourself – disappears to the profit of the third-person singular ("My dad," "he") or plural ("people," "they"). An inability to speak of oneself that stands out against the mediatization and the culture of me, myself, and I that constitutes the middle-class imaginary in the world's most technologically advanced countries. Could the family unit represented in *Today* be impervious to all the psychological dramas aired on the major television networks? To all the shrink advice columns in popular magazines? To all the infovarietyshows? What does the father watch when he's not working? Where do Vera's thoughts about sexual behavior come from? Why doesn't she appropriate the information that she gives us to build her own way of life on the margins of the standards she rejects? Vera's mono-logue swings from general considerations about the local petty bourgeoisie to recounting a dream ("I see a two-storied animal eating walls from the house. A rattling tram pronounces my dad's name"). To wit, two types of discourse that she cannot seem to connect in a conscious way to her own experience (de-scribing without conscienticizing). While she's talking, the camera lingers on a bottle of alcohol, a glass, a toaster, a thermos, a pile of newspapers (signs of lived time) and moves through a train corridor and a forest (places with a strong symbolic thrust). Two image registers that reflect an incompatibility between the contexts of experience – of lived time and oneiric time – and those of discourse. A sequence of images that do not derive from Vera's discourse and that devel-op independently from the sequence of domestic gestures on which the camera lingers. The slow motion shot of Vera washing up as emphasizing the domestic work that she does not talk about and in which she seems to engage no value – no engagement in constructing a subjectivity through her work. An absence of experience of the self here and now. The abundance of comments on ques-tions foreign to this same work (extrinsic to her condition) as a promise of eman-cipation. An emancipation that comes up against her incapacity to appropri-ate time for herself. As if the fact that she is not the conscious subject of the thoughts, images, and discourses that run through her deprived her of a sense of self in the present. By removing herself from her activity (here, washing dishes) to focus her attention on what she is not living (I am not thinking about this moment that I am living but about what others are living), Vera not only denies her own lived time, she also precludes any possibility of translating it into experi-ence and thereby freeing herself from it. Consequence: Vera lives the house more than she lives in the house. Question: How is it possible not to live to the rhythm of the chores to be done?

Has the possibility of experiencing *ownness* and proximity to the self been definitively annihilated by the society of the spectacle (life deported behind the screen) and the normalization of behaviors (conformity)? Vera's disillusioned reply: "Newspapers glorify pain and horror. Pleasure is pornography or petty bourgeoisie. Exactly the ideas which start to clot are merchandise" (the spectacle)…"The streets are swarming with people who look alike, and boast about having done precisely what's undone" (the standard of presentability). If pleasure has become a product, if it only takes shape in a representation codified by the law of supply and demand and if, in the case of pornography, this same representation is built out of an exclusively male point of view (the camera as duplicating the male gaze – the subject of desire – fixed on a female body fragmented into objects of desire), then the *I* in the feminine gender cannot agree with pleasure (deported outside her body) nor can it be the subject of its own desire. Experience the spectacularized body (make use of pornographic images) or relinquish pleasure. Accept the absence of exchange with the people around you and articulate your emotional potential with its representations or else sink into isolation. Giorgio Agamben rereading Guy Debord: "The spectacle does not simply coincide, however, with the sphere of images or with what we call today the *media*: It is 'a social relation among people, mediated by images,' the expropriation and the alienation of human sociality itself."[64] Yet the culture of the spectacle and its standards do not constitute the sole causes of self-dispossession here. Between two sobs, the father recalls his father ("At home, in the morning he made coffee and held a newspaper so that he couldn't touch anybody") and what he used to say ("Your life is just drifting from one accident to another. You can't even decide, you can't even decide.") But hasn't the father inherited his isolation and his passive acceptance of physical weakness from the grandfather (atavism)? An atavism that shows through in a few verbal tics picked up from his father, particularly in the way he too has of ending statements of general truths – here about his incapacity to make decisions when it comes to the main direction of his life – by repeating the last phrase. To wit, an inadvertent revelation of hereditary determinism that stands out against the social determinism that Vera talks about. Two forms of determinism coupled with an incapacity to speak for oneself. A difficulty in speaking one's own language that is paradoxical in a mise-en-scène that gives pride of place to speech. Indeed, in most of Eija-Liisa Ahtila's video works, in *If 6 Was 9* and *Today* as in her "commercials" *Me/We*, *Okay*, and *Gray*, moments of silence are rare. The mise-en-scène gives

64 *OP. CIT., THE COMING COMMUNITY,* P. 79.

priority to speaking and telling stories over action and experience (the need to fill the void with a flood of words)…For want of experiencing a lived moment (being here and now), give it a verbal representation. Moreover, Ahtila's filmic construction gives priority to monologues over dialogues. *Today*: three people who seem to be living (in) separate realities. Realities (monologues and shots – the daughter looking at the father, a quick shot of the girl in the garden in the middle of Vera's soliloquy…) that may intersect but that share no feelings, no activities, no desires, no common story. The story of a family with no story and of its members with no biography. In addition, whereas the relationship between the father and daughter is clearly stated, what makes us think that the third person is part of the family unit? If the man asserts that he has a daughter who "throws a ball" and asks her to "look," and the teenager describes her father's state of despondency, Vera gives us no information whatsoever about her relationship to the teenager or the father. Who is she? A mother, a companion, a wife, an aunt, a friend? All we know for sure is that the three people live in the same space and one of the last shots accompanying the father's story shows them together in a car speeding through the forest. A car that seems to sweep down on a man lying in the middle of the road…A man who barely has the time to jump up and turn to face the headlights…The screeching of tires, a harsh white light over the entire screen and the sound of an impact in the form of a question (Who ran over the grandfather?)…Cut. The choice of the monologue form and of splitting the stories on three separate screens projected alternately in the exhibition space as formulating the split between the members of the family (the separation of affects). A separation of affects that is found again in the description of the grandfather who, according to his son, avoided physical contact with the people around him. Behaviors that freeze the circulation of meaning inside the family unit and monologues that do not contribute to constructing the same story. A family with no story.

To whom, then, are the protagonists speaking? When Vera, up to her arms in dishwater, talks to the camera, what type of picture are we looking at? A documentary on the condition of middle-class women in Finland? A talk show? A commercial that hasn't yet shown us the product being hyped? A fiction film? How do these general considerations on the society of the spectacle relate to the different points of view on the accident that inaugurate the three narratives? The blurring – or rather the mixing – of different types of discourse, different aesthetics, and different contents – fictive, documentary, and commercial – as a proposition for representations in step with the tools offered by contemporary

middle-class culture. A culture in which our existences are built up after a delay, after the fact (the shrink's, the TV or radio talk shows, advice from experts, etc.). Work from the contexts and narrative structures of media aesthetics to try to translate into experience a time that we seem to be having a hard time living.

PRACTICAL LIVING: IS THERE LIFE BEYOND USE? (FOR CONFLATING MODES OF REPRESENTATION)

1998. A cellular phone commercial informs us that "calling has become a sixth sense"...Based on what we read in magazines, hear on the radio, and see on certain TV shows, it seems that our lives boil down to our sole use of products and services available in the world's most technologically advanced countries. One look at the number of hours spent shopping each week confirms the becoming-user of man. A life of demands in a world of supplies. If the television and film industries influence our behaviors, our desires, and our representations as much as their detractors claim, then why not work on these issues of representation from within the forms and modes in which they are played out and codified – in the event, from inside an advertising aesthetics? 1993. *Me/We* (Eija-Liisa Ahtila): While hanging the laundry out to dry, a man turns to the camera to communicate the state of his relations with various members of his family. Consider a ninety-second film in which Eija-Liisa Ahtila diverts the function of commercials. If the aesthetics, the narrative structure, the framing, and the directing that characterize the advertising form are maintained (the position of the protagonists around the white sheets, the dazzling brightness of the laundry, close-ups of a typical spot of dirt, ultra-bright smiles of satisfaction, etc.), the words commenting the supposed action of the advertised product – here, a detergent – soon give way to words of intimacy. The man approaches the clothesline... His wife is already busy hanging a sheet on the line: "Sometimes I feel that I do not know what my wife really wants." To wit, a statement introducing the need to select a new detergent...Ultra-bright smile from the wife. "My daughter, however, has always got on well with her mother." If the pictures are still embedded in a process of exhibiting the product's qualities (an ultra-bright smile from the daughter), the father's monologue builds up a narrative that, instead of attracting the viewer's attention to the dazzling whiteness of the laundry – or the teeth –, refers to the difficulties in communicating and living together that seem to afflict more and more families: "But she does not have very close relationships with others." Psychological communication is substituted for product communication. Cut. Camera moves to the center of the garden. At a table, before entering the discussion, a young man is sorting socks...At this stage in the commercial, a

question: What accounts for the smile addressed to the camera? The presence of the father/husband or the effectiveness of the detergent?

If over the past few decades our aspirations and desires have often been materialized by the acquisition and use of products, if a good part of our emotional capital has been invested in their management, are we to conclude that being in the world boils down to using it (the becoming-user of man)? Guy Debord: "The spectacle is the moment when the commodity has attained the *total occupation* of social life. Not only is the relation to the commodity visible but it is all one sees: the world one sees is its world."[65] Can we be something other than a man or woman vacuuming the carpet or hanging the clothes out to dry? Are there any reasons for smiling other than those hyped by businesses in their attempt to increase their shares in the market? Could the whiteness of the clothes in *Me/We* be a last ditch effort to get the people in *Today* to smile? Has the laundry penetrated my subjectivity to such an extent? And does the refusal to live to the rhythm of the supply and the desires it implies condemn me to depression? Has the practical dimension become the sole dimension of our lives? When we hang out the laundry, what are we thinking about? The laundry or something else? Is our consciousness totally occupied by use? Has the intensification of the dynamics linking supply and demand brought with it a total absorption of the self in the product? If telephoning has become a sixth sense, if the radiance of the person I'm living with depends less on our way of being together than on her relationship to the products she uses, are we to conclude that our capacity of being and our imaginary are necessarily linked to the way in which we integrate the supply?

How can we mix utility with interiority without reducing the latter to a way of being a user? In the event, *Me/We* connects two incompatible dimensions – the advertising dimension and the psychological dimension. A connection that conflates a mode of identification aimed at a specific psychological family situation close to the mode of confessions that can be heard on TV and radio talk shows with a mode of representation aimed at a population seen in generic, statistical terms (potential customers in target categories). Brought to the screen, our lives appear broken, splintered, and reduced to the dimensions needed to meet the criteria and functions of each different mode of representation (advertising, fictional, documentary, etc.). Dimensions separated for reasons of genre

65 OP. CIT., SOCIETY OF THE SPECTACLE.

specialization. To the question "Who are we and how do you see us?" advertisers, reporters, and the makers of clips, documentaries, or fiction films reply: consumers in commercials, crazy about you or rebels in clips, employees in trouble in documentaries, in love or pain in comedies and dramas, psychopaths in serial-killer movies, action heroes in blockbusters, fuckers in porn films, and citizens on the six-o'clock news. The adman's approach stops where psychic life, affect, or professional activities start. The clip filmmaker's, where working life starts. The reporter's, where affect and private life starts. The documentary filmmaker's, where the spectator never goes. The fiction filmmaker's, when men and women start getting dressed to go to work.

To focus spectator attention each time on one single dimension of our modes of being and thinking, on the *objective* description and mere appearance of certain practices of the self while disregarding the complexity that constitutes them (what is not *visible*) and that motivates them (the political, economic, and social context and conditions of their appearance – the historical dimension), amounts to not only fragmenting us into separate dimensions that never tally (thereby converting us each time, with each genre, into unidimensional individuals), but also, and more especially, to precluding any possibility of grasping the complexity of individuals today. Rare are the films (in the generic sense of the term) that foreground, relate, and put into perspective the different dimensions of our existence. Recreating (reflecting) a day at work requires switching between a variety of genres. The timetable as the storyboard of cinematographic production. 7 A.M.: Bad night? Bad breath? Need a pick-me-up? (Ad). 9 A.M.: Gregg is personnel manager at Euromaster (Documentary). 1 P.M.: Digestion problems? B.O? (Ad). 2:30: Gregg has a meeting with union representatives (Documentary). 5:45: Hi! It's Gregg...Remember me?...I was wondering if we could get together this evening...(Dramatic comedy). 6:30: Outdoor café...Keeps you fresh and dry all day long (Ad). 8 o'clock: TV dinner... Ready in no time (Ad). 8:50: He doesn't even want to see his own son (Drama). 11 o'clock: It's the same old story...They're always fighting out there...Brnng... Telephone's ringing, but I won't answer...What's the point? I'm down, down really down...(Clip). 1 A.M.: That's the way she likes it (X-rated film). Slots of time for slices of life. Have we become a television generation to such a point? A television that supplies us with a series of postures and clichés that are never embodied in experience (the look without the life that goes with it) but that appear as moments cut out of a stream of images and sensations (the scanning of the camera) that assault us (the heterogeneity and complexity of the social

sphere) when we watch life in passing (feeling versus analysis).

Ahtila's commercials may act, in this respect, as models of reappropriating the separate spaces and forms of representation that speak to us (and for us), that shape, fragment, and isolate us. If the spaces and forms of representation of our media culture founded on the specialization of these same representations – a specialization that ineluctably conveys unidimensional representations of ourselves –, reduce us to the single dimension needed to satisfy sponsor interests (the consumer dimension for admen, the citizen for politicians, etc.), then relating separate forms of representation may indeed constitute an aesthetic issue.

On a table covered with a tablecloth, four cups of coffee. In slow motion, a hand deliberately knocks one over. Why was the coffee spilled on the tablecloth? To make a coffee stain that only this specific detergent can get rid of? Or because the father was upset? The father: "We had more or less an ethical crisis. [...] I can see the reason...probably love had faded away." The image: A stain that needs to be cleaned. A fusion of advertising and psychological reasons. In the event, *Me/We* conflates documentary (the confession and addressing the viewer), fiction (a family story), and advertising (the commercial showing the whiteness and brightness of the laundry being hung out to dry) into a synthetic form. Re-appropriate situations in life (here, a moment of family life and a household activity) and an interiority of which we have been dispossessed by fiction and ad narratives. Jürgen Habermas: "The literary patterns that once had been stamped out of [privacy's] material circulate today as the explicit production secrets of a patented culture industry whose products, spread publicly by the mass media, for their part bring forth in their consumers' consciousness the illusion of bourgeois privacy."[66] Re-become an actor in your own story. Retrieve our place as subjects in a media and film culture that has turned us into targets (advertising), objects of scrutiny (documentary) or spectators in want of experiences (fictional events representing what we are unable to live). Deepen our practical lives (the moment of using a product) with an existential dimension.

66 *THE STRUCTURAL TRANSFORMATION OF THE PUBLIC SPHERE: AN INQUIRY INTO A CATEGORY OF BOURGEOIS SOCIETY*, TRANS. THOMAS BURGER, FREDERICK LAWRENCE (MIT PRESS, 1989), P. 161.

MY WIFE'S WAITING FOR ME (THE DIMENSIONS OF THE KITCHEN AS THE DIMENSIONS OF LIFE)

Before being in a position to retrieve our place as subjects, cease being targets, targets reduced to the needs of a culture still written in the masculine gender. Do away with a culture of house arrest. A look back at a few of the milestones in the history of an aesthetics of disalienation. 1972. *Womanhouse*: In a Los Angeles mansion, twenty artists – all women – propose environments exploring the domestic activities that make up the daily life of most average American women. *Ironing* (Sandy Orgel): A woman meticulously ironing a sheet…*Leah's Room* (Karen LeCoq and Nancy Youdelman): A woman putting on and taking off makeup all day long…Consider two performances evidencing the way in which the time-consuming repetitiveness of household chores totally absorbs (confines) feminine subjectivity. A time-consuming repetitiveness that precludes any chance of acting on the world. Exhibition of a subjectivity which, in the feminine gender, is still conjugated in the passive form. *Waiting* (Faith Wilding): Alone in a room, a woman rocks back and forth on a chair. Silence and immobility imposed by a condition…Break the silence…Wilding's performance condenses into a litany: "Waiting for my breasts to develop…Waiting to get married… Waiting to hold my baby…Waiting for the first gray hair…Waiting for my body to break down, to get ugly…Waiting for my breasts to shrivel up…Waiting for a visit from my children, for letters…Waiting to get sick…Waiting for sleep…" The statement of a condition. A statement that implies a fixed position of the body (waiting). The rocking as a sign of boredom. The latitude of the rocking as evidencing the latitude of possible initiatives. The body confined to the house as the sole form of presentation of the self. The repetition of the same verb as replicating the repetition of days and thoughts. A verb of inactivity conjugated in the passive form…A verb that only agrees with signs of getting old (the total absorption of the self in an awareness of getting old). Signs of getting old that only affect the body. A verb that does not even require a personal pronoun (the elimination of the "I" as an absence of subjectivity). Waiting is a condition, a condition that is there no matter who else you live with or take care of…"We have received orders not to move…" We are at the beginning of the seventies, a time when strategies of disalienation and emancipation underpinned a good number of aesthetic practices…Compared with that time in history, an aesthetic approach based on the literal exhibition of the conditions of alienation may seem paradoxical…What are the reasons behind the symbolic refusal of the emancipated movement? What explains the insistence on positions assigned by patriarchal culture? Why did so many of the works performed by women at the beginning

of the seventies exaggerate the features that characterize these positions (the stereotype) to such a pitch? Did the context of enunciation of these works necessarily coincide with that of the condition they were denouncing? Laura Cottingham: "Given the absence of other cultural symbols or circumstances, first-generation feminist artists really had no choice but to begin their production within the language of patriarchy, consequently, many of the art experiences and objects produced out of seventies feminism appear to document or describe, rather than obviously subvert, the traditional patriarchal assignation of women into positions of sex worker and housekeeper. In order for feminist artists to develop a visual language, they necessarily had to begin with the female-coded signifiers that already existed for them."[67] If the household constitutes the main focus of the traditional patriarchal assignation of women, if the public sphere is still the setting of the male assignation of women into positions of sex workers or passersby who are whistled at or strangers to whom we offer flowers, then go back to study and work from within the language of patriarchy to find a way out of it once and for all.

1975. On a monitor screen, close-up of a blackboard hiding much of the person's face who's holding it. In chalk on the blackboard: *Semiotics of the Kitchen*. Consider a seven-minute black-and-white videotape (Martha Rosler). A general theory of kitchen implements and their connection with practical life. Camera pulls back to broaden the context. We're in a kitchen. A kitchen and a woman who remind us of certain late-morning TV shows. Is the woman a host about to demonstrate a recipe for chicken gumbo? She puts down the blackboard, puts on an apron, and announces to the camera: "Apron." Then she picks up a bowl, which she presents to the camera and names: "Bowl." And so on right through to the last letter of the alphabet. The list of implements as the statement of a condition. By naming cooking implements in alphabetical order, Rosler sets the context and dimensions of an existence reduced to making meals. In the event, the housewife is not the subject of her acts; she is performing a score. A score written to satisfy the needs of her family. The naming of each implement is accompanied by its presentation to the camera and followed by a gesture illustrating how it should be used. An illustration with no ingredients. The absence of ingredients as highlighting the gesture in and of itself...the condition of the housewife itself. Gestures that are repeated and combined in a prescribed way

67 "ARE YOU EXPERIENCED? FEMINISM, ART AND THE BODY POLITIC," 1996, REPRINTED IN *SEEING THROUGH THE SEVENTIES: ESSAYS OF FEMINISM AND ART*, G+B ARTS INTERNATIONAL, 2000, P. 129.

(the recipe). The recipe as the text regulating a good share of existence in the feminine gender. Until the "eggbeater," everything seems all right...But when she gets to "fork," her illustrations begin to go haywire...She stabs the fork in the air with a violence unrelated to its ordinary use. As if a silent revolt, a contained violence, were suddenly surfacing. There will be no recipe. The exaggerated force of the gestures as a sign of the limited freedom of movement that a woman's body can enjoy in a context assigned to her by the patriarchal power that will probably be coming home any minute now...But to whom is the violence of this gesture addressed?...Are her nerves on edge? Is she simply fed up? Or would she like to stab him with it somewhere or another? The violence quickly subsides in a return to automatic, mechanical gestures. The ice pick illustration reveals no desire for revolt...The woman sticks to her housewife role (and gestures) until the "knife"...A knife which she brandishes like a weapon, stabbing the air with it several times...A knife that is not shown as an implement for cutting meat...If the prospects of a recipe have receded, the call to revolt has become manifest...Why brandish a knife in a kitchen a few hours before dinner? A call to insurrection (women viewers unite)? A call to take up arms and kill the patriarchal culture to put an end to the gestures that they teach us to repeat? As if suddenly the demonstrator had decided to refuse to transmit skills that maintain women in a state of subservience. The subversion of the conventional usage of kitchen implements as a way of undermining the transmission of knowledge. A transmission that induces each new generation of girls (television viewers) to pick up the heritage from the preceding generation before passing it on to the next. Refusing to transmit as the sine qua non condition of emancipation.

1999. When it's time for dinner, even if ad aesthetics now hesitates to reduce being in the feminine gender to being exclusively a housewife, it continues to present women wondering what they could possibly cook up for their families tonight...Pre-cooked meals as an answer...The ultra-bright smile of relief as the result. Are we to resign ourselves then to the idea that women have been liberated from their enslavement to the kitchen by frozen meals? Back to the seventies...Time to present the ladle...Twice the demonstrator mimics perfectly the movement of dipping a ladle into a bowl, and twice she imitates the gesture of flinging out the contents of the ladle. A woman who's not about to end up like Jeanne Dielman. The making of the vegetable soup is cut short. If Jeanne Dielman is a housewife who never takes time to become conscious of her condition, then the demonstrator in Semiotics of the Kitchen is her consciousness... The one who shows her the path to follow...Throw away your vegetable soup

before your son comes home to eat it without even looking you in the face...
"Opener"...The demonstrator's face twitches (it's hard to open a can with this)...
Thereafter the demonstration degenerates: Her gestures become increasingly
exaggerated and mechanical...the rolling pin is brutally thrust back and forth...
the implements begin dancing on the table...After the letter T, the demonstrator,
fed up with naming these instruments of alienation (instruments for conducting
female bodies), grabs a fork and knife, spreads her arms out in the form of a
U and declaims: "U". The rest of the alphabet follows. Letters figured in bodily
postures (the female body bound to the figures of a patriarchal language). To
finish: a Y posture (self-crucifixion on the altar of the condition of housewives)
and a Z for Zorro sliced through the air with a knife...So much for the alphabet.
The demonstrator folds her arms (having accomplished her emancipation duty).
A shrug of the shoulders, an apologetic gesture of the hand, and a knowing grin
to conclude. Cut.

At this stage in the emancipation, a question to the one who'll be coming home
any minute now. Would you like something besides a nice supper when you
get home from work? 1965–74. *Untitled (Bowl of Fruit), Body Beautiful* or *Beauty
Knows No Pain* series (Martha Rosler): In a model kitchen, a chopping block,
a bowl of fruit, some cutlery, a pile of dishes, and a naked blond striking a *Play-
boy* bunny pose. A picture from a magazine for men in a picture from a maga-
zine for women...A photomontage. A collage of a real bunny set in our home
environment...In the background, another bowl of fruit, some cupboards, and
a built-in oven. Consider a radical reification of what the male gaze sees as a
woman's sexual assets. The come-hither look in her eyes, the firm thighs and
a magnificent ass. Her back is turned to us, but the enticing look she throws
over her shoulder acts to tempt the spectator's voyeuristic appetite (Got a hard-
on, honey?). A look, an ass and thighs, there to arouse and no doubt to satisfy
our desires. The bowls of fruit as allegories of the eroticization of women's bodies.
A blond ready to be eaten up (firm, round buttocks). Fruit as a symbol of the in-
junction imposed on women: Thou shalt not age. The life expectancy that the
male gaze accords to the apple of his eye is short. Stay young and ripe for con-
sumption. Shrivel up and be desired no more. Erections as the power of life
and death over the subjugated woman. Stay ripe or rot. A ripe body fragmented
into desirable parts...Parts that, in the imagination of the desiring male, are com-
parable to pieces of fruit: From a vulva in the form of a ripe apricot to melon-
shaped breasts. Placing the images (the collage) of the woman and the bowl of
fruit on the same plane as a staging of the metaphor of desire. A plump, golden

apple…Woman as temptress…The plump curves of the body as promises of pleasure: A pleasure that associates the juiciness of the pulp to the firmness of breasts and buttocks, and that turns secretions into liqueurs…A fruit to be picked and a desire to be tasted. Luce Giard: "Love is inhabited by a fantasy of devouring, of a cannibal-like assimilation of the other to the self, a nostalgia for an impossible, identificatory fusion. […] Everyday language states this in no uncertain terms when people speak of being 'hungry for someone' or 'starving for a piece of ass' like they might be hungry for a good meal or starving for a piece of steak. In the love exchange the partner is sometimes turned into an appetizing dish, called endearing food-related names ('sweetie pie,' 'my precious lamb,' 'my little ducky,' etc.), devoured with the eye and consumed with caresses."[68] In the event, honey bun strangely resembles a *Playboy* bunny. The pictorial parallel between fruit and the female body as a visual translation of a link that exists in language. From Granny Smith to Betty Crocker's great recipes, we are continually binding the condition of women to the food register. A way of making the bondage seem natural. Revising language as the sine qua non condition of emancipation. A bondage that is continually being updated…1965–1974. *Untitled (Kitchen II)*, *Body Beautiful* or *Beauty Knows No Pain* series: On a uniformly gray ground, an open refrigerator. Covering the whole surface of the bottom door, a color photo of a woman's belly…A bulging belly-door…The navel as focal point. Shopping is mommy's job…A mommy who fills up the refrigerator and a refrigerator that keeps mommy busy…As if women had totally absorbed the advertising message (I am the object that occupies my time). A furniture body, built into the kitchen. The door of the freezer (the doorway to our liberation?) is open…A freezer bursting with flesh-colored meat…Plan ahead and avoid having to shop every day…A freezer in place of a head. A bond between the female body and flesh that goes back to Genesis: "And the woman perceived that the tree was good for eating and that it was a delight to the eyes, and that the tree was desirable as a means to wisdom, and she took of its fruit and ate; and she gave also to her husband with her and he ate. Then the eyes of both of them were opened and they realized that they were naked. […] And to the woman He said, […] your craving shall be for your husband, and he shall rule over you." A screenplay for a porn film…A screenplay that, in its contemporary version, would yield *Succulent Tits* (a Climax Production).

68 "FAIRE-LA-CUISINE," IN MICHEL DE CERTEAU, LUCE GIARD, PIERRE MAYOL, *L'INVENTION DU QUOTIDIEN, 2. HABITER, CUISINER* (GALLIMARD, 1990) PP. 276-277.

If, in the advertising imagery, women no longer waste time looking for what they could possibly make for dinner tonight (liberation through frozen meals), does that mean that they have gained more freedom of movement? Has the near disappearance of preparation time (the time it takes to peel the potatoes) and the reduction of cooking time (Ready in no time!) freed any time for the self? If there's no more need to scrub with Mr. Clean, what could possibly keep this woman in her kitchen? The bondage of her condition to language is coupled by the bondage of her body to assigned images and places. As if patriarchal culture had liberated women (the temptress) only to enable them to take time (and pains) to perfect the image it has assigned to them. Replace the hours of peeling and cleaning by hours of step aerobics, stretching, body toning, and UVA. Hours of working out in order to come home with convincing reasons to get your man to stay put. The progressive slippage from an appetizing meal to an appetizing dish. An advertising aesthetics that has taken the place of mom's home cooking. To wit, a slippage that is accompanied by a defunctionalization of the kitchen and of ingredients. A defunctionalization that works to the profit of their eroticization (functional subversion as a sexual practice). A practical context and work setting that turns into a setting for experiences that will make your relationship last (*Cosmopolitan*). What turns men on?…Kitchens? Roger (thirty): "If the cooker gets you hot, why not? Every room has an erotic potential." Herbert Marcuse: "For example, compare lovemaking in a meadow and in an automobile […]. In the former case […], the environment partakes of and invites libidinal cathexis and tends to be eroticized. Libido transcends beyond the immediate erotogenic zones – a process of nonrepressive sublimation. In contrast, a mechanized environment seems to block such self-transcendence of libido. Impelled in the striving to extend the field of erotic gratification, libido becomes less 'polymorphous,' less capable of eroticism beyond localized sexuality, and the *latter* is intensified."[69] Back to *Untitled (Bowl of Fruit)*, *Body Beautiful* or *Beauty Knows No Pain* series: The bowl as a fruit container (appeal to our taste buds). The kitchen as a woman container (appeal to consumer desires). A blond built into a fully equipped kitchen – from the built-in oven to the fitted chopping block. A built-in body in a space eroticized by male culture. An all-purpose, fully equipped woman, ready for use. Herbert Marcuse: "[…] there was a 'landscape,' a medium of libidinal experience which no longer exists. […] The environment from which the individual could obtain pleasure – which he could cathect as gratifying

69 *ONE-DIMENSIONAL MAN* (BEACON PRESS, BOSTON, 1964), P. 73.

70 *IBID*.

almost as an extended zone of the body – has been rigidly reduced. Consequently, the 'universe' of libidinous cathexis is likewise reduced."[70] Before, there was the image of nature as liberator. A nature with gently sloping wheat fields beckoning couples to wrap their arms around each other and tumble down to the bottom of the hill. There was "a little pool, whose surface was all green with duckweed" (*Madame Bovary*). Nowadays, there are kitchens. Then, there was Emma who dropped her head on Rodolphe's shoulder, "flung back her white quivering head and swooningly, in tears, with a shudder that shook her whole frame, hiding her face in her hands, surrendered." Nowadays, there's the chopping block where I'm gonna screw you from behind. Agenda for an exhibition: Write a history of representation of male desire from *Déjeuner sur l'herbe* to *The All-Purpose Woman*. Reappropriate in the feminine gender images conceived in the masculine. Start speaking our minds from within the images that reduce us to silence. Get images to speak right where they structure our most intimate behaviors. A look at what's behind an advertising representation.

1993. *Okay* (Eija-Liisa Ahtila). A ninety-second black-and-white film in which the Finnish artist subverts the function of commercials while maintaining the narrative structure. In an apparently well-kept middle-class apartment, a woman (the housewife) speaks to the camera: "I become numb with longing." All of a sudden she's speaking with a masculine voice – "When I feel nothing (the deactivation of a sense of self), I strike" – then a female voice – "I strike him so that I'll feel something" (the incapacity to constitute the self as the subject of one's desire) –, a masculine voice again – "And every time I strike him, he punishes me. For every strike, he doesn't make love with me for two weeks" (a way of legitimating her subjection to the masculine will)…She gets up and walks to the center of the living room…"I serve my sentence and the race begins. Each time my desire overtakes my fear." Nervous pacing up and down in front of a disconnected TV set (one of the few ways of getting away from home mentally). Home as a place of confinement. Confinement as grounds for becoming aggressive. Confinement as the place where you wait for your man to come home (the woman's condition). The changes in voice as expressing the obliteration of the self as subject. A woman (the housewife) who does not speak but is spoken. Her lips move but it is the man who speaks…who bespeaks the expropriation of her own words and who writes the role he expects her to perform. The absence of the feminine voice in the female protagonist as a sign of the reduction of the self to an image. An image of the woman produced (spoken) in the masculine gender. The logic informing the advertising instrumentalization of women gives

way to a logic of masculine instrumentalization. To wit, an incapacity to break away from the image (place and function) assigned to her.

"After a long period of time when I beat him twenty-nine times, I had to stop for fifty-four weeks" (the reinforcement of captivity). Subjective-camera view of a television set and a chair (elements punctuating the daily life of a housewife)... Faster, frenzied movements of hand-held camera...quick glance at the window ...the tension turns to madness. Frontal shot of the woman who tells us: "If I could, I would transform myself into a dog and I would bark and bite everything that moves. Woof, woof!" The madness as a sign of possession. Stay confined inside (the quick glances at the window), feel bored after the household chores (the TV and the sofa), lose touch with yourself (feeling numb), go nowhere (pacing up and down), go out of your mind (the fast, frenzied movements of the subjective camera). The house becomes a cage. The caged woman inside the house (domestication) becomes a literal bitch (woof, woof). To wit, a long series of little things that end up driving her mad, or rather an exemplary process of alienation. Her master's voice (the masculine voice) as a reason for losing her mind. Her barking fades into the barking of the man who – still in an offscreen voice – imitates her and continues while she keeps pacing nervously back and forth: "So many shocking sentences have poisoned the air between the two of us." Her back is turned to us, the man's voice continues: "Arguing about work, money, trust. The most horrible sentences. The words do not work." The words do not work because she has no words of her own. Words – sentences – with neither subject (the disappearance of the woman's voice) nor object (the causes of the arguments are not the real cause of her anxiety). Sentences with no beginning and no end. Words that do not work because she is not the master of her words, because sentences run through her that belong more to her social condition as a housewife and the ensuing behaviors (the plights) than to herself. Gilles Deleuze and Félix Guattari: "The various forms of education or 'normalization' imposed upon an individual consist in making him or her change points of subjectification, always moving toward a higher, nobler one in closer conformity with the supposed ideal. Then from the point of subjectification issues a subject of enunciation, as a function of a mental reality determined by that point. Then from the subject of enunciation issues a subject of the statement, in other words, a subject bound to statements in conformity with a dominant reality. [...] What

71 CAPITALISM AND SCHIZOPHRENIA: A THOUSAND PLATEAUS, TRANS. BRIAN MASSUMI (MINNESOTA UNIVERSITY PRESS, 1987), P. 129.

makes the postsignifying passional line a line of subjectification or subjection, is the constitution, the doubling of the two subjects, and the recoiling of one into the other, of the subject of enunciation into the subject of the statement."[71] The need to feel something ("I strike him so that I'll feel something") and the condition of being a housewife as points of subjectification. The chain of violence (the passional line) as the line of subjection. Taking care of the house and making love when he comes home as the subject of enunciation. The woman going out of her mind as the subject of the statement. Mainstream middle-class reality as the dominant reality. The changing voices as the recoiling of the subject of enunciation into the subject of the statement. The loss of voice as a dispossession of the self. The barking as madness. Capitalism and schizophrenia.

"Of course I realize most men are animals." Abandon language (exchange). Shot of a nearly empty parking lot with a church on the right (the boredom of small-town life). To be the position assigned to us (the home as the sole territory of the imaginary) or not to be. To accept this position or to enter into a process of self-destruction by denaturing your relationship with the other. The male voice continues to make her say what the man inspires in her: "You bugger, a despicable nature and a face like a horse's cunt." The woman continues: "It is okay, it is okay, it is okay" (the acceptance of her own condition and all the repressing this implies)…"In what way can I tell him something?" She raises her arm swiftly. The need for love turns to hate. "I open my mouth and I close it on my lover's arm" (the advent of the becoming-bitch of the housewife). A becoming dreamed up by a man's voice. The mouth (the site of speech) does not speak anymore. To be unable to speak. Simply to scream ("you bugger"). Woman's place swings between house and body…between the silence and the scream (the bounds of speech). Speech as the site of masculine production. He speaks inside her and for her. She has nowhere of her own from which to speak. In the event, speech has no place from which it can originate. Unable to get herself heard (the loss of her own voice), she reacts with her subjected body (the sense of humiliation as a new point of subjectification). "I bite." To be nothing but a body that reacts. To be unable to act (just react). Unable to construct (just count the days).

In the event, Ahtila's "commercial" is the negative counterpart (the black and white) of the positive thinking discourse (positivizing use) that characterizes the advertising form. A negative that has nothing to do with the use of a product or service and everything to do with the way our living environment – and related conditions – acts on our behavior. Decode the structuring forms. Expose what the

145

advertising discourse is telling us. Expose the situations that underpin advertising representations…representations that structure our desires, our lifestyles, and our ways of being…representations that speak in our name and on our behalf.

THE LAW OF THE HOT NEW LOOK AND DEMAND
(FOR A REAPPROPRIATION OF REPRESENTATIONS)

LET REEBOK LET U.B.U (THE SUPPLY AND PROZAC)
1995: *Cosmopolitan* (Hearst Communications, Inc.) She's wearing: off-the-shoulder silk tee by DKNY, $88. Sequin skirt by Louis Vuitton, $1129. Shoes by Christian Louboutin, $370. He's wearing: Cotton-silk-and-polyester V-neck sweater vest by Issey Miyake, $665. Cotton shirt by Donna Karan New York, $165. Cotton gabardine khakis, $310. Leather Superstar II sneakers by Adidas, $60. Consider a set of instructions for embodying the advertising or fictional figure of your choice. The one we dream of and aspire to on the 6 P.M. train home from work, at the beauty parlor and at the cosmetic counter in our favorite department store. A set of product offers and models delimiting, specifying, and ultimately reifying my sensations and my ways of being...1999. *My Catalogue* (Claude Closky): "My terry robe. After a game of tennis, some jogging, or a dip in my pool, my terry robe provides me with a feeling of supreme comfort and sophistication. Superbly tailored and easy to wash, my terry robe throw-on, made of 10% cotton loop terry fabric, is perfect for daywear, yet it is so plush and elegant that I can wear it over a shirt or polo on cool summer nights. I have discovered all the luxury and comfort of my terry robe at an incredible price." If we have reached such a point in projecting ourselves into products that we order and that we dream of, if my subjectivity, my sensations and my ways of being belong less to me than to the clothes I desire, then working on countering advertising representations is an urgent issue. 1987. TV *Spots* (Stan Douglas): A Canadian TV network commissions Stan Douglas to produce a series of very short films (about thirty seconds each), films to be randomly slotted into the ad blocks aired at prime time. In between two men sharing the marvelously virile pleasure of a beer to the sound of music that boosts the outward signs of friendship (back slapping, satisfied grins, guffaws of laughter) and a couple boasting ultra-bright advertising smiles and trendy haircuts, a close-up of a nervous looking man in an uncomfortably skimpy, greenish suit. Standing alone in front of a peeling wall covered in graffiti, in the midst of the silence characteristic of residential outskirts, the man seems to be waiting for someone or something. A man who cannot accept himself as he is...A man who's tugging on the flaps of his jacket...A man lacking (in search of) representations. To wit, the staging (hyping) of a discrepancy (awakening TV-viewer consciousness) between the way that we live and the way that product designers, salesmen, and admen represent us. The necessity of economic growth as intensifying the discrepancy. The reception of the discrepancy as intensifying the sense of lack. The figures proposed by the advertising society as producing a sense of self-devalorization. The supply produces more ways of being out than ways of being in. The man in his

skimpy suit as a counter-representation, a counter-representation completely out of sync with the amplified forms of conviviality and well-being that the commercial aesthetics stages. To fit into Daniel Hechter or not fit in anywhere. To be capable of integrating the model (self buying power) or to feel out of place (excluded from the community of well-being). As if the presentation of the self was inexorably linked to a basic income. To be cotton-silk-and-polyester V-neck sweater vest by Issey Miyake and cotton gabardine khakis or not to be. To be able to offer yourself that personalized touch (cotton gabardine khakis) or to content yourself with a generic cut (pants). Is life without fitting into advertised clothing conceivable? How can you feel self-confident on a low budget?

1994. *Untitled, n°3* (Valérie Jouve). Consider a color photo (3.3 x 4.3 ft, 100 x 130 cm). In a medium shot, she's wearing: a tailored short-sleeved nylon shirt, unbuttoned at the neck, and a matching scarf. In the background, a low-income high-rise. A brunette with a hairdo that does not resist the gust of wind visible in the picture and a nylon shirt that does not fit into any current trends in fashion. To go out without worrying about your hair's shine and vitality, and to dress in clothes picked up in the women's wear department at Wal-Mart's. Your hair just the way it is…The frizz-free gel and natural styling made just for me? The best way to spend my day holding my head down, switching positions to prevent the wind from undoing my hairdo! Live naturally (don't let the wind get you down) rather than letting the way you move be alienated by L'Oréal (Because I'm Worth It). Find a way of my own to wear a bargain shirt and then think of something other than *my* hair and *my* shirt. Stick to one's own ways of being independently of models of attitudes index-linked to buying power (fashion). The matching scarf and the unstylish, unattached hair as signs of a measured appropriation of clothing. Substitute an unassuming mode of appropriation for choice (the dress that I simply can't resist). Portrait of a young woman who does not fit into advertising criteria of self-presentation…A young woman who seems absorbed by an object outside the frame…An absorbed look, with something soft about it… A hint of makeup…Makeup and eyes slightly turned to the right that underscore a degree of interiority…An interiority that the picture simply calls to mind…To call to mind an interiority at a time when the law of trends (the supply) and irresistible cravings for that dress (the demand) has gone quite a distance in invading our consciousness of ourselves. An absorption, a softness, and an interiority about which we know nothing, since we are in the public sphere (the passersby), but around which the image (the portrait) is built up…Meet people animated by thoughts that have more to do with humanity than with advertising (How can I fit

into that great dress I saw at the Gap yesterday?). The medium shot (the person from head to hips) as an aesthetics of attention brought to bear on the presence of a person…An attention brought back to bear on what animates a face and diverted from the criteria of self representation connected to social membership, criteria often reduced to the sole identification with fashionable modes of appearance (the designer outfit: from Gucci Mule Wedge sandals to the striped ribbon skirt by Markus Lupfer…An outfit that can only communicate with other outfits: Ed is wearing a silk shirt by Yohji Yamamoto pour Homme, cotton drawstring pants by Dries Van Noten, canvas slip-on sneakers by Vans, and Polo sport socks by Ralph Lauren; Cindy is wearing a pink-and-purple sleeveless dress by Missoni and black sandals by Versace). The medium shot (the face and the arms) versus the model's figure (the outfit). The sustained attentiveness emanating from this face looking at an object unseen by the eye of the camera as a sign of something beyond the representation of the self (the image) and as a trait of individuality all too often concealed by foundation makeup. Life is off camera. Leave your eyes as they are and leave Eye Shimmer in Pale Silver by Bobbi Brown to all those who want a megawatt metallic sheen, perfect for highlighting cheekbones too. Eyes looking outside the frame (elsewhere) versus eyes looking at the camera (the magazine image). Absorbed traits (the self) versus the anti-wrinkle foundation (*Cosmopolitan*). Impose your concerns on the landscape and the situation…A way of being true to one's own state of mind in all circumstances…Impress the environment with your own designs and not with the designer clothes we wear. Present yourself with a biography that you have written yourself and not in a pose signed by others who represent us… Counter the bold wide stripes, shifty swirls and irregular geometric shapes (Alberta Ferreri and Zucca) by my state of mind. A state of mind that imbues my body…A state of mind that builds a personal character. Instead of counting on designers to show off your body at its best, count on your state of mind to make you stand out no matter what you're wearing. The person versus the fashion figure (the absence of states of mind). Audacity of the self and manner as project.

But when even the slightest appropriation of an item of clothing seems difficult, when self-audacity is asking too much of us, in what way can one show oneself? 1996. *Untitled, n°17* (Valérie Jouve). In the center foreground of a 3.9 by 4.9 ft (120 x 150 cm) color photograph, seated on a low white wall, head bent over, seemingly absorbed by something she's holding in her right hand, a young woman stands out against an architectural background. A figure wearing a dark top and a flowery skirt that stands out against the neutral background.

A background that consists of a deserted yard and a white building front in the distance. Loud colors in a place that looks deserted…A photograph in which the background isolates the figure (solitude in a deserted space)…The woman's head is bent over, her eyes have a strained look about them…Her hands appear tense, her arms a bit too close to her body…A figure who seems cut off from the place (the absorbed look)…An attitude that does not fit into advertising models of self-presentation: straight hair, held back by a hairband, a man's shirt, sleeves rolled up, skirt with flower and checked pattern…On her bare legs, some scratches and a bruise. Red nail polish as the sole sign of coquetry. Feeling bad or deliberately detached from the outward signs of feeling good? The downcast eyes as a sign of the absence of other eyes (the attention brought to bear on people we meet). Could she be feeling bad because she's out of step with the models of self-presentation? Is it a deliberate choice? And if she is feeling bad, is it for economic reasons or for psychological reasons? Is it due to a lack of sufficient buying power (access to accessories that make you feel good) or to a sense of not meeting the canons of self-presentation (not liking yourself as you are)? How can one circumvent magazine and fashion imposed figures? Can there be a sense of self beyond your look? Is it possible to be attractive sitting on a ledge with your hands folded over your skirt when you don't have the means to buy yourself something classic from Ralph Lauren? And what if you have no desire to buy something classic from Ralph Lauren? What if you couldn't give a flying fuck? Shift your outlook…Stop dwelling on the distance separating a way of wearing clothes from an advertising model…Focus on presence and on what the look does not convey…Even though the viewer of Valérie Jouve's photos is but a potential bystander, even though we are not being asked to sit down on the ledge, even though we go by this woman without having to take an interest in her story, what type of perspective do we have or should we adopt? A compassionate perspective? But isn't that just an all-too-simple byproduct of a habitual perspective? A perspective that regards a person as feeling bad because s/he doesn't correspond to any of the images of feeling good that we know. But we know very few images. Search for other images. Images that accord better with our ways of being and living…The tenseness of the body as the affirmation of a story. A story that is missing from the picture. The tenseness of the body – and the story that is related to it – as presence… The scratches and the bruise as traces of a story about which we know nothing. But why dwell on these small bruises? Because I have the feeling that they might have some relationship to what I interpret as an attitude of feeling bad? Witold Gombrowicz concerning his novel *Cosmos*: "Out of the infinite number

of phenomena occurring around me, I isolate one single phenomenon. I notice, for example, an ashtray on the table (the rest disappears in the shadows). If this perception is justified (for example, I noticed the ashtray because I need it for the cigarette I'm smoking), everything is perfect. If I noticed the ashtray by chance and I don't come back to it, that's all right too. But if, after having noticed this phenomenon for no specific purpose, I come back to it, that spells trouble! Why do I come back to it, if it doesn't mean anything? [...] And so, by the simple act of concentrating on this phenomenon with no reason for one second too long, the thing begins to stand somewhat apart and becomes charged with meaning."[72] If, after having noticed the scratches and the bruises, I come back to them, that spells trouble! Why do I come back to them, if they don't mean anything? And so, by the simple act of concentrating on these two details with no reason for one second too long, they become charged with meaning. With no reason? But what about her closed look...her tense hands...her head bent over? Witold Gombrowicz about two details that are far removed from one another but which one of the protagonists in his novel notices (a hung sparrow and the lips of another protagonist) and, in so doing, turns them into "two problems [that] begin to clamor for meaning": "Seeing how we build our worlds by associating phenomena, I wouldn't be surprised if there had been a gratuitous, repeated association at the very beginning of time that fixed a direction in the chaos and established an order."[73] The scratches, the bruise and the girl's closed look begin to clamor for meaning? Seeing how we build our representations of people we meet by associating phenomena, I wouldn't be surprised if, after having seen a certain number of pictures of feeling good, there had been a gratuitous, repeated association of signs that fixed one particular representation rather than another...Yet these traces (signs), accidental or not, concern not so much the picture as the young woman's story...In the event, the picture does not support the fiction. We won't learn anything more, but we know that we cannot content ourselves with our gaze.

Go back to the place where certain representations are structured, prior to the programmed chain of advertising attitudes...Attitudes that we are supposed to make our own (Levis, Make Them Your Own), attitudes of desire and craving... A desire and craving for products (L'Oréal, Because I'm Worth It). If the advertising society is continually updating offers, if these same offers are designed to

72 "QUELQUES EXTRAITS DE MON JOURNAL AU SUJET DE COSMOS," IN *COSMOS* (DENOËL, 1989), PP. 10-11.
73 *IBID.*, PP. 9, 11.

elicit a demand, is a representation of the self without desires and cravings for products conceivable? Is it possible to imagine a representation of the self with no craving for a particular product, a representation that would not be read as a sign of a consumer slump and a drop in the confidence index (Gallup)? Formulating the absence of desires for products sublimated by advertising discourse as the first stage in reformulating my demand…A demand that would no longer be related to the supply. Slot pictures of an absence of desire and a lack of choice into the chain of advertising messages.

1987. *TV Spots* (Stan Douglas): In the middle of ads hyping togetherness or the multiple advantages of new technologies of communication of the self or some great interior decoration ideas for your home, a tracking shot to the sound of a telephone ringing…An empty table, flowers, and a small statue on a piece of furniture, dishes drying on the counter…A tracking that comes to rest on the hand of a woman holding a cigarette by an answering machine. The hand approaches an ashtray near the telephone but doesn't answer the call. The answering machine picks up the line…the caller leaves an interrogative "hello" after the message. In the event, if the setting of Douglas's spot corresponds to advertising standards, the attitude exhibited does not correspond to an actor hyping the use of this setting. The kitchen becomes the backdrop of an absence of activity, and the call-filtering function, the sign of a state of depression. To wit, the exhibition of a moment that comes after use (off the advertising stage), an idle time in the midst of commodity time (product purchase, use, and the satisfaction that results), a moment of fiction (the exhibition of a psychological state) in the midst of a form of promoting and codifying exclusively utilitarian behaviors. A flash of life in the midst of a world of practical living. Douglas's *TV Spots* act as the negatives of a blissfully positive representation of being in the world based on appropriating the constituent signs of fluctuating identities (from ways of being in Benetton or in Dior to ways of being homeowners by the seaside) or generic identities (employee, user, customer, etc.), identities produced by the turnover and circulation of products and services. Slot negative figures unrelated to representations necessitated by economic growth (unhinged), unaffected by the eventual value that goods and services may add to existence – figures, or rather attitudes, naked (un-designer-clothed) subjectivities whose presentation and construction do not derive from the use or appropriation of goods and services. Attitudes without models (unlabelled). The thick wool cardigan, the T-shirt that loses its shape after the first washing, or the creased blouse versus designer clothes. The negative figure-attitude as evidencing an ever-widening gap between

our own ways of being (life) and those with which we are supposed to identify (the supply), between what we live and what we supposedly want to live, between what we have and what we supposedly desire, between the context of our lives and the decor, between the rhythm of the self (habit) and that of the growth rate (market turnover). Disrupt the logic of choice. If we can choose between a way of being in Nike or in Benetton, can we choose between a way of being in Dior or in a hand-knitted wool cardigan? If the advertising message generates the demand, what does a woman filtering her calls generate? What is the power of identification of a man who's uncomfortable in his scrimpy suit? Commit desire suicide. Arouse the urge to zap. Insert pictures of fragile bodies into the torrent of pictures of bodies feeling great and of outward signs of personal satisfaction. The closed faces on the D train during rush hour and the smiles plastered all over city walls as a measure of the discrepancy between the representations of life necessary to growth (the supply of value added to existence) and the time spent in the office, on the commuter train, at the bank, or at home (the demand for tranquilizers and antidepressants).

To put an end to all these bodies feeling great about themselves and get nearer to fragile bodies, another *Spot*: Between two sequences of images sustained by voice inflections expressing unrestrained gusto (yes to the offer) and a scansion that turns every second into an exceptional moment (yes to what I'm living), between the dynamic movements of a camera following the day of a young businessman, proud of the sheen in his hair and glowing with professional satisfaction, and close-up shots of some accessories of well-being, a thirty-six-second static shot of a man with dull, flat hair wearing a T-shirt that's too tight at the shoulders. In a monotonous tone, unsustained by voice inflections expressing any gusto whatsoever and by a scansion amplifying the slightest instant, he delivers a confession about a precarious existence...: "Everything seems to catch my attention. Even though I'm not particularly interested in anything. I'm speaking to you right now, but I can still hear voices going on next door and in the corridor...I find it difficult to shut these things out. And it's even more difficult for me to concentrate on what I am now saying to you...often the silliest things seem to interest me. No, that's not true, they don't interest me, but I find myself attending to them anyway." Thirty-six seconds of black and white in the midst of a display of colors. A discount look in the midst of an aesthetics of superlatives and eye-catching scenes. Counter the confident, overdone rhythm of enunciation sustained by a sound track that matches the commodity form, with a silence of proximity to the self (the silence characteristic of the residential areas

surrounding the man in the scrimpy suit), a silence that eschews use, that declines the invitation to blissful consumption (the woman with the answering machine), a monotonous voice lacking in confidence (the digressions of the man in the T-shirt), and so on, in oppositions that characterize our modes of occupation of time and space, our experiences, our attitudes without qualities, our wavering, our way of acting without thinking, the repetitive acts that numb our consciousness. Thirty-six seconds to wonder why (what is he telling us?). Thirty-six seconds that pertain more to the register of the soliloquy than to that of communication. Words selling nothing (addressing no demand) and no longer subjected to the commodity (non-purchased airtime), words without a target (that do not construct any behavior), words refocused on the self (the portrait)... But especially, words that have no business being in this ad block and that are unlikely to interest us because if we are indeed used to "fictional speakers," they are "fictional speakers" who "unilaterally surround" us "with their commodities and the politics of their commodities" (Guy Debord).[74] Replace the need for a new dishwasher by the need to speak. Replace the product by what it generates (isolation). The promotional and codifying form challenged by its missed target. The positive, satisfied and radiant body challenged by its depressed counterbody. The figure of the man who needs to talk as a consequence of the "spectacular system" which, "from the automobile to television" participated in the "constant reinforcement of the conditions of isolation of 'lonely crowds.'"[75] *TV Spots* exhibits isolated figures. The people are seldom together in twos or in groups, with the exception of a spot in which Stan Douglas shows a man and a woman walking silently down the street at dusk...A silence punctuated by signs of their difficulty in being together ("What's the matter?...Nothing...What's the matter?...Nothing"). The other spots show people by themselves, alone in an underground parking lot, alone in a booth, alone behind an answering machine, alone in a deserted street, or even laughing out loud at the back of a bus under the curious, stiff, or disapproving eyes of other passengers. Where then is it possible to soliloquize? And facing whom? How is it possible to break through the solitude of the depressed user? By inviting h/er on a talk show. The ad block as a momentary blocking of the self. An airtime to be purchased by users instead of advertisers...an airtime to divert spectators from their function as consumers and turn them into a good shrink audience. An absurd airtime replacing products by patients.

74 *OP. CIT., SOCIETY OF THE SPECTACLE.*

75 *IBID.*

FICTION, BECAUSE I'M WORTH IT (FOR AN AESTHETICS OF FLIRTING WITH AD IMAGES)

Divert the ad form from its codifying promotional function. Overturn the logic of the spectacle: Deport a figure behind the screen so that, during the time of the spot, "the spectator's consciousness, imprisoned in a flattened universe, bound by the screen of the spectacle behind which his life has been deported," may come to know a "fictional speaker" who unilaterally surrounds him for once with something other than his "commodities and the politics of [his] commodities."[76] Inject a bit of *being* and disjunction into the utilitarian flow. The Canadian TV station, having accepted the principle of a perfect balance between the airing time and frequency of the commercials and of Douglas's spots, with a spot following each commercial, TV viewers were able to witness the formulation of a symbolic balance – a balance between the underequipped figure of the TV viewer without qualities and the accomplished figure of the model responding to the needs of economic principles. The insertion of underequipped figures without qualities as a break – a break during which viewer consciousness can act once again. Break the frantic chain of offers (the accumulation) by exposing moments devoid of events, attitudes without qualities, gestures that are not instrumentalized by advertising, figures of being in the world that make no demand, figures unlabeled by the supply. Jam the repetitive, seductive mechanism by breaking – suspending – the thinking positive momentum. The static shot of a face devoid of desire for what we have just seen versus the buying reflex.

Aired at regular intervals but always between different commercials, the same spots lent themselves to different readings as a function of the relations, connections, and articulations established in the mind of viewers between the various elements of the commercials and Douglas's films. At the same time, the commercials' reception was modified by the way in which viewers related them to certain elements of the spots. Another *TV Spot*: The camera follows a woman walking alone in a dark underground parking lot. She walks quickly, her hair held back by a hairband, the curves of her body hidden under a thick wool cardigan buttoned up to the neck. She stops, sneezes, and resumes walking. Set into a relationship with commercials for pharmaceutical products, the viewer can organize the meaning of the spot around the wool cardigan buttoned up to the neck, the sneeze, and the eventual chilliness of the parking lot. If the spot is slotted between a commercial for shining hair and slimming products, the figure

76 *IBID*.

of the woman in her buttoned up cardigan embodies someone who's unhappy with her body and who's knitted a cardigan long enough to hide her backside. Seen outside the context of the ad block, the spot of the woman in the parking lot can be read as a condensed representation of fear – the fear of being assaulted in a parking lot late at night. Increase the number of possible connections between the signs that make up the commercial aesthetics to the point of disrupting and deactivating its codes of representation. Divert the attention of the viewer from the monolithic meaning built on a scheme of monovalent communication (selling) by offering several possible readings (fiction). The desire for fiction versus consumption. The construction of a story (the active form) versus the buying reflex (the passive form). The principle of insertion works on the basis of dilating commodity time. The spot as a critical moment.

If ad aesthetics is a form of alienation of viewer consciousness – in the sense that it participates in structuring our behaviors, aspirations, imagination, myths, and inmost desires, and distracts us from questions that have to do with History (what the media call "news") –, it is nevertheless one of the forms of projection and representation that seem to correspond best to some of our modes of experience and of being in the world. If businessmen wearing suits and ties in commercials seem a bit too busy and dynamic, one could hardly deny the fact that the speed, stress, and the accumulation of things to deal with before 5 P.M. find in this form of representation a relatively effective mode when it comes to conveying the concatenation and acceleration of tasks or the effects of time compression. Are we to stop desiring a situation or an object simply because such a turnover in desire seems to be patterned on the supply turnover? Are we to deprive ourselves of the smell of toast and coffee in the morning on the grounds that it's an advertising cliché? Must I force myself to hold back a smile because my teeth are white and I'm standing in a doorway, and I'm afraid that I might look like a guy in a Hugo Boss commercial? Live with the advertising culture. Make do with it. Give up denouncing the spectacular aesthetics and dare instead to reappropriate the alienating forms of our contemporary culture. Accept the perfectly trendy outfit but refuse the transparency and negation of the self that it implies. Stop letting the brands we wear represent us, cease letting trends feel the times we're supposed to be living on our behalf (no more feeling by proxy), and make another body of experience for ourselves. Redefine the conditions of a "proximity to the self"…A proximity to the self that would not be synonymous with "authenticity" or withdrawal, but that would pose certain sine qua non conditions of access to the experience of situations other than those

that suggested by Ed with his silk shirt by Yohji Yamamoto pour Homme, cotton drawstring pants by Dries Van Noten, canvas slip-on sneakers by Vans, and Polo sport socks by Ralph Lauren, and Cindy with her pink-and-purple sleeveless dress by Missoni and black sandals by Versace. Find a common sensual ground with advertising models.

Here, depressed or trendy bodies, elsewhere, anonymous bodies. If the cinema has left "dream bodies" (fantasy aesthetics) to advertising and concentrated its attention on ordinary bodies (the aesthetics of characters representing a social group or a generation), if stars (the aesthetics of the inaccessible) have been replaced by symbolically anonymous figures (the aesthetics of proximity), does this signal the emergence of representations in step with our desires? Has desire shifted toward figures more in tune with our cellulite, our balding heads, our short legs, and our cold sores? What is the power of the slow motion shot of Nathalie Baye pedaling in *Sauve qui peut (la vie)* (Every Man for Himself/Slow Motion, Jean-Luc Godard) compared to the shapely legs of the hostesses on *Wheel of Fortune*? Liz's reply in *Marie-Claire* as a sign of the incapacity of movie images to deactivate the figures imposed by manufacturers, advertisers, and magazines: "I asked him pointblank whether he would rather be with someone who weighs 120 or 150 pounds. Looking embarrassed he said that he still prefers someone who weighs 120."[77] Who can truly say that s/he doesn't give a damn? Is there any way to counter the power of identification of game-show hostesses? Is there any way to escape the power of fascination of this dream body that confines the being to the position of an object of sexual desire? Is the projection of the being constituted as a subject conceivable? If film, television, and advertising production companies seldom offer us representations that accord with our aspirations and our ways of being, if the images they disseminate impose models and behaviors on us that do not correspond to our practices in life, how can we construct representations on our own scale? How can the distance that separates us from advertising models of existence be reduced? How can we reappropriate the modes and forms of representation underpinning an imaginary around which we do not necessarily feel like organizing our lives? And if our desires are affected by certain images, is some form of reappropriating name brands still possible?

[77] *MARIE-CLAIRE*, JULY 1997, P. 90.

1979. *Every Man for Himself/Slow Motion*: Full-face then in side view, switching between slow motion shots and freeze frames, Jean-Luc Godard dissects Nathalie Baye's movements as she bikes through the Swiss countryside. The bells of a flock of animals by the roadside give way to a series of piano notes. Dancing round a bend, hair blowing in the wind, Nathalie Baye flirts with a L'Oréal commercial. If we are lacking (seeking) representations, then accept to work on existing representations – not in utopic projections removed from the lived world (elsewhere) but in the sociocultural environment that is given to us (for an aesthetics of making do). How can we reduce the distance that separates us from advertising's amplified, magnified attitudes – like a sound system amplifies and magnifies the sound environment? Reappropriate representations that represent us (speak on our behalf). Embody a dream attitude even if you're wearing an old tightly-knitted green cardigan. Follow the flow of your body (hair blowing in the wind) and of space (the invitation to breathe), unbutton your wool jacket and let the flaps bounce to the rhythm of a body that starts dancing. Nathalie Baye in her cardigan as having accepted herself. The woman in the parking lot in her cardigan as having integrated the complexes generated by advertising aesthetics. The hair held back as self-closure. The hair blowing in the wind as a movement toward the landscape.

How can moments in life, which are always presented to us in terms of generalities, types, or categories, be personalized? Project yourself in a dream representation of the self without makeup, without complexes...and without leaving yourself behind. Go place yourself in the landscape. Blend the color of your clothes into the greenery and the movements of your body into the twists in the road. To feel good in the landscape, retain the body movements found in advertising images, not the accessories. The picture of a woman with a cigarette holder, walking haughtily and unsteadily on high wedge shoes down a street in a village (a perfect match to the cow in the living room in *L'Âge d'Or* by Luis Buñuel) as a way of retaining only the accessories found in advertising images (the inability to escape from behaviors derived from advertising aesthetics). Project ourselves by means of our own pedaling and at our own pace...A way of being close to nature...a way of living an advertising projection of well-being that meets a demand intrinsic to conditions of life in cities (the craving for nature and *authenticity*)...a sequence of your own movements...a way of appropriating certain advertising poses, poses usually decontextualized from forms of singular experience...Giorgio Agamben: "[Remove] the thin diaphragm that separates bad mediatized advertising from the perfect exteriority that communicates only

itself."[78] In the event, Nathalie Baye communicates only the perfect exteriority of her rhythm, her movements, her face, her hair, and the clothing she wears. Adhere to the image without letting it absorb you. When the point comes that the model of movement begins to restrict my body (pedaling at a rhythm that is not my own), that a certain size or a certain measurement requires work on my body (losing weight), that a particular brand of clothing reflects an attitude that is not mine, then I have reached the borderline between bad advertising and perfect exteriority. Flirt with models without reproducing them. Make do with the landscape you've got without dreaming of elsewhere. Make do with your buying power without going overboard. Make do with yourself without *making as if*. And especially stop forcing ourselves. Move with my body without seeking at all costs to slip into the pants I bought last winter. Just the Way We Are. "Because if instead of continuing to search for a proper identity in the already improper and senseless form of individuality, humans were to succeed in belonging to this impropriety as such, in making of the proper being-thus not an identity and an individual property but a singularity without identity, a common and absolutely exposed singularity [...], then they would for the first time enter into a community without presuppositions and without subjects, into a communication without the incommunicable."[79] Cut. Here, a way of feeling good about your body in the country without worrying too much about the way you look, because, at any rate, there is no pressure from outside...But what happens when I get back to the city? What if I like name-brand clothing?...What if I feel like going for a walk in Nikes and a Chevignon jacket...How can I subscribe to images that stir my imagination without letting myself be absorbed by them? How can I exhibit my own singularity in clothes that reflect precise communities of belonging and codified behaviors? Am I doomed to reproducing product-derived gestures, attitudes, and behaviors that will never be my own?

1991–1993. *Untitled*, New York series (Beat Streuli): Between photography and film, a slide projection of slow dissolving images depicting traits and gestures that constitute an attitude, a manner of crossing a street, a way of passing by in New York. The telephoto lens chases the oppressive clichés of cities and crowds to the background or pushes them outside the frame. We're in New York ...Happy youngsters emerge...Groups in jeans, T-shirts, and Nikes...In Nikes or in Reeboks...In Chevignon or in Benetton...Fleeting groups (brief sequences)

78 *OP. CIT., THE COMING COMMUNITY*, P. 65.
79 *IBID*.

forming haphazardly over the space of a few feet as individual paths intersect. Faces that do not yet bear the marks of an individual story (no wrinkles), anonymous faces that we glimpse in passing in the course of a day without knowing anything about them (no biography, no origin, no destination). Young people who do not seem to define themselves by an activity, a belief, a place, or a "culture" ...Multicultural youth, free to go where they wish, free from identity fantasies... Young people who appear to resemble what Giorgio Agamben termed "whatever singularities," "belonging to [their] impropriety as such, [...] making of [their] proper being-thus not an identity and an individual property but a singularity without identity, a common and absolutely exposed singularity."[80] Just the Way We Are. A slow dissolving of images that look a lot like those produced by the name brands that the people are wearing...Projected over nearly the whole exhibition wall – from floor to ceiling – these images assume the proportions of outdoor advertising (billboards)...Sublimation of the image...But is such a subliminated image on our scale? The people caught by Streuli's telephoto lens are shot in medium shots...Medium shots with which we are directly confronted... As if we were being asked to join the stream of passersby, to step into the city movement...The distance (indifference) between the exhibited bodies and our own seems to diminish. The representation space and the exhibition space are conflated...Walk right up to the image and step right in...The passerby, whose waist level is slightly above our own, becomes a projection of ourselves. A slow dissolving (a slow motion) that imparts a sensuality to images and bodies that would soon be lost (disappear) in the crowd at a normal speed...Identify in slow motion the tiny variations between one way of waiting for a light to turn green and another, with a Chevignon bag slung over the shoulder. Streuli's slow dissolving – slow fusion-substitution – works in a space (an emotion) made up of relative proximities and differences between anonymous attitudes, imperceptible at normal speed. Sensual slices of free-flowing movements. Effortless ways of being (athletic, sexy, or fun)...Moments suspended between leaving the office, slamming the car door, and keeping an appointment...The joy of proximity to the social body, of a fleeting and superficial relationship to others...A crowd of bodies exhibited outwardly, drawn out of indifference and retreat (the private space and the silent promiscuity). Streuli combines certain cinematographic procedures of engaging spectators in a narrative (the subjective angle, the progressive moving in, the slow motion) with behaviors inherent in our way of visiting

80 *IBID*.

81 *IBID*., P. 48.

exhibitions: The way we have of walking through the gallery paying scant attention to the works, stopping and trying to find where to stand in relation to the format and type of object or image, looking for the proper distance. Focalization. Here, a young woman is slowly walking out of the image in our direction…: Fiction of a meeting between us, fiction of a place left for us in the projection… near a man in Levi's…A man facing a garage door with his back to us. Focus on a certain intimacy with some people in the crowd. Images that call on our bodies more than our eyes…Fiction of a kinesthetic experience of arteries and the body movements they produce.

If the violence of the decibels produced by big cities contributes to undermining exchange and converting passersby into monads whose paths meet but who never listen to one another, then replace this mute promiscuity by a non verbalized proximity. In Streuli's installation, the proximity operates by adjusting the rhythm of the dissolving images to our own supposed respiratory rhythm. The appeal of a certain internal slowness. To internalize someone else's rhythm, that of a young woman carrying a child or of a teenager, with a bag of French fries in his hand, holding a conversation…In the event, the projections are edited together with sounds that do not offer an illustration or an equivalence. They provide instead a backdrop for our interiority and our drifting in the form of soliloquies in several languages; hushed sounds that keep coming back at the same slow pace as the overlapping images, the changes in shot distance, and so on. A pocket of interiority that quiets the exteriority, evacuating violence, stress, and other urban plights to become the guiding body of a movement toward others and the backdrop to our receptiveness. Walk along with someone, for the time of the sequence, just up to the red light on the next corner. Proximity of breathing…A community of silent bodies that do not speak to each other. Projected desire. An aesthetics of being in step with others for the time it takes to get the keys out of my pocket or wait for the light to turn green. To wit, a projection of dissolving images that brings us closer to a dreamed, but not realized, way of being, exhibited in advertisements. Move in the direction of advertising images but draw bodies out of the abstraction in which advertising procedures fix them. Give them fluidity (actualize their presence) by moving from one moment (position) to another at a pace that gives us time to grasp each movement without arresting it…A fluidity accentuated by the slide's nearly immaterial quality (no graininess and no support other than the wall). A concatenation of instants that does not favor a particular moment, feature, story, or unicity. (Giorgio Agamben: "The task of the portrait is grasping a unicity."[81]) A concatenation of instants

that removes the people from their personal background, from what they are doing, from why they are where they are at the point in time when they pass in front of the camera lens. People about whom we know nothing more than what we see at the moment when the camera catches them. Whence a sense of another duration, a frame of time unrelated to what's beyond the frame (what comes before or after the picture)…The passersby projected in Streuli's work are not embedded in fragments (excerpts) of a time that surpasses them. Their manner of being produces a duration of its own…A manner not of getting to the office or going home but simply of passing by. A manner of passing by that produces its own path…The projection of dissolving images as formulating a momentary release from timetables, a moment in which each passerby, each being, whom we come upon in the picture seems to be "continually engendered from its own manner," to borrow Agamben's terms.[82] To wit, an advertising dream come true: Escape from work time and the rhythm it imposes, slow down the stepped-up pace of body movements that work imposes. Step out of your own day.

Let an advertising moment appeal to you without letting it dispossess you of your body and attitude…1997–99. Deauville. *Téèfun* (Claude Closky): Every fifteen minutes, in a covered Olympic-size pool, a familiar jingle. A jingle reiterated immediately thereafter and followed by silence…for a quarter of an hour. A familiar jingle that announces the start and close of commercial breaks on TF1, one of France's major TV networks whose name is phonetically transcribed in the title of the piece, but instead of framing different forms of standardized behaviors, here it is used to frame our way of climbing out of the pool or having a refreshment. Two brief musical sounds to underscore a leisure moment (activity) …A sound installation in a public space…A sound piece (an audio CD), conceived for a museum or gallery but moved to a place of leisure and relaxation …Temporarily step out of the separate sphere of art (the exhibition space) and put an aesthetic proposal to the test of the object with which it is dealing and on which it draws. Articulate a sound taken from mediatized culture with behaviors and situations specific to the context to which it refers. A jingle that, much to the surprise of the people at the pool, suddenly and briefly (for a few seconds) fills the whole space. A pool that acts as an echo chamber…An architecture that envelops the pool's blue tones…A musical note that comes out of nowhere… A note coming from nowhere that bursts in on our activities…A sensual note

82 *IBID.*, P. 27.

that instantly transcends the voices and screams…the movements and bodies …A few seconds of suspense that do not project us elsewhere, but that impart to here and now a dimension that we thought, until this very moment, pertained to an abstract field, to an advertising elsewhere, to the time of a break between the Saturday night movie and the commercials…When mental pictures become reality…

And then, before we realize what we've heard…a new musical note comes…The repetition of the jingle in the seconds that follow as the moment of realization, the moment when we become conscious that we really did hear the familiar jingle that we hear every night on TV…A jingle that frames slow motion images of people staged in spontaneous movements – filmed in slow motion and choreographed…A jingle that is telling us: You are like this. Becoming aware of what we are hearing as a moment of smooth, sensual conscientization (with no critical dimension) of the manner that we practice an activity of relaxation, played and replayed on TV. At this stage in the swim, a question: Does my way of having a drink at the refreshment stand look like a Pepsi or Coke commercial? Worse: With my teeth as white as they are, can I allow myself to smile when I climb out of the pool, knowing that it might look like an Aquafresh commercial? And besides, to whom does my smile pertain? To the fun I've been having swimming sidestroke or to Aquafresh? When advertising images become reality…A good laugh as a response and a good fifteen minutes to resume my normal activities. Claude Closky's installation confronted us with a choice: Get out of the pool and have fun watching others suddenly embodying advertising postures or enjoy the immense, unexpected pleasure of letting ourselves go to this sound installation…When a TV jingle that nobody notices turns into a stasis of sensuality…For once: Just Do It…We are all images.

SILENCE AND IMAGES (WHAT TURNS MEN ON?)
If we resemble advertising images to such a point, if our gestures are less and less our own: find our way out of images. 1979. *Every Man for Himself/Slow Motion* (Jean-Luc Godard): *1. The Imaginary*. End of the bike ride through the countryside. Conversation between Nathalie Baye and a photographer. He touches her hair: "You still have such beautifully black hair." Baye: "You were the one who was always griping about systems of heritage and now you're repeating your father's gestures." How can I prevent him from taking the liberty of touching me when I look like an advertising figure? Can the presentation of the self in an advertising figuration that sets me up as an object of masculine desire

be reconciled with the need to constitute the self as subject? Photographer: "It's true. At first it felt really weird to take over my father's business. It was horrible… What an end to the revolution!…Now I don't mind. At least, there's the landscape here." She's talking to him about his way of arrogating to himself the right to touch her and he thinks she's talking about his work. She's talking about his way of addressing a woman as if she were an image, and he doesn't hear her. She relates the gesture to the body. He relates it to work. To wit, the staging of an undesirable mix: the image of a woman (the object of desire) and the words of a man (the subject of desire). A mix that reveals two modes of self-construction: building the self on an image of well-being and seduction (the feminine version) and building the self on a professional image (the masculine version). If women are images, if your way of blending into the landscape makes it even harder to constitute yourself as a subject, then, in order to be heard, you'll have to get your figure to stand out against the background where the masculine gaze has grown accustomed to seeing it.

A look back at the origins of the instrumentalization of the feminine body in advertising aesthetics, and more especially at the binding of the feminine body to the landscape (the movement arrested in space). Gilles Deleuze and Félix Guattari about *Swann's Love*: "The face of Odette with her broad white or yellow cheeks, and her eyes as black holes. But this face continually refers back to other things, also arrayed on the wall. That is Swann's aestheticism, his amateurism: A thing must always recall something else, in a network of interpretations under the sign of the signifier. A face refers back to a landscape. A face must 'recall' a painting, or a fragment of a painting. A piece of music must let fall a little phrase that connects with Odette's face, to the point that the little phrase becomes only a signal. The white wall becomes populous, the black holes are arrayed. This entire mechanism of signifiance, with its referral of interpretations, prepares the way for the second, passional subjective, moment, during which Swann's jealousy, querulous delusion, and erotomania develop. Now Odette's face races down a line hurtling toward a single black hole, that of Swann's Passion."[83] Swann's aestheticism as evidencing the reduction of feminine identity to landscape in the Western imagination. Years ago in novels and paintings, nowadays in advertising (from figuring masculine desire to publicizing this same desire)…1965–1974. *Untitled (Isn't it nice…)*, *Body Beautiful,* or *Beauty Knows No Pain* series (Martha Rosler). A full page in a magazine: "Isn't it nice to feel feminine again?" Consider

83 *OP. CIT., CAPITALISM AND SCHIZOPHRENIA*, PP. 185-186.

an advertising concept of emancipation. In illustration of this subject, one foot in the water, the other on firm ground, a young brunette is standing proudly facing the camera. The very picture of well-being…A color photo of a stream flowing between two dry banks and of a woman who is integrated into landscape. Her negligee is see-through, her legs perfectly hair-free. A very short negligee and legs spread sufficiently wide apart for the libido to rush into the opening. A libido (a view) that follows the river bed. The river bed being the slit in the landscape. Superimposed on this color picture of well-being, two pieces of the body in black and white: a bushy pubis between her thighs and breasts…A pubis and breasts that no longer need to be imagined and that show through the polyester transparency…The face of a model with her broad white or pink cheeks, and her breasts as black holes. But this face and this body continually refer back to other things, also arrayed on the wall. That is the consumer's aestheticism, his amateurism: A thing must always recall something else, in a network of inter-pretations under the sign of the signifier. A face and a body refer back to a land-scape. A face and a body must 'recall' a painting or a fragment of a painting. A piece of music must let fall a little phrase that connects with the model's face and body, to the point that the little phrase becomes only a signal. The white wall becomes populous, the black holes are arrayed. This entire mechanism of significance, with its referral of interpretations, prepares the way for the second, passional subjective, moment, during which the consumer's desire, arousal, and erotomania develop. Now the model's face and body race down a line hurtling toward a single black hole, that of the urge to screw her. Giorgio Agamben: "In the early 1970s there was an advertisement shown in Paris movie theaters that promoted a well-known brand of French stockings, 'Dim' stockings. It showed a group of young women dancing together. [...] that calculated asymmetry of the movement of long legs sheathed in the same inexpensive commodity, that slight disjunction between the gestures, wafted over the audience a promise of happiness unequivocally related to the human body."[84] If the surface of the advertising image becomes etched inside us in the form of a promise of happi-ness, its composition is unequivocally related to sex. Martha Rosler's photo-montages reveal the precise moment at which, in the reading of the advertising image, we discover that the model's pose calls for an erotized use of the prod-uct proposed. A moment when the reader's body does violence to the body that he's about to turn over. A moment when masculine culture colonizes the body of the desired woman. The model's decidedly photographic pose as the symbol

84 OP. CIT., THE COMING COMMUNITY, P. 47.

of a body movement designed and directed exclusively by the male eye. Reconstruct the form of desire that links body and eye. Gender war as project.

To fight against this colonization of the feminine body, a look at two counter-models (two militant looks). *Every Man for Himself/Slow Motion* (Jean-Luc Godard): In front of a movie theater, a couple deciding whether to go see a film. The woman has straight, greasy hair and is wearing a worn-out leather jacket: "I'll take my panties off so you can touch me in the dark." The man's wearing a faded corduroy jacket, a creased white shirt with a wide collar folded down over a dull green sweater, round glasses, and a cap. He's reading a magazine: "Do you think they'll show film news?" Woman: "I guess so." Man: "I think you can keep your panties on." Woman: "Don't you realize I'm trying to build a real relationship between us?" Man: "You can't build it with a hammer." What can she do with the will for desire that inhabits her? What can she invent that could compete with a good skin flick? What turns men on? Is the lack of desire related to a lack of advertising images of the self? Can the look that doesn't fit into available advertising representations structurally explain such a deficit of imagination? Can we live without representations? Refuse to create a look for yourself. Refuse to integrate the models of self-presentation. Does the desire to build a being-together freed from the figures imposed by the society of the spectacle have a chance against the industry that produces images of desire and behaviors (advertising and film)? Are we condemned to choosing between resignation (the man with the faded corduroy jacket) and the embodiment of advertising and movie figures that structure the imaginary of most everyone (Nathalie Baye)? How to get your rocks off when you're wearing a loose sweater knitted following a pattern in *Family Circle Easy Knitting Magazine* as the point at issue and as a challenge to the society that produces images of desire. 2. *The Fear*. Back to a couple that get along better. Nathalie Baye throws herself in slow motion into Jacques Dutronc's arms. Face beaming. Hair, soft and shiny…An expression of joy that looks like an advertising picture in a perfume commercial. Marguerite Duras's voice offscreen: "The silence that is always there around a text…there, I would say, not in the text but in the reading of it…well it is speech that can bring it out, speech that creates it. If there is such a thing as a woman's place…I'm not sure there is…but if so, I think it must be somewhere not far from this…a place of childhood…well…much closer to childhood than a man's place…men are more childish than women, but there is less childhood in them." A child who throws herself in the arms of her man. A child who suddenly gets upset because her man has made a decision that was hers to make, not his…A child who can't

understand "why [he] keep[s] on making decisions for [her]…why [he] keep[s] on thinking for [her]."…You talk, I listen. Write your own role (your own speech) or submit to your condition as an image.

1982. *Identification of a Woman* (Michelangelo Antonioni): Tomas Milian and Daniela Silverio walk by the window of a boutique where a young woman is fitting underpants on a masculine dummy, a dummy in the form of a cardboard silhouette with a photo pasted on it. A bit of Italian popular music. A long instrumental. A binary rhythm, akin to those used in skin films. The salesgirl smiles and gives the couple a teasing look as she slowly slips the palm of her hand to the protuberance formed by the genitals of her cardboard man. The shop window as a space of projection of desires. The dummy as a stud. The salesgirl as an agent of activating desires proposed by the market (the invitation to consume images). Voyeurism as a behavior specific to the society of supply. Reverse angle. Daniela: "Do you see that girl? Two days ago I was riding a motorcycle with a friend and we had a flat tire. There was a car nearby. I approached to ask for a screwdriver. This girl was inside the car, completely naked with a guy…You see. She recognizes me." Reverse the relationship of possession of the body reduced to its image (masculine desire). Take possession of the image of a man reduced to a body. Consume the image. Are we to see in the salesgirl's suggestive pose an element of reflection for a feminine form of pornography or merely the staging of a reproduction of the masculine model of behavior (the inherited gesture evoked by Nathalie Baye)? Cut. The porn-type instrumental music intensifies. On the bed, flat on her stomach, her left hand violently clenching the sheet, Daniela lets the spasms from Tomas's caresses run through her body. Spasms that take her to a mirror beside the bed: Tomas's hand pursues his work. Daniela abandons her vulva to Tomas but turns her back to him (away from his presence and from his image), grabs the mirror, moves her hand over her own reflection and her tongue over her lips…and climaxes right up against her own image. End of the orgasm. Close-up of her face at rest in three-quarters view. Bluish lighting. The nape of her neck against the wall. Her hair sleek with perspiration. A face whose features are patterned on advertising models – from the contours of the eye to her hairstyle. If Tomas possessed the feminine body, if Daniela's pleasure was derived from a masculine gesture, her desire was directed exclusively at the reflection of her own image…An image that turns to an advertising blue and a more and more energetic masturbation that seems to be reproducing the gestures of the pornographic aesthetics that the instrumental music evokes (taking possession of her sex organs as an echo of the salesgirl's

gesture). The porn rhythm as the rhythm of the self. The magazine image as the image of the self. To whom then do these gestures belong? To the porn industry or to Tomas? And this face? To *Vogue* or to Daniela? What is he thinking about? His gesture or her? What is she thinking about? Him or another woman? Appeasing fantasies available on the market (the remake of advertising and pornographic representations) as a way of avoiding one's own "precarious existence." The use of pornographic images as an emotion booster. Turn away from the "whatever body" (Daniela's turned back) and accept the way images work on your own libido.

How can I have sexual pleasure here and now (the present) with another (you) in a society whose imaginary is founded on the promise of happiness (the future announced by advertising) and on the projection of ideal figures (the models)? Think about culture so as to get more pleasure from you. Instrumentalize your body (the gesture) and finish myself off on an image (the projection). The concentration on oneself – on a gesture or an image – versus an exchange of looks. Question: Can culture clones look at each other while they're making love? Observation: Lovers hardly look at one another anymore…and neither do our two unstylish militant figures in front of the movie theater (*Every Man for Himself/ Slow Motion*). The exchange of looks is now situated between the consumer (the couple in front of the shop window) and the eroticized model (the salesgirl and her cardboard dummy), between a customer who has a craving (arousal) and an image that attracts h/er eye (advertising strategy). The reproduction of the image as a love strategy. Finding a way out of the logic of instrumentalization of bodies and reproduction of images as the point at issue. Giorgio Agamben: "To appropriate the historic transformations of human nature that capitalism wants to limit to the spectacle, to link together image and body in a space where they can no longer be separated, and thus to forge the whatever body, whose *physis* is resemblance – this is the good that humanity must learn how to wrest from commodities in their decline. Advertising and pornography, which escort the commodity to the grave like hired mourners, are the unknowing midwives of this new body of humanity."[85]

85 *IBID*., P. 50.

DANCING WITH THE LAW
(UNITED STRATEGIES OF ALIENATION)

OFFSTAGE LAWS AND THE REDUCTION OF THOUGHT TIME (STEPPED-UP RATES AS A MODE OF EXECUTION OF THE SUBJECT)

1990. *Shit in Your Hat – Head on a Chair* (Bruce Nauman): In a dim room, a sound track…Hanging from the ceiling, nearly in the middle of the room, a screen and a chair. On the chair, a wax-cast head…a green head. Offstage voice: "Put your hat on the table. Put your head on your hat. Put your hand on your head with your head on your hat." A neutral, calm, and steady voice…Brief, simple instructions…A steady, staccato pace. A tone that calls for a mechanical execution. On the screen, an androgynous mime obediently and mechanically executes the instructions. No sign of suffering or humiliation on h/er face as s/he successively executes the orders "shit in your hat," "show me your hat," and then "put your hat on your head." Contrast between the nature of the instructions and the care taken in executing them. The willingness to submit is more astounding than the nature of the debasement. To make a gift of one's body to power. 1975. *Salo or The 120 Days of Sodom* (Pier Paolo Pasolini): The nature of the ritual and the debasement of the victims imprisoned in the Republic of Salo in 1944 is comparable to the mechanism staged by Nauman, but the torturers (the power) have a name and a face: a duke, a bishop, a judge, and a banker. Gilles Deleuze and Félix Guattari: "The face or body of the despot or god has something like a counterbody: the body of the tortured, or better, of the excluded."[86] *Shit in Your Hat – Head on a Chair*: The body of the tortured is no longer a counterbody because the despot and God were divested of their power long ago. The orders come from somewhere else. Their place of enunciation is offstage. Out of sight. An offscreen voice. And if the body of the tortured still has present-day relevance, the exercise of power has become more cerebral: It no longer leaves a mark on the body. The body reduced to slavery (to nudity) by political, religious, legislative, or economic powers, as shown in *Salo or The 120 Days of Sodom*, has given way to a body employed for the execution of precise tasks in specific working garments (the mime's outfit). The face has lost the marks of torture. Emancipation has powdered over its traits. A white face ready for use. Power (the offstage voice) can write on it, and impose its desires without leaving the mime the possibility of representing what s/he desires. The mime is no longer master of h/er own gestures. S/he enacts words that are not h/er own. H/er androgynous body acts out a statement (a desire) of which s/he is the instrument but not the subject. A body dispossessed of gender and desires.

86 *OP. CIT., CAPITALISM AND SCHIZOPHRENIA*, P. 115.

1935. *Modern Times* (Charlie Chaplin). The division of labor deactivates the range of possible body functions in order to employ one and one alone. The production line dispossesses Chaplin of his body in order to specialize it in bolt-tightening. Take on the form of your function and live to the rhythm of its execution. The reduction of the body to a function is only possible by the stepped-up work rate imposed by the factory manager whose face appears on the section leader's control screen: "Workshop 21: Maximum speed." The speed of task execution takes possession of the body. The reduction of break time turns the subject into an economic tool. Longer pauses between tightening bolts would have enabled Chaplin to gain consciousness of what an increase in productivity really means (the unionist phase). Slower, more varied movements would have enabled him to regain awareness and possession of his body (access to leisure activities). The speed of task execution and the lack of pauses in between prevent the mime from gaining consciousness. Past a certain speed of enunciation (of task execution), the absurdity and abjection of the orders are no longer legible. Stepped-up rates as a mode of execution of the subject. For Chaplin, the reason behind the dispossession of his self has a face, the face of the boss appearing on the section leader's screen. If "the face is a veritable megaphone," if "a language is always embedded in the faces that announce its statements and ballast them in relation to the signifiers in progress and subjects concerned,"[87] what are we to make of instructions that come from nowhere? For the mime, the reason behind the dispossession of his self has no face. The offstage law has taken the place of the master's law.

The division of functions, the need to stick to the work rate (regardless of the finished quality), and the spread of robotics have made activities (workstations) increasingly abstract. Taylorism has undermined the unique, close relationship between the making and what's made by depriving workers of the possibility of signing their own personal savoir faire and apprehending the totality of the product. By eliminating the human hand, or rather by subjecting it to technology, robotics has eliminated the connection to the world and to a certain form of acting on – and even controlling – the world (sculpting the material world, leaving one's imprint, style). Objectless work. But if we are no longer capable of appropriating the product of our work, are we still in a position to appropriate (our) working time? How can a repeated gesture at work be translated into experience? Fiction: If the work rates imposed on us dispossess us of our gestures,

87 *IBID.*, P. 179.

can we project ourselves in an image where we *would be* in work? Can we represent ourselves in the process of being in the work world?

1979. *Every Man for Himself/Slow Motion* (Jean-Luc Godard): Dilate the time of a function's execution (the movements of a craftsman at work) in a slow motion shot to bring the rhythm of production (the rate) back in step with the rhythm of the body (the beat). Frame hands working and stretch out the time of production to substitute the rhythm of a gesture's enunciation (the consciousness) for the rhythm of its performance. Mix the emergence of a consciousness with the performance of a task. Sitting on a window ledge, Nathalie Baye, thoughtful: "Life – a rushed movement, an arm dropping, a slowed step, a fresh breath of irregularity, a false move, everything that, in this ridiculous patch of resistance against the empty eternity that constitutes the workstation, testifies that there are still events, no matter how minute, that there is still time, no matter how monstrously stretched out…The clumsy or unneeded movement, the sudden haste, the hand trying a second time, the wincing, the falling behind, everything that is silently screaming inside each man on the production line 'I am not a machine,' – all this is life clinging on." Stepping up work rates as a mode of execution of the subject. Economic needs as grounds for converting the modes of symbolic and anthropological inscription of the individual into modes of instrumentalization (the dispossession of the self). Dilating the time of gestures amounts to distending the connection (the contract) between a series of movements and their instrumentalization (the employment). A monstrously distended breach in work rates, a dilation of work conditions in which consciousness can be constructed. If it is not possible to reduce the distance between the making and what is made, then bring out the feeling that goes with a gesture whose product and meaning escape our control (economic needs). The effort dissolves in the sensuality of the slow motion (the illusion). If stepped-up rates automate gestures (taking them away from workers), then keep your eye out for places and moments – monstrously dilated by slow motion – where life is still clinging on. Go bike-riding in the country (the slow motion shot of Nathalie Baye pedaling) or practice a sport (the slow motion shot of Jacques Dutronc's daughter warming up at the stadium). But adhering to this sole technique of representation (slow motion) – a highly appreciated technique in advertising and pornographic aesthetics in the eighties – amounts to aestheticizing a spectacular logic that consists in detaching the subject from the historical field and definitively cutting the subject off from h/er symbolic and anthropological mode of inscription (the workstation). Life can't be captured with close-ups. Liberating feelings does not suffice when it

comes to reappropriating the gestures and movements of which we've been dispossessed (the technique). Jacques Dutronc to Nathalie Baye: "You think that all you need to do to change your life is buy a bike and go to the mountains? [...] You and your bike...you say that it's movements but it's only words." Godard: Creating a tension between two types of motion, that of the body imposing its rhythm on the machine (Nathalie Baye pedaling on a mountain road) and that of the workstation imposing its rhythm on the body (slow motion shot of the movements of a craftsman at work). Leisure time versus working hours. Introduce a disjunction in the speed of their respective development: normal speed and slow motion versus stepped-up rates.

BANKS, EMPLOYERS, AND EMPLOYEES (THE SYSTEM SCREWS THE WORKFORCE)
Representing individuals at work requires representing the conditions that employ them (the contract of instrumentalization). Sitting behind his desk, an employer organizes a pornography chain with himself as both the starting point and the end. The functioning of the chain depends entirely on his instructions.

The boss: "Nicole, lie down on your back...Right there. Thierry, you put your thing in her mouth. Isabelle, come over here...Bend over..."
The assistant: "You want me to lick her ass?"
Boss: "I didn't say anything to you yet..."
Assistant: "Sorry, boss."
Boss to Isabelle: "You'll put lipstick on me when he licks your ass. And Thierry, you'll lick her ass when the other sucks you off...And you, you'll suck whenever I touch your tits with my foot. Now let's give it a try...Okay, the image is fine, now let's work on the sound. When I touch your tits with my foot, you say 'Oww!' and you suck. Go ahead: 'Oww!' Now you Thierry, when she sucks, say 'Ahh' and lick her ass. Let's go:...'Oww!'...'Ahh'...and you, when he eats your cunt, you go 'Oooh!'. And don't answer back if he does anything uncalled for. Go ahead Thierry: 'Oooh.' And after, put a bit of lipstick on him, just once. And if you see me smiling at you, then you kiss me. Okay everyone, let's go:...'Oww!'...'Ahh!' ...'Oooh!'..."

Here, the bodies are employed to produce the supply (the pleasure) to which they are chained. Their positions recreate the meaning and the symbolic chain of command that bind economic agents to their directives. 1935–1979. The employed body lost its integrity because the production line employed only one

172

of its possible functions. 1979. Even though gestures in this closed-circuit production system have only a minimal place (the postindustrial society), other functions separated from the body are employed (the service sector): lick, suck, penetrate, put a foot on a breast, etc. All functions are in the nature of the market, each and every one of them can be invented and justified to meet the supply turnover rate. And when the satisfaction of the supply does not succeed in bringing out a distinct functional hierarchy in the company, when the employer's directives are the same as the market's: Invent new functions, new positions, and new modes of functioning (personnel management) to justify the exercise of a power about which we have doubts. If the law of supply and demand has replaced employers, if the economic machine has cut off the Prince's head, its agents still need to represent, and even to incarnate the power exerted upon them (to attach a face to the command). Thus, the last link in the chain of command, Isabelle Huppert (at the bottom of the ladder), is instructed to "put lipstick" on the grim, pale face of the boss (the head of the department) as if he needed to produce an image of his own power ("Okay, the image's fine," he concludes during the preparations). The arrangement of the bodies and the connection to their function (specialization) produce the meaning of work (to produce the supply – the pleasure – to which the bodies are chained and to produce an image of power on the company scale). The meaning of work moves through the employees without stopping in them – for them. The function contributes to the construction of a meaning separated from those who are constructing it (the instrumentalization). Here, as in *Shit in Your Hat – Head on a Chair*, the absurdity of the orders reveals the sheer exercise of power over bodies and their reduction to things. Bodies employed in the service of an offstage law and dispossessed of their free will. Pasolini saw *Salo* as a "visionary representation which, through the form of sexual relations, becomes a metaphor for the relationship between power and subject. The sadistic relationship is nothing but the commodification of the body, its reduction to a thing."[88] Today, the abstract economic *machine* has cut off the Prince's head (the unique subject of enunciation). Power is no longer localizable (the offstage law) because it is fragmented and diluted in a tangle of networks and interests.

If the boss is no longer responsible for the subject's rhythm and mode of execution, if he is nothing but one more link in the economic chain: then widen the

88 PIER PAOLO PASOLINI, *UNE VIE FUTURE*, (ED. ASSOCIAZIONE 'FONDO P. P. PASOLINI'/ENTE AUTONOMO GESTIONE CINEMA, ROME, 1987), P. 308.

circle of responsibilities. Leave the company (resign) and find yourself like Isabelle Huppert in the parking lot of a supermarket (the link in the chain to which the company is bound), your head pushed and held inside the window of a car. Man inside car: "You wanna be independent? [...] Get this straight. Nobody's independent. Repeat after me. Nobody's independent. Not prostitutes, not typists, repeat after me [...] Not rich women, not duchesses, not waitresses [...], not tennis champions [...] Only banks are independent." Submit to financial laws. If submission to the exercise of a power is ineluctable, then earn a little "being" for yourself by becoming in your turn the employer of someone else's body who will take some of the workload from you (division of labor). Submission before, emancipation after. Find someone below you. Fiction: Isabelle's sister, who needs thirty thousand francs to go to the West Indies, offers Isabelle her services as a prostitute. After making sure that her sister meets customer requirements (the job interview), Isabelle proposes a "fifty-fifty" contract. Continue submitting to the chain of command while giving commands of your own and earning a profit from it. Reproduce the pornographic chain of command. Here, sharing submission time brings with it the responsibility of passing on commands (we are always someone's employee). The boss as model. The exercise of power as added value (the success). Here, translating your position in the economic chain of command into experience involves reproducing the mode of your own body's instrumentalization. Pass on what you endure. Transmitting gestures and experience gives way to transmitting techniques of exercising power. Replay the role of your superior on the chain of command (project yourself) by having your work played by your underling (the representation).

THE LAW OF SUPPLY AND BONDAGE (ALL I WANT IS PROGRAMMING)
And after work, when the body is no longer a counterbody (a martyr or a slave), when it is no longer a mechanical arm in a production line (the blue-collar worker) or a corporate instrument (the employee subjected to h/er hierarchy), it regains possession of its senses and can at last enjoy the products that were forbidden until then (the consumer). 1985. *Porno Chain* (Bruce Nauman): On a wall, seven neon silhouettes interlocked in a horizontal chain, practicing all possible categories of sexual intercourse. The commodified bodies are dissociated from the instructions that fix their place and function, but anyone who does not feed into the chain of supply and demand, and who is not fed by it, is invisible. Produce and reproduce pleasure, or be turned off. The consumer logic. *Every Man for Himself/SlowMotion*: In the pornographic chain organized by the boss, each movement triggers another movement (the production of the supply), but

it also provokes a reaction (the consumption of the supply). "Oww!" Distributing a supply requires nothing other than reflexes or programmed behavior (the buying reflex). The law of supply and demand produces nothing but consumer habits and reflexes that negate the possibility of individualizing experience. It offers an array of possible combinations and assemblages of goods and services. The economic agents who are subjected to it (boss, employee, and consumer) perform a text dictated by the market.

Words of power and their modes of structuring move in a single direction through the bodies of the mime, the employees, and the neon silhouettes. They move around and flicker inside us until we are nothing but desire for the product. 1985. *Hanged Man* (Bruce Nauman): in a small room, on the rear wall, a neon stick figure of a hanged man…The life and death of a man suspended to norms, in three phases: waiting for the message (the gallows light up), reading the message (the man lights up), and consumption (erection, product use, orgasm). The entire body of our hanged man is occupied by the message. The mass dissemination of the supply goes together with a uniformization of the demanders. The neon figures refer less to individuals than to types. Consumption disfigures (They're all platinum blonds!) and consumers assume the form of what they consume. Statistics negate interiority and individuation. Distribution requires nothing other than reflexes or programmed behavior. The mechanical nature of desiring has replaced the mechanical nature of producing (*Modern Times*). The neon-man has no individual features because the economic machine produces nothing but consumer habits and reflexes which negate the possibility of individualizing experience. It offers an array of possible combinations and assemblages of goods and services. Let yourself be persuaded. Somewhere else, in another room, a slogan is flashing on and off: *Normal Desires*. A slogan and a neon sign that substantiate and trivialize the extent to which man is attached to products. The man who is not turned on (inhabited by products) is invisible. The eye-catching, flashy colors of ads, the rhythm of fashion models, the absence of causes and reasons to the profit of effects alone (Tracy Lord moaning as soon as she meets someone) – all this puts the demander in the position of immediate consumption. 1985. *Masturbating Man, Masturbating Woman*: Two flashing neon silhouettes masturbating (turning each other on) like mad. The neon as conflating the commercialized model with the model economic agent. The impact of the message on one person becomes the message that will turn on another neon-person. To be turned on by (get off on) a product or not to be. Burn to get a product or burn out – without having experienced the pleasure of it. In Nauman's

neon silhouettes, only the actions light up (the active, working population): getting a hard-on and marching in single file in *Five Marching Men* (1985)…saluting, sucking, killing, and committing suicide in *Sex and Death by Murder* (1985). These neons concatenate states, positions, reactions, and effects with no links or pauses for reflecting anything besides the demand (the movement of economic growth). We have entered the age of behavioral programming and impulse management. Behaviors desired by instinct (march, fuck, kill) and programmed by societies of supply and demand. Giorgio Agamben: "The process of technologization, instead of materially investing the body, was aimed at the construction of a separate sphere that had practically no point of contact with it: What was technologized was not the body, but its image. Thus the glorious body of advertising has become the mask behind which the fragile, slight human body continues its precarious existence."[89] The flashing of the neons and the concatenation of positions as magnifying the process of technologization of the body's image. The sexualization and spectacularization of bodies without organs (sensations that have left us and gone to find the vitality inside you through advertising). Technologization and commodification as a process of devitalization of bodies. Fiction: Frustrated spectators and dream neons…Glorious neons (Five foot ten for the ones that are saluting, sucking, killing, and committing suicide, six feet for the five that are marching) before which the spectators continue their precarious existence. Spectators who have impulses…Impulses that they cannot satisfy but which they can channel into henceforth authorized representations. Flashing lights and a hypnotic repetition of fantasy positions (the sex-shop aesthetics) to catch the eye of spectators looking for standard types of satisfaction (up my ass, in my mouth, etc.) Unexpected situations that never come to pass (stay tuned for the next episode)…Expected situations that are replayed continuously. The looping of different positions of the silhouettes (the repetition of sameness) as a fictive device for heightening an expected moment in the story (the moment of the murder, the moment when they fuck, etc.). A stabilization and a hammering out of typical situations to check the appearance of other situations and other possibilities…Programming will not put up with specific demands. A technological censure (the unprogrammed situations and possibilities) that imposes standard representations on spectator consciousness. Representations that allow us to satisfy our basic fantasies. When politics takes care of channeling our impulses (do this here and not somewhere else)…Channeling to facilitate governing…Supply places for unwinding (pornography, sports, thrillers,

89 *OP. CIT., THE COMING COMMUNITY*, P. 50.

etc.) to facilitate the subjection of bodies that must be in good shape and in a good mood during working hours. The flashing as a spectacularization of a situation and as a solution to our incapacity to experience representations without stage effects...A spectacularization that focuses our attention on moments removed from any narrative or temporal context beyond what we are seeing – the negation of what precedes (reasons) and what follows (consequences). The splendor of an everlasting present. An eye-catching present flashing and displaying itself nonstop to the detriment of a past (the sequence of events that constitute a biography) and a future (the projection of the self). A flashing that displays more of itself than of the situation. The speed of flashing and phase assembling as events. Stay put and content yourself with the clashing of pictures (the zapping). Cease being the subject of your desires, but be able to appease them immediately. Immediate consumption, right away, now. Fascination screen. The movement from picture to picture more than the pictures. Remote Control.

1998. *Fruité* (Claude Closky): In color and in video-projection over the entire wall, a ten-minute looped montage of adjectives, superlatives, and some consumer products emerging from a dark ground. Adjectives, superlatives, and photos of products taken out of magazines and out of their original context...Words emerging in their original colors and typography but without the picture of the products or articles to which they refer...products emerging without the page in the magazine where they came from...Consider a concatenation of elements rising out of the depths of the screen, spinning and swelling – gaining in legibility –, swooping down on us and disappearing at the four corners of the dark screen...As if they were running through us...: "Fruity...precious...healthy... clear...easy..." A bottle of milk: "nature..." A hypnotic, radical concatenation... A bottle of champagne spinning like a top...a bottle that bears in on us until only its label is legible: "dry..." A "dry" that gives way to a "refreshing" that vanishes in turn... "balanced...revitalizing...firm...lasting...anti-slackening...ultra-reliable ...dual action...advanced...3 in 1 cream...shiny, intense, sassy, awesome..." A Gervais *Extreme* ice cream cone: "exquisite...bright...radiant...alluring..." Descriptive terms and superlatives hammering at TV-viewer consciousness...A concatenation of advertising typographies and colors fixing in our consciousness terms in the imaginary around which our lives are structured...A compendium of contemporary life in the world's most technologically advanced countries... A generic market indicator related not to products but to the attitudes required by the market economy..."majestic...enchanting...personalized..." Interlocked

elements – one appearing as the other disappears – that never leave the screen completely blank (a free interval)...An interlocking that leaves no room for choice (the time it takes to decide)...no room for other elements – elements belonging to another register –, no room for anything besides these commonplace terms that invade our mental space (the way the elements swoop down on us as formulating a method of dissemination from which we cannot escape)...no room to breathe. "Ultra-shine...super-rich..." A magazine cover: *Glamour*. A random concatenation. The method of random concatenation as an ironic reference to the programming principle. A programming whose reasons and motives elude us, but that excludes any terms and referents that do not fit into the register of dynamism, exuberance, and vitality (the youthful)..."Sublime...scintillating... sensual...super-simple...new...toning...anti-wrinkles..." A programming that shuns pauses, critical distance, idle time, and anything old (old age?)...A programming that requires a reflex (yes, now, right away), a programming that requires on-the-spot consumption under pain of being excluded...Dynamism (the rapid concatenation of elements) versus stagnation (zero growth)...A shampoo: "newer...truer...fuller...touchable...luxurious." A face cream: "energizing... hydrating...smoothing...exhilarating...anti-stress...ageproof...dramatic radiance." A tube...A tube of toothpaste? A tube of glue?: "universal." A disk: "High Density ...double-sided...reliability..." A videotape: "Durable...for daily use...excellent picture quality...Outstanding performance..." A market indicator of an existence punctuated by more and more superlatives (the myth of intensity) and fewer and fewer objects...Who cares about what, when and where! What matters is how intense! Whatever, as long as it's new, super, extra, and not drab. A concatenation of superlatives that end up becoming incomprehensible at times: "extra-night, anti-time." As if the mediatization of our imaginary were pursuing its logic of overdoing things independent of the existences it supposedly addresses...Always more, always better...Always more than we can, always better than we are...The speed of concatenation of adjectives and superlatives as representing the quickening pace of product turnover...A pace that no longer leaves us the time to get used to a product (we scarcely have the time to recognize a term before another one takes its place)...A pace that prompts us to quickly replace the product we're now using (we scarcely have the time to get used to the "rich" product and here comes the "new extra-rich" product)...A pace that makes no attempt to secure our loyalty to a product (the demise of the myth of Uncle Ben with his rice that transcends trends and generations)...A supply turnover pace at which the advertisement of new products outpaces their use...A supply turnover pace that – given the lack of need for new objects and

178

the extent of product saturation – now requires advertising design (typography). We have entered a post-product society. We have gone from an era of product design to an era of supply design (packaging)…Packaging, or how to promote supply even if demand is falling and the market is saturated with products we don't need. As if our societies had already passed the stage of projecting the self into products. The position of the spectator fascinated by this hypnotic concatenation of messages with low meaning content as replicating the position of the consumer incapable of choosing from such an overabundance of product offers…

From the consumer society, Claude Closky retains only the acme, the highest pitches of intensity that the advertising society lends to it. To wit, a radicalization of the spectacular process that has deported life behind the screen…Henceforth, only the intensity (the superlative) is deported – without the life that goes with it. Superlatives and elements that pertain to the register of dynamism and vitality, and that reflect and mediatize the ideology needed by the world's most technologically advanced countries to attain their growth targets. A growth that requires our vitality, our dynamism, and our desire to think positive to keep market turnover going. The eighties: If the acts and desires of Bruce Nauman's neon-men were programmed to a frantic rhythm – a rhythm that was already no longer their own (machine time) –, and if they espoused the form of what they consumed, they were still living a product experience. The nineties: Closky's concatenated elements invite the spectators not to live a product experience but simply to watch the procession of adjectives and superlatives (packaging) that designate them streaming past. It offers an experience in the procession of signs generated by a market that pursues its growth without us. An experience that refers us back to our position as magazine readers, TV viewers, and radio audiences exposed to strings of advertising messages that refer to nothing other than a rough idea, not of products but of certain representations that society has of itself. In the event, Closky's work does not refer us back to a society of objects or products, nor to our behavior as consumers or users. It confronts us with the simple procession of elements that can be read as a compendium of our imaginary…a compendium that refers us back to our deficits of experience… An imaginary that by simple, carefree positive thinking in each and every moment would give our thrill-lacking existences a new purpose. A purpose (energy) in the service of economic growth and competition.

Back to the end of the seventies and the eighties, back to bodies instrumentalized by employers who have doubts about their power, back to neon-men. A word or a message becomes effective when it circulates in and through bodies. After making bodies keep step with infernal work rates (machine time) and programming their modes of appeasement, what modes of instrumentalizing bodies does the future hold in store? What rhythms will be theirs? Prediction: No matter what modes of instrumentalization will be used in the future, the movements of tomorrow's mimes, prostitutes, or hanged men will have to dissolve into the movements of their chains and their networks (living to the rhythm of our day). Hypothesis: The law is a rhythm, a pace that circulates inside bodies. The more our impulses beat to the rhythm of the law, the easier it is to perform a task. First rule for a contemporary power: Use feeling to make words effective. Bring us to a point where we feel pleasure in doing what we are told. 1968. Consider two loudspeakers built into the walls of an empty room, addressing the eventual visitor: *Get Out of My Mind, Get Out of This Room* (Bruce Nauman). The sound of footsteps, and then the two commands repeated nonstop in a hollow growl that makes us feel like running away or in a light, bouncy tone that makes us feel like dancing. In which case, the visitor is led to subscribe (dance) to a discourse ("get out of my mind, get out of this room") which rejects h/er but which s/he no longer hears. Step into the rhythm of your own eviction. Integrating the law becomes a matter of following your feelings. The exhibition of an empty room where there is room for the subject – in the event, the visitor – to come in and actualize the terms of a law. The terms of h/er own manipulation.

The chain of behaviors and reactions that the employer tries to set in motion takes time to produce the desired image because his employees have to learn their jobs as they proceed. On the other hand, the mime's execution is immediate and the image of the hanged man is composed rapidly because the former has been trained and the latter programmed. Michel Foucault writing on the training of pupils: "All the activity of the disciplined individual must be punctuated and sustained by injunctions whose efficacity rests on brevity and clarity; the order does not need to be explained or formulated; it must trigger off the required behavior and that is enough. From the master of discipline to him who is subjected to it the relation is one of signalization: it is a question not of understanding the injunction but of perceiving the signal and reacting to it immediately, according to a more or less artificial, prearranged code."[90] 1984. Consider four columns

90 *OP. CIT., DISCIPLINE & PUNISH*, P. 166.

of affirmative imperatives written in neon on the wall: *One Hundred Live and Die*. Some fifty verbs and adjectives combined with "live" or "die" flashing on and off on a binary mode: "SHIT AND DIE…SING AND LIVE…SMILE AND LIVE… SMILE AND DIE…" 1985. In an empty room that can hold a small number of people (a group of students), the same proposals shouted by children at the top of their lungs. An invitation to join in the dance. Obsessively chanted combinations that, once they're learned, will make the mimes and hanged men of tomorrow. Neon pictures and chanting designed to "place the bodies in a little world of signals to each of which is attached a single, obligatory response: it is a technique of training, of *dressage*, that 'despotically excludes in everything the least representation, and the smallest murmur.'"[91] The mime and the hanged man are nonrepresentations of the self. The mime is but the representation of words being applied, and the hanged man's erection is but a reaction triggered off at a predetermined moment. The content of the instructions must be immediately apparent. The structure of *One Hundred Live and Die* is generative. It proposes formations of possible sentences (actions) – formations into which other verbs and other properties could be inserted. Once the chant has been assimilated, once we've got the tune running round our heads, not only is it hard to get rid of it (to think of something else), but more importantly the most absurd and even dangerous contents can be absorbed and disseminated by this obsessive chanting without upsetting us in the least: "YELLOW AND DIE…KILL AND LIVE…" All pauses are reduced here, the pauses that would empower consciousness – the critical faculty – to react, to say "no" or to decide not to follow (not to join the dance). How many people have the time (the consciousness) when watching a TV show or listening to the radio to notice the incoherence of certain pieces of information bracketed together? 1991. "According to the Pentagon, the total weight of bombs released in the last few hours is one and a half times greater than the tonnage dropped over Hiroshima. According to the Pentagon, twenty-three civilians were killed." Here, the bracketing of two contradictory pieces of information broadcast by the media during the Gulf War prompts our support (the *pro*-Gulf War). The mediatized metrics provides no transitions (no connections between elements that could be at the origin of the event). It delivers but makes no attempt to analyze. It creates a vacuum around the headlines in the news. The event is an inflection (numbers without the story behind them). The concatenation of newsworthy events is too rapid, but overly explanatory connections would be too time-consuming; those that could have

91 *IBID.*

endangered the process of transforming the public into practicing believers have been cut out. The mediatized metrics calls for dancers who are in favor of pursuing operations. The image has an impact but not a lasting one. The commentaries of our special correspondents as a mode of structuring collective behavior. The break in the rhythm, the pause in the pace as a mode of criticism (opposition journalism).

Herbert Marcuse: "The defense laboratories and the executive offices, the governments and the machines, the time-keepers and managers, the efficiency experts and the political beauty parlors [...] speak a different language and, for the time being, they seem to have the last word. It is the word that orders and organizes, that induces people to do, to buy, and to accept. [...] the structure of the sentence is abridged and condensed in such a way that no tension, no 'space' is left between the parts of the sentence. This linguistic form militates against a development of meaning."[92] Political news, military reports, and advertising (the media), as well as the verses and lyrics that we have to learn by heart for tomorrow (education) are linguistic forms that militate against a development of meaning apart from the one needed by the sponsors of these forms. If these linguistic forms are already effective in magazines, on billboards, and on television, if the concatenation of terms from the imaginary around which we organize our lives, which Claude Closky formulates in *Fruité*, radicalizes these forms that abridge and condense sentences by relying on an absence of space between elements, it may very well be in audio media that these linguistic forms succeed best in militating against the development of meaning. 1994. *Restez à l'écoute* (Stay Tuned, Claude Closky): Five-minutes of a looped sound track on an audio CD. "Call now area code 512, 658 4449, Take advantage of our special two-for-one offer, Don't miss happy hour at Happy Harry's, Get ready, Play and win, Discover the amazing world of Barney's bathrooms, Don't wait for the crowd, Find out what Jack the hack has to say, Buy now, pay later, Don't forget, Stay tuned..." Excruciating! Impossible to put up with this harrowing litany delivered by male and female radio voices...A litany of the various accents, intonations, and tones that make up the daily soundscape of radio audiences. But, in the event, the messages are incomplete and only a certain type of message is retained: namely, appeals to consume. A litany of consumer appeals...A litany of condensed phrases...Phrases from which Closky retains only the strongest accents, the points at which the voice grips audience attention, the point at which

92 *OP. CIT., ONE-DIMENSIONAL MAN*, P. 86.

the mediatized metrics pulls us out of the activity that occupies us, the point at which the message turns into a catchy tune. But in this case, it is impossible to resume our activites: The brevity of the messages, the speed of their delivery, the rhythm at which they grip us, and the total absence of space between them militates not only against a development of meaning but also against any chance of catching our breath. Turn it off or go nuts. *Stay Tuned*: A machine that begins racing...that picks up and condenses our centers of interest...Centers of interest that we use to organize our free time...A free time imposed by this same metrics. Delivered at this speed, even the friendly appeals reveal their injunctive thrust: friendly appeals that become orders. But at the same time, delivered at this speed, these orders, this metrics and especially this culture of hyping the slightest product offer, seem even more grotesque than they do during radio broadcasts. A litany in which the laughable aspect overrides the disclosure of techniques of alienation. *Stay tuned*: A way of amplifying the manner in which mass media "unilaterally surround" us (speaking to us in the second person) "with their commodities" (the supply). A supply that is linked not to a demand but to a response: "Don't wait for the crowd. Call area code 512..." As if, in the society of communication, the law of supply and response had replaced the law of supply and demand. When the culture of communication extended to the slightest commodity ends up cutting itself off from the system that underpins it...A premonitory representation of the society of advertising communication at its apogee...In the event, the contemporary imaginary delivered at such a rapid speed cannot circulate inside our bodies. It cannot circulate inside us because the lack of pauses in the phrasing excludes us from the rhythmic pulse, a rhythmic pulse that leaves no room (no interval) for us. A lack of room that doesn't give us enough time to call area code 512 658 4449...We no longer have the time to respond to the demand of those who are offering the supply. Off.

Back to more alienating statements...Statements that are even more alienating because they do leave room for us...more alienating because they are structured to make us join the dance (Bruce Nauman) not to leave us out (Claude Closky). Orders ("HEAR AND LIVE"), commercials ("YOUNG AND LIVE"), public service messages ("FUCK AND DIE"), or educational campaigns ("GOOD BOY/BAD BOY") are more effective when they are delivered in a straightforward, binary, easy-to-retain rhythm. Gilles Deleuze & Félix Guattari: "We are segmented in a *binary* fashion, following the great major dualist oppositions: social classes, but also men-women, adults-children, and so on. [...] it is a particularity of modern societies, or rather State societies, to bring into their own duality machines that

function as such, and proceed simultaneously by biunivocal relationships and successively by binarized choices."[93] As if every possibility in life had an opposite (good and evil, integration and exclusion, right and left, etc.), as if one followed from the other on the basis of cause and effect ("FUCK AND DIE"). As if each situation necessarily implied a choice between two antinomic possibilities (refusing or accepting, succeeding or failing, etc.). Our reflexes and our decisions respond to a binary logic. Yes or no...Drink or drive. And each choice has a consequence (the right choice or the wrong choice) and a penalty ("KILL AND DIE"). Reward or punish. The society that emerged after the collapse of the Ancien Régime formulated an art of punishment that was meant to be, as Michel Foucault put it, "as unarbitrary as possible" – it was an art that was to rely on "a whole technology of representation [...] an art of conflicting energies, an art of images linked by association, the forging of stable connections [...] a matter of establishing quantitative differences between the opposing forces, of setting up a complex of obstacle-signs that may subject the movement of the forces to a power relation."[94] The society today eliminates quantitative differences to the profit of a game that relies on the arbitrary. Bruce Nauman: "When I take the game, I take it out of context and apply it to moral or political situations."[95] 1983. *Musical Chairs*: Two metal chairs fixed to the ends of two steel beams suspended from the ceiling...If you don't move your feet, you lose your seat (competition). The children's game turns into a grownup game. *Hanged Man*: If you don't find the solution, you gain an erection. Games as the structure of our imaginary. The cruelty of an imaginary structured by the enterprising spirit, the love of taking risks and the pleasure derived from leaving others out. But in this game for adults "the parts of the figure are put into place without you."[96] The hanging does not result from not being able to spell the word correctly. It has been programmed in advance. Nobody can escape the law.

The little leeway that Nauman's recent works grant to spectators may correspond to the little leeway that power grants to subjects. 1996. *World Peace (Received)*: Five monitors, each playing words spoken by a man with a very convinced look on his face. Five monitors set in a circle around a chair (Why

93 *OP. CIT., CAPITALISM AND SCHIZOPHRENIA*, PP. 208, 210.

94 *OP. CIT., DISCIPLINE AND PUNISH*, P. 104.

95 "BREAKING THE SILENCE: AN INTERVIEW WITH BRUCE NAUMAN BY JOAN SIMON," *ART IN AMERICA* 76, SEPTEMBER 1988.

96 *IBID*.

don't you take a seat?) addressing you in an aggressive cacophony – "I'll talk and you'll listen to me" – and all the while letting you know that they are listening to you – "You'll talk, I'll listen to you. They'll talk, we'll listen to them." Impossible to get a word in edgewise. The television speaks to you (speaks for you). An international symposium? A televised debate? An exchange of views?...Empty promises of dialogue. A chair invites us to take a seat, faces speak to us and let us know that we are the actors in a process, and that we have access to speech...But these spaces for being and speaking turn out to be restricted. These faces (sound boxes for words that are not their own) give us a deceptive sense of self-awareness. The intensification of the harangue eliminates the delay (the distance) required to achieve understanding and imposes an immediacy of reception that makes access to consciousness impossible. The time of the subject (the time of understanding) is interstitial and silent. The time of mediatized speech is continuous. Temporalities apart.

JUST SAY NO
Does this mean that we will have to content ourselves with an exhibition of processes of machination and of negation of the subject. If we admit that Bruce Nauman's works tell us something, we probably also have to admit, at that very point, that they tell us nothing else. On the other hand, each of his exhibitions confronts us with a choice: Accept or refuse the way the works affect us ("STAY AND DIE/LEAVE AND LIVE"). 1987. *Clown Torture*. *Clown Taking a Shit*: A room...as soon as we step into it, we are assaulted by a cacophony of insistent, repetitive phrases. On three walls, simultaneously and continuously, four videotapes, each representing a clown in a different situation...A clown sitting on a toilet filmed by a surveillance camera, a clown recounting a story with no end, a clown getting a bucket of water on his head when he opens a door, a clown balancing on a chair as he balances a bowl of goldfish on the top of a broom, and a clown lying on his back on the floor saying "no, no, no, no" with his feet... The whole in four sound tracks, two videotape projections, and four monitors, one upside down, and another on its side...The colors are garish, the stories overlap, the phrases drown each other out...Is there any reason to accept this unbearable cacophony produced by the clowns talking to us ("Pete and Repeat were sitting on a fence. Pete fell off. Who was left? Repeat. Pete and Repeat...") or refusing to do so ("No!...No!...No!...No!...")? Is there any reason to stay here trapped in this room with its low ceiling, amid a profusion of loud colors and images that are not all upright, just to see two clowns being doused in water, another saying "No!...No!...No!" with his feet, and another taking a shit?

Their torture becomes ours. Here, as on the seat surrounded by the five speaker-monitors, seeing and listening become impossible and unbearable. Instead of telling us something, these installations attack us. The chant (*Get Out of My Mind, Get Out of This Room*) has turned into a cacophonous din…its effect has been amplified. A simultaneous conflict of sounds and images that puts our bodies into a state of hyperesthesia. The paradox of a challenge to our ear that leaves us no room to catch our breath. The hyperesthesia turns into sensory deprivation. You walk in and you simply have to get out.

1991. A huge room plunged into near total darkness: *Anthro/Socio (Rinde Facing Camera)*…Close-up of a bald man projected on three walls and six monitors, bellowing with deafening intensity: "Feed me, eat me, anthropology…Help me, hurt me, sociology…Feed me, help me, eat me, hurt me." The installation becomes a demonstration of force, with the room serving as an echo chamber and amplifying the scansion…Surround effect. A "kind of intensity" that surprises us, "like getting hit in the back of the neck."[97] The creation of three-dimensional sound environment that gives the chanting a feeling of depth. The repetition of the imperative inflections and the simplicity of the injunctions obsess us. An alterity that imposes a contact. Go toward it or reject it. The neon silhouettes suck and kill one another but they don't concern us. Rinde's face is unavoidable. He forces us to recognize his demand. Feed him and feed on him, help him and hurt him. A confusion of feelings of attraction and repulsion. *Get Out of My Mind, Get Out of This Room*: The tone and the scansion invite us to join in a dance that rejects us. "Feed me, help me": The chanting appeals to us. "Eat me, hurt me": The chanting circulates inside us until we feel ourselves pulsating to the rhythm of the other's destruction. To be at one with the pulsing power of the chanting (move to the rhythm of the text). Let yourself be carried by words that reduce you to silence. A system of sound amplification and a projection of Rinde's bald head that call to mind other faces and other injunctions. A string of hammered-out orders that call for an impulsive response. Unlike *Clown Torture, Clown Taking a Shit* or *World Peace (Received)*, the setup here seems to address not a single person or a small group of people but a crowd – the entire social body. The logic of stadiums. The logic of bellowing bass riffs that dispossess us of the desire for anything beyond this chanting. Be fascinated by the spectacularization of power or get out (dissidence).

97 *IBID.*

Combining the power of fascination with the aggressive charge of decibels elicits a question that Bruce Nauman, speaking about some earlier pieces, formulates as follows: "How does normal anger – or even hating someone evolve into cultural hatred? At what point does one decide it's OK to wipe out an entire race? How do you become Hitler? When does it stop being something personal and turn into the abstract hatred that leads to war?"[98] Probably at the point when this obsessive chanting (this rhythm) becomes etched inside us – when we join in the dance –, when we move into the stage of subscribing to it (the stage of alienation). A discourse becomes effective when the body internalizes it. Michel de Certeau: "The *credibility* of a discourse is what first makes believers act in accord with it. It produces practitioners. To make people believe is to make them act. [...] Because the law is already applied with and on bodies, 'incarnated' in physical practices, it can accredit itself and make people believe that it speaks in the name of the 'real.'"[99] Rhythm as an opinion structuring element. Nauman's works never name the nature of power. They only evince the form of its exercise on the body and the condition by which subjects become "believers." At what point are we dispossessed of our free will? At what point do we become objects of power? *Clown Torture. Clown Taking a Shit, Anthro/Socio (Rinde Facing Camera)*: Our relationship to these installations is based on a power struggle. Through the spectacularization of mediatized forms, the activation of injunctive speech, the recourse to certain allegorical figures, and the mechanisms of entrapment, these installations confront us with – force us into – a threshold experience, a point of no return: At what point does the pressure exerted on us become unbearable? At what point do we switch from being the subjects of a discourse to being its instruments or its targets?

1988. *Learned Helplessness in Rats (Rock and Roll Drummer)*. Consider a makeshift, not very impressive-looking installation: On the floor, an empty Plexiglas maze scanned by a video camera. On the wall, alternating video images of a terrorized rat trying to get out of the same maze (the document), a drummer playing a frenzied solo (the clip), and the maze scanned by the camera (live). At the beginning of the seventies, the practice of spaces restricting body movements and the use of closed-circuit video surveillance cameras were embedded in the aesthetic experience alone. You entered a first corridor and followed your own movements on a control screen...then you went into a second corridor and

98 INTERVIEW WITH KATARINA MCKENNA IN THE *LOS ANGELES TIMES*, JANUARY 27, 1991.

99 *OP. CIT., THE PRACTICE OF EVERYDAY LIFE*, P. 148.

watched people coming and going in the first corridor...In the eighties, the relative control of the spectator gave way to the total control of the subject of experiments. Ambiguity of the title: Who is being put in the situation of helplessness? The rat because it can't get out of the maze or the spectators because they can do nothing but watch? Bruce Nauman: "My work is basically an outgrowth of the anger I feel about the human condition. The aspects of it that make me angry are our capacity for cruelty and the ability people have to ignore situations they don't like."[100] Let yourself be seduced by the rock 'n' roll rhythm or become conscious of the violence exerted on the subject of the experiment. If the title of the piece may suggest that the rat is frightened by the drumming, nothing in the work proves that someone was actually playing when the rat was being filmed. The switching among the three pictures seems to discredit the hypothesis of concomitance. In addition, the speed of the rat's movements is not necessarily an indication that it is under stress...The association of these two images (the montage) may, in this case, be just the projection of a fantasy: watching the rodent running back and forth in the maze exhibited at our feet. The installation exposes and conflates voyeurism (the empty maze), pleasure (the solo), and compassion (the rat). The subject of the experiment is not who we think. The object of the installation shifts. The second version of the piece, – *Rats and Bats (Learned Helplessness in Rats II),* – further weakens the hypothesis that the rodent is suffering: A baseball player has replaced the drummer and the maze, which is spread out over four levels, has assumed grotesque proportions. The aggressive charge inherent in many of Bruce Nauman's pieces here gives way to derision. The pictures lose their force. The sounds take hold of the body and separate it from the seat of judgment. Headless bodies.

1990. *Shit in Your Hat – Head on a Chair*: On a suspended chair, opposite a screen on which we see the body of the mime losing its dignity (its power of volition) as it executes instructions issued by an offstage voice, a green cast-wax head with closed eyes resting on a chair. A head severed from its body and its activity. An activity that is happening on screens and in neon lights...An activity of which we have been dispossessed (the instrumentalization). 1989–1991. Back to silence. At eye level, dangling from wires in a room that we cross, other heads...: *Hanging Heads...Ten Head Circle/In and Out...Ten Head Circle/Up and Down...Four Pairs of Heads*...The confiscation of bodies. Making our way through couples and communities of frail, hanging heads. Monochrome casts

100 *OP. CIT., LOS ANGELES TIMES.*

of expressive eyelids, mouths, and wrinkles. Frozen interiorities. Subjects without their body of experience. Subjects disembodied from their individual stories. The suspension of these heads at eye level reveals the empty space that separates them from the ground. A space that the installation invites us to occupy and that underscores the frail, fragile presence of our own bodies and their precarious existence. The wax, the monochromy, and the dangling as a weakening of our own field of experience. The closure of faces (private experiences). A closure that the continual deafening speech imposes.

WE HAD A DREAM
December 1995. Paris: Walking, biking, skating, or rolling, thousands of men and women try to get to work or go back home in a capital paralyzed by transport strikes, a capital with no bus and no metro. Thousands of men and women who slowly but surely, without realizing it, start to slow down (if not actually block) the speed of production imposed by the market economy. A brief vision of a disconnection between two speeds...Two speeds which, in commodity-time, form one: the speed of the circulation of goods and services and the speed of employees who are subjected to them. A dream of a winter when thousands of men and women would no longer work to the rhythm of the economy but would make the economy work to their rhythm, at least for the time that the strike lasts. A happening on the scale of current events.

III. FOR A FORECAST REPRESENTATION

GROWTH TIME AND SELF TIME
(FOR AN AESTHETICS OF REINTEGRATION)

WHEREIN WE SEE HISTORY BEING BUILT ON AN ABSTRACT PLANE FOR GOALS THAT ARE NOT MINE

1999. If it is true that economic principles and interests have gradually dispossessed people of their capacity to act on their social, economic, and political environment, if the globalization of the economy has dispossessed nation-states of their sovereignty and of their power to control their own destiny, then what sort of goal do actors in contemporary History set for themselves? And who are these actors? Big corporations? Firms? The market economy? Flows of capital? If the survival of our societies depends on economic and financial activities, if these activities have only one goal and that is growth, then do our needs, aspirations, and desires accord with the maintenance of this system and the pursuit of this goal? If the principle of growth in the money supply has recently gained ground to the profit of the financial field only, and if this financial field has become increasingly autonomous, what could this growth in the money supply possibly mean to an ordinary citizen? If the growth in this money supply has gone together with a growing scarcity of jobs and a reduction in salaries, if the growth of wealth has produced exclusion, then how can one find a place for oneself? Are we doomed to watch corporate results, rising share prices, mergers, and relocations without ever getting any returns? André Gorz: "In this way capital has finally achieved its ideal essence of supreme, undivided, and unrestricted power. Divorced from the living world and sensible realities, it has replaced the criteria of human judgment by the imperative of its own growth and removed its power from human powers: It has succeeded its Exodus."[101] A growth whose only goal is itself. If the separate field of finance is not our place, does this mean that the economic actors are working on the construction of a space where there will be no room for the men and women who participate in the production and consumption of goods and services?

Underscore the growing discrepancy, the discontinuity between the goal (growth) that economic actors set for themselves in a world reduced to a market and the events that punctuate our daily lives. What is the relationship between Ford's profits in 1998 and your signature as indicated at the bottom of the page, please? If the objectives of the group that employs me are foreign to me, if my participation in the earnings of this same group is hardly noticeable, not to say nonexistent, what share of my professional activity can I appropriate? What will be my

101 *MÉTAMORPHOSES DU TRAVAIL. QUÊTE DU SENS, CRITIQUE DE LA RAISON ÉCONOMIQUE*, GALILÉE, 1988, P. 17.

margin of inscription (my capacity to take the floor) when faced with Matsushita or Vivendi? What relationship is there between OECD forecasts and the package I have to deliver before 4 P.M.? To wit, the acknowledgment of a time lived at work separate from the History in which this same time is supposed to be embedded. The acknowledgment of a discontinuity. A History that is being built on an abstract plane for goals that I cannot make my own. Does this mean that I am doomed to experiencing this History as a trial and an ordeal? A History translated for me into an experience of unemployment, stress, or exclusion?

1987. *La Comédie du travail* (The Work Comedy, Luc Moullet): A film about two or three ways of living without a job in France in the eighties. An exemplary scene…: A job hunter – sunglasses to hide his embarrassment – is about to punch a guy waiting on line with him at the unemployment agency simply because he has recognized him: "D'ya hear me?…Ya never saw me before…Is that clear?" To be unable to accept being recognized as being unemployed. To be unable to accept living without a timetable. To be employed or not to be… Being employed, beyond providing a basic income, is still a matter of identity today. After the reunification of Germany at the beginning of the nineties, the triumphant West proceeded to modernize ex-GDR's "obsolete" and "unadapted" production facilities without worrying too much about the consequences on the former East Germans. Yet, aside from the inevitable prospects of unemployment, the abrupt closure of so many factories put a sudden end to tens of thousands of personal stories and confiscated one of the principal modes of an individual's anthropological and symbolic inscription. It was not only a production system that West German leaders and businesses were wiping off the economic map, it was also a system that participated in the constitution of being. The working population in *La Comédie du travail*, as elsewhere. Instead of constituting themselves and fulfilling their own projects, they fulfill or don't fulfill forecasts (they do the job or they don't). How can we define (constitute) ourselves in and through work when the market economy instrumentalizes the people it employs, when employees have to condense desires and feelings into the form of their function and live to the rhythm of its execution and repetition? In what way does the individual fulfill h/erself through what s/he produces when the distance between h/er and the product of h/er work is continually growing? How is it possible *to be* behind a counter? How is it possible *to be* at your service around the clock, seven days a week? How can you represent yourself in Ford's profits in 1998? Is there life beyond OECD forecasts?

Unemployed time and the questioning of the significance of action and shared values at work are depriving individuals today of what used to enable them to act on the world and to represent themselves through their work. Birth of a sense of not having a place. For a long time, work was a means of subjectification, a mode of anthropological, symbolic inscription of the individual. Our need to recognize ourselves in stable, identifiable forms of representation found in professional activities and in their capacity to reveal us as agents in the construction of our environment, not only a means of building an image of ourselves – an identity –, but also of embedding ourselves in History and participating in its construction. Giorgio Agamben: "If man finds his humanity in praxis, this is not because, in addition to carrying out productive work, he also transposes and develops these activities within a superstructure (by thinking, writing poetry, etc.); if man is human – if he is a *Gattungswesen*, a being whose essence is generic – his humanity and his species-being must be integrally present within the way in which he produces his material life – that is, within praxis."[102] In the seventies, many artists embedded their work in a logic of activity – the process of activity itself building up a subjectivity of being at work. But this activity, this work, was located in the separate, autonomous field of art. It transposed a process into the aesthetic field that was specific to the history of industrial production. This approach corresponded to the building of a specific field of self-inscription. An alternative field, parallel to the social field. This affirmation of a field of inscription detached from the social field, this time of self-production (the process) separated from the time of industrial production, detached the subject (artist and spectator), by its very specificity, from the History of the community. If professional activity can no longer act as a means of subjectification, does this mean that only artistic activity can now play this role?

Step outside the separate sphere and observe the damage caused by the increasing scarcity of jobs. A scarcity that raises problems not only in economic terms (exclusion) but also in terms of our ability to inscribe ourselves in a community to which we are supposed to belong as subjects. Have we not entered a period of capitalism when economic growth acts as a process that negates any possibility of construction of the self within a praxis? Yves Clot: "Are we not entering a period of history when people will have become superfluous? [...] They will no longer be asked to work, to do a job. These people, driven out of the public sphere, will no longer form part of the symbolic chain of generations

102 *OP. CIT., INFANCY & HISTORY*, P. 119.

(with each person in his or her place picking up the legacy from the preceding generation and passing it on to the next). [...] Today, there are an increasing number of people who are not being asked for anything anymore, except to stay out of sight. [...] May it be that this request for forgetting the self gives rise to a deep sense of guilt and bad conscience that can go as far as self-hatred? We are going through a period when for masses of human beings their identification as such is getting more and more difficult."[103] If human beings are being driven out of the public sphere and the History that employed them, if they are being deprived of the work that allowed them to act on the world (to work on the world), if they have nothing left to transmit, then not only has self-inscription in collective time (the public sphere's production time) become impossible, so has the construction of one's own history. If work, in the sense we have just used to define it, disappears, what still ties me to the community and especially to the History that is apparently being constructed without me? Acknowledgment of a separation. In what way can I still have a place in this History? How can the time of the individual be articulated with the time of History? Two times that no longer move at the same speed. Two times that no longer move toward the same goal. The business that employs me is intent on growth, I'm intent on my weekend, my detached house, my next vacation, or having another kid. How can the gap between growth time and time for the self be reduced? How can I feel concerned about the rise or fall of the Dow Jones? Guy Debord: "What is really lived has no relation to the official irreversible time of society."[104] To wit, an incapacity to represent oneself today as an actor in present-day History. How is it possible to become an actor again in a History that is repeatedly presented to us by CNN in the form of past results and forecasts but from which we are excluded in our daily activities? The reintegration of the self in History as the point at issue.

CORPORATE CULTURE, ECONOMIC GROWTH, AND SUPPLY TURNOVER
...WHAT TO DO WITH IT?
However, if our relationship to History has gained in abstraction, if our engagement in our professional activities has weakened, if the growth objective has become increasingly foreign to us, this same growth – its necessity – seems paradoxically to be structuring a good part of our imaginary. André Gorz: "Growth of the economy as a system, growth in consumption, growth in individual income,

103 CONFERENCE PUBLISHED IN *LE TOUR DE FRANCE DES ÉTATS GÉNÉRAUX DE LA CULTURE*, VOL. 1, 1997, P. 123.

104 *OP. CIT., SOCIETY OF THE SPECTACLE.*

overall wealth, national power, dairy cow production, an increase in the speed of planes, bikers, swimmers, skiers, etc. – a single quantitative judgment is applied indistinctly on all levels [...]. Quantitative measurements, as a substitute for a rational value judgment, confer supreme moral security and intellectual comfort: what's Good becomes measurable and calculable."[105] Experts, journalists, businesses, and banks use curves, charts, indexes, rates, quantities, categories, and so on to represent the present day. The public or private situations that we experience and that are related to us in the form of articles, reports, surveys, or statistics, gain in abstraction. The appeal of a village is index-linked to its authenticity rating, your skin's freshness should increase, average conversation time during coffee breaks should decrease, etc. Is measurement being definitively substituted for feeling? When will growth become the meaning of existence? What is the meaning of this world and of the activities subjected to the measurements and calculations that produce it? Is there anything about my employment that is not quantifiable and calculable? Something related to knowledge and experience? A way of working that is my own? Something that would elude the logic of interchangeability of positions and functions? Something irreplaceable when I'm on sick leave or when I retire? André Gorz about Husserl's concept of the science of mathematized nature: "The subject no longer thinks and lives as a subject of a certain intentional relationship to reality but as an *operator* that carries out a set of calculation procedures. [...] In sum, the technilization allows the subject to leave itself out of its operations."[106] If the subject leaves itself out of its operations, if the construction and the symbolic inscription of the self are no longer enacted through work, does this mean that we must necessarily reconcile ourselves to the idea of being removed from ourselves and from our activities all workweek long? Is life to be definitively relegated to leisure time (work time as synonymous with pain)? Without attaching too much importance to semantics, it is nonetheless interesting to note the way in which a term such as "employment" has gradually taken the place of "work" in France, much as a young person might take the place of a skilled turner...The first term has more to do with employing one's time than with a specific activity. Employment involves an activity that is paid for by an employer, while work entails a conception of construction of the self through an activity, which now seems out of date. If work no longer constitutes a mode of anthropological and symbolic inscription for the individual, must the representation of the self at work necessarily come

105 *MÉTAMORPHOSES DU TRAVAIL. QUÊTE DU SENS*, P. 154.

106 *IBID.*, P. 156.

down to a constant image of the absorption of the self in the abstraction of the working population (the disappearance of the subject in the corporate project)? A disappearance that reinforces the cliché of crowds in uniform, homogenous clothing and attitudes rushing into commuter trains in cities around the world? Are we to reconcile ourselves to a representation of the self within the corporation founded on eliminating the culture of the self to the profit of corporate culture? A representation that would acknowledge the triumph of the suit and tie over one's own way of being. Without subscribing to this corporate culture, is there any way to conceive of representations of the self at work other than in the form of the dehumanized, animalized figures frozen in lifeless postures that Katarina Fritsch pictured at a board of director's meeting in *Tischgesellschaft*? If undermining corporate dispossession of the self seems to be a point at issue, how can we conceive of it other than on the mode of a statement of fact?

Find images that make it possible to reduce the distance that separates us from business time. Meanwhile, what are the images (representations) that we now have of being at work? Images of an activity embedded in industrial society (images of being in pain). To wit, a representation articulating the gesture (the worker) with the machine (the assembly line), the workforce (the instrumentalization of bodies) with the hardship of the task (the mine). Can you imagine a fiction today depicting characters who construct themselves through a professional activity (the production system as a system of self-production)? Consider two examples selected from the cinema...*Brassed Off* (Mark Herman) and *Amsterdam Global Village* (Johan van der Keuken). 1997. *Brassed Off*: Ten years after the big strike in 1984, a majority of Yorkshire miners reject a project to keep the mine open and vote for a mass layoff with severance pay. The identification to the community and to the miners' history is dropped in favor of paying bills and working on the house. The profession (the construction of the self through an activity) has given way to a salary (the house bought on an installment plan). Look for other modes of constructing subjectivities...modes of construction that would be more in step with the imaginary of entertainment and fun around which our existences and aspirations are constructed...Hypothesis (project for a job after school): Why not tack some of the offbeat attitudes generated by teenage culture onto work time? 1996. *Amsterdam Global Village* (Johan van der Keuken): In the streets of Amsterdam, a young messenger rides his moped (his work instrument) to the rhythm of techno music that he listens to at home. Subjective camera: Zigzagging between buildings and in and out of the obstacles on his way. The subjective camera as a mode of projecting and integrating the self into

the outside. The cityscape takes on the shape of the rhythm and speed required for the satisfaction of a demand: namely, to deliver the photo prints as soon as possible. Choreography of a way of being productive. The discontinuity between work time (the collective time of the company) and personal time (the individual time of the imaginary) gives way to a continuity (the enjoyment). The rhythm of the self (techno music) joins up with the rhythm of business (the deadlines). Leisure culture and corporate culture are juxtaposed. A reappropriation (a transcendence) of stress. And then, for a change of scenery, while keeping to the same rhythm, go have fun revving up your bike and riding on the back wheel with your buddies. Create a continuity between *your* way of being in free time and *your* way of being productive by hopping on your work instrument for free (with no obligation to achieve results). A staging of rhythms, speeds and movements peculiar to the offbeat way that teenagers have of being hyper, and to a culture in which differences between the qualities demanded by the employer (qualifications) and the qualities required to practice an activity (the skill) become indistinct. Farther on, teenagers use a roller track (the favorable environment) with great skill. The camera gets swept along. Follow the imposed figures of style and velocity on the U-shaped ramp. Put the spectators in step with (into the rhythm of) the object of the film. In the event, the filmed situation structures the film form. The camera does not impress the landscape. Styles of our world and of our day versus the auteur's style. Every object and every situation calls for a specific form. Imposing a style (a signature) amounts to missing out on the present day. Let the camera move in the direction and to the rhythm of the people and the environment that we are trying to capture (the representation). Put our eyes and our modes of perception in sync with new forms of being in the world or else lapse into ignorance of the present day by leaving it offstage and out of sight (reassure oneself as to the permanence of the world, and consequently of its forms, by working with framing and editing techniques conceived for outmoded ways of being in the world). The movements of the world as movements of the camera.

Without subscribing – out of naïveté or under duress – to the need for and the culture of economic growth (the abstract part), how is it possible *to be* in step with the rhythm of economic growth? The corporate response: Give form to this growth. Resize it to fit the scale of the managerial staff and employees by translating it into performance. A good many company brochures or magazines do not hesitate to depict the executives they are looking for positioned in the starting blocks on a racetrack in their suits and ties…Executives ready and raring to

take a flying start to win the 110-meter hurdle race (the obstacles in a manager's career)…The recourse to an athletic metaphor seems to have gradually taken the place of its warrior equivalent. The economic war has been supplanted by international competition, economic expansion (the conquest) by an increase in market shares (the good performance). Increasing your productivity and consequently that of your company = improving your performances. To make the company that employs me number one in its field, optimize my work capacity and my skills. Maximizing the self in the service of the company as the objective. Critique of art: In this context, is an aesthetics of non-competitiveness desirable? An aesthetics of cycling vacations (vitamin-packed dried fruit packages versus EPO)? An aesthetics akin to going on strike? Putting oneself on standby as soon as one hears the sound of gunfire? An aesthetics of preindustrial *flânerie* or of a hippie scene? Jean-Yves Jouannais about the artist as dilettante: "'Not doing' is a response not so much to all-out industrialization as to the commercial logic of society. What is problematical is less the object than the prospect of stocks that it harbors, less the craftsman's work than the becoming-commodity of paintings, the surplus and the bombarding that it nurtures. There is nothing that the dilettante appreciates less than the bland, violent slogans of marketing. He is not campaigning. He is not one for selling or lying. He prefers being lazy. Selfish to the point of independence, he pays scant attention to constraints of productivity and profitability."[107] Here, an aesthetic response to all-out industrialization, a challenge to the need to produce and consume objects. An aesthetics that sets an attitude (the being) against production (the object), a material desert against overabundance. What forms of resistance to all-out growth could take over from the Duchampian refusal 'to do' or to produce advocated by certain Conceptual artists? Avoid the pitfall of reestablishing aesthetic values based on the gratuitousness of an artistic act conceived in terms of undermining the logic of profitability. In fact, although all-out growth necessarily relies on criteria of profitability, it is already embedded in an imaginary of the gratuitous. After all, this growth has no aim besides itself. The prospect of stocks at the final stage of the production chain has given way to the prospect of "more," "better," an "increase," a "rise." The culture of growth is clearly abstract and dematerialized. On the pages of the electronic journal *Ctheory*, a proposal by the Critical Art Ensemble: "Hospitech Magnetic Resonance Imaging Device: This state of the art medical technology delivers a corporate promise, since it is the perfect medical sight machine. The Hospitech MRI device articulates the space of the body

107 *ARTISTES SANS ŒUVRES. I WOULD PREFER NOT TO* (HAZAN, 1997), PP. 100-101.

with such clarity that there can be no place for a biological invader to hide. When used excessively the MRI protects capital and increases profit. From Hospitech… $299,999.95."[108] To wit, a diverted advertisement that deals not with the object but with its instrumentalization by capital. What effectiveness could an art of de-materialization possibly have in a historical context in which materializing a professional project counts less than turnover? If undermining objects and profit imperatives no longer makes sense today, if art is embedded in a logic of opposition rather than subscription to the models around which our lives are organized, can undermining all-out growth constitute an object on the aesthetic plane?

Meanwhile, how is it possible to subscribe to all-out growth in the office? How can anyone believe in the performance imperative? How can I commit myself to a business project that involves "entering worldwide competition" and "increasing market shares" when my participation in this new History of business seems to have more to do with believing in market economy values than with my real participation in this same History? Michel de Certeau: "The media transform the great silence of things into its opposite. Formerly constituting a secret, the real now talks constantly. News reports, information, statistics, and surveys are everywhere. No story has ever spoken so much or shown so much. […] Narrations about what's-going-on constitute our orthodoxy. Debates about figures are our theological wars. The combatants no longer bear the arms of any offensive or defensive idea. They move forward camouflaged as facts, data, and events. They present themselves as messengers from a 'reality.' Their uniform takes on the color of the economic and social ground they move into. […] Narrated reality constantly tells us what must be believed and what must be done. What can you oppose to the facts? You can only give in and obey what they 'signify,' like an oracle, like the oracle of Delphi. The fabrication of simulacra thus provides the means of producing believers and hence people practicing their faiths."[109] Economic facts and data have not only become unquestionable and unavoidable, they now concern everybody. This reality may be abstract, but its hold is hegemonic. And even though this narrated reality does not necessarily turn everyone it addresses into a believer, all those who live in free market countries necessarily practice its faith. Nobody can escape the necessity of working and consuming.

108 REPRINTED IN *ELECTRONIC CIVIL DISOBEDIENCE AND OTHER UNPOPULAR IDEAS* (AUTONOMEDIA, 1996), P. 79.

109 *OP. CIT., THE PRACTICE OF EVERYDAY LIFE*, PP. 185-186.

If art is a mode of perception of our societies, if these same societies present themselves in terms of figures, statistics, indexes, curves, trends, and so on, if this data turns us into practicing believers: Work on the way that this data is communicated to us and on the way that our societies represent themselves. Question: In what respect can or should art assume this charge? If art is apt for working on several forms of perception without restricting itself to a specific form, then it is apt for working on certain types of images, discourses, and codes that our societies adopt or on some of the characteristics of the modes and systems of thinking on which our societies are based. Working on them by investing their very structures not with a deconstructionist aim (with the intention of *revealing* the discourse's nature, the laws or the representations of the world) but with the aim of reducing the distance that separates me from the History in which I am supposed to be embedded. Underscore the distance that separates the History that is transmitted to us by experts, journalists, businesses, and banks, and the events that punctuate our daily lives. Explore the ever-growing gulf between trends dictated by the market and the way I employ my time… Confront growth time with the time of the self. The search for ways of being in this distance as a first step toward reestablishing contact with History.

The ways that we spend our time, be it in our professional activities or elsewhere, are increasingly patterned on the model of corporate culture – a model that places the promise and prospect of figures and performance at the center of its activity. We are constantly focusing on improving performances – beating video game scores, breaking the 100-meter world record, increasing my computer's storage capacity, or receiving an ever greater number of satellite-broadcast TV stations. Self-maximization as the condition of getting in step with a winning world. If growth, the performance imperative, and self-maximization structure a good part of our imaginary, are there any areas where growth, performance, and maximization are meaningless? Is it still possible to make love without being forced to perform? Is it still possible to spend a quiet weekend without having to go through a dozen documents by Monday? Is it still possible to use your computer and not care how much time it takes to start up? Is it still possible to spend hours watching the Tangkuban volcano without checking your watch every few minutes so as not to miss the bus to the village where we'll be attending a concert of Angklung music? And when the pressure lessens and the activity slows down, then economic growth forces the supply turnover on us. A turnover in supply that is translated in our behavior into a turnover in our desires. Desires that follow trends, desires that are just dying for a brand-new

showerhead to provide new erotic effects and for satellite and cable TV to re-place the monotony of watching the major national networks…Does the fast turnover of supply necessarily entail an equally fast proliferation and turnover in our desires? Is supply commensurate with our needs? Is what we experience as a lack (the distance that separates us from advertising images) in the process of becoming the sole rhythm of our lives? A rhythm that never ceases to project us someplace else, for something else, at some later date? A rhythm that ends up removing us from a sense of self in the here and now…A rhythm alienated by economic growth…But if the aims and desires that the society of growth of-fers us vary as a function of what I don't have and what's left in my bank ac-count (sufficient purchasing power to obtain a particular lifestyle), our condition is stabler and easier to define…The condition of a permanent lack…With (per-manent) credit as a solution. André Gorz: "By quantifying for purposes of calcu-lation, economic rationalization eliminated criteria that allowed people to be satisfied with what they had, what they had done, or what they were planning to do."[110] Dissatisfaction as the condition of contemporary man.

Devise forms of being in the world that are not subjected to the necessity of "more" and the need for "something else." Is it still possible to imagine a soft-ness that eludes comparisons? A softness that is not subjected to competition from even softer products? A softness that is my own, not Downy's? If youth is in Nike, beauty in Dior, and power under perfect control in a Subaru, what is left in people? Is it still possible to imagine forms of life that do not develop inde-pendently of people and affects? Feeling and behaviors do not pertain to us any-more…In fact, they seem to pertain to the functions we hold, the situations we live in, the spaces we move through, and the products we consume. I am what I live in, what I eat, what I wear, what I use, etc. Disqualify products. Reappro-priate the qualities of which they have dispossessed us. If the dematerialization of the world is effective when it comes to disqualifying products, is it sustain-able in a context of desubstantialization of the self? Slow down production. A production that produces nothing but more lacks and more frustrations…The desire to slow down…The urge to be slow and lazy (the temptation). But what can being slow and lazy achieve apart from putting us on the sidelines of a History that already seems to be racing along without us. Look for a rhythm of understanding with History. Try to reappropriate a movement (growth) that has gradually escaped our control. Get back in touch with this movement by working

110 OP. CIT., MÉTAMORPHOSES DU TRAVAIL, P. 144.

your way back up the only chain that still links us to it: its transmission ("reality" as it is represented to us and the way in which the myths that inform this reality are etched inside us).

Olivier Zahm: "Capitalism, after having been a violent economic regime, and then a mediatized consensual one ('Society of the Spectacle') now releases a tremendous mental charge. [...] Consuming (when it is possible) does not so much involve appropriating products, symbols, lifestyles, or distinguishing marks as hooking into an immense mental circulation and vibration. We have entered an age of capitalism integrated into subjectivity, generating manifold dissociated identities. This is how you are, now be like this...enable different subjective sequences...become many, variable, open-ended, connection oriented..."[111] Providing that you are what you wear...Providing that I reduce my subjectivity to the dimensions of my shoes...Providing that you accept the fact that a way of being lasts only as long as a trend. Providing at last that you be here now and only now, without thinking about tomorrow, without projecting yourself, without planning, without a history, and without a biography. *Just do it...You are what you wear*, and I am what they are: a victim of economic growth (the supply of new models) and of what I happen to encounter (networks, attitude groups, taste communities). Mehdi Belhaj Kacem: "From the outside, nothing distinguishes me from them and since everything nowadays boils down to what's outside, I am doomed to be them."[112] Consider the condition of being-in. Being-in may escape dress formatting (the negation of subjectivity), but it relies on a network. To be in on new trends in order to hook into one behavioral network or another. Being-in is a generic being, since it is open to all new trends...To be in or not to be. Play with the marks of visibility (wear a logo) or fade into invisibility (be out). In the event, to be in involves living to the rhythm of economic growth. Before going any farther in getting our desires in step with the market economy, one question: If embedding the self in growth time can constitute an issue, must it be to the detriment of our "whatever singularities" and to the profit of a readjustment of rhythms of the self? Rhythms imposed by the necessity of being competitive...A competitiveness translated into a turnover in identities and subjectivities (when economic interests become attitudes). Spend the summer in Nike and then die (Who will you be this September?). Growth as a movement of self-dispossession (being "wear" it's at). The Desperate Generation.

111 "D&G CORPORATE SONG," *PURPLE PROSE* 12, SUMMER 97, P. 132.

112 *VIES ET MORTS D'IRÈNE LEPIC* (TRISTRAM, 1996), P. 17.

It remains to be seen what facets of capitalism artistic activities can work on. Beat Streuli's slow dissolving images, by recording singular attitudes and ways of being in a crowd, work on the facet of consuming the advertising image, or rather on possible appropriations thereof. But does skating over the surface of the image of consumption, or rather of the consumption of the image (how I consume Nike), allow us to deepen our subjectivity with dimensions not available on the market? Doesn't the turnover in the supply (of possible subjectivities and identities) definitively abolish the time of the self – a time that is necessarily slower and more continuous?...Cease having the time for becoming...Be content to flirt with what one could become. Trend time is a by-product of commodity time, and behaviors are a spin-off of advertising informed by economic interests. Abandon the facet of image consumption and appropriation. Why must we necessarily conceive of our ways of being in relationship to the supply? If supply begets demand, what necessary relations exist between supply and art? Why should the consumer facet be the seminal one? Does art's sole capacity to generate a crisis today reside in its ability to disrupt the law of supply and demand? Has the imaginary of subscribing to dominant models definitively won the day?

FOR REAPPROPRIATING FORMS OF TRANSMISSION OF THE MYTHS AROUND WHICH OUR LIVES ARE ORGANIZED

Meanwhile, while waiting for the aesthetic revolution, concentrate on the tenuous bond that still exists with the society of growth, and go take a look at the image production side of things. Get past the stage of disseminated images (communicated behaviors) and delve into the process of their making. Hal Foster: "The political artist today might be urged not to represent given representations and generic forms but to investigate the processes and apparatuses which control them."[113] Work on the way we integrate the myths and representations that our societies give of themselves. Intervene in their process of transmission. Interventions in which the point would not be to re-present these myths and representations, or to reformulate the globalization of behaviors and the outlooks to which they respond, and even less to accept or refuse their turnover, but rather to use a few – necessarily modest – possibilities that artistic activity offers in order to enter certain processes of initialization of the components in our imaginary. Retrace the stages in the transmission of beliefs, myths, and the collective imaginary (the components and their modes of concatenation) that allow our

113 *RECODINGS, ARTS SPECTACLE, CULTURAL POLITICS*, BAY PRESS, 1985, P. 153.

societies of growth to function smoothly. A few examples in passing: To probe the logic inherent in the forms and idioms of our representations, examine the way the terms used in ads, technical handbooks, video-game rules, tourist guides, catalogues, insurance contracts, progress reports, or job offers, for instance, crystallize the contemporary imaginary, in the sense that they are continually appealing to our cravings for "more," for "better," for "access," for "variety" in the "choice," and so on. In the case of articles on sports or economic news, the enunciation form relies on the need for performance, competition, and so on. And in the case of certain news bulletins or scientific texts of popularization, phenomena and events are stated as facts, without any explanation or contextualizing – which gives us the illusion of a world we can readily grasp, a world in keeping with the way we picture a region that we visit as tourists, etc. All these forms of transmission of our environment also exhibit many similarities when it comes to the type of images used, their structure, their style, their rhythm of enunciation, and the way the information is connected and arranged hierarchically...To wit, a whole array of languages and representations designed to format consciousness and behavior...A formatting that consists in producing "believers" and "practitioners" capable of participating actively in the economic system in force in our societies of growth. In the event, this active participation (the instrumentalization) is not a conscious participation. Conscientize our relationship to the economic system.

If the emancipation of the self has repeatedly constituted one of the major issues of modernity, this aim may need to be reactivated and contextualized in the present day. Elude the strategies of formatting consciousness and behavior. Nicolas Bourriaud in the lineage of the conception of subjectivity developed by Félix Guattari: "We'll have to learn how to 'capture, enrich, and reinvent,' subjectivity or else we will see it turn into a rigid collective apparatus in the exclusive service of power."[114] Retrace the stages in the transmission of beliefs, myths, and the collective to raise our consciousness of the unprecedented History that constitutes the History of societies founded on the necessity of growth. A History that eludes us because its rhythm is not ours, because its rhythm is solely conceived on the scale of economic actors and not of our consciousness, and because this rhythm is in Exodus. Raising consciousness of this new form of History as a key issue in art, if art – as the possibility of arranging signs and forms, regardless of their context of enunciation – is apt for work on representation

114 OP. CIT., ESTHÉTIQUE RELATIONNELLE, P. 93.

forms that still act as a screen between this History of growth and us. Advertising, news bulletins, curves, OECD forecasts, and so on, are all forms of transmission of the History of growth that act as screens because this History lacks forms of representation conceived on the scale of our consciousness.

A growth without representations and hence without conscious minds to experience it. If the societies of growth have economic agents (businesses, interests, creditors, banks, etc.) to pursue the objectives that make their survival possible (expansion), if they still manage to give functions to their members (producers and consumers), they do not yet have roles tailored to fit their affects and their consciousness. Gaining an awareness of what characterizes present-day History involves gaining an awareness of the modes of alienation that are bound up with it. How can we escape from the guidance and instrumentalization of our consciousnesses and bodies? A guidance and instrumentalization whose effect is to reduce our agency to a function…A function legitimated by an economic principle of employing time and space. An employment of time and space structured by working hours from nine-to-five, deadlines, hours spent commuting, and worrying about my company's poor annual results or about what's left in my bank account…When the world's fictions have been reduced to functions, it is high time to reinvent subjectivity. Loosen the constraints of the "collective apparatus," open up spaces and intervals in which subjectivity can be deployed. Instill humor and desire into places where there is nothing but conducted bodies, formatted consciousness and a limited capacity for invention…Go roll around in the grass before getting back to work…While waiting for something better: try to find a way out.

GET BACK IN TOUCH WITH HISTORY
(CURRENT AFFAIRS IN SEARCH OF REPRESENTATIONS)

THE COLLAPSE OF THE FORMER SOVIET UNION (AN IDENTITY BETWEEN
BANKRUPTCY AND BUYOUT)

1993. *Les Enfants jouent à la Russie* (The Kids Play Russian, Jean-Luc Godard):
An American television station commissions a film on Russia from Godard.
Consider a one-hour video film. A video film in which actors, directed by an off-
screen voice, read fragments from the history of Russian literature. Actors who
play the part of characters from Tolstoy, Dostoyevsky, Chekhov, or Jules Verne
(play Russian), who try to rent a twin-engine plane, or who hold forth about the
future of the audiovisual sector and the demise of cinema...Intercut or superim-
posed, silent or sound pictures taken from Soviet film history and archival foot-
age. All this is punctuated by written texts displayed on the screen and under-
scored by a looped offscreen commentary from a filmmaker who sometimes
appears on screen dressed as the Idiot (gray overcoat, red striped pajamas and
a woolen cap, or woolen cap and CCCP T-shirt). So much for the form. Action:
A young actor is learning Prince Myshkin's part: "I don't know what will be after,
I don't want to and I can't know..." Godard offscreen: "With a deeper voice..."
The actor: "But if this is what I want, if I want fame, if I want to be famous, if I
want to be loved by men, am I to be blamed for wanting this, for wanting this
alone, living for this alone, yes, only for this? This I will never tell anyone, but God
almighty, what am I to do?" Jean-Luc Godard's offscreen voice: "When you say
'what am I to do,' throw your head back. You're speaking to the sky up above."
Is it still possible to speak to the sky up above in 1993 without getting your lines
wrong? Are our acts still motivated and guided by some divine force over and
above us? If the actor's tone and voice cannot convey the torments of the
Prince, if his voice remains monotonous (lacking the interrogative intonations),
perhaps this is because his role was conceived by a culture and society that has
been dead for more than a century. Cultures and societies do not repeat them-
selves. The figure of the tormented, possessed hero (the voice of truth) has given
way to an actor lacking the referents that would enable him to understand and
to feel what he is reading (the voice of heritage). To wit, the incompatibility of two
cultures: a contemporary culture no longer concerned with the sky up above
(materialism) and a nineteenth-century literary culture (grappling with the forces
of one's destiny) that no longer concerns us. Music...Quick succession of slow
motion shots of soldiers falling under fire...Offscreen voice: "Deeper, death,
wounds..." Cut to close-up of a woman's head thrown back, with blood on her
lips. A picture that calls to mind another picture – that of another woman's ter-
rified face, looking up to the sky in the very first moments of the film. A woman
watching a fighter plane. An image of fiction (film heritage) watching an archival

image (newsreel footage). *The Kids Play Russian* as an exploration of History through fiction. Revisit fiction to understand History.

Bring out the significant lines of a culture (here, fear and fate) by weaving up a skein of representations that the society gives of itself. The interval of time between the two pictures as the delay of activation of historical consciousness. If Godard disseminates and relocates these pictures in their historical context, it is up to the spectators to do their own flashback (the memory – the impression – of a picture akin to the one we are seeing). The call to montage as a call to activate historical consciousness. The delay needed to achieve this consciousness as replicating a historical reality that remained without representation until the nineteenth century. In fact, the Russian/Soviet people had to wait until the second half of the nineteenth century (in novels), and the first half of the twentieth century (in films) to see their own inscription in History represented. A representation built up around the figure of the victim of torture…An imaginary in which beings abandon themselves to forces over and above them (fate). An imaginary of collective suffering and self-sacrifice (be it during the struggle for independence from the Tatars of Mongolia, the dekulakization, the codification of serfdom, the crushing of peasant uprisings, or the repression and massacre of striking workers in 1910). The eyes directed at the sky above as figuring the impossibility of taking hold of one's own destiny (one's own history). Representing the subjection of bodies and the lack of sovereignty as the first task of fiction. A History, an imaginary, and fictions anchored in the relationship of a people to their land. Cut. A tracking shot following a funeral procession in the Russian countryside intercut with a low-angle shot of a desperate, frightened man trying to escape…Escape or die. Cut. The slow sound of the narrator's deep voice repeating: "But aren't all these versts to be crossed also as many verses recited by all these souls singing the psalm of Russia…But aren't all these versts…" Cut. The desperate running and the tracking as a representation of the condition of Russian man. A condition characterized by the need for flight…A condition implying all those versts to be crossed. If the history of this condition involves traveling the length and breadth of the country without being authorized to find a place in it as a sedentary body, then the representation of this condition requires perpetual motion, a motion that accompanies fleeing bodies (the bodies of the tortured) but which frames no landscape (a place to settle down). The pictures quoted and edited in *The Kids Play Russian* are pictures that follow this movement of flight. Shoot faces and bodies (the extreme low-angle). Skate over the surface of the territory (the tracking shot) and don't ever stop (the

forbidden sedentarization). The images Godard chooses from the stocks of footage on Russia are of faces and bodies, seldom of landscapes. Motion without a setting. Static shots of landscape pertain to power (to the aristocratic powers that possess it or the occupying powers that conquer it). To be bound to the land and subjected to the landed aristocracy (the 1649 code) or to be emancipated by abandoning the land (the condition of the wanted fugitive). Gilles Deleuze and Félix Guattari: "History is always written from the sedentary point of view and in the name of a unitary State apparatus, at least a possible one, even when the topic is nomads. What is lacking is a Nomadology, the opposite of a history."[115] The Russian territory was the scene of the mass peasant flight to the East in an attempt to escape serfdom in the seventeenth century, the evacuation of Moscow after the invasion of Napoleon's troops, and the retreat from the German occupation in 1941, but Russian history exists only from the point of view of those who possessed the land (the nobility) or those who conquered it (the invaders). Those who were dispossessed (the servitude) or chased away (the exodus) have no history. The condition of fugitive, of being in exodus (the condition of people dispossessed of land) requires a Nomadology.

The moving picture versus the static picture. The overlaying of images as an overlaying of periods in History…Periods that repeat themselves. *The Kids Play Russian* as generating a parallel (the montage) between attitudes and behaviors that are repeated unchanged decade after decade. The montage and the choice of pictures as a mode of critical video writing. Consider a lap dissolve between History and its criticism (fiction). Overlay fiction onto the History that inspired it. Appropriate the movement of History and make a narrative form out of it (let the story impress the image). Traveling across the country (the tracking shot) as the only way of being in relationship to the Russian land (the scenery filing past). If the image cannot represent a sedentarization (the promised land), then the future of the characters is out of camera sight (at some vanishing point). Fear as a reason for the projection of the self out of sight. Flight to the vanishing point as the perspective. The psalm as a narrative of this movement of perpetual flight. In the event, the vanishing point constitutes a vantage point on the history of the Russian people. Brief headlong flight of the fugitive. Cut. Hands clenching her breasts, a white woman swells her torso and throws her head back…Janis Joplin's voice covers the narrator's voice. A voice imported from the United States…a voice that draws on the Gospel…that calls to mind an attachment to

115 *OP. CIT., CAPITALISM AND SCHIZOPHRENIA*, P. 23.

the land and an experience of slavery. A suffering that vibrates in the voice…A voice that matches the forms of a body and of an *injured*, *humiliated* community (black people's slavery as the equivalent to serfdom). The voice blends into a silent picture (the picture of speechless suffering). Here, the voice, a few seconds later, religious music. Provide this suffering with a representation. Music and vocals as an alternative mode of representation of a history that lacks images (the victim of torture has only h/er body). In the absence of images and texts, the body becomes a medium. If Western culture can no longer hear suffering that seems foreign to it because it is remote from its own history, then translate it. The grain of the North American voice as a tangible translation of a suffering condemned to silence by those who have written Russian history.

If the representation of Russia and the Soviet Union (the Nomadology) often refers to movements of flight, does the representation of post-Soviet Russia involve similar modes of representation? Can the commissioning of a film on Russia by a North American television station trigger a movement of flight? Will the occupation of Eastern territories by a Western film crew produce the same images? How can those who've known only novels and films cope with the arrival of the audiovisual? Seated in an armchair, a man playing Alcide Jolivet – the journalist sent by France to cover the Tartar invasion in Jules Verne's novel *Michel Strogoff*: "Words are not merely indicative of history, they are also historical factors. The historical world is written in words but to begin with it is constituted through language. Such concepts as people, history, and nation do not merely evoke what has happened since 1789. What happened could not have happened if these words had not existed." Who wrote and who writes History remains to be seen. If the broad lines of History were long written by conquerors (the expansionist logic) and landowners (the domination logic), if these lines drove a good part of the people outside themselves (the deprivation of land and representation), has Russia's opening up to the West (the market) changed the course of this History in any way? A man in a black suit (the business suit): "I'll give you 450,000 words. [...] What's our budget, mom?" Mom: "450,000 dollars." The man in the black suit: "A dollar per word." Jolivet's reincarnation (the representation of the nineteenth century): "No. What the West has to do is provide aid on an altogether different scale than it has up till now. As far as the rest is concerned, it's up to the Russians and the Russians alone to determine the type of reforms, their rhythm and scope. The United States has no business telling them what to do, all the more so since it knows nothing about the country or its history." A secretary: "You've just spent seventy-five dollars, Monsieur Jolivet."

Political history (people's self-determination) collapses in the market economy (the demise of History and the birth of index-linking personal and collective behaviors to the circulation of goods and services). A History (the construction of identities around a common project) recycled into a product. Russia (the Movie). The History of Russia as a by-product of the collapse of the Soviet empire. Western and Eastern Europe invented fiction long ago, now the West is concentrating on inventing products. A culture founded on the necessity of being united has given way to a culture founded on a capacity for production. Offscreen voice: "It's plain to see why the West wants to invade this country again: it's the land of fiction, and the West has run out of ideas." If fiction is the site of the projection of the self in a collective representation, is the West still capable of projecting us in any form of collective representation besides the inscription of the self in a project of economic growth and expansion (the company that employs me increasing its market shares as the purpose of History)? Is the projection of the self in corporate values (the engagement of the self in the expansion project) the only form of engagement of the self in a collective narrative? If business has become the place where the History of the West is being constructed, if business has definitively replaced land in its function of uniting a group around a common project, if Toshiba has supplanted the homeland, if we identify with Bill Gates more than with Anna Karenina, does this mean that we must reconcile ourselves to reducing the History of the world to the history being written by business?

Does History today offer roles only for economic actors? "What makes you think you'll succeed where Napoleon and Hitler failed? Maybe you should drop the audiovisual sector and concentrate on others: cigarettes, for example, or Coca-Cola, or blue jeans…" *The Kids Play Russian* as staging the passage from territorial expansion (conquering new lands) to economic expansion (conquering new markets). On the screen, three characters around a table: a secretary, a journalist, and a producer. The characters embodying a specific Russian identity have vanished from the screen. Fiction is henceforth being handled like the world, and business deals have replaced narrative plots.

In the first few minutes of the film, images of a woman crossing herself (the unwitting embodiment of a saint seen in profile as represented on icons) and images of a group of radiant naked women playing in a pool (the liberated Soviet woman) are intercut with an image of nostalgia formed by Jean-Luc Godard's actors: Guided by a man's hand, a woman's hand writes "Our Holy Russia" with

lipstick on a mirror. The male hand as a representation of his-story written in the masculine gender. Michel de Certeau: "The sacred text is a voice, it teaches […], it is the advent of a 'meaning' (un 'vouloir-dire') on the part of a God who expects the reader (in reality, the listener) to have a 'desire to hear and understand' (un 'vouloir-entendre') on which access to truth depends."[116] The man's guiding hand as figuring the transmission of a "meaning" on the part of a god who expects the Russians to have a "desire to hear and understand." To wit, the text of a sacred voice writing the History and destiny of "Holy Russia." The mirror as an image of self-recognition in collective space – in this case, in the homeland (the collective mirror stage). "The capitalist scriptural conquest is articulated on that loss and on the gigantic effort of 'modern' societies to redefine themselves without that voice."[117] How can one redefine oneself as being-Russian without that voice? Can one do without a voice? And if not, does Coca-Cola have a voice?

Consider the bracketing (the cross-montage) of two representations of collective future: the color image of a young peasant woman, radiant with joy, lying in the hay, a blade of wheat between her teeth (the glorious, radiant construction of the Soviet Union), and the black-and-white image of Teutonic invaders throwing a child into the fire in the name of the Christian crosses they're brandishing in *Alexander Nevsky* (the destruction of a nation and its values). The stroboscopic flashing as cutting rhythm. Offscreen voice: "Hope belonged to them but that was a trifle for the Russians. The thing was to know what they belonged to, how many powers of darkness claimed them for their own." Cut to a succession of pictures quickening to the flashing rhythm. Intermittent flashes evoking the "dark" forces that reclaimed the Russian people during the course of their History: a wounded soldier, scenes of masturbation and orgies from pornographic films, soldiers strolling in a city and turning to watch a young brunette in jeans, and Teutonic and Livonian knights beheading the men defending the land of Russia in *Alexander Nevsky*. In tsarist hands, the attachment to a land turns into nationalism and hate, and people pay with their lives (the gift of one's body to state power)…In capitalist hands, people sell their ability to work for commercial purposes (the donation of one's body to economic power). Consider two forms of subjection: war and pornography. Two forms of subjection that follow the movement of bodies (the urge for destruction and the libido) to ensure their enslavement. An overlapping of images (and forms) that we do not want to see,

116 OP. CIT., THE PRACTICE OF EVERYDAY LIFE, P. 137.
117 IBID.

that we do not want to recognize…Furtive inserts that the spectator's consciousness scarcely has time to grasp (the stroboscopic rhythm). The furtive insert as formulating the repression of images that cannot permanently settle into collective memory and consciousness…Is subjection – possession by dark forces – the only possible form of being in the world? Is being dispossessed of the self and of the capacity to write one's own history an ineluctable condition? The projection of the self and the community in an elsewhere and an otherwise as a major issue of political and aesthetic representation. "Where did the idea of projecting something arise? Before the invention of film…the invention of utopia." Close-up of Stalin's image (the rallying figure) projected to an attentive audience in a movie theater (the site of collective projection). The figure of power as the origin of a political form of projection.

COLLECTIVIZATION AND PRIVATIZATION OF REPRESENTATION (THE PROGRESSIVE SLIPPAGE IN IDENTIFICATION)

1993. Is it possible to give a new twist to the pictures of promise constructed in the fifties and destroyed through experience? How can a firmly contemporary culture be constructed when the search for a Russian culture seems to lead ineluctably to representations and signs inherited from a History that is over and done with (tsarist Russia)? In a church, an old woman lights a candle (hope)… Her image dissolves into a cinematographic heritage buried in collective memory. Different representations of the History of Russia intermingle on the celluloid surface: from Russia's unification in the sixteenth century as depicted by Sergei Eisenstein in *Ivan the Terrible* to the disillusionment following the collapse of the Soviet empire, via the construction of socialism in Stalin's day. The candle-lighting ritual in church as a ritual that escaped the revolutionary movement of History. A candle-lighting ritual intercut with pictures of old women crossing themselves seventy-five years after the Bolsheviks came to power and pictures of the tsar receiving his last rites from seven priests in *Ivan the Terrible*. Consider a representation of Christian culture acting as a link between seemingly incompatible periods in History. To the slow, repetitive rhythm of religious music, Ivan, his face rigid, his eyes staring fixedly, slowly lays his body down to receive the sacrament. In the slow movement of the image: furtive inserts of Lenin, his eyes shut, during his funeral. The cross-montage between the two figures of power quickens. Resumption of the stroboscopic rhythm. The brevity of the image on the surface of the screen seems to correspond to the brevity of the image on the surface of our consciousness. Images of culture stored in the collective imaginary emerge on the surface of consciousness through formal analogy – that is

to say, independently of a deliberate will to construct. To wit, a montage that concatenates images and brings out the significant lines (the recurrence of certain facial and cultural traits) that more or less consciously compose the imaginary. The slow pace of the sacrament scene gives way to the stroboscopic rhythm (the quickening pace of History). Between the face of tsarist Russia (Ivan) and that of Soviet Russia (Lenin) appear the faces of the Russian people. The bracketing of these faces in an analogical coming and going between two figures of a dying power as formulating the process of identification with power's rallying face – from Ivan the Terrible (Ivan IV) to the "Little Father of the People" (Stalin). Gilles Deleuze and Félix Guattari: "The face is the Icon proper to the signifying regime [...]. The face is what gives the signifier substance: it is what fuels interpretation, and it is what changes, changes traits, when interpretation reimparts signifier to its substance. Look, his expression changed. The signifier is always facialized."[118] Ivan's face is what gives Russia's unification substance. Lenin's face is what gives the Union of Soviet Socialist Republics substance. The radiant face of a young woman singing and marching with a group of musicians at a popular demonstration is what gives the Russian people new horizons. Cinematographic production as producing the meaning of History. Fade out. In superimposition, a young athlete jumping off a diving board and a radiant young woman waving at a passing procession of trucks on a country road. Two images that body forth Socialism's social and political project. The face of power is what gave force to the young athlete (sports as meaning) and to the young woman riding to work on her bike (work as meaning). The contrast (the black-and-white picture of power and the color picture of the people) between the rigidity of the ailing features (Ivan) or dead features (Lenin) of the figure at the origin of the History of Russia and the energy of the bodies that incarnate this same Russia's social and political project. This representation of power acted on the audience as a call to fight or to work (people on the march). The succession of figures of power ("Look, his expression changed") as the rhythm of History. Overlapping faces as bracketing together different phases in History.

But these images no longer adhere to the surface of the film strip and of collective consciousness because they are not articulated with any reality in contemporary Russia. If the type of project and social construction projected by these images can no longer be etched in our consciousness, what types of images are capable of projecting meaning to us – the meaning of our History?

118 OP. CIT., CAPITALISM AND SCHIZOPHRENIA, P. 115.

The reference to peasant engagement (tightly framed faces) rallying around the figure of Alexander against the Teutonic invaders (the masks) in *Alexander Nevsky* as a reminder of a form of projection of the self in a common combat (the unity of a splintered country rallying around the figure of Stalin against the German invaders). Sergei Eisenstein about the scene on the steps in *Potemkin* or the attack of the knights in *Alexander Nevsky*: "This is the glorious *independent* path of the Soviet cinema – the path of the creation of the *montage image-episode*, the *montage image-event*, the *montage image-film in its entirety* – of equal rights, of equal influence and equal responsibility in the perfect film – on an equal footing with the *image of the hero*, with the *image of man, and of the people*."[119] The structuring of faces (of social strata) around a common cause as the issue of a phase in History that is over and done with. Can images – the dynamics of their narrative – still cement a community around a project (the meaning)? And if so: around what project and with what kind of images? In the course of the film, a theoretical exchange: "You have written that there are no shot-reverse-shots in Soviet film. What do you mean?" Reply: "Indeed, there are icons, there are spaces or people filmed from the same camera angle at more or less close range but there are no locking glances." "But then where does the shot-reverse-shot, shot-reverse-shot, bam-bam, bam-bam come from?" Reply: "I don't know. I guess it was sometime around 1910 in American movies. They thought it would be more useful [insert of a pinup girl over an American flag, and the word 'DREAMING' written on the screen] to teach people to watch mindlessly..." Gradual insert of a shot of the rear end of a nude woman bent over an actor. Locking glances, shots of actors looking at one another were absent in Soviet film because the images addressed the political dimension of the imaginary (the History of Russia). The images projected actors looking in the direction of a common combat. Shots of actors looking at one another presupposes setting a common cause aside. A setting aside that promotes the development of a fiction addressing the private dimension of the imaginary (the love story). Shot-reverse-shots (alternating points of view between two people) as formulating relations between couples (bam-bam). Shots of people filmed from a single angle (the community's point of view) as putting on an equal footing the image of the hero, the image of man and of the people (socialism). The collectivization of representation versus the privatization of representation. The USSR versus the USA. The otherwise (the revolution) versus the elsewhere (the dream). Politics (the large stretches of land) versus intimacy (the bedroom). The crowd (being

119 *FILM FORM, ESSAYS IN FILM THEORY*, ED. AND TRANS. JAY LEYDA (HARCOURT, BRACE & CO., 1949), P. 254.

together) versus the beloved (being with you). The people (the motion) versus the pinup (the product). The radiant face versus sex. *The Kids Play Russian* as staging the collapse of representations (of illusions) conceived on the scale of Russian History. Representations (illusions) that have collapsed because they have no specific story anymore…The collapse of the Soviet empire has opened the culture to the highest bidder ("I'll give you 450,000 words"). Representations that collapse, ousted by the means of representation: "Maybe you should drop the audiovisual sector and concentrate on others: cigarettes, for example, or Coca-Cola, or blue jeans." "Our government will never neglect the TV industry, which represents a key principle in our country's economy"…"What about the cinema?" "My poor man! The cinema has been dead for ages. We drove Méliès, Stroheim, and Eisenstein to suicide. We paid the Germans to found Universal and invent Mickey Mouse. And now we are having Steven Spielberg recreate Auschwitz. So what are we talking about? You have $449,827 left." The representation of History is converted into a recreation of History, historical players into bit players, and the land of fiction into market shares. Whereas Soviet cinema projected the prospects of power, the television publicizes the products of manufacturers looking to break into the Russian market. Does the demise of fiction coincide with the birth of production? Does production necessarily spell an end to representation?

Given that an identification with the figure of Mickey Mouse is hardly desirable – the Disneylandizing of shopping in the West having already greatly contributed to turning customers into Toons (and shopping malls into friends) –, with whom can we identify? Are we doomed to live without representations? Meanwhile, the offscreen voice examines what has happened to former figures of identification: "Prince Myshkin took the train with Anna's two sisters. […] But were they, in fact, the real sisters and the real seagull? Anna Karenina was, but I have doubts about Prince Myshkin, and I don't know about the gull. Anyway, I hope she won't end up like the woman on the Odessa steps, in a porn film on one of the twenty-odd mafia-run television stations. I'm all for fiction…but reality has to deserve our help." Does contemporary Russia deserve our help? Eisenstein thought the revolution deserved his help, but does the belated opening of Russian markets to capitalism deserve our help? A capitalism that substitutes the supply for the imaginary. Close-up: The open mouth of a porn actress mimicking pleasure slowly superimposed onto the mouth of the woman on the Odessa steps. The pretence of pleasure (the supply) superimposed onto the representation of pain (History). Faces of production (the instrumentalization of bodies)

and of fiction (the representation of a collective drama) dissolve into one another ...The frightened look of the woman on the steps vanishes from the screen leaving the image of the porn actress (the market economy), which ends with her legs spread apart (the demand). The lap dissolve between two forms of subjection: the subjection of the self to history (the woman-as-victim) and the subjection of the self to the market (the woman-as-object). Eliminating the meaning that emanates from the image of fiction (subverting the features of the face and of a culture) to the profit of the pornographic image as allegorizing the process of commodification of culture, images, and bodies. In Soviet film, the impact of the image extended beyond the duration of its projection. The image projected the audience into a collective project, a social and political endeavor. It served as a model. In the logic of the audiovisual industry, the image requires immediate consumption. Satisfaction versus projection. In the aesthetics of Soviet film, the image projected an outlook that called on spectators to take a stance (to adhere or not). Projection for the community. The audiovisual image asks spectators to choose. The flow of images versus the constructed image. And when the face of the woman on the Odessa steps surfaces (flashes) on the screen again, how do we know that she's not actually climaxing (the negation of History)? If the cinema has been dead for ages, if television has supplanted meaning by demand, how can we be expected to remember the History in which this face is embedded? Who will remember the baby carriage? An insert to conclude: "A world that accords with our desires" (the definition of movies). To wit, a definition which, reclaimed by the audiovisual sector, gives: "A supply that accords with our demands." Faces of identification disappear (the loss of History), the traits of pain and pleasure are conflated (the confusion of planes of reality). *Capitalism and Schizophrenia*: "Conversely, when the face is effaced, when the faciality traits disappear, we can be sure that we have entered another regime, other zones infinitely muter and more imperceptible where subterranean becomings-animal occur, becomings-molecular, nocturnal deterritorializations over-spilling the limits of the signifying system."[120] If the faces of tzarist Russia and of Soviet Russia are gone, if their respective traits (Holy Russia and socialism) have been effaced, what regime has Russia entered? Jean-Luc Godard hasn't a clue. He's cold, he's coughing, and he plays the idiot (out of the mouth of narrators). Absorbed in reading Russian History, a red towel over his head, surrounded by Russian dolls, the Idiot pursues his research on fiction, images, and icons... Meanwhile, what remains of Russia? Icons? Texts? Images of gymnasts at the

120 *OP. CIT., CAPITALISM AND SCHIZOPHRENIA*, P. 115.

Olympics? Russian dolls? History gives way to culture – a culture where be-comings-product occur, becomings-commodified, deterritorializations over-spilling the limits of Russian culture...A culture that is now being disseminated by the media. The market as the issue and financial constraints as the setting. Fade out. Text: "The kids play." Violins under their chins, a group of children walk toward the camera. Text in red: "Russia doesn't play anymore"...Then in white: "The kids are still playing." Kids whom we see playing hockey. Kids in red jerseys (Russia without the CCCP?) versus kids in blue and white jerseys (the United States without the USA?). The disappearance of the name as a sign of the deter-ritorialization of identity. If territory no longer constitutes an issue insofar as its integrity is no longer threatened, if the cultural values that young Russians in-creasingly share resemble those of their American counterparts (the global-ization of behaviors), then kids are no longer playing on the same field as their parents. Nations have been replaced by teams, battlefields by ice rinks, and war by play...There are helmets instead of heaumes, jerseys instead of armor, and the ice of the rink has taken the place of the ice on the frozen lake. Scores ver-sus territories (make sport not war). Competition versus conflict. The war of nerves versus the cold war. Michael Jordan (the poster) instead of Lenin (the face). The progressive slippage in identification. Russian kids have entered the audiovisual age.

BALANCE OF TERROR AND WAR OF REPRESENTATIONS (HISTOIRE(S) DE LA TÉLÉVISION)
1998. A Western television station...1:13 A.M. The mediatized metrics follows its course to pictures of missiles flashing in the sky above Baghdad, and with a total disregard for the History it's supposed to be covering: "...and we have just learned that a presidential palace in Baghdad has been hit by missiles. Ambu-lances are converging on the scene in the Keradar district. That's all for tonight. This is Bob Jones, saying goodnight for CBS News." A stereotyped sign-off, immediately followed by a violent explosion in the capital of Iraq...It was the end of the year, a few weeks after impeachment proceedings were instituted against the president of the United States, accused of having lied under oath to the American people when he stated that he had had no sexual relations with a young White House intern, even as she brought material proof that the head of the world's most powerful country had, in fact, ejaculated on her dress. If the offhandedness and the obscenity of the news commentary about the American attack on Iraq with its total disregard for the civilian population can only shock TV-viewer consciousness, if political news commentators have recently been

bracketing private affairs together with international relations in a way that reveals the extent to which they have confused different planes of reality in their minds, if the sensationalist principles of handling information that inform the tabloid press are now being applied to treat public and international affairs, are we to conclude once again that History is over and done with, that the society of the spectacle has definitively annihilated the possibility of critical consciousness and that the representation of geopolitical developments has become impossible? Before responding to these questions or contenting ourselves with observations of this type: invest the principles governing televised modes of representing the very events that are supposed to partake in the construction of contemporary History. Principles that seem to have distanced us progressively from the historical conditions and contexts in which these geopolitical developments are taking place. If these developments reach us in images deprived of their historical context, how can we make History out of them? How can we articulate whatever critical capacity we have left with the representation of factual events given to us by the media? Work back from the events (the images) to the law that produces and organizes them (the ideology or interests). Choose a category of events (a topic), analogous in their manifestation, and explore their mediatized representations.

Consider the example of Cold War international relations seen through a history of aircraft hijackings...Select archetype images produced by the two blocs, images that influenced the history of these relations, and edit them together with the behaviors that these very same images involved...Show how these images answered and countered one another. Here, East-West relations, elsewhere, resistance in the Middle East and in Asia to Western hegemony in international relations...A resistance that gradually took the form of an armed struggle...An armed struggle that the big powers defined as "terrorist" acts. Show how the commandos used these acts and the mediatized images to attract attention to their demands...

1997. dial H.I.S.T.O.R.Y (Johan Grimonprez): To a narrative line structured by an offscreen monologue, sixty-eight minutes of quotational montage. Quotations – pictures – taken mainly from television archives (news broadcasts, special reports, cartoons, commercials, etc.) and from some fiction films. Even though the film's economy is structured around a monologue, the space in which Grimonprez works is exclusively televisual. A space that informed our collective consciousness during the second half of the twentieth century. A space on four levels: that

of media coverage of a certain number of plane hijackings or the destruction of passenger airlines (from the first recorded hijack in 1931 when Peruvian revolutionaries dropped pamphlets over Lima, and the hijackings with hostages in the seventies, to the regular passenger airlines shot down by combat aircraft in the eighties); that of its ideological and political contextualization (texts, declarations, and testimony concerning the political motives of terrorist acts, stereotypical archive footage showing public political manifestations of the ideological systems that inspired the hijackers, parallels with other forms of terrorist acts against civilians and heads of state, etc.); that of its cultural contextualization (representations of acts of violence in popular culture and of the desire to attract attention to oneself, psychoanalytical approaches to terrorism, analyses of terrorist behavior, etc.); and that of its mediatized treatment (from its dramatization to its trivialization). Four levels that depend on the available stock footage. Stock footage that reflects the ideology informing our political consciousness and our opinions. Stock footage and a construction of information that subsumes our capacity of reception of History.

Between sequences: A brief insert in the form of an image of picture interference suggestive of zapping. The switch cut (the zapping), from one representation to another, from one point of view to another, from one period of History to another, as a model of bringing together information that was not available when the events were first aired. Replaying these images as a first step in distancing them from the facts they supposedly contain. Their articulation (the montage) as revealing a sense. A sense that was drowned in the profusion of heterogeneous pieces of information when these images were first aired on television.

The montage proposed by Grimonprez acts as a model of conscientization of a History that surfaces on our consciousness (on TV) in fragments (flashes) decontextualized from their historical conditions of appearance. To wit, a model (an invitation) for getting back in touch with History (*dial H.I.S.T.O.R.Y*) using the little that has been given to us (the information). An aesthetics of induction and of *making do*. *Make do* with the media, with its gaps, and with the untreated elements – untreated for reasons of ideology or because of an inability to apprehend certain phenomena beyond observing their mere existence. A critical aesthetics of *making do* that requires a delay – the delay needed to interrelate pieces of information accumulated over the years. Live broadcasting addresses an exclusively emotional apprehension – from the mounting suspense during negotiations to the relief when the hostages are freed or the shock when the

hijackers carry out their threats. Live broadcasts may be commented (immediate reactions) but not analyzed (the missing elements and the lack of perspective); *dial H.I.S.T.O.R.Y* addresses a consciousness freed from the initial context of enunciation, the topicality and the technical conditions of broadcasting these images (from live recording to recreations), a consciousness that is not dealing with these images for the first time. A consciousness that Grimonprez places at the center of his principle of montage. Giorgio Agamben about Guy Debord's film work and Jean-Luc Godard's *Histoire(s) du cinéma*: "Repeating and stopping are the two transcendental conditions of editing. They require no filming. Together they constitute a new epochal form in film history. What changes is not the fact that editing constitutes the compositional technique, but that it is moved to the foreground and displayed as such. That is why we can say that film has entered an area of indifference in which all genres may coincide: documentaries and stories, reality and fiction. Films can be made using images from films."[121] If this observation holds true for *Histoire(s) du cinéma* and for a number of other films more focused on the history of cinema than on History, it may no longer hold true for a work on contemporary History. Since the latter is broadcast (television) more than it is represented (cinema), it may be necessary to make films – videos – using images drawn not only from films but also (and especially) from TV. Work within an extended area of indifference in which all (ex-) genres – or rather, all images – may coincide: TV documentaries, radio reports, special news broadcasts, home movies, corporate films, commercials, demonstration films, public service messages, amateur videos, and cinema. Fixed forms (and faith) in fixed genres as a mode of representation conceived for the past.

Back to Grimonprez's work. Above the clouds, a subjective camera embarks the viewers on a plane commencing its approach to the landing strip…Offscreen voice: "Shouldn't death be a swan dive, graceful, light-wing, and smooth, leaving the surface undisturbed?" Violins…sentimental music from some postwar American comedy…The plane lands: Cut to two dummies inside a cockpit during a crash test…Violin crescendo…: Explosion…Cut. The plane nosedives into the camera and crashes to a sound track that simulates and heightens the dramatic intensity of the sequence. A fiction shot dissolves to a documentary shot. A sound track that detaches us from the picture and plunges us into a sensational,

121 "LE CINÉMA DE GUY DEBORD," TRANSCRIPT OF A SPEECH DELIVERED BY GIORGIO AGAMBEN AT A CONFERENCE ON GUY DEBORD HELD DURING THE SIXTH INTERNATIONAL VIDEO WEEK AT SAINT-GERVAIS, GENEVA, IN NOVEMBER 1995. REVISED BY AGAMBEN AND PUBLISHED IN *TRAFFIC* 22, SUMMER 1997.

emotional register…Telephone rings, the word "dial" appears on the screen…a cartoon character picks up a phone and dials seven digits that form the word H.I.S.T.O.R.Y…Somewhere in the middle of the film, an offscreen voice provides an initial explanation of the title: "Some people make bombs, some people make calls…anonymous…bomb threats. People who make phone calls don't set off bombs; the real terrorists make their calls after the damage is done…if at all." Unless what we are dealing with is an appeal to viewers to get back in touch with a History that has eluded us.

Some time after the opening titles: a scene of a fight in a saloon (Western violence) crosscut with a shot of a woman polishing her nails. Shot of the TV screen: "We interrupt this program to bring you a special bulletin…" Close-up shot of a siren, a question mark superimposed on a cloudy sky…a radar…: representation of a map of the Soviet Union. A representation of the Soviet Union from which an animated simulation of a fleet of bombers (Eastern violence) emerges: Flash alert. The program interruption as symbolically formulating an eventual attack on the heart of the American society of the spectacle. A society of entertainment (the Western) and lack of worries (the woman polishing her nails) suddenly disturbed by an implacable war machine: missile-launching…panic scenes…four members of an average middle-class family rushing away from the table to take cover in the four corners of their dining room…single-family homes blown to smithereens…the Statue of Liberty collapsing…a cataclysm that destroys the symbols of property and liberty to the rhythm of brass and percussion instruments. A feared cataclysm that ends with a fifties-cartoon-like image of explosion and a profusion of special effects and sounds that call to mind science-fiction movies. The spectacularized representation of fear (the fantasy) as cementing the Western community against communism. Display of an international tension integrated and culturalized by the movie entertainment industry. A culture constructing the imaginary of a threatened American way of life. History informs culture which deforms History in turn. Some images later, after a short sequence of scenes of emotional reactions to Stalin's death and of collective festivities in the Soviet Union (images that act as a counterpoint to the American fantasy), a short sequence on rats subjected to electrical stimuli in a closed space. Offscreen voice: "There must be something about family life that generates factual error, overcloseness, […] perhaps something […] like the need to survive […]. Fictions proliferate." Which families? Which errors? Those that involve imagining that the communists are coming to destroy the fruits of our success (the well-being of our families and our detached homes)? Those that may force us at any moment

to rush away from the table, take cover in the four corners of the dining room, and lose everything? Mass culture (the stimuli) as ideological conditioning. Stimuli (the production of representations of the other bloc's belligerent intentions) that act as forms of communication of reflexes (rush away from the table to take cover in the four corners of the dining room). Herbert Marcuse: "Today, the mystifying elements are mastered and employed in productive publicity, propaganda, and politics. [...] the scientific approach to the vexing problem of mutual annihilation – the mathematics and calculations of kill and over-kill, the measurement of spreading or not-quite-so-spreading fallout, the experiments of endurance in abnormal situations – is mystifying to the extent to which it promotes (and even demands) behavior which accepts the insanity."[122] Inserts of images of experiments on animals in a state of weightlessness as designating the mystifying approach projecting the Western bloc into the eventuality of a post-human existence. The Third World War as fiction. The balance of terror as a mental construct. Cut.

Historical reverse shot: Athletes parading on the streets of Moscow. A parade of beaming faces. Perched above files of young women marching, an athlete on top of a pole, arms outstretched in a flying position. The athlete as the figurehead of collective enthusiasm. A collective enthusiasm sustained by a sound track of Soviet songs (the rhythm of enthusiasm). The parade as the projection of a desire. Shots of faces in a happy crowd, eyes full of pride and wonderment. Here, Grimonprez retains only the propaganda images from the cultural production of the two blocs, and ignores all representations that may have originated outside an ideological context. Images of propaganda that, transferred into the imaginary of the enemy bloc, instantly turn into clichés that reinforce the fear of others and the desire not to resemble them. The Manichaeism of the opposition in the montage as replicating the Manichaeism of the culture of opposition to the enemy bloc. To wit, a shot-reverse-shot pattern of stereotype pictures. A shot-reverse-shot of lifestyles: the Americans depicted inside their homes (the culture of the private sphere) and the Soviets in the street (the culture of collectivization and the absence of values invested in private property); the former shown with their families, the latter in crowds; the former surrounded by consumer goods (nail polish, convertible furniture, detached house), the others with nothing but their enthusiasm to boast (the outlook of the West easing its political conscience)...Tension between an imaginary of capitalizing goods and an

122 OP. CIT., ONE-DIMENSIONAL MAN, PP. 189-190.

imaginary of pooling energies for collective purposes. Shot-reverse-shot of two forms of representation produced by two incompatible approaches: the collectivization of references and the growing individualization of references. Shot-reverse-shot between constructing one's self-image (doing your nails) and rallying around an ideological figure (Stalin). Opposition between an imaginary of impulsive, individual violence (settling scores in the saloon) and the eventuality of an organized, collective violence (the threat of a Third World War). Montage of two types of representations of the self: a representation of the self founded on an individualization of states of mind (my fist in the face of the cowboy who I already told to get the hell outta here) and a representation of the self founded on collective states of mind (adhering to the project of constructing the Soviet Union). A Cold War between the bloc of materialization of the imaginary (house, nail polish, furniture) and the bloc of projection of the self into an immaterialized future, yet to be constructed (sports as the symbol of the projective movement). The collective (History) versus the individual (anecdote).

A HISTORY OF EYE-CATCHING VISUALS (IS TV-VIEWER CONSCIOUSNESS ANALOGICAL?)
Back to Soviet enthusiasm and the parade…The songs fade into some piano notes…Keith Jarrett…A giant effigy of Stalin is raised…An effigy buoyed up by two blimps…A figure that rises to the sound of the piano…piano notes that touch on a more inward dimension of feeling. National feeling dissolves into a sense of closeness to "our little father of the people"…Effects of weightlessness …Shot of Stalin's figure in the clouds…An American musical score to underscore a Soviet emotion. Are we to conclude that Soviet culture was incapable of producing joyful, lighthearted musical representations of self-transport? Were the Soviets condemned to gravity and heavily underscored scansions? Exclusively collective scansions made for marching in step with political directions set by five-year plans? Are we to hear these Western notes as music imported to meet the emotional needs of the Soviets? Emotional needs that the Soviet cultural industry did not want, or know how to satisfy? An emotional Marshall Plan for reconstructing a private imaginary suppressed by Soviet authorities, supposedly recalcitrant to the individualization of references? Unless we are dealing with a formal choice meant to facilitate the reading of images that have become illegible to the Western imaginary more than thirty years after their appearance. If *dial H.I.S.T.O.R.Y* was conceived by and for Western eyes, the recourse to American musical culture acts as a way of translating a collective emotion that we would not be able to understand in its original language version. Indeed,

when Grimonprez works on the emotional and emphatic register of an image, he uses music with which we can immediately relate. Since Russian and Soviet music is remote from us and far from our habits of cultural consumption, it might be perceived as folkloric and exotic. To wit, a departure from the radicalness of a montage founded mainly on selecting and setting into tension visual and sound documents taken from mutually exclusive cultural registers (blocs), a departure legitimated by the need to take into consideration the conditions of reception. The structuring march of the East (the propaganda cliché) is not opposed to Western rhythms of emotional internalization and individualization (the praise of individuality). The orchestra (the collective expression) is not opposed to the solo (the individual expression)…The song (the cement of the community) is not opposed to vocal silence (interiority). Even though the Cold War prohibited cultural exchanges and promoted a proliferation of visual representations based on what could not be shared with the enemy bloc, even though jazz was long censured in the Warsaw pact countries, Eastern Europeans did not project themselves in a belligerent imaginary. To wit, an obvious fact but one that was always censured in Western modes of representation. A death march rhythm: a panning shot of crying faces intercut with a shot of Stalin's face, his eyes closed, at his funeral…A death march rhythm that gradually fades into the melody that accompanied the raising of the dead man's effigy…In slow motion, children in festive costumes running with bouquets of flowers in their hands…faces beaming… Cut…the image continues to slow down and the notes to sustain it…Perched on a unicycle, an acrobat bear lifts a small child on a hoop up off the ground… On the first floor of a building, a woman on a window ledge is helped down to the ground by some people…The montage of mediatized images is suddenly detached from the logic of historical contextualization…Is this woman running away? Is she trying to join a crowd? To join in the festivities? To join in a protest? Where were these pictures filmed? In the Soviet Union? In Prague? In Budapest (which the next sequence on a Hungarian passenger flight hijacked to West Germany would seem to indicate)? From a building top, the slow motion fall of a cardboard star…Images and symbols, movements, dynamics that lose their sense or rather their contextualization in a historical process. A concatenation of slow, internalized images…Images of rising and falling bodies…sustained by the piano notes…Movements rendered abstract by a montage that seems to echo the preceding sequences – sequences made up of images taken from televised Western culture…Sequences that bracket together an ice skater's triple jump and a small house, sequences in which what the narrator describes as "a smell about the place of unhappy lives in movies" is given the form of a stuffed

animal falling down the stairs or two buildings exploding simultaneously…
Symbolic images that form what seems to elude the ideological context of enun-
ciation: here, desire, a sense of loss, innocence…elsewhere, joy, ordinary soli-
darity…As if some parts of the montage stressed moments of interiorization and
privatization of collective emotions. Emotions that elude the imaginary of oppo-
sition that structures the cultural and political representations of the two blocs.
An echo of recurrent processes, movements and desires in the East as in the
West. The piano as a possible form of bond between the two imaginaries that
everything seems to set apart. Images as a political form of representation (the
Cold War). Music as an apolitical form (détente).

At the same time, this concatenation of images, which seem to be self-sufficient,
works on a more critical dimension. In fact, if the internal dynamics of images
(the impressions and emotions that it reflects) is etched in our consciousness,
the dynamic in which they were embedded (the historical reasons) has been
forgotten. In the event, the radicalness of the principle that consists in associ-
ating certain images on exclusively formal criteria (rising or falling movements)
or emotional ones (the feelings that seem to inhabit the protagonists during a
moment in history independently of the specificities of this same moment) acts
to reveal a logic of televisual montage that gives priority in the rushes to the "eye-
catching" visuals (the condensation of the news). Emotion as an element of ad-
hesion to images or rejection thereof. A movement of adhesion or rejection that
is unreserved (the critical distance) and unmediated (the commentary). Images
that television viewers remember (the impact) – at least those who saw them
when they were first aired – but that they can no longer situate (the memory).
If the television is an instrument for recording collective memory, are we to con-
clude that the historical context to which these eye-catching visuals belong
has been definitively erased from this same collective memory? If the principle
of condensing news events answers the desire to place viewers in a position
of empathy with the events they are watching, must this same principle obliterate
History? A History – or rather events in the news – that can be shared by the
majority of people (emotional content as the lowest common denominator). As
if events in the news had to be shared…As if events in the news needed to ad-
dress a compassionate consciousness…As if the montage and the mediatized
choice of images were addressed to an analogical not an analytical conscious-
ness (formal or anecdotal parallels instead of analyses). To wit, a critical sequence
on "now here's a wrap-up of the major news in pictures"…Pictures that work
to the detriment of an "analysis from our special correspondent."

The game of opposing representations (shot-reverse-shot) in which the two blocs were engaged also participated in redefining international law. A definition that changed depending on which bloc was doing the defining. June 1965. Televised report: "A Hungarian airliner stands on a NATO airstrip in West Germany at the end of a daring flight to freedom across the Iron Curtain." Freedom is the West...Herbert Marcuse: "Such nouns as 'freedom,' 'equality,' 'democracy,' and 'peace' imply, analytically, a specific set of attributes which occur invariably when the noun is spoken or written. In the West, the analytic predication is in such terms as free enterprise, initiative, elections, individual."[123] Whenever the West is mentioned in a context as being opposed to the East, the attribute "freedom" invariably appears. "The analytic structure insulates the governing noun from those of its contents which would invalidate or at least disturb the accepted use of the noun in statements of policy and public opinion. The ritualized concept is made immune against contradiction."[124] An immunization that, even today, permits Western countries to identify themselves invariably with "freedom," "peace," and "rights" in the conflicts that oppose them to countries in the Southern hemisphere. The recent example of the Gulf War and the ensuing policy of disarmament control in Iraq as corroborating this identification. An immunization that gives rise in Western consciousness to a world of out(market)laws. Text: "Neither East nor West applauds planes seized to the 'wrong side' of the Iron Curtain. New Word Invented: HIJACK!" So much for the sequence taken independently of the film's overall economy (the sequence as it was broadcast). On the other hand, the montage in *dial H.I.S.T.O.R.Y* makes it possible to articulate this information embedded in the history of the Cold War with the abstract desires, movements, and dynamics highlighted in some of the earlier sequences. An open-ended montage directly connecting feeling to History and bypassing ideology. A craving for freedom identified not with the West but with the ice skater's triple-jump, with the feelings that probably animated the athlete perched on the top of the pole arms outstretched in a flying position, or with the imaginary conveyed by certain silent movie images, like the one of the motorcyclist trying to grab hold of a rope ladder to climb onto a plane that is taking off... Moments of interiorization and of privatization of emotions that can take on political forms...An unresolved question: When can movements of desire rejoin movements in History?

123 *IBID.*, P. 88.

124 *IBID.*

PICTURES TAKEN HOSTAGE (ABOUT ATTEMPTS TO HIJACK HISTORY)
The seventies. Hijackings of passenger airlines accompanied by hostage-taking in the name of political reasons deemed criminal by the targeted powers become ever more frequent. To possess a territory, to take part in the construction of the History of international relations, or to be dispossessed of this land and have to go underground. When the Western countries refuse visibility to political conceptions and identities that do not serve their interests (the ones dictated by the market economy), when these conceptions are forced underground, then a form of war based on threat and terror emerges. A war that escapes the bounds defined by international law and the East-West dialogue. Regular armies give way to commandos. To wit, a deterritorialization of conflicts. Deprived of a territory (a land), the actors in this hitherto unknown form of conflict reterritorialize themselves in an interstitial space – outside the land that is refused to them, between the nations that make up the international community and are recognized by it. Airspace as a symbolic space for communities deprived of territories. Airlines as symbols of mutual recognition between existing states. Conflicts between armies give way to terrorism.

A terror that is no longer informed by a hoax (the representations that sustained the balance of terror in East-West relations). A terror that has a direct impact on the bodies and consciousness of TV viewers (carrying out the threat of executing a hostage). The feared moment loses its phantasmal character. The eventuality can turn into a reality and conflicts that were localized in the Southern hemisphere begin to have repercussions in the Northern hemisphere. The elsewhere and the near future land here and now. Reality catches up with fiction. Jacques Derrida: "Among the filters 'informing' the information reported in the news, and despite an accelerated and hence all the more ambiguous internationalization, is the ineradicable emphasis on local, national or Western events which overdetermines all the other hierarchies [...]. This emphasis subordinates enormous quantities of events distant from the nation's (supposed public) interest [...]. In the news, the information is spontaneously ethnocentric; it excludes the foreigner, sometimes inside the country, and this independently of any nationalist passion, doctrine, or declaration, and even when the subject of the news is 'human rights.'"[125] In fact, the media grants visibility to representatives of a cause distant from Western preoccupations when, and only when, they threaten

125 JACQUES DERRIDA, BERNARD STIEGLER, *ÉCHOGRAPHIES DE LA TÉLÉVISION*, ÉDITIONS GALILÉE/INA, 1996, P. 12.

our integrity directly. Subordinating the different liberation movements, subordinating territorial deprivations in the Middle East, subordinating Maoist opposition to the social and political model of capitalism...The terrorist logic probably involved reducing the distance (the ignorance, indifference, and contempt) separating Western ethnocentrism from remote minority causes by appropriating the media logic. Use Western media to fight against the same media's tendency to reduce minority causes to silence. Take the image by storm. Surface violently on Western collective consciousness (or rather, the lack thereof).

If the threat is no longer a hoax – because it has been carried out –, it constitutes, nevertheless, an element in the construction of a representation. A representation that works on the level of our relationship to a part of History that has been hidden from us. Back to the first few minutes of the film...May 1970. Hiroshima airport. A hostage is executed in front of the cameras. Consider the construction of an unbearable image that, relayed by the media, was to impress the collective consciousness. An image that can be read on an exclusively emotional register. An emotional shock that negates any possibility of distance (the representation) between the event and the spectators (the rational, analytic apprehension). A shock but no comment (no language). The unnamable can be neither uttered nor explained. To wit, a reintroduction of terror into the Western imaginary. If terror was always present in the news in the form of crime stories, as it was in literary and cinematographic fiction, it had never been mediatized in this way before. The terror had always taken place in the past or somewhere else, never directly in front of cameras and aired live. Offscreen voice: "All plots tend toward death. This is the nature of plots, political plots, terrorist plots, lovers plots." If all plots tend toward death, terrorist plots remain invisible until the final act. In TV-viewer consciousness, only the final act exists (from the hostage-taking to their liberation or execution) – its history, its context of enunciation, its historical conditions of emergence are never televised. Final acts that only let a part of the narrative plot seep through: namely, the relations with the hostages and negotiations with the authorities. Final acts that are articulated in TV-viewer consciousness not with the commando's political and historical motives, but with the threat of death hanging over the hostages. In the event, the dramatic tension is all that exists in the audience's consciousness. Terrorist acts are always situated in a history whose existence we ignore, out of a lack of information. To wit, the impossibility of articulating these acts with other images – images that the media would have brought to us prior to the event. Herbert Marcuse: "If the linguistic behavior blocks conceptual development, if it militates against

abstraction and mediation, if it surrenders to the immediate facts, it repels recognition of the factors behind the facts, and thus repels recognition of the facts, and of their historical content."[126] If the media surrender to immediate facts (here, the hijacking of passenger airlines), if they repel recognition of the historical conditions behind the demands, then the History in which the minorities making the demands are embedded is left without representation (the invisibility).

Back to the execution of the hostage in front of the cameras (during the time of televised coverage): a final act (a picture) with no History. A History that gives way to fiction. In the event, the live broadcasting and the program interruptions to "keep you up-to-date as soon as there are any new developments" introduce the necessary ingredients for making the news as enthralling – even if it has become horrifying – as a good thriller: namely, apprehension, suspense, and anxiety. Birth of the "news noir" genre. Dramatic tension (live broadcasting) versus History (knowledge). The framing of the aircraft immobilized on a runway evacuated for the circumstance as a magnifying device. Another voice: "It's a curious knot that binds novelists and terrorists. What terrorists gain, novelists lose. [...] Years ago I used to think it was possible for a novelist to alter the inner life of the culture, now bombmakers and gunmen have taken that territory; they make raids on human consciousness." Raids (the surprise effect) whose historical basis is far from our concerns. Raids whose abruptness fits perfectly into the news flash. Flashes (raids) that break into (interrupt) the stream of information that composes a pseudo-History broadcast live (our consciousness). To wit, a form of action that was in step with the emerging news aesthetics in the seventies. When visual impact (the emotional thrust) was turned into the foundation of news broadcasts, the media became the objective ally of the terrorist enterprise, even though one of its initial functions was to ensure that minority political demands remained invisible. If History requires time for analysis (the delay needed to develop and contextualize an event), raids call for the flash (the impact). Raids that burst in on our consciousness, that wrench us out of the torpor (the indifference to the Other and to the otherwise) that we need to continue dealing with our affairs (our private interests). If novelists made us aware of the political and social environment in which we were embedded by attracting our attention to the different types of relationship that we had with the components of this same environment, terrorists work on our consciousness by depriving us of any other possibility of constructing a relationship to the History in which they are embedded

126 OP. CIT., ONE-DIMENSIONAL MAN, P. 97.

than the one based on shock, a refusal to understand, and rejection. The novelist's work took place over time in a slow process that offered us elements of analysis, the terrorist operates on the spot. With the televised news for support. Abruptness for rhythm. A support and a rhythm that definitively cut us off from a History already declared an out(market)law by the main Western powers. A History that we are no longer capable of understanding but that upsets worldwide public opinion. When sensational history replaces History…

August 1975. Kuala Lumpur, Malaysia: Shot of several men boarding a plane. The Japanese Red Army flies to Libya. Cut to close-up of Mao Tse-tung slowly turning his head. Cut to shot of a crowd holding up Mao's Red Book. Text: "Mao said, death can be light as a feather or heavy as a mountain." Cut to a series of short sequences of crowds animated by the same thoughts…"Let a hundred flowers bloom." Crowds chanting Mao's name while holding up his writings… Crowds wearing headbands, marching to the rhythm of a revolutionary ideal… Crowds brandishing slogans and clashing with the army…Crowds dragging a man to the ground…Crowds pushing their representative up to a tribune to the sound of applause. Crowds actualizing words (implementing a projection). Back to the offscreen voice closing the sequence on the Cold War: "We understand how reality was invented. A person sits in a room and thinks a thought, and it bleeds out into the world. Every thought is permitted, and there is no longer a moral or spatial distinction between thinking and acting." The History of the twentieth century was often written before it was constructed (in the sense that Lenin and Mao Tse-tung's writings preceded the history of the Soviet Union and of the People's Republic of China), but this same History – this plot – is still perfectly illegible to TV-viewer consciousness in the West. In the event, the pictures in Johan Grimonprez's montage flit by too fast for our eyes (our memory) to grasp their exact thrust. Pictures that we can no longer situate on a map (where did these demonstrations take place?) and chanting that we don't know how to translate.

HISTORY SUBJECTED TO THE TEST OF IMAGES (EMOTION AS A WEAPON AGAINST DEMANDS)
The History of the second half of the twentieth century was recorded by cameras caught in the confusion of events, and delivered in incoherent bits and pieces… Bits and pieces that now must be articulated with one another. Editing stock footage as a mode of writing a History that was televised live, with no delay (critical distance). Offscreen, the same chanting…tens of thousands of offscreen

voices (the crowds)...A chanting that fades into the sound of Muzak and pictures of a plane immobilized on the runway in Kuwait in 1973. Hundreds of flowers and a chanting that is translated into the act of taking hostages. Cut to images of negotiations being conducted in a control tower in July 1973 at Baninah airport, Benghazi, Libya. Pictures of negotiations that end in the explosion of the immobilized aircraft. Shot of a cameraman...Thick black smoke. The cameraman moves offscreen: shot lingers on the camera. At this stage in the sequence, neither the visuals nor the montage specifies that the commando exploded the Japan Airlines Boeing 747 after having evacuated the 143 passengers. Is this to underscore the symbolic dimension of the explosion? An explosion, or to be more precise, a spectacular image addressed exclusively to the media? The freeze-frame on the camera as designating who's being addressed. A symbolic image in which only the dramatic tension counts (the plane, hijacked over Amsterdam, was taken to Dubai before being flown to Libya) and its spectacular end (the explosion)? A spectacular image that does without passengers and without actors? Is Johan Grimonprez's selection of information, or rather his obliteration of certain information – in particular whatever concerns the demands and the identity of certain commandos (with whom are the Libyan authorities negotiating?) – meant to expose the mediatization process alone? A process that consists in detaching events from their political context to etch them in a succession of exclusively spectacular moments (the different stages in the negotiation, the eventual execution of hostages, the different stopovers, etc.)? As for the spectators who have either never seen these pictures before or saw them when they were so young that they cannot situate them in their historical conditions of appearance, how can they read the montage proposed in *dial H.I.S.T.O.R.Y*? Is there nothing left on the surface of our consciousness besides bits and pieces (the spectacular effects of History)? A succession of places and names? Places that seem to have marked TV-viewer consciousness more than the political motives or the identity of the factions involved. A concatenation of facts with no history. If motives and negotiations cannot be visually recorded, then they are simply left out (and offscreen). A historical offscreen that serves the logic of detaching the subject-viewer from a consciousness of History.

Johan Grimonprez's montage acts as evidence of the slow dispossession of History by the media. A concatenation of images detached from their topicality that seems to construct not so much a history of international relations as that of the mediatized treatment of History. A treatment that turns mediatized History into news topics (decontextualization), and news topics into facts (events

reduced to an accumulation of facts that are visible to a cameraman). The hijacking without the motive. Giorgio Agamben: "The historical experience is through images and the images themselves are charged with history. Our relationship to paintings can be regarded from this perspective: they are not motionless images, but rather still frames charged with the movements of a motion picture that we lack."[127] The pictures in *dial H.I.S.T.O.R.Y* are charged with political and social movements from a History that we lack – or rather from films that were never made. Films that would have provided us with a representation of the ideas, projects, and reasons that animate the militants of a cause, and which are hardly ever mentioned in mediatized treatments. To wit, a montage sequence of different moments (different shots) generated by a point of view (an ideology) about History in the making – from its theoretical projections (Mao's Red Book) to its different interpretations (from street demonstrations to plane hijackings).

HISTORY SUBJECTED TO THE TEST OF ANECDOTES (THE CAUSE AND THE COUCH)

After the political point of view, the point of view of Dr. David Hubbard, founder of the Aberrant Behavior Center, Dallas, Texas, concerning the skyjacker's profile: "A large number of them are very acutely suicidal, so to threaten a skyjacker with the possibility of death, is like telling a child, 'If you'll be bad, I'll give you candy.'" Consider an attempt to articulate the psychological together with the historical. An articulation that reduces the political dimension (the motive) to a pretext. Cut to image of a plane prototype nose-diving and crashing. Cut to David Hubbard: "There are certain rather uniform aspects about them, including a most unusual aspect of dream life…": black-and-white shot of a man running and swinging his arms up and down with two planks attached to them in the guise of wings…"in which they dream of being able to fly." To wit, the statement of a point of view that isolates individuals from the collective movement to which they belong (the crowd and the chanting). A psychological point of view that refuses History. When the scientific point of view serves the approach of its ideological context of enunciation…The individual versus the class, individualism versus communism, the self versus the people. But at the same time, inserting psychological reasons (the private) into a montage of political motives (History) seems to respond to a question rarely conscientized on the scale of geopolitical historical developments: How can we articulate intimacy with History? The

127 *OP. CIT., TRAFFIC.*

technique of insertion in the montage as evidencing modes of insertion of the self into the course of History. The unconscious pursuit of a dream that certain skyjackers have had since they were children as a mode of bursting into political History. A History that, insofar as terrorists are concerned, would not involve actors fully motivated by a common, political cause. Cut. Advertising Muzak… Color shot of stewardesses sitting around a table in miniskirts and knee-high boots under the flashes of photographers. Stewardesses or models? The silent visuals show us one of them speaking into a microphone held out to her by one of the journalists, but what is she talking about? About a recent hijacking (which the narrative structure would seem to imply) or the new outfit she's wearing?… Back to the doctor's face and some further information regarding the point in question: "There is one little airline that has real short-cut skirts and a real sexy sort of a rig and that one little airline has been hit in complete disproportion with the magnitude of the traffic that it hauls." Cut to brief insert: A man wearing a hat and a mask waving. A brief insert of an odd picture…The binary logic articulating the private together with the political becomes muddled…A rider welling up out of childhood? A masked man who thinks he's Zorro? A righter of wrongs in an air terminal? A solitary avenger of victims expropriated from their territories? An insert that represents the typical profile of a skyjacker as described by David Hubbard? "But here is a man who has really no sexual experience at all and he looks at a hostess as a sexual symbol and when he takes his gun and sticks it in this good-looking girl's belly and says, 'Honey, we're going all the way …to Cuba,' he may very well be making the first sexual gesture in his life. […] First time in his life he has ever scared a woman." When sex serves political interests (the libido in the service of ideology)…Is this an attempt to empty certain terrorist acts of their political substance (the demands)? Who is speaking? The doctor (the psychological reasoning) or the American citizen (the ideological stance)? Does the libido count as a historical motive? Must we accept this cliché that involves implying that sexual frustration is sometimes at the origin of world affairs? Can impulses act on History?

CAUSES AND DEMANDS WITH NO IMAGES (AN EMANCIPATION IN SEARCH OF VISIBILITY)

Music: A disco beat and lyrics very much like those used to present products on a TV game show…A middle-class interior…Shot of a piece of living room furniture from the late fifties…A housewife wearing a tight-waisted flared dress and boasting an advertising smile demonstrates a sort of convertible coffee table–cum–television. Rhythm intensifies, close-up of the television screen. To the

same sound track, cut to a woman wearing a short plaid skirt carefully frisking a young woman wearing red bell-bottoms…A body search that dates to the end of the sixties…Camera follows the movements of the hands running over the clothing…and then lifting up the bottom of the pants to reveal white wedge sandals and a revolver taped to the calf. Body search or fashion show? Advertising pose or arrest? Fiction or demonstration film? Documentary or public service announcement (Beware of stereotypes…Anyone can be a terrorist)? Meanwhile, was the person who filmed this scene aware that h/er framing was informed by advertising aesthetics? An aesthetics to which the young woman being searched also seems to have subscribed? Indeed, if the attitude of the woman who is searching makes her look like a suspect, the pose she strikes while being searched seems especially designed to show off the cut of her clothes and the elegance of her bearing…A fashionable figure (the cover) in the service of an armed struggle. Step out of the baby-doll image (the one to whom you can say "Honey, we're going all the way"…) and become active. The masculine hegemony that reigned over the armed struggle loses ground. To the continuing sound of the disco music with its refrain, "I'm every woman," that becomes etched inside us, cut to two images of Leila Khaled (a photograph and footage from a film)…Two images – two facets – of a single woman: the smiling activist wearing an army uniform and holding a machine gun, and the worried activist in civilian clothes…Montage of two attitudes in the face of History: engagement in its construction and subjection to its pressure (the place it assigns to us). A statement by Khaled written onscreen: "My rendezvous with history was approaching…" To wit, a refusal to submit to the historical process that dispossessed Palestinians of their territory. A conception of History in which individual acts can modify the direction of History…A conception that stands out against the one imposed by capitalism. Contrast between the smile of the sex object who is silent and that of the woman activist who speaks her mind. Contrast between a submission to the order of things (the reduction of the self to a body objectified in an image) and an affirmation (the capacity to say "I"). An "I" that attempts to participate in the writing of History. The woman of action (a woman engaged in an armed struggle) versus the Western woman as sex object (the sexy TV host, the woman polishing her nails, and the stewardesses). The outdoor woman (the participation in a collective movement) versus the interior housewife (the retreat into the private sphere). Stay at home and let History take its course without us or leave the place assigned to us by capitalist ideology and participate in changing the course of this same History. The montage of different types of images of women as staging the clash between two myths,

two manners of being in historical time. A way of settling down (the detached house, interior decors…), putting oneself in the position of a spectator to a History that we leave to the media to tell us about (the shots of television sets and news reports), remaining passive and staying out of affairs (the sexy chick), and a way of participating actively and directly, without mediation, in the movement of History. A clash between two imaginaries: an imaginary of opposition (the undermining of the model) and an imaginary of subscription to the model of alienation (the consumer boom at the beginning of the sixties).

A shot of Mouna Abdel-Majid: "For you Westerners, you don't understand, you have all the Israeli propaganda, you think the Arabs…the dirty Arabs…We have to fight outside our territory." Cut to Yasir Arafat and Fidel Castro raising their arms, fists joined, in front of a crowd. Question from a Western journalist: "The people that you helped to release were responsible for the death of a small child, what are your feelings about that?" Mouna hesitates…Adel Abdel-Majid replies: "You have just said the death of a small child…I want to ask you, the death of thirty children of a school in Egypt, the death of about seventy human workers in Egypt…the death of many human beings that have been killed, murdered I could say, by the Israelis." The shot-reverse-shot (the creation of a tension between two points of view that do not work on the same plane of reality) as an allegory of incomprehension, of an impossible dialogue between imperialism and liberation movements. An incompatibility between a culture overly attentive to individuality and a commitment to an armed struggle aimed at gaining recognition for a people wiped off the map by Western contempt. September 6, 1970. Palestinian activists, including Leila Khaled and Adel Abdel-Majid, hijack five planes. To wit, an attempt to attract world attention that Adel Abdel-Majid explains at the end of the sequence: "It's not hijacking, let's say. You should say it's trying to tell the people what's our problem. All these twenty years none of you foreigners had ever known that there exist people called Palestinians…two million human beings thrown out of their home, of their land, of their pride, of everything." The mediatization of the issue as a response. Shot-reverse-shot between unexplained images of hostages being liberated before two aircraft explode and Western reporters asking questions. Shot-reverse-shot between silence (the cause) and chattering (the reactions)…The reaction of a woman in her sixties who had to run across the airstrip without shoes when the commando gave the signal…The reaction of a boy who, in answer to the journalists' insistent questioning about whether he was frightened, replies that he wasn't scared and that he actually had a good time…The reaction of a member of the crew

disgusted by the twenty-five million dollars going up in smoke. Shot-reverse-shot between a mediatized cause without words and a spectacularized event...An event spectacularized in terms not of the cause but of trivial personal anecdotes. The close-up of the woman's feet without shoes as a way of disregarding the political reasons for the hijack. Divert Western attention from the cause to make sure that Western consciousness continues to ignore what it must not know.

Opposite what captures the attention of Western TV audiences – the dough (twenty-five million dollars), the anecdotes (the bare feet), and the spectacle (the explosion) – Adel Abdel-Majid's words (the demands) with no images. An absence of images linked to an absence of territory. Territory as the stage of representation of the self. The absence of territory (the stage of representation) forces the Palestinian people into invisibility. The representatives of the Palestinian cause as figures expropriated from the setting (the land) of their inscription. A deterritorialized people, deprived of the stage of representation of its history (the visibility), forced to express themselves without being able to offer an image of themselves. 1993. Giorgio Agamben: "Before extermination camps begin to be opened again in Europe (which is starting to happen), it is necessary for nation-states to dare to question the very principle of inscription based on nativity and the territory-nation-state trinity founded on it."[128] This principle of inscription still governs people's rights to recognition. In fact, before the recent developments in what the main Western powers define as the "peace process" (a way of diverting attention from the expropriation of territories), what images did we have of Palestine? What representations did we have of the Palestinian people and the Palestinians? None. Recognition of an identity requires being able to present an image of this identity...Recognition of the Palestinian identity by the international community required an image of this same identity...Deprived of land (the territorialization of the self), a Palestinian identity could not take shape. An identity reduced to a movement (a will to become), a movement to reconquer this same land. 1993. Giorgio Agamben: "One of the options being considered to resolve the problem of Jerusalem, is for it to become the capital of two different state bodies without any territorial division. The paradoxical condition of reciprocal extraterritoriality (or better yet, of aterritoriality) that this implies could be widely applied as a model of new international relations. Instead of two nation-states separated by uncertain, threatened borders, it would be possible to imagine two political communities based in a single region and in exodus inside

128 *LIBÉRATION*, JUNE 9 AND 10, 1993.

one another, connected to one another by a series of reciprocal extraterritorialities in which the guiding concept would no longer be the *jus* of the citizen, but the *refugium* of the singular."[129]

In the meantime, if the image of a community is still founded on belonging to a land, if knowledge and experience of the world is now being constructed on the basis of cinematographic and televised images, and if speaking into a reporter's microphone only means something when it is supported by images (words as sustaining images), then Adel Abdel-Majid's declaration cannot make sense in the minds of TV viewers. It cannot make sense because the spectators have no pictures to relate to what they are hearing. Mao Tse-tung or Nikita Khruschev's declarations took shape in (and were strengthened by) movie images or images showing policies being implemented (portraying the community on the march or at work), those of Adel Abdel-Majid refer only to themselves. Declarations that ran counter to the interests of the Western community…Words that ran counter Western images. Demands for rights that could only come up against contempt from this same community of interests. A contempt that would mark the start of a radicalization of violence. In fact, since words could not have the impact of images (could not reach TV-viewer consciousness), the representatives of the Palestinian cause seized the images (made raids on consciousness). The birth of terrorism.

A SENSATIONAL HISTORY (REPRESENTATION YEAR ZERO)
Back to one of the early sequences in the film. November 1969…First transatlantic hijack…An image of too little significance in itself (the fantasy of reenactments). An absence of pictures of the plane and of the escalating tension during the hijack…An absence of pictures that calls for a form of substitution…: drums …long guitar solo…bass guitar riff…archival footage…carabiniers embarking on a manhunt. The repetitive bass notes as a practice of news dramatization at the end of the sixties and in the seventies (the replication of the heartbeat). To compensate for the non spectacularized images, which leave few traces in our consciousness, sound tracks were often used as a mode of communicating the gravity of the reenacted event. Birth of an aesthetics of dramatization of History. A dramatization that terrorism was to turn into one of its main weapons.

129 *IBID.*

Offscreen voice: "Some people make bombs, some people make calls, anony-
mous, bomb threats. People who make phone calls don't set off bombs, the
real terrorists make their calls after the damage is done, if at all. The next time
– he thinks – there won't be a call." By catching the media off guard (the tele-
phone call), terrorism countered the absence of televised representations of
its demands. Since the media had reduced the news to shock images and
phrases, terrorist strategy consisted in producing shocks. Shot of a public place.
Hundreds of people sitting in an auditorium…Sound of gunfire…: The people
duck and try to protect themselves under the seats…Cut to same shot replayed
in slow motion. Exhibition of a televisual method of spectacularization of an
event. Since the action is too sudden and rapid for TV-viewer consciousness
to grasp at normal speed, journalistic representation stretches time so that we
can thoroughly immerse ourselves in the event. Paroxysm of an aesthetics of His-
tory in flashes…Flashes that can interrupt the course of our lives (our programs)
anytime, and especially anywhere…Flashes the intensity of which is the only
element that is reenacted (the impact versus the demands). An intensity that
occupies the entire surface and the entire duration of the image. News events
fall into a state of shock. A state of shock spectacularized and stretched out
by a technique (slow motion) commonly used in fiction films (from horror movies
to X-rated films) and sports broadcasting…A "let's see the action again in slow
motion" approach to the world…An approach that plunges consciousness into
horror so as to divert it from History. A way of attracting attention that relies on
the voyeuristic impulses of TV audience consciousness. Teleportation of a thrill.
A treatment of images that satisfies our craving for emotions more than our
need for knowledge. When History starts to satisfy a demand…A few sequences
later, to the shot of a tight-rope walker who ends up losing his balance and
falling, offscreen voice: "Every disaster made us wish for more, something bigger,
grander, more sweeping." The performance imaginary (sports, competition, etc.)
fills viewer consciousness with a History whose spectacular manifestations are
renewed at a stepped-up pace (the escalating violence). A treatment of images
that fictionalizes History to the detriment of its meaning (the escalating demand).
A History (news) converted into a TV serial. Shots of gunfire in bluish images
taken from fictional representations…But we haven't a clue to the motives be-
hind it. The spectacle of violence retains only the gunfire and its impact (the
gratuitousness). Information is over. The show can begin.

The rhythm of the film picks up speed…A few sequences on terrorism in the
Reagan years (antiterrorist training courses, assassination attempts on different

heads of state, etc.) to the sound of Western music countered by crowd movements carrying Ayatollah Khomeini's effigy to the sound of Oriental music…Cut to a fiction film projection in an airplane…: a man falling into the void…subjective camera…Exhibition of a technique of embarking the spectator into the movement of fiction…A now common technique in the treatment of current events… A technique that needs no comment…A technique that removes us from History and drives us definitively into the sphere of the spectacle…: History as if you were there…Dark screen: 18.21.55 GMT, interior of a fighter plane cabin… radar tempo…offscreen voice…Soviet pilots: "'What are the instructions?' 'The target is decreasing speed.' 'The target's altitude is 10,000.'" 18.23.37 GMT: "I'm dropping back, now I will try a rocket…" 18.25.11 GMT: "I'm closing on the target." 18.25.46 GMT: "Missile warheads locked on…" 18.26.20 GMT: "I have executed the launch…" 18.26.22 GMT: "The target is destroyed." It was September 1983…The target was a passenger plane…A Korean Airline…and this sequence was aired all over the world. News turned into gore. When the mediatized representation becomes the circumstantial ally of barbarity…The narrator's offscreen voice: "We don't need the novel." At this degree of efficiency in re-enacting an event, a question: Are images still subjected to political or ideological interests? If the dramatic density of this document could still nurture violent anti-Soviet feelings, the reasons behind showing it had more to do, no doubt, with TV ratings than with propaganda policies…Acknowledgment of a separation between government and media…A media that gains in autonomy because political powers no longer have the means to control it. A media freed from political supervision but subjected to economic control. The propaganda is over.

Whereupon comes an eleven-minute sequence of shock scenes…Scenes decontextualized from their conditions of appearance (The Highlights of History) …The montage resembles a pop clip…: Rescue crews arrive on a scene, rush to transport wounded hostages to a techno beat. Cut to a blank screen: "Insert commercial here." Cut…sound and picture interference that evokes zapping… Cameras swept into the heart of the action, a sequence of subjective shots of street fighting…we follow a group of armed men…gunshot: camera falls…A conception of current events that sweeps the viewers into the fall: oblique shot of a piece of the wall as seen by the camera on the ground…as if you were there …Cut to shots of a TV show audience applauding. Cut to flashes of commercials for a carpet-cleaner, toothpaste, fried sausages…The consumption of current event images dissolves into product consumption…A growing sense that

the news is turning into a commercial...A commercial for life endangered just about all over the world in all those places that don't concern us anymore...A horrifying History that becomes entertaining...Pictures of a variety of catastrophes ...Cut. Shaky camera: heartrending scream...pan to the place where the scream is coming from...: Kennedy airport...zoom in: A woman lying on the ground... A woman screaming as she hugs someone in her arms: "My baaaaaaaabyyyy!" A scream to the clicking of flashes...Spectacular emotion...Tears that need no comment...A few scenes later, gunshots resume...a special intervention unit attacking an Air France aircraft at the Marseilles airport in 1994, bombs exploding in the streets...Resumption of the-camera-swept-into-the-heat-of-the-action aesthetics...November 1990 and February 1993 in Leningrad/Saint Petersburg: Music from an American TV series...The Russian police break into a building where terrorists have just taken refuge. TV viewers are right behind the man who is chopping the door down with an ax...the door gives way: gunshots...a man on the ground, fatally wounded...the microphone approaches: "'Can you talk?' 'Stomach...a bullet in my stomach...' 'Why do you want to take hostages?'"... The man is dying!...A policeman crosses himself...Close-up on a wound...The army evacuates the rest of the commandos as the techno music resumes... The men are dead or wounded...Sequence of close-ups of bared parts of the body dragged on the ground and of faces twisted in pain...A pornographic aesthetics in the treatment of current events. Comments and analyses have disappeared long ago (the pictures that the television stations buy again and again are not meant to inform). A form of journalism that takes over from terrorism when it comes to staging the unbearable. Cut to Boris Yeltsin singing into a microphone at a festival in a provincial town...Boris is drunk...he can barely stand on his feet...And the Western television networks wonder how Russian affairs are being handled...The same television networks that buy images of candid on-the-scene reporting that allow us to follow armed interventions as if we were there...A picture of the Russian president that is aired as if it were a major political event on the evening news...A picture that allows networks to dispense with focusing on specifically social, economic, and political questions...In short: Seen from the West, Russia = Yeltsin; Yeltsin = Vodka; Vodka = Russia. A neat circular reasoning, too neat to be disturbed. A way to revel in the idea of Russia on the decline. And for confirmation, while Boris holds his note as long as he can, Donald Duck rings a bell in the middle of a crowd singing along with their president...An image far from the White House...An image far from the Soviet Union...Brief insert in slow motion of young children in festive costumes running with bouquets of flowers in their hands...A reminder of beaming faces...That

242

was in the fifties...in the Soviet Union...Western powers have always enjoyed stereotype representations of this region of the world. The reconstruction of a representation of Russia as the point at issue.

Back to the West...Blue sky...Air France plane coming in for landing...Music... music that we know from the first few notes...music that was a hit in the sixties ...music with a chorus and an instrumental section that made us swing...a hit that made us swing...one of those hits that gets your feet moving..."Oooh, oooh, oooh, oooh, oooh...Do it...oooh, oooh, oooh, oooh, oooh...Do it..." (The Hustle)...Cool music to sustain the picture...A shot of the plane, seen in three-quarters view, that could figure in an American TV movie or in a commercial for the French national airline. Pan...the plane is heading right into the woods... it's gonna crash...: thick black smoke rises...the instrumental intensifies as the woods catch fire...Vocals gets louder, repeating the refrain "The Hustle...Do it..." The tragedy dissolves into a cool hit...Great crash...An explosion that comes with the refrain...A cool shot...A super crash with no hijacking, no history, nothing. A spectacular crash with no political motives. In the meantime, while waiting for information that the black box will deliver and to end the film: a final shot of Bill Clinton in a fit of laughter, backslapping Boris Yeltsin. What a cool History this is! "Oooh, oooh, oooh, oooh...oooh...Do it...The Hustle...Do it..." Taken out of context and placed in conclusion to this montage of events that participated in the construction of the second half of the twentieth century, these final two sequences constitute two emblematic images of contemporary media logic. A logic that consists in hijacking images, diverting them from their history... Two sequences that, articulated together with the others that form the narrative line of Johan Grimonprez's film, suddenly appear to be relieved of the burden of their political thrust and of the individual fates that they mask...Images that mean something by themselves to TV viewers who, encouraged by Bill Clinton's uncontrollable fit of laughter – not to mention his slap on Boris's shoulder (That Boris is one hell of a guy!) and V. McCoy's refrain –, can let themselves go... "Oooh, oooh, oooh, oooh, oooh...Do it..." What a great crash that last one was ...So cool that Grimonprez adds a couple for the road...A Best of Crashes, all airlines considered...in slow motion..."Oooh, oooh, oooh, oooh, oooh...Do the hustle...Do the hustle..." A compilation of the top of the contemporary tragedy chart to the music of one of the top hits of the seventies...What a cool crash clip that was...Crashes to be appreciated more than commented...Crashes the likes of which TV-viewer consciousness is always asking for...Replay ("Do it"): the terror dissolves into the cool song and viewer consciousness into the rhythm.

Current events staged in clip form ("Oooh, oooh, oooh, oooh, oooh…") as an end to History. Birth of indifference.

GO BACK UP THE CHAIN OF SIGNS THAT CONNECT US TO WHAT WE PERCEIVE OF HISTORY

THE ORDER OF THE SOCIAL (THE USE OF ANALOGICAL CONSCIOUSNESS) 1997. *Déposition* (Jean-Luc Moulène): Consider a set of fifty-two photographic images...An animated discussion between two men, a man squatting by the side of a car on a street in Paris, a guard crouching in a supermarket, a blind man pissing on himself, a handshake in a public place, three fire department vehicles parked in front of a station, two people filling out an accident report on the hood of a car, a dog with an erection, a man reading a history of Poland on a bus in Paris, a police car in Berlin, a woman carrying her sleeping child in her arms, a woman inserting her credit card in a cash dispenser, a street demonstration, sleeping dogs, a deserted street in which the green color of a fence around a construction site picks up the color of a bank logo, and so on. Photos taken for the most part in major European cities...A few pictures taken in the mountains or in the countryside...Street photos shot with all the profusion of signs, details, anecdotes, and phenomena that make up our day-to-day cityscapes...Street photos taken on the way to the bank or on the way to a friend's place, with a point-and-shoot or disposable camera...Street photos of poor image quality, silk screen printed and blown up to billboard format, restored to city scale (3.9 by 5.8 ft, 115 x 175 cm).

In a place of transit, somewhere – around an airport or a train station? –, a support of a concrete building...a massive, imposing structure...in untreated concrete. A three-pillar support whose branches meet at the base. Three imposing branches that occupy the center of the picture...A picture (a view) that is necessarily structured around the pillars...At the foot of the base, amid greasy paper and empty cups, three sleeping dogs...Some people in the background...: short-sleeve shirt with a floral design, tank-top, Bermuda shorts...It's summer. In a white light, some barely discernable buildings, buses, and a number of parked cars...Some people waiting. Masked by one of the pillars, a person astride a barrier...bare leg nonchalantly dangling...Slow pace...Stiffling atmosphere... Dogs seeking a bit of shade...A bit of shade on a dirty littered ground...Not much light...An atmosphere that becomes oppressive...heavy...: Vision of three branches piercing through the ground like an arrow. The sleepiness of the animals suddenly calls to mind another image...an image of three corpses around a pillar. On another poster, in the center, a woman walking on the street past two men unloading a truck...On the sidewalk, some tools: a spade, a broom, a bucket, a yardstick, a cable...Behind the woman, scaffolding covering the front of a nearby building. The woman has her hands pressed against her cheeks... Has she forgotten her keys? Does she have a toothache? Is the noise deafening?

The noise of the city? Of an alarm? Of construction work? The picture is slanted, the angle of the shot tilts the scene to the left...A contemporary *Scream*? An attempt to give a representation to a sensation that has none? There is nothing in the rest of the picture to retain our attention ("everything is normal")...passersby heading home with their shopping, walking to a metro station, waiting for a light to turn green...The other passersby do not retain our attention because they have grown accustomed to the noise...Integrated violence (culture). *Déposition*: An aggregate of tiny, ordinary details, drowned in the torrent of activities, pointed and shot before they disappear into the flow again. Details that we start relating to other details...elsewhere, in other pictures (the montage)...: a little girl holding her leg in pain...a blind man pissing on himself at a crosswalk...Details that become signs (the interpretation)...Signs of harshness...Signs that gradually direct our gaze and organize our view of the cityscape around certain constant features that we begin to discern...Constant features that we end up noticing and capturing – recording – and that seemingly organize our reality, even though there is no apparent order organizing this same reality. The journalistic approach (photojournalism) as a mode of formulation. A mode of formulation that we are used to when it comes to apprehending distant realities and being informed about things that are foreign to us...A mode of formulation that seizes distant realities in pictures (photo-reportage). Jean-Luc Moulène: "Selecting these images involved an editorial thrust, pushing the consequences of press-type pictures to their limit. [...] These are photos that cannot do without textual comments...The captions make the story."[130] The use of photojournalism for reading nearby realities. If we are no longer able to translate into experience the space and time in which we live every day, if we go home "wearied by a jumble of events, [...] however entertaining or tedious, unusual or commonplace, harrowing or pleasurable," none of which will become experience, and if "this non-translatability into experience [...] now makes everyday existence intolerable"[131] (Giorgio Agamben), then appropriating a mode of apprehending distant realities and applying it to the scale and dimensions of this jumble of events – however entertaining (a passerby in front of a shop window, whose yawn makes him look like one of the grotesque masks in the window) or tedious (the rain), unusual (the absent expression on the father's face) or commonplace (a dog with a hard-on), harrowing (a man pissing on himself at a crosswalk) or pleasurable (the rear end of a young woman in tight shorts) – could constitute the mode of translating into

130 UNPUBLISHED INTERVIEW WITH THE AUTHOR.

131 *OP. CIT., INFANCY & HISTORY*, PP. 13-14.

experience that we lack. The montage of signs (the constant features) scattered over social space and time as a model of access to a dimension that exceeds what the eye of a passerby can apprehend in a single moment (an isolated anecdote that does not yet constitute a sign). Relating and setting into tension images that do not necessarily evoke the same space, the same time, and the same situation as formulating a conscientization of events that we encounter. The montage of constant features scattered throughout the cityscape as a way of activating consciousness of the forces, laws, and History that underpin social order.

Back to the pictures of the man pissing on himself and the girl holding her leg in pain and crying...The blind man is alone, and nobody seems to be paying any attention to what's happening to the little girl – neither the two men standing nearby, nor the one who took the picture...Should the photographer have intervened? Isn't there something more urgent to do at this precise moment than to point and shoot? Probably it's nothing but a little scratch...But then why take the picture? And what are we to see in this picture?...A picture that reflects our vantage point as onlookers, passersby, magazine readers, or TV viewers...In the event, Jean-Luc Moulène's shot seems to have more to do with the way we have of seeing such pictures, or of behaving if we had been where the men are, only a few feet away, rather than with the scene per se...A picture and a way of seeing that calls other pictures to mind. Pictures of a little girl trapped in the mud, dying as her family, neighbors, rescuers, and journalists looked on powerlessly...A struggle with death that lasted several days...Was it in Colombia? Was it after an earthquake? A hurricane? A mud slide...We don't know anymore...It was in South America...It was in the midst of rubble, and television networks from around the world had rushed their TV crews over to follow what was to become a death aired live...A death followed around the clock...Accompanied to the point that our compassion was turned into obscene voyeurism. The live broadcast of a child's death...What made me think of it? What made me relate the pictures of these two girls? On another poster: a woman carrying a sleeping child in her arms...In the background, a building that is hard to discern and a railroad track ...The picture is dark, the colors have turned bluish...The child's legs are completely relaxed...The woman is walking straight ahead...She is seen from behind ...The space in front of her is empty. She's crossing a street in Paris, but what we see is another picture, a picture that left a mark on audience consciousness during the Vietnam War...A woman walking straight, alone...alone with a child in her arms. Our consciousness is analogical. We see with other images. Back to

the picture of the little scratch…Is our way of seeing informed by our TV audience consciousness? A consciousness alienated by the spectacle of pain dramatized in pictures and its mediatized use? If TV audience consciousness is voyeuristic, then transposed to our experience in the social sphere (the experience of the bystander), this same voyeurism produces a refusal to help. As if we were dealing with an image, a spectacle…a scene in the life of a city. The derealization of what is close to us as a consequence of the spectacularization of what is distant. The transposition of the journalistic form (photojournalism and montage) to the social sphere as revealing a way of seeing what is close to us. A way of seeing that limits our experience to the sole dimensions of what we see. We are not part of what we see. The coming and going between the mediatized experience of what is distant (the little girl dying in Latin America) and our gaze here and now (the little girl holding her leg and crying) as a form of inserting a moment in time (the anecdote) into History.

THE USE OF SURVEILLANCE (SOCIETY OF SUSPICION)

Jean-Luc Moulène: "What is a testimony? What is a document? What is an event or a fact? How is a fact formed by the nature of the testimonies? What is its result? How does an urban anecdote turn into a moment in History, when others don't?"[132] In Ireland, two friends on the same bike…They're riding down a street, that won't go down in History. 1992. *Disjonction, Untitled n°5*: On a sidewalk, in front of a police station, a man in sunglasses casually strolling by…Behind him, another man adjusts his glasses to read a piece of paper that he's holding in his hand…Is he a simple passerby looking for an address or a plainclothes policeman? Vincent Labaume: "We have all the grounds for presumption. His overly plain clothes betray him to the practiced eye. The piece of paper he's examining while he adjusts his glasses has all the characteristics of an ID card. What could be more natural than an identity check in a place like this?"[133] Birth of a suspicion.

1996. For weeks after the explosion of a makeshift bomb in a Paris train station, France's major cities lived under the threat of new attacks…Birth of a psychosis. Attacks imputed to "armed Islamic groups" even though no one had claimed responsibility for them. Armed Islamic groups with relays located in some low-class suburbs, labeled "problem areas" by the media and by government authorities.

132 UNPUBLISHED INTERVIEW WITH THE AUTHOR.

133 "UNE DERNIÈRE," IN *JEAN-LUC MOULÈNE, ŒUVRES*, EXHIBITION CATALOGUE (ÉCOLE RÉGIONALE DES BEAUX-ARTS, NANTES, 1995), P. 3.

Birth of a form of paranoia. Authorities who ask the public to stay vigilant and to alert the police if they see any suspicious-looking packages. A call for vigilance that revives a culture and a history of mistrust and fear of the Other (the one with a "criminal face"). A mistrust and fear of the Other that legitimates the reinforcement of identity checks. When reasons of state join up with a Western community consciousness founded on rejecting other ways of being and thinking ...The society of suspicion. A suspicion cultivated in the Northern hemisphere where "criminal faces" are spot checked (the discerning eye) and where the public is advised of the need to stay vigilant (from the anti-terrorist security operation codenamed "Vigipirate" to the xenophobic discourse of the far right). A public constantly on the lookout for signs of eventual disturbances to public order. Suspicion as a mode of educating a certain type of civic consciousness. A civic consciousness that turns every passerby who is not immediately identifiable as belonging to the same community as I do (the difference) into a suspect. Vincent Labaume: "Even though we can't see the face that we assume is on the card, nor can we see that of its eventual legitimate possessor, any more than we can see the face of the shifty 'inspector,' the whole optical setup of identification is configured on the picture [...]. Oddly enough, we have only clues not faces, yet we can feel the injunctive force of their conformation."[134] If the passerby is not guilty, what are the elements and laws (the configuration) that arouse suspicion in civic consciousness? The sunglasses? The casual stride? The presence of someone nearby that makes him look like he's under close surveillance? The color of his skin? The news? Unless it is a matter of unconsciously relating a number of heterogeneous factors, such as the setting (a big city, the front of a police station) and the presence of a man examining what looks like an ID card. Factors that turn the passerby, whom the racist, xenophobic culture describes as a foreigner (the "criminal face"), into a suspect...As if the figure of the foreigner could only surface on Western consciousness in a context of suspicion. Jean-Luc Moulène about Geneviève Clancy's thesis on the aesthetics of violence: "She concluded with the idea that one day there would have to be an aesthetics of suspicion. I can't help noticing that this same suspicion constitutes the 'basis' of human relationships in the West. [...] I decided to use the notes I had taken during her dissertation as the editorial line for this exhibition. The images are strung together as much visually as word by word."[135] Birth of the *Déposition* project for the Paris Musée d'Art Moderne.

134 *IBID.*

135 UNPUBLISHED INTERVIEW WITH THE AUTHOR.

1992. *Disjonction*, *Untitled n° 5*: suspicions that undermine being-together (the atomized community of paranoid individuals). 1997. *Déposition*: Surveillance devices lost in the hustle and bustle of the city. Somewhere in Paris, in front of a Nouvelles Frontières travel agency, a double-decker Paris-Vision tour bus and a couple pushing a baby carriage in the middle of the street. No other traffic and few passersby. The men are in short-sleeve shirts, the trees have lost their leaves…Picture of a nice fall day. A postcard picture (Paris Vision) of a lazy day for a stroll (the carefree couple walking in the middle of the street)…So much for the background. In the foreground, a white car. Three men inside. A fourth man squatting by the right front door of the car, eyes turned toward an object situated outside the frame. Three people who seem to be watching something, while the passenger in the backseat consults a document. A car that looks too plain in a city form that abounds in signs and logos. People who look a bit too discreet on an unusually calm day. A plainness and a discretion that indicate an unmarked car. Figures of suspicion set against a peaceful background. A vision of law enforcement (police surveillance) in a society in the Northern hemisphere. The point & shoot or disposable camera as a means of capturing contemporary practices of control. The exhibition of the image in a 3.9 by 5.8 ft format as a mode of revealing (the enlargement of the foreground) the workings of a society of surveillance and an imperceptible moment in History. Here on the scale of the city under police surveillance, elsewhere on the scale of a private company. First picture…In a store, amid cleaning products and photo equipment, hiding behind a column with a fire extinguisher, a guard leans his head out to watch a suspicious-looking customer. An uncomfortable posture that is waiting for proof (caught red-handed). A posture employed in the service of profits. Second picture…The guard in the same position seen from closer up. The passage from one picture to the next and the disappearance of the surveilled customer as modifying the nature of our gaze as spectators. A surveiller who becomes the one who's surveilled and a spectator who becomes the surveiller. Birth of a suspicious gaze. The articulation of the two pictures as formulating the passage from a society of surveillance to a society of self-surveillance. The "deposition" of captured pictures in a museum as an aesthetics of deciphering procedures of surveillance and control in the democracies of the Northern hemisphere. In the event, Jean-Luc Moulène's images do not serve to document the suspicious conduct of some foreign-looking person but rather the suspicious presence of some form of close surveillance. A *Déposition* in response to the society of surveillance: If this same society surveils me or asks me to be vigilant, then am I not entitled to wonder about the motives behind its policy

of surveillance? Suspicion as the sine qua non condition of emancipation.

THE CITIZEN, THE CUSTOMER, THE USER, AND THE PASSERBY (HISTORY'S BIT PLAYERS)

Déposition: An example of an assemblage (the editorial line) that makes it possible to go from information (the images) to History (the order of the social). An example, because if the pictures were placed together with different pictures or in a different exhibition context, the anecdotes (the signs) would form another editorial line. An example of an assemblage in the form of questions: In what context (the History) are citizens, customers, users, and passersby (the social) embedded? Around what History are our representations organized? What relationships do citizens, customers, users, and passersby (the characters) have with their History?

Posing at the foot of a monument of Karl Marx and Engels, a woman in a dark coat raises her eyes to the sky. A dark coat whose color and cut seem to go perfectly with the monument's straight lines and smooth texture. A citizen pose in a context of remembrance (the historical consciousness) or a souvenir pose (the touristic consciousness of History)? The monument as reflecting a bygone political representation: that of projecting the individual into a collective project based on common ownership. Unless we are dealing with an original representation of the trinity, a trinity meant to take the place of dialectical reasoning …Eyes raised to the sky as figuring a mystical pose. A pose that stands out against Marx seated with his hands on his thighs. Souvenir photo of a nostalgia for revelation at the foot of the utopia of pragmatism. Elsewhere, in other images, the recurrent presence of a bank logo – that of the BNP (with 1,400 ATMs throughout France at the time of these scenes)…Logos (forces) around which less contemplative behaviors are organized…Image of a woman withdrawing money from a BNP ATM. The BNP? An economic force that substitutes the figure of users and customers for that of citizens and believers. What figures does my bank statement allow me? Figures adapted to my means? Must I reconcile myself to the idea of my financial status determining my status in the world? Is what I have left in my account the only medium between the world and myself? A world whose marketable dimensions are the only ones accessible to me? Money as the only possibility (means) of giving shape to my projects? Buying power as doing power? Money as a contemporary mode of world perception. The possibility of withdrawing cash around-the-clock seven-days-a-week no matter where you are as the prospect. Overdrawing as the limit.

A relationship to the world that is handled and calculated on the basis of income …The control of my expenses as the control of my destiny. A destiny to be revised solely as a function of my revenues or unforeseen expenses? A destiny decreed not by a superior or transcendental force but by what's left on my account? A budget-destiny? Is my destiny in the hands of banks? If the spiritual and the political are no longer apt to act on History, are we to conclude that banks will be decreeing our History from now on?

Apparition: In a bus in Paris, a man absorbed in reading (the past) a history of Poland…The book cover is in the colors of Poland – red and white – as is the reader, who's wearing white clothes and has a red bag slung over his shoulder. A total identification with the nation (giving oneself over, body and soul) or a coincidence? And if there is really no coincidence, is such an attachment to the nation tenable? What contemporary figures can still be drawn out of a national history? Elsewhere, in another picture, two men in short-sleeve shirts are arguing. One is holding a newspaper…An exchange of political views? Comments about a sports event? A discussion concerning a private matter? If the context and subject of debate elude us, the proximity of the history of Poland and of a monument to dialectical reasoning seems to point us in the direction of a political discourse (the expression of a political stance). A discourse that is no longer incarnated in representations, but that circulates among citizens (the exercise of direct democracy). Here, the figuration of democracy, elsewhere the unconscious figuration of power. Blue sky…unobstructed view: At the top of a mountain, looking down with their hands on their hips, three men in the middle of the landscape. Three hikers looking with satisfaction at the ground they've covered or three men about to divide up the territory they've just conquered? Three men who seem to belong to three different social classes but who are united in the way they have of unwittingly embodying figures of power. Manliness personified …An attitude with no object (the mountain belongs to everyone). A vacation photo or a poster celebrating the end of the class struggle? An ad for Evian (health and fitness) or for the middle class (making it to the top)? The introduction of a new Holy Trinity (the absence of debate)? A show of satisfaction (the work accomplished)? The picture tells us nothing more. Three figures that do not seem to be imposed by any context…Sole certainty: Whereas most of Jean-Luc Moulène's pictures work on a disjunctive principle, here the figures seem to be in perfect harmony with the context in which they are set. Three ways of being perfectly integrated into the landscape, three ways of feeling perfectly at home in it…In short, a picture of consensus.

Vincent Labaume: "If [Moulène] picks out what seems like the most anecdotic aspects of information, this is because information is always a tissue of forces, law, and history which are never proclaimed as such. And yet, this is one thing that photography really can render: simple anecdotes that configure a play of forces, a state of the world."[136] Blowing anecdotes up to poster format as a model of appropriating a form used for the public display of behaviors (advertising and information). A dream of public display. A dream of displaying what has no representation…A dream of displaying images of desires that are not for products (the supply)…A dream of displaying behaviors that escape the market economy (two men in Ireland whose friendship has nothing to do with beer)…A display of behaviors that escape instrumentalization (a white woman and a black woman whose discussion has nothing to do with a public campaign against racism)…A display of a way of being lost in one's thoughts while waiting for the light to turn green…

136 OP. CIT., DÉPOSITION.

FOR CANCELING THE DEMAND (THE AESTHETICS OF SATISFACTION OR
YOUR MONEY BACK)

If our lifestyles and ways of being in the world are handled and calculated on the
basis of income, are we to reconcile ourselves to the idea that limited financial
resources necessarily result in an existence of limited scope and no financial re-
sources in being excluded from the community? Does living inexpensively mean
living less well? If products shape our desires, if their use is a materialization of
our needs and desires, then haven't a number of us stepped into a discount
lifestyle? A lifestyle that would be the mere shadow of the existence to which we
aspire? A lifestyle, reduced in choice (generic products) and in taste (artificially
flavored products)? Are there any alternatives? Without breaking the law (becom-
ing a thief) or sponging off others (becoming a burden), is there any way of by-
passing the market economy that index-links our existence to our income? Far
from the back-to-nature subsistence farming of the sixties and seventies, is an
alternative consumer mode conceivable in the conurbations of the Northern hem-
isphere? An alternative consumer mode that could keep in step with the law
of supply and demand, even though its practitioners are on welfare? 1996. Paris:
Every morning for three months on the metro line between Champs-Élysées
and Nation, Matthieu Laurette gets on the train: "Good morning. Instead of ask-
ing you for money I'm here to tell you how you can get money by buying prod-
ucts with refund offers." Thereupon follows a brief description of how to obtain
refunds after using all kinds of food and other consumer items available at the
supermarket…On to the next train. An operation on the scale of the economy
and of our expectations.

Are you going to believe what you hear on the metro? How is it possible to get
your money back on a product you've already used? Can buying products with
a "satisfaction or your money back guarantee" suffice? Matthieu Laurette: "For
more than three years, I've been eating for free using 'satisfaction or your mon-
ey back' guarantees and I'm in great shape. I've been able to wash and shave,
and keep my clothes, my dishes, my windows, my floors, and bathroom clean
for free too."[137] A look at how one person managed to use the marketing strate-
gies developed by our economic system rather than spend his time accumu-
lating the money necessary to enjoy this same system: shopping for special of-
fers. Forget about choice and make the most of the system. An example of an

137 "LES BONS PLANS DE MATTHIEU. MANGEZ SATISFAIT OU REMBOURSÉ," *BONS PLANS MAGAZINE*, NO. 1,
OCTOBER 1996, P. 36.

offer made by Charles Gervais for a new caramel custard dessert: "If you are not satisfied with our new caramel custard, your money will be refunded. We will refund the full price of your purchase, postage included upon written request, by credit to your card account or by business check if you made your purchase with a check or in cash. One refund per customer only. Simply write within 120 days of purchase to 'Charles Gervais Caramel Custard Dessert. Satisfaction or Money Back Guarantee Sogec Management. 91426 Morangis,' explaining the reasons for your dissatisfaction so we can continue our ongoing program of product improvement. We require that you send the register receipt showing the store of purchase, the date and the price you paid."

After making sure to ask for a register receipt for this item alone and eating the Caramel Custard, Matthieu Laurette's reply by letter: "I am not satisfied with your Charles Gervais Caramel Custard Dessert. I find it much too sweet and artificial tasting. What's more, it's hard to open. Please send me my money back. Enclosed you will find a copy of the register receipt. I also request, as specified in the terms of your guarantee, a postage refund. Thank you, Matthieu Laurette." A few days later, reply from Charles Gervais: "To whom it may concern, Thank you for writing to us about our new Caramel Custard Dessert. We would like you to know that your comments will be taken into consideration in our ongoing effort to improve the quality of our products and increase customer satisfaction. Charles Gervais has taken the utmost care in the preparation of our new Caramel Custard Dessert, made with fresh eggs and then oven-baked delicately at just the right temperature until it is golden brown on top. In the hope that you will be satisfied in the future with Charles Gervais products, please find enclosed a check covering the cost of your purchase and postage. Please do not hesitate to contact us for any farther information at our toll-free number, 877 892-4563. Yours sincerely, Charles Gervais, marketing department." A reply that turns into a promotional blurb for a consumer who is not going to read it. Is it possible to make a custard dessert with eggs that are not fresh? Can we imagine the Charles Gervais group broken down into as many pre-industrial-style shop confectioners as the demand for authentic home-style cooking requires? Who can mistake a brand name (Charles Gervais) for a man's name (Charles Gervais)? A correspondence with a fictive correspondent (Charles Gervais) using culinary terms that have lost all meaning (Imagine a hand rising lovingly out of a container on the assembly line to delicately place the custard in the oven!).

To change our eating habits: break the habit of looking for a certain taste and a certain brand, and get used to a different rhythm – that of new product offers and market turnover. Adapt my eating habits to match the pace of new product launches and special offers...The paradox of a situation in which the body is necessarily in on the latest products on the market even though only very small sums are deposited in the bank account...the sums of product refunds...: $1.29, $2.79, $0.89, etc. The paradox of a body that cannot satisfy its tastes (choose) but is getting to taste all the latest products on the market. The total alienation of one's body by special promotional offers and the refusal to choose as a form of resistance to a mode of life subjected to the law of supply and demand. Divert marketing and communication strategies developed by corporations (Matthieu Laurette versus BSN) in order to develop an aesthetics of living outside the conditions imposed by market economy societies. Consume without paying. "I started because I had money problems and it was a way of eating without breaking the law. Now, it represents a saving of two to three hundred dollars a month." Consume without contributing to economic growth (cancel the purchase). Consume while depriving the manufacturer of its expected profit on the sale (get your money back). Undermine the relationship of necessity linking the supply to the demand. A supply suddenly deprived of its demand. Turn the consumer pattern around: Ask the supply to pay for its demand. Adapt your demand to the promotional offer (accept your condition as a target) and then reverse the direction of the monetary flow. Ask the manufacturer to pay the consumer and not the other way around. A payment made not for a product but for a refusal to pay (demand a refund). A change of directions that suddenly strips the product of any commercial value...A product stripped to its practical value (taste and nutrition). An aesthetics of diverting and blocking: diverting commercial strategies and blocking the economic circuit.

CONSUMERS OF THE WORLD, UNITE

If Matthieu Laurette started out because he had "money problems," by 1996 he was mediatizing his strategies on "how to eat for free." A mediatization that was intensified and diversified in 1997. His strategy of diverting and blocking (which was, of course, never stated as such) became the subject of articles and interviews in the media: from the columns in housekeeping or practical magazines to the front page of the authoritative French daily, *Le Monde*, or prime-time network news. In 1997, Matthieu Laurette opened a web site, *The Web of Refunded Products*, with a call to a radical economy ("Everyone can eat for free"), which he followed up on by handing out tracts, organizing guided tours of

supermarkets, and giving presentations on the road, from his truck. Six years of public information operations during which time the marketing departments of the major manufacturers had to find legal ways to tighten their refund rules in an attempt to limit their use: "Most offers are limited to one per household [...]. To buy the same product more than once, simply ask your friends and relatives to use their addresses and accounts."[138] The mediatization as a way of politicizing resourcefulness. A dream of an extension to this strategy. Fiction...Stage 1. Go along with economic indications, market studies, product designers, and manufacturers by buying their products. The proliferation of purchases (and buyers) as participating in the development of a market (the custard cream dessert market). Stage 2. When the market is booming (the successful custard cream launch), send back the promotional "money-back guarantee." If new products are crucial to growth, then the great number of refund demands is a first move against all-out growth.

138 *IBID.*

IV. DEFICIT OF IMAGES AND LACK OF REPRESENTATIONS

IS THERE LIFE BEYOND THE LATIN QUARTER?
(FOR A DECENTRALIZATION OF THE "I")

TENEMENTS AND WOOD-PANELING

A question to begin with: Can you imagine Bergman shooting a film in the Bronx or Desplechin in the poor suburbs of Paris? Is it possible to conceive of existential questions and intimate psychological dramas that are not set in deserts or in upscale city centers? If wood crackling in the fireplace and wind gusting over deserted plains offers an atmosphere that is highly appreciated in cultural circles, is it impossible to get back in touch with oneself without them? Does the absence of wood paneling imply an absence of psychology? Is Janet's contempt for Bill who is secretly in love with Susan and unable to make up his mind peculiar to the interior architecture of New York's Upper East Side? Is the silence that absorbs Mary too deep for a tenement building, five minutes from a commuter train into the city? Could the function of cinema boil down to plotting a map of affects that coincides with recent urban developments (the spatial fracture)?

Given the urbanization of mental constructs and the urban use of psychoanalysis, the staging of intimate, psychological, or existential dramas seems to have gradually moved from rural areas to the major city centers in the Northern hemisphere (the climb up Stromboli set in the Latin Quarter). Fiction: In the sixties and seventies, the cafés on the Left Bank were a favorite place for getting together (and for the exchanges necessary in the construction and exploration of the self). Cafés as a place and time suspended between two periods of activity. The break as a private or political moment. A cup of coffee or a glass of beer as a social bond. Places for getting together, exchanging thoughts and developing awareness. To construct a space for words right in the midst of the hustle and bustle of the city. The image as framing a context for speaking. 1973. *The Mother and the Whore* (Jean Eustache): shot-reverse-shot between faces (the staging of an exchange) in a café in the Latin Quarter on Saint-Germain-des-Prés. Alexandre delivers a series of abstract thoughts on the subjects of love, money, politics, and society. Veronika listens. Alexander transposes, Veronika speaks body and desire...Alexandre speaks about love (speaking of a third person), Veronika speaks body (speaking in the first person). Gilles Deleuze and Félix Guattari: "The face constructs the wall that the signifier needs in order to bounce off; it constitutes the wall of the signifier, the frame or screen. The face digs the hole that subjectification needs in order to break through; it constitutes the black hole of subjectivity as consciousness or passion, the camera, the third eye."[139] Framing the face as a form of enunciation of the self. To become the subject of

139 *OP. CIT., CAPITALISM AND SCHIZOPHRENIA*, P. 168.

one's desires. The body acts or is acted upon. The dialogue between two faces makes it possible to shape the "I." Cafés as settings for faces to emerge from the crowd (the emergence of the "I"). Henri Lefebvre: "We have seen the consequence of eliminating streets (ever since Le Corbusier's 'new towns'): all life disappears, towns become dormitory towns, and there is an aberrant functionalization of existence."[140] If nineteenth-century cities – modeled on Paris – offered a balance between circulation (the activity) and places for getting together (the cafés), modern cities give priority to circulation over meeting places. Manhattan's grid pattern as archetype. Fast-food as a get-together reducer and productivity booster. Circulation and the exchange of goods and services versus being together. If many European city centers are still capitals of the "let's get together and have a drink" scenario, what type of scenarios can suburbs, new towns, satellite towns, overspill estates, and cities without city centers offer? Deprived of centers, are they doomed to generate feelings, attitudes, and behaviors that have nothing to do with intimate, psychological, or existential matters? L'Ami de mon amie (Boyfriends and Girlfriends, Éric Rohmer) to demonstrate that people can still fall in love in Cergy-Pontoise's high-rise blocks on the city's outskirts as long as there is a café-brasserie and an esplanade as a remake of the town square. The Decalogue (Krzysztof Kieslowski) to demonstrate that concrete highrises can still house existential questions as long as there are people capable of using their imagination to create the conditions for meeting others (get a job as a milkman to meet the woman who lives in the building facing your apartment or send her a fake registered letter to get her to come to the post office where you work). If modes of being in relation to places (the practices) are now patterned on the functional separation of zones (shopping zones, industrial zones, residential zones, amusement zones, etc.), then being a resident becomes a matter of occupying a parenthesis between two periods (two zones) of activities – commercial or industrial. Dormitory towns. 1993. "Urban zoning regulations are based less on density than on the more or less intensive principle of functionally separate spaces."[141] So where can people meet one another? On the platform of train stations? In night clubs? Waiting on line at Super Wal-Mart? Could Alexandre and Veronika have met each other and talked about themselves at McDonald's? Can parking lots and stairways become sites of the self?

140 LA RÉVOLUTION URBAINE, (GALLIMARD, 1972), PP. 29-30.
141 CIRCULER DEMAIN, DATAR/ÉDITIONS DE L'AUBE, P. 174.

ZONING AND BECOMING-STATISTICS (AGAINST THE PANORAMIC VIEW)
The nineties. The urban sprawl went along with the progressive disappearance of cafés and public squares as city centers organized around a town square were supplanted by business and shopping zones situated on the periphery of residential zones. Zones where "the supermarket, slot machine, and credit card habitué communicates wordlessly, with an abstract, unmediated commerce; a world thus surrendered to solitary individuality, to the fleeting, the temporary, and ephemeral" (Marc Augé).[142] Martha Rosler on the spread of shopping malls in such cities as Toronto, Minneapolis, and Houston: "The primary justification for this internal importation of the suburban mall is simply to remove the pedestrian/shopper from the street. Demoted to a site of surveillance and vehicular passage, the street is abandoned to maintenance services and the occasional spectacle."[143] The deserted public space loses its function as a place of meeting and sociability and becomes, in the case of a logic of zoning in which functional specialization is pushed to its term, "a waste space left to the socially fugitive and the unhoused – those unable to buy or to serve."[144] If the urban sprawl has been accompanied by a growing scarcity of places of identity and relationships and a functional specialization of space, if many peri-urbanites feel that there is no place for them or that they are superfluous because there's less and less work to share (the conjugation of the self in the active form), does that mean that living in tenements is necessarily conjugated in the passive form (waiting for a job, waiting for unemployment benefits, waiting for a train) within a state of isolation? Does living in peri-urban zones necessarily mean living on the outer fringes of the imaginary around which people in upscale city centers organize their lives? The proliferation of satellite dishes as substantiating the isolation of tenants.

What representations do we have of living on the periphery of places where intimate, psychological, and existential matters take place? Urbanists and architects, national and local governments, the media, and a number of filmmakers objectify and massify "peri-urbanites," "concentrations of populations," and "tenement tenants" in generic spaces devoid of specific qualities ("new towns," "peri-urban zones," "residential zones," etc.) and in statistical groups (the "working

142 *NON-PLACES: INTRODUCTION TO AN ANTHROPOLOGY OF SUPERMODERNITY*, TRANS. JOHN HOWE (VERSO, 1995).
143 "FRAGMENTS OF A METROPOLITAN VIEWPOINT," *IF YOU LIVED HERE* (DIA ART FOUNDATION, BARY PRESS, 1991), P. 19.
144 *IBID*.

population" and "social and occupational categories") that have nothing to do with ways of being or thinking. Category-specific descriptions as representation subsets (low-income households, executives, the jobless, teenagers, immigrants, etc.). Descriptions and divisions that deny cultural and individual singularities (the emergence of the "I"). Designed in terms of sprawl and periphery in relation to the city center, the outskirts are turned into a representation conceived by this same city center. A representation based on hearsay, and pieced together from what can be glimpsed from a passing train and confirmed by the evening news. The poor outskirts are too far removed from the wealthy center for singular figures to stand out. Birth of the panoramic view. Pictures of these outskirts, in movies, on television, or in ads, leave out psychology and interiority and focus on classes, social groups, or communities (extreme long shots or panoramic views of behavioral groups). As if the point were to oppose "populations" to "individuals." An opposition between panoramic views or extreme long shots of social groups in poor outskirts (the "they") and tightly framed close-ups of faces in the Latin Quarter (the "I"). A representational discrimination. The faceless tenements. An opposition between the time for telling about yourself (ninety minutes) and the time for obtaining information (four minutes). An opposition between the close-up view (the café) and the panoramic view (the housing project). And when the desire to obtain information leads to stopping and examining places that are usually seen in passing, the images brought back only widen the distance (the divide) between the exurbanites and the urbanites. Martha Rosler: "Documentary photography may inadvertently support the viewer's sense of superiority or social paranoia. [Especially in the case of the homeless,] the viewers and the people pictured are never the same people. The images merely reproduce the situation of 'us looking at them.'"[145] To wit, an issue of representation: How can we overcome this reifying distance (the feeling of superiority or paranoia) and compensate for the deficit of images and projections of the self? Construct a visibility for the self in the singular where the city center insists on seeing only in the plural.

Contrast: How can I resolve myself to my absence of visibility in the singular when the lives of social and economic insiders revolve around the culture of me, myself, and I? Late capitalism has promoted this culture of self-worship in forms that could serve its own expansion. Our practices – in business (the success), pleasure (the climax), sports (the performance), body building (feeling strong and sexy), and psychoanalysis (write your own story and become its reader), all tend

145 *IBID.*, P. 34.

toward a certain form of self-fulfillment. These practices are relayed and promoted by the forms of representation that society gives of itself: advertising (the personalization of our environment and construction of one's own image), music (the vocal and guitar solos drifting in search of the self), literature and film (the action of the "I," its introspection and its reaching out to another). The deficit of images and projections of the self in the singular comes down to embedding each resident's biography in a history that is purely collective and necessarily peripheral.

But what kind of biography are we dealing with? Biographies presuppose desires (projects) and not only the feeling of being excluded from a community to which we would like to belong. Biographies – writing about the self – require the construction of a space of one's own and not a sense of being forced to reside in residual spaces (public housing high-rises, slums, housing projects, new towns). If exclusion underpins and shapes our perception of life in tenements, then there is a risk that tenants will be represented in stories that reduce them to the way they are seen and shown by the media day in and day out (the lack of critical distance). If unemployment leads to an impossibility to find a place for oneself in the social sphere and construct the self (to become identified as a man), then the story of life in tenements belongs to the register of social drama. The plot of this drama? The problems shown on the evening news (drugs, muggings, riots, social difficulties). The context? Unemployed time. The rhythm? Escalated. Consider the reinforcement of a cliché: Psychological dramas are confined to upscale city centers (sites of self-love) while social dramas take place in the poor outskirts (sites of self-hate). Between the self-visibility of insiders and the self-invisibility of outsiders, there is a social fracture. Desire as a projection of the self in the Latin Quarter. The fall as a fatality in the poor outskirts. *La Haine* (Hate, Mathieu Kassovitz) as a remake of the media scenario. *Hate* as a series of causes leading to "what cannot be undone." *Hate* as a montage of the sole images that the city center expects and fears. *Hate* as leaving out all feelings, attitudes, and practices that do not pertain to the reductionist context of exclusion, idleness, and an absence of projects. *Hate* as the complacent dramatization of a descent into hell (the media cliché) figured by the fall from a building filmed in subjective camera. *Hate* misses out on representation because it picks up the point of view of the city center in the way in which it characterizes what it condemns and fears. How can a life in tenements be represented when you let yourself be guided by a storyline based exclusively on social problems? Pier Paolo Pasolini: "Lucien Goldmann, in his theory about homology, asserts that literary texts

reproduce social structures, and in my opinion this is true of films too. During the capitalist period of free competition, a parallel existed between the fictional hero and the economic hero. This type of hero disappeared with the transition from liberal capitalism to monopoly capitalism. Whence the collapse of characters, stories, and so on."[146] Is the figure of the person excluded from economic growth (the tenement tenant) the only conceivable figure for a cinema trying to work on a representation of the being in tenements? A figure with no story and no trajectory in life other than h/er own fall. A trajectory determined by a social structure that has lost the underpinnings of its projection (work)…A figure that lets h/erself fall because there is nothing to hold h/er back? A question addressed to Vivendi in order to define the issues underlying policies of representation production: What is the imaginary informing the lives of people about whom the Latin Quarter knows absolutely nothing?

FILMING FROM WHERE PEOPLE SPEAK (FOR A CLOSE-UP VIEW)

Shift the point of view. Film life in tenements from the tenements and not from the city center. Find a vantage point. The subjective versus the objective camera point of view. Let the tenants impress the film. A shift in perspective that presents other pitfalls and dangers, like speaking "on behalf of" the people in whom we are supposed to be interested ("The images merely reproduce the situation of 'us looking at them.'") or looking down on them with the kind of condescendence (paternalism) that comes from a sense of taking an interest in radical otherness by assigning to them the role of outsiders (the substantiation of a condition produced by the market economy and the sense of privilege). Or yet again imagining that we can "speak of" or "speak about" using our own language and our own modes of representation (the myth of universalism). The legitimacy of Pier Paolo Pasolini's work resides no doubt in his attempt – be it naive and vain – to exchange his viewpoint (the place and class from which he spoke) for that of the people to whom he proposed a representation. His early films were informed by a will to construct a representation of underclass life in the suburbs of Rome. The history of art and literature shows us that the classes that act on History (the dominant classes) produce a representation of themselves in each historical period. It also shows us that the "classes" that cannot act on History – that are subjected to it – have no representations of themselves. Being excluded from the historical process means being invisible. A lack of participation in the historical process means a lack of projection of the self. To wit, the situation

146 OP. CIT., UNE VIE FUTURE, P. 8.

of the underclass in Rome's suburbs at the beginning of the sixties. Pier Paolo Pasolini: "My interest in the underclass, by which I mean a preindustrial humanity that is still archaic, rural, and religious, derives not from the simple curiosity of a writer, poet, or tourist but from a historical necessity for Italy itself."[147] In *Accatone*, filming life in a shantytown from the shanties and not from the city center entailed adopting the underclass' perspective. The religious perspective as a case in point: "I used 50 and 70 mm lenses, which added weightiness, relief, and chiaroscuro; they accentuate the heaviness of shapes, and ugliness of the eroded wood, the spongy rocks, and so on, especially when they were used along with 'dirty' lighting, like the backlighting that deepens the darkness around the eye sockets, and the shadows under the nose and around the mouth, or along with grainy enlarged copies, etc. This is what imparts the 'grim aestheticism of death' to the film's figurative machinery [...]. Ultimately, the religious dimension did not come from the character's supreme need for salvation [...] nor, seen from the outside, from the fatality of the final sign of the cross that determines and concludes it all, but from a 'way of seeing the world' and a technically sacred way of showing it."[148] Shooting a film through the eyes of others involves dropping your own way of seeing (stepping out of the city center or the insider imaginary). In the event, Pier Paolo Pasolini relied on a perspective that was totally foreign to him. He staged and directed a film while leaving its perspective to others. Louis-Ferdinand Céline used a similar approach in literature. The only way to talk about life in Bezons was to drop classy Parisian French and write in the language people spoke in Bezons. At a time when each social class had its own idiom, depicting the lives of workers required writing in their language: "Slang is made to express the true feelings of wretchedness. Read *L'Humanité* and all you see is the gobbledygook of a doctrine. Slang is made to allow the worker to say to the boss he hates, who lives well while he lives badly, who exploits him, and who drives around in a big car: 'I'm gonna screw you.'"[149] You can't speak of the oppressed using the oppressor's language. The only thing to do is speak from the tenements (from the place where the language originates), not about them (the outside point of view).

147 *IBID.*, P. 9.

148 *IBID.*, P. 19.

149 LOUIS-FERDINAND CÉLINE, "L'ARGOT EST NÉ DE LA HAINE. IL N'EXISTE PLUS," *CAHIERS CÉLINE* 1, GALLIMARD, PP. 171-172.

The images produced by and for economic actors only make slum tenants suffering from unemployment more aware of not belonging to the values and imaginary conveyed by film, television, and advertising aesthetics. How can you possibly identify with a community bent on enjoying products that are out of your reach? How can you identify with practices and modes of being together that are conceived by and for upscale city centers? How can we see ourselves in an imaginary that revolves around deterritorialized forms (the myths of communication, access, compatibility, and exchange) when our living conditions exclude us from the modes of access to this deterritorialized culture and its contents? What can the construction of a global culture mean when our monthly pay forces us to stay where we are and to think in terms of survival? To wit, an urgent issue of representation. Reverse the point of view. Representation year zero. Start over by filming faces.

1997. *De l'autre côté du périph'* (The Other Side of the Tracks, Bertrand and Nils Tavernier). Opening credits: "You've noticed how people never have time to express themselves on TV, they never have time to stop and think. They are always being rudely cut off, be it on the evening news or on talk shows. It's not a matter of censorship; there's simply not enough time. Bertrand and Nils Tavernier have taken the time to listen to common people, people living in tenements in Montreuil. They have taken the time to show them basic human respect, to let them speak, stop, think, and even stammer." This somewhat naive introduction written for the TV airing of the film masks a project with a different ambition. The aim was to spend time in a "public housing project" – here, the Pêchers project in the Paris suburbs of Montreuil –, to drop the perspective of the TV viewer and filmmaker from the city center and let residents speak up and impress the image (How can you say "I" if you're not allowed to speak?). Speak your mind (without minding your speech). Take the floor (take it back from the media). Stop being an object of documentary curiosity or a statistical specimen and become a subject. The reappropriation of one's own image as a fundament in the reconstruction of a representation. The film opens with a shot of a face, that of a young man speaking about his work. The close-up shot of faces as the film's economy. The face is the first image of the subject (the emergence of the "I") in places that the city center perspective and zoning considerations conceive in terms of population groups and communities. Tight framing versus zoning. Become the subject of your own story and history. Write your story (your history) yourself. A history from which the tenants of this project have been expropriated by the media. Get yourself recognized by others (the

viewers living in the city center).

Take time. Time to undo images that don't resemble us but that we have ulti-
mately integrated. In the first few minutes of the film – or to be more precise, in
the first few days of the shooting –, the residents end up more or less conscious-
ly embodying the kind of clichés that the media are regularly picking up and dis-
seminating. As if they were playing the part that TV viewers were expecting from
them. One young tenant: "They're all assholes here, nothing but assholes in a
bad fucking way." Another resident, a little older than the first: "Hey what kinda
game ya playin'?" The discussion becomes heated: "Whatcha mean?" "Put your
hand down when ya talkin' to me." "Don't fuckin' look at me like that." The ag-
gressive charge in the rhythm of enunciation seems more indicative of their need
to appropriate words and images for themselves than of any real resentment
between them. Take the time to come back and speak again, to pick up your
story where you left it a few days or weeks ago – a story that was impossible
until now. The time to come back to what you were saying or what you believed
you had to say (the critical distance). Delay as the sine qua non condition of re-
presentation. The time for building an image of living in tenements is usually a
time without delays – a time of news reports (the need to edit the footage for the
evening news) or documentaries (the exploration of pictures we have seen on
the news). To wit, an omission of all forms of image apart from those dictated by
what is considered a worthy "topic" on the evening news. If youngsters causing
serious damage to school property have every chance of gaining access to vis-
ibility, the mere fact of living is not spectacular enough to merit visibility. The
condemnation of life in slums to invisibility and to silence. In a way, Bertrand and
Nils Tavernier fall into the trap of reproducing the type of images they wanted
to avoid insofar as they expect the residents to rectify and modify images that
have been imposed upon them. The film explores in detail all of the problems
picked up and exaggerated by the media, but it does not encourage the people
to speak of themselves in other terms or to talk about other dimensions of their
lives. Does being in a tenement boil down to being in trouble? Is it the residents
who lack desire or the filmmakers? The film comes up against the same diffi-
culties as rap music. Voicing the problems of living in slums in the language of
the slums is a way of reappropriating the stories of which the media has dispos-
sessed us, and yet the exclusive focus on these problems ends up eclipsing
other dimensions of existence. If Bertrand and Nils Tavernier seem to favor
speech over images, it may be out of fear of reproducing the clichéd pictures of
concrete blocks and relative bleakness that have been etched in our collective

269

consciousness with connotations that could impair our receptiveness to other voices.

For the time being, be satisfied with this modest, but necessary, expression of the self. If tenement tenants have been dispossessed of their own story and history by the media, the reappropriation of speech is the sine qua non condition of access to visibility. The filmed exchange between the residents as a way of speaking words and appropriating pictures (taking your own pictures) usually commented by people who live elsewhere and know absolutely nothing about you. Confront viewpoints that swing between the commonplace (resignation) and the will to construct (affirmation of the self): "Unemployment has made this housing project, it has made us, what we think, what we do," and later: "Real work is taking wood and making a violin from scratch. [...] I don't mean to knock the guy doin' the odd job. Better be a street cleaner than to do nothin'…At least the street cleaner's doing something useful for society…but society ain't everything… it's up to him to use his strengths and make somethin' of himself." The delay, the exchange, and the montage of words that never meet as the construction of a consciousness. Stop conceiving the lack of visibility of life in tenements in the unilateral terms of the city center (the insiders) viewing its periphery (the outsiders). Reverse the point of view.

THE REHABILITATION OF THE SELF (FOR AN AESTHETICS OF PRESENCE)
Imagine other modes of symbolic and anthropological inscription of individuals, forms of representation and projection of the self that do not disregard the urban setting. 1996. Valérie Jouve: "How can we inhabit this new space? Our era has built blocks, types of spaces that we have not yet managed to integrate."[150] The bonds (the images) that link residents to the places where they live are not given, they are to be invented. Find other images while staying put. Images of the self that, instead of looking for some other place in the "here" (the naive outlook), look for some other representation of the self in this same "here." Proposal: Dilate the time of exposure of one's own subjectivity (four seconds), underscore a grin, make the colors of a dress shine, intensify a gaze, assert a disjunctive pose "on a real scale so as to obtain a face-to-face relationship with the spectator."[151] Take a step back from these faces. The aesthetics of the medium shot.

150 INTERVIEW WITH PIERRE LEGUILLON IN *DOUZIÈME ATELIERS DU FRAC DES PAYS DE LA LOIRE*, PP. 58-64.
151 INTERVIEW WITH MICHEL POIVERT IN *LE BULLETIN TRIMESTRIEL DE LA SOCIÉTÉ FRANÇAISE DE PHOTOGRAPHIE* (OCTOBER 1997).

The medium shot as a way of focusing attention on faces without disregarding the environment. 1994–96. *Untitled n°20*: In front of a car dealer's shop window, an arrested image of a body bursting with joy...Image of a young woman throwing her head back in an explosion of laughter...A laughter seized in all its breadth...A laughter and a breadth dilated by the camera right at the moment when she is spreading her arms out, right at the moment when the laughter is running through her body and shaking her, right at the moment when her mood is detached from her environment...A mood that is brought out against the environment...An environment that seems to vanish into the functional neutrality of its architecture...An architecture made of glass and French windows in PVC. Windows behind which a BMW disappears...Windows in the reflections of which bleak high-rises disappear...A laughter (a figure) that reduces the environment to a barely noticeable backdrop. Dominique Baqué: "Faced with the urban architecture that threatens to overwhelm it, [the body in Valérie Jouve's photos] exists; it insists, it manifests its obstinate, stubborn, unyielding presence. As if an energy were traversing and animating it, and enabling it to withstand the gray mass of architecture that had lost its original vocation of constituting a place for living."[152] If the architecture no longer offers us a place for living, then take up a place in space until this same space fades away...Take up a place in space until this same space no longer imposes its compulsory figures on me. The power of a laugh that takes hold of the whole body until it forgets all about the surroundings. A laugh and an infectious power that overturn all clichés about dehumanizing architecture in their way. A laughter and a power of being that couldn't give a fuck about an overly expensive car, excessively dull high-rises and a housing project that the upmarket city center knows absolutely nothing about. The oppressive surroundings and the social determinism vanish from sight...As does the housing project conceived on the scale of masses, not individuals... The colors of the clothing shine, the face is beaming...The whole body is taut. Chutzpah...And if my tenement lacks color, why let the signs of grimness rub off on me. Break free and explode. Acting happy-go-lucky? Feeling carefree? Striking an advertising pose? Unimaginable in tenements. For advertisers, targeting customers who live in tenements involves espousing the forms of a community of presumed behaviors (market research). Jean-Paul Gaultier or Dior Rive Gauche because he or she is unique, and Nike for the Bronx because everyone else is wearing them. As if the more personally customized models could only fit people living in upmarket city centers, detached homes, or single-family-housing

152 "TERRITOIRES DU CORPS," *ART PRESS* 219, DECEMBER 1996, P. 19.

271

estates. As if the culture of the self were inexorably index-linked to a minimum income (self buying power). As if low wage earners could only identify with social groups (the plural). Shining colors and a taut body versus the fall (*Hate*). A statement of the self versus the monthly bank statement.

Actress or resident? Valérie Jouve: "The people I work with are not professional actors but they do not necessarily live in the places where I photograph them. They are simply people whom I've met and sometimes the idea arises of working together."[153] The meeting and the construction of a relationship as the time of construction of the image. If the photo-reportage seizes the instantaneous aspect of a situation or a person (the myth of objectivity and spontaneity), the picture of living in housing projects that Jouve proposes is constructed prior to the taking of the picture. Take time to get rid of inhibitions, time to get used to the idea of an eventual image of the self…A time that becomes a learning experience…Learning about one's capacity to take up space (self-confidence), to impose yourself on a setting in which you usually get lost…Test yourself in space… Become an actor. Gain some distance on the picture you used to have of yourself (urbanism's determinism and inhibition)…Take hold of the picture (of the surroundings). Gaining possession of the image as gaining consciousness of the self (the capacity to be the actor). Bring out in the figure what escapes social and economic dimensions. Expose the indomitable part of the self, the part that no forecasts and no statistics can contain. Jouve counters the typology of behaviors and portraits generated by environmental structures (behavioral groups) with an aesthetics of theatricalized, singular presence…A theatricalization in which the aim is not to dramatize roles that do not belong to us, but to lessen the dramatic force of our relationship to our environment. Lessening the dramatic force for oneself and for the distant eye (the city center viewing its periphery). Stop being subjected to your environment, turn it into a backdrop. The theatricalization as an affirmation of an "I" who has decided to turn h/er environment into a stage for the self and not a space in which our consciousness is absorbed and dissolved. A theatricalization and a presence that manage to construct a different type of image because the image is constructed in the photographed place and not in the distant consciousness of the city center. Let the actors take charge of their own paths in space and their own stories. Encourage them to compose their own roles in the picture…In front of the camera, try "to bring back into play [their] capacity to act and to find [their] place again." Play with the

153 UNPUBLISHED INTERVIEW WITH THE AUTHOR.

camera…impress it with our own mood and let a close-up view dilate just the right amount of exposure time. The impression of your own mood as an aesthetics of resistance: Impose your own figure onto housing projects and zoning policies. Demand stages of the self and impress the image. The living environment as a backdrop, the theatricalization and the framing as a liberation. The frame of the photograph as framing a call to exhibit your own ways of being in a place. Burst out in laughter (stand out) in an environment conceived in statistical terms. Stand out in a public housing project conceived in terms of behavioral categories. Break out of the framework conceived by government authorities…Become the subject of a history (say "I") written not by economic and urban mutations (the time of economic growth and related lifestyles) but by residents (the time of the self).

THE PASSERBY, THE USER, AND THE CUSTOMER (FOR A DECENTRALIZATION OF REPRESENTATIONS)

If high-density housing projects do not constitute places of identity, must we accept the idea that living in such projects necessarily involves turning off a sense of self here and now? A here too standardized to send a signal (the place of identity) and a now that, for want of activities and events, is too trivial to be conscientized. 1996. *Billboard Series*, *Little Story* (Pierre Huyghe): a bus shelter, somewhere in the vicinity of a housing project. Stop H, line no.15. A billboard a couple of feet away…A billboard on which the people waiting for the bus are projected for the time it takes the bus to come (the time to project the self outside the here and now). But here the billboard does not offer a picture of a product, an advertising message, or a public service message…It displays a representation, an exact duplicate of the place where the bus no.15 users are waiting. An image in which the users can see the bus shelter where they are sitting and the building right behind them…An image where we can see a smiling young man, hands in his pockets, headphones on his ears, leaning against one of the bus shelter posts…An image where we see two women – one with a bag on her lap, the other holding a bunch of flowers – sitting where we are, on a bench… We're in Amsterdam. Somewhere else, in front of a group of trees, on a road that passes under the railroad track, another billboard. On the sidewalk below the billboard, a recycling container. A recycling container, a sidewalk, a group of trees, an overpass, and a railway that turn up on the billboard. Behind the trees, in the distance, a high-rise…A high-rise that looks like the one we've just passed …Two billboards that turn up on our path and that refer us back to a representation of the places we're passing through. Images that begin to punctuate our

path and refer us back to an image of this very same path. To be lost in thought and happen upon a picture that little by little brings us back to ourselves and to the place where we are. A place to which we pay scant attention because there is nothing to arrest the eye (the standardization of the cityscape) and because we are used to it.

From the commercial billboard policy of capturing our attention by showing a disjunctive picture (the sublimation of forms and colors as the difference with the here), Huyghe has retained nothing but the format (the landscape format). Drawing the passerby out of a space that s/he uses without thinking. An exact duplication of the here that works as a surprise…A growing awareness (from one billboard to another) of one's own presence here and now. A sequence of billboards that begins to project us into a cityscape through which we usually move without really thinking about it…Here, as in the picture, the sky is blue but slightly overcast (a non commercial blue)…On the picture, a young woman in a white sweater is passing in front of the container…She is right where we are and walking in the same direction…An image displaying a movement not a product… As if this picture were accompanying the movement of the young woman and the passersby…A young woman whom we've already seen…The same woman who was on the other billboard. On top of the container, the flowers she was holding in her hand…Birth of a storyline. *Little Story*…Farther along, in a more animated district, a third billboard. The young woman is buying flowers at the corner of a small street – the one where the billboard is placed. The space of projection merges into the city space. A storyline running between a periphery (the housing project) and its center (the animated district). A storyline running in both directions. What is the order of the story? It would be reasonable to imagine that the first picture is the one in which we see the woman buying a bouquet in the center; the second, the one of her waiting for the bus on the periphery; and the third, the image somewhere between the periphery and the center, in which we see the flowers that she has probably just put down on the container. But nothing tells us that she was the person who placed the flowers there, and nothing tells us that she did not go to places that do not appear in the pictures. It is perfectly conceivable that the young woman's day began before buying the flowers in the center…And, for that matter, is it really the same bouquet, and were these pictures taken the same day?…It matters little (*Little Story*). One certainty: The storyline articulates a center with a periphery (that is if we admit that an animated district can be regarded as a center). The story as a connector. The mode of representation built on the principal of a distant gaze loses ground.

The construction of a representation of the journey as reducing the distance from the center to the periphery. The back and forth movement as a way of formulating a close-up perspective in which points of view are exchanged. An image of living in the periphery addressed to the center and the periphery, and an image of living in the city center addressed to the periphery and the center. Shift the focus of attention. Follow and enact a story of a possible journey of our own (the subjective tracking shot) wherein movement prevails over the specificity or non-specificity of the places. A shift that would send a signal in a city form that no longer lets us index-link an identity to its qualities.

Little Story: Three pictures that do not refer to an elsewhere but that are articulated with their social and urban context of exhibition (billboard displays). A duplication (an image) of here and now. The same place on the same scale. The use of space (the walk) merges with the gaze (the landscape). A landscape and a journey through this same landscape that coincide with the duration of our passage. The projection of the self onto the image is accompanied by an appropriation of the billboard format (a format usually conceived on the scale of the general public) and of the image (an image that represents me). A passage that activates the meaning of the picture. In the event, the representation of here and now is not constructed in the picture but in the relationship that we construct with the picture. A relationship that constructs the story of our own journey or rather an interpretation thereof. The similarity between what is represented on the picture and what is happening in the vicinity of the picture as formulating a question: Who are the actors interpreting the story? The passersby or the models? To wit, a questioning of our relationship to the advertising image – a relationship in which the image usually communicates a model to be interpreted. Fiction of a series of billboards in which the actors interpret a moment of our day… Unless we ourselves are the ones who are acting out what we see on the picture, reproducing the journey we see or trying to construct the young woman's story…Turning around and blurring the advertising strategy of communication as evincing a possible emancipation from advertising forms of behavior. An emancipation in which I become (once again) an actor in a public space. A public space whose functionalization had ended up reducing my presence to an exclusively functional matter of circulation. The duplication of our own passage as the possibility of a fictional circulation. Pierre Huyghe: "I don't point to reality in order to show it. I have the actor reenact it. It is a matter of establishing a distance, a gap between the scene that may happen again and the image. It's a *connecting* image. It doesn't exclude, since we're in the place of the image.

Even though we are not the actor, we are at the heart of the story."[154] The mode of representation in which "the viewers and the people pictured are never the same people" loses ground as we become actors again in a world whose spectacular culture had excluded us. The practice of space (the experience) versus the dreamscape (the spectacle). The duplication of lived situations and time as a model of reappropriating a story that advertisers, journalists, and filmmakers have been writing in our name and on our behalf.

If advertising representations try to draw us out of the here and now and project us into an elsewhere and an otherwise that is better (the supply), the duplications in the *Little Story* script reverse the advertising scheme by proposing representations of the self in step with here and now. The script's generic character and the shift in attention – an attention focused on the journey not the landscape – as a possibility of articulating this picture form with other urban situations and other cities in Europe or elsewhere. A picture form that lends itself to articulating the local (the here) with the global (the communication of market economy images) on a mode other than opposition. 1996. Montpellier, *Géant Casino*: On the parking lot of a hypermarket, a billboard. A 13.2 by 9.9 ft (4 by 3 meter) advertising space available for rent from the Avenir billboard network. On the poster, a young woman is pushing an empty shopping cart toward the main entrance of the hypermarket that's facing us. Take spectacularized products out of the picture…Substitute a consciousness of our customer status for our status as product consumers and spectators. Instead of representing the products onto which consumers (the targets) project their desires, represent the movement of the ordinary consumer…A movement that consists in going to do the weekly shopping at Super Wal-Mart, Super K-Mart or elsewhere. Here, it's the Super Géant Casino…Represent a time of day when we are not in Nikes or busy tasting all the available flavors in the world (the time of consumption and use), a nonconscientized transitory time…A time in which we seldom project ourselves. Indeed, can pushing a caddy afford as much pleasure as, say, driving or preparing a meal? Is there such a thing as a successful shopping job comparable to a successful professional project or a successful meal, and affording as much satisfaction?…If few people derive pleasure from pushing caddies, if emotions are rare in hypermarkets, must we reconcile ourselves to a lack of a sense of self in activities that occupy a good part of our time in an ordinary week?

154 UNPUBLISHED INTERVIEW WITH THE AUTHOR.

If "translating into experience" (Giorgio Agamben) all the hours spent waiting for a bus, getting from place to place, shopping, and so on, may constitute an issue of representation today, then the relationship that we construct with the billboard display of our behaviors as passersby, users, or customers may be seen as a possible model for this translating into experience. The intrusion of a representation of the passerby, user, or customer here and now in the advertising landscape as a model of access to self-visibility refused by the public space and its visual culture (spectacular culture). Must the display of the customer's behavior in his brand new Peugeot 206 necessarily go with a negation of our way of being bus no.15 users? Must national outdoor ad campaigns necessarily throw the local into invisibility? If the space of representation is purchased by advertisers, does that mean that only advertisers can represent us? Is supply the only possible form of representation and does it meet our demand? If the profile of residents in a particular here and now does not correspond to the criteria defined by some trendy agency, must we reconcile ourselves to self-invisibility? Is life without name brands (unlabeled by advertisers) conceivable? Can a sense of self in the here and now (I'm thinking that I'm waiting for the bus) be represented in the same way as a sense of self in the romantic nearly bewitching settings of places that archaeologists and explorers used to haunt in days gone by?

The display of the self on the *Billboard* series as an aesthetics of conscientization of the self as customers, users, or passersby in a space and time during which we are neither consumers (advertising time), nor employees (work time), nor involved in leisure activities (free time). A time generally thrown into the category of idle time (a non-conscientized transitory time), and a space often assimilated to a non-place (a space with no identity), between two periods of work time or free time during which our subjectivity engages a certain number of values and conscientizes its way of being in relation to the place where it is. A space and a time usually occupied either by a spectator consciousness (the projection of my desire onto the products displayed on the billboard) or a dreaming consciousness (I'm thinking about what I have to do today or what we talked about yesterday). Conscientizing idle time and our ways of being here and now as the point at issue.

WORK AS THE DISREGARDED FACTOR IN ART
(FOR A REPRESENTATION OF WORK)

DOING AWAY WITH THE ART OF LEISURE...

If art implies a reading of today, if it means to propose a point of view on the History in which it is embedded, why are the majority of contemporary art approaches so intent on working with the dimensions of the imaginary whose forms are only found in non-work time? If business keeps us occupied five days a week, if employers are looking for qualities in us that contribute to economic growth, if the greater part of our physical and emotional energy is channeled into and instrumentalized by corporate projects, then how can an art that is supposed to be probing our times simply skip right over what constitutes the main driving force of our History? If economic growth is the tide of contemporary History, how can we ignore this same growth, what it represents, what it means and what it implies? Does art stand firmly outside the tide of History, outside the issues that are determining the key developments in our contemporary societies? If art overlooks the time and area of production of History, does this mean that its area of inquiry is limited to the time and area of consumption, to the time and area of relaxation, pleasure, or enjoyment – a relaxation, pleasure, and enjoyment that are supposed to counter the pain and alienation of work? A time and an area that it perceives naively, without taking into consideration the historical conditions that determine them? Dominique Cabrera on filmmaking: "Most of the time, filmmakers have experience of work in their own field only and not as salaried employees. Making a film about what's happening in another universe requires a considerable amount of observation, for which they have neither the time nor the desire. [...] You have to delve into the interests of social groups besides your own, and this means breaking free from your idea of society."[155] Acknowledgment of an incapacity to grasp History. Here, for a nearly practical reason (ignorance), elsewhere, because of an archaic caricatural vision of the artist, fortunately less and less common in the sphere of art: "Filmmakers also tend to identify with wacky, romantic, asocial, marginal characters. It's easier to identify with people free from social ties."[156]

If undermining processes of alienation, conditioning, and instrumentalization of consciousness can constitute a major issue, how can it be activated outside the paradigm in which it is supposed to operate? Will art continue to cut itself off from History and hang on to its sole filiations with art history? A history that continues to evolve without taking into consideration the impact that recent economic

155 INTERVIEW WITH CÉCILE DAUMAS IN *LIBÉRATION*, JULY 5, 1999.

156 *IBID.*

changes may have had on our lives? A parallel history, unaware of historical conditions and new aspects of experience? To keep our questions and explorations outside the History of economic growth and work time amounts to consigning ourselves, whether we realize it or not, to a particular place, or rather a slot, in History: that of free time. Must we reconcile ourselves to the idea of a free-time art? An art that could only work in the limited context of free time and leisure activities, as an object of curiosity and entertainment (visiting exhibitions) or as an activity (making art). Is art simply another "activity," on a par with fishing or stamp collecting?

Freed from moral constraints and political opposition, economic principles instrumentalize our consciousness, our skills, our emotions, our cultures, and our landscapes. Freed from critical attacks and aesthetic opposition, the capacity of economic principles to instrumentalize the world and our consciousness will continue to grow.

If many artists or groups of artists in the past years have appropriated certain modes of functioning of businesses or certain characteristics of corporate culture – from Philippe Thomas's agency Les Ready-Made (Ready-Mades Belong to Everyone) to Fabrice Hybert's company UR (Unlimited Responsibility) –, most of these approaches mimic procedures which they displace into the field of art. Approaches that substitute actors in art for salaried employees. Approaches that pick up the conditions of production inherent in business and reactivate them in the separate sphere of art, but that do not question the sphere of business and salaried work. Approaches that produce artworks. Artworks that continue to be at the center of aesthetic concerns. An art for the condition of production of artworks. An art that focuses on itself or rather that focuses on the business world the better to focus on itself. The acknowledgment of a deficit of representations of work.

In this image deficit context, the exacerbation and mediatization of some recent trends in the European economy (such as the end of full employment, the reassessment of certain social rights and job benefits, the increasing number of job seekers, etc.) have, on the other hand, produced an inflation of representations of misery. Some rare approaches have emerged on the art scene in recent years that seem to be affected by these economic and social mutations, without compensating for the deficit of images or proposing counter-representations. Inquiry.

WORK TIME AND GAINING RECOGNITION FOR THE SELF (FOR AN INTRUSION
OF REPRESENTATIONS OF WORK IN THE CULTURAL LANDSCAPE)

1994. *Chantier Barbès-Rochechouart* (Barbès-Rochechouart construction site,
Pierre Huyghe): In the Barbès district of Paris, Huyghe noticed a billboard in the
middle of a new construction site where work on revamping an intersection had
just gotten underway. He asked five actors to come in work clothes and stand
in for the workers and the site foreman while he took a picture. Actors who ap-
propriated overalls, hard hats, a wheelbarrow, shovels, and pickaxes for a while.
A scene of appropriation – of fiction – that became the subject of a photograph
…A photograph immediately blown up to billboard scale. A few days later, after
the billposters had put up a commercial billboard, Huyghe came to cover the ad
with his picture of five workers on the job. The illegal posting and the act of cov-
ering up the commercial image as an intrusion of a representation of work in an
advertising space and culture that display products of work but seldom repre-
sent their production. Partially hidden by the gray and green barriers that delim-
it construction sites in Paris, the real workers were barely visible. On the other
hand, the billboard had been raised by the billposting company to make sure
that the advertisement remained visible from a distance. The picture of workers
on the job stayed there for a week before it was covered up by an advertisement.
Chantier Barbès-Rochechouart: A billboard that does not display a product, a
model of behavior to be adopted, or practical information. The exhibition of a
picture of five people working…Five people who are not being instrumentalized
by a commercial or an electoral strategy.

In a culture that never ceases to represent its finished products, there is a need
to represent the production dimension of work (the construction). If the consumer
imaginary represses time that is not related to the use or contemplation of the
sublimated product, does it mean that our world is given as such, and need not
be constructed? The representation of products only as a negation of work. A
society that displays its products (the shop windows) but hides the processes
needed for their production. The picture of the Barbès construction site versus
a picture of the traffic circle. The representation of work versus the postcard. The
representation of a process versus the promotion of finished products. Workers
versus sales reps. Recording work time as the point at issue.

If in the days immediately following the appearance of the poster, the state of
construction work corresponded more or less to what could be seen on the
picture (the *mise-en-abîme* and the illusion of a picture that is synchronous with

what is pictured), the gap between the progress of the work on the new traffic circle and the moment represented on the picture gradually began to modify the status and sense of the billboard. In fact, as the traffic circle progressed, the actual work – which was the only visible phenomenon during the first few days – gradually gave way to its product (the new traffic circle). The construction gradually yielded to the constructed. A picture that gradually became the record and memory of a process. Representing work requires a form of live recording. The necessity of a synchronous form of representation.

Work opposite an image of your own work…See an image of yourself that our culture never provides (that it refuses you). An image of the self that is unrecognized because the (advertising) image that our societies have of themselves only recognize those forms that constitute an imaginary determined by the exclusive needs of economic growth: dynamism (non-stop phone calls, meetings, appointments, instructions for Betty with five o'clock deadlines, etc.), decisions (the board room), expansion (conquering new markets), and so on. As if my work did not contribute to the growth movement…As if dynamism were to be measured exclusively in terms of the number of miles I've covered this year or the amount of decisions I've made…Strikes as the only means of access to visibility if the work in which we are engaged does not fit into this category of images. Strikes as a mode of taking the floor. The billboard display of the self as a possibility of constructing a representation of the self. Illegal billposting (the intrusion) as a mode of questioning the conditions that underpin my invisibility. Conditions that are connected to the imaginary (the ideology) of all-out growth, but also to the law of supply and demand…Advertising as a mode of overrepresentation of the middle-class (the buoyant market). The absence of representations of certain forms of work in the advertising aesthetics as the myth of an end to the proletariat. If ad men only target customers likely to be consumers of products whose purchase ensures a continued upward trend in growth, the most underprivileged classes in financial terms seldom constitute a target. A reasoning that index-links access – the right – to representation to a minimum income (the representation discrimination). The covering of an ad space from which the working classes have been excluded as a political act. An act that elicits a question: How can I get others to recognize me when they have no images of me? The absence of an image of the self as creating a sense of invisibility and nonbelonging to a community that cannot see me. The *mise-en-abîme* of the self at work as a possibility of gaining recognition for oneself. Recognition of the self as the sine qua non condition of belonging to the community. Finding a way out

of invisibility as an emancipation and as the point at issue.

WHAT CAN I DO 'BOUT IT? DUNNO WHAT TO DO! (EXCLUSION FROM ECONOMIC GROWTH)

If the representation of the self at work constitutes a key issue of representation, how can its absence be represented? How is it possible to represent such phenomena as the growing lack of job security without reproducing the image of misery disseminated in mediatized representations? If the lack of work gives rise to a sense of not having one's place (self-depreciation), is it possible to conceive of a representation of the self detached from this same sense? 1998–99. Le Havre. *Manœuvres* (Suzanne Lafont): In silk-screen on PVC, twenty-four segments of four photographs…8.5 x 42 inch (22 by 106.5 cm) segments associating a series of recurrent pictures: three people (the figures) with nothing to do and container ships (the setting). Slightly hunched, in a worn beige coat, a cap pulled down over his forehead and a bag strapped over his shoulder, a young man casts a glance to the side as he paces back and forth. A man who walks in and out of the scene (the lack of work)…A man pacing back and forth in front of the selfsame brick wall. When the workforce is forced into becoming (is reduced to) a witness to an activity (container ship traffic) in which they no longer partake (unemployment)…Means with no object. The recurrence of the pacing figure as formulating unemployed time. Exhibition of a becoming-crazy. In front of the same wall, his foot on a green and blue ball, a young man in a sailor's jacket stares off into the distance…A way of spending unemployed time…Exhibition of a loss of awareness of being here and now. Standing with his back against the same wall, lost in thought, another young man folds and unfolds his arms…Exhibition of an interiorization. Three men thrown out of the working world. Three characters who appear separately (the loss of work as a loss of belonging to the community). Three ways of living with inactivity. Three expressions of a sense of being dispossessed of the capacity to be actors in the world that once employed them. The recurrent – obsessive – presence of the container ships (the setting) and the insistence on the idleness of the three people as formulating a separation between economic activity and the subject. An economic activity (the rapid turnover) that goes on without us (the lack of pictures depicting port activities). Useless gestures (the pacing, the foot on the ball, the folded arms). Aimless gazes. Peopleless ports. The empty pier as a sign of the exclusion of people from trade activities. The lack of pictures of people working (the lack of a relationship of necessity between the container vessels and the characters) as a lack of connection between the world and the subject. Figures (subjects) now separated

from what was once their context of inscription (work). To wit, the exhibition of a discontinuity between the movement of the market (the container ships) and the movement of the self (the idleness). A discontinuity between linear, exponential commodity time (the growth) reflected in the association and repetition (turnover) of pictures of passing container vessels, and unemployed time figured by the characters arrested in long-exposure poses. A discontinuity between the horizontality of the container ships (the movement) and the verticality of the figures (the posture), between the brightness of the sea (the future) and the darkness of the wall (the dim prospects). The discontinuity between a world where work has gained in abstraction (What traces do we still have of work?) and the nostalgia for an activity that is no longer practiced – and that will not come back. Being lost in thought and unable to leave the scene as an allegory of an attachment to an outdated form of identification to a company. A company whose products have become more and more unfamiliar to us. The standardization of containers as a sign of a lack of differentiation in the products of work and an impossibility of projecting ourselves in the image of the company that employs us. Containers that now belong to rental pools and not companies. Standardized containers that travel over land and sea, indifferent to the places they pass and the companies that transport them. Amodal transport as the perfected form of separation between economic growth and the working world. Overcome your attachment to the working world. A working world that is being supplanted by a world of economic growth.

In the event, there is no relationship of necessity between the people and the setting in which they are merely posing. Their final exit from the scene would have no effect on the container ship turnover. But if they are no longer actors, why then do they stay on the scene of economic growth? If freight transport can do without workers, what are these figures with nothing to do doing there? Why are they there pacing back and forth or simply loafing around? So as to enact their drama: that of leaving the working world. The sublimated open seas as a bygone imaginary (rail-sea transport networks have replaced voyages). The wall as a reference to Greek theater…A wall in front of which actors enact a lack of anything to do beside while away their time doing nothing. The exacerbation of traits of inactivity (folding your arms) and the theatricalization of the effects of inactivity on behavior (pacing back and forth as if you were waiting for a call from an employment agency) as a way of distancing one's own drama. Suzanne Lafont: "Whenever dramatic events take place, there's a need to represent the figures of the drama. By playing out your own drama, you project yourself outside

the distress. This distance allows you to start thinking your own story through."[157] Objectify your distress in order to visualize it. Objectify it in order to have a better grasp of it and especially to endure it a bit less. A dramatization without conviction...The cap is pulled down a bit too far, the green and blue ball seems a bit too out of place in this setting...The surplus of representation as a guarantee of undergoing less. Henceforth, where will we construct a place for ourselves outside the working world? Since work is not about to come back (the demise of the myth of full employment), start constructing a representation – a story – of finding a way out of the working world. The aesthetics of disengagement as the point at issue.

157 INTERVIEW WITH THE AUTHOR.

UNITED CLICHÉS OF STRAIGHT SOCIETY
If certain manners of being have had to deal with the ever widening gap be-
tween mediatized representations and their own experience living a precarious
existence, take a look at people who have never had access to visibility except
on the mode of a difference that is tolerated. If some filmmakers have contributed
to the construction of non-heterosexual representations – including Luchino
Visconti, Sadie Benning, Pier Paolo Pasolini, Ingmar Bergman, Michelangelo
Antonioni, Rainer Werner Fassbinder, Patrice Chéreau, Chantal Akerman and
Wong Kar-wai –, such representations remain rare and fragmentary, and often
confined to the ghetto of art films and absent from "mass culture." When will
movies made for the general public and for all ages depict homosexual couples
or affairs without being about homosexuality? When will we see a lesbian version
of *Kojak*? If movies working toward the emergence of gay and lesbian cultures
constitute a major issue of representation today (the necessity) – because the
representations that society gives of itself still exclude representations of the self
as a homosexual –, doesn't a film "on" homosexuality risk being seen as a re-
duction of gay or lesbian identity to a form of essentialism or a matter of sexual
practice (the difference not accepted by mainstream or dominant discourse)?
Michel Foucault: "I'm not sure that we have to create our *own* culture. We have
to *create* culture. We have to realize cultural creations. [...] I am not at all sure
that the best form of literary creations by gay people is gay novels. [...] What do
we mean for instance by 'gay painting'? [...] I am sure that from the point of
departure of our ethical choices, we can create something that will have a cer-
tain relationship to gayness. But it must not be a translation of gayness in the
field of music or painting or what have you, for I do not think this can happen."[158]

1995. *Rome désolée* (Desolate Rome, Vincent Dieutre): While we hear the nar-
rator describing a heterosexual couple who has invited him and some friends
over, we see a sequence of heterosexual representations, poses, and attitudes
from Hollywood movies or commercials: the joyful reunion, a man choosing a tie
while a woman lies in bed still asleep, a spoon delicately dipping out a scoop
of strawberry ice-cream, couples about to kiss, wives confiding in one another at
the beauty parlor, a model middle-class couple in a public garden...A sequence
underscored by flashes of advertisements promoting products apt to participate
in this construction of the model couple which excludes all non-heterosexual
forms of being-together. A sequence and a portrayal that stand out against the

158 *OP. CIT.*, "SEX, POWER AND THE POLITICS OF IDENTITY."

overall thrust of the film informed by the offscreen narrative of a series of love affairs. Descriptions of homosexual experiences and of people who never appear on the screen. Onscreen, intercut with static shots of the streets of Rome (with so few cars and passersby that they nearly resemble photographs), flashes of advertising and news from Italian TV, with the sound turned off. Here, the narrative of a love affair is in words because homosexual representations are absent in mass culture. A deficit of images that takes the form of an absence of pictures linked to the narrator's story. The scenes are related and described but never pictured (the invisibility). A deficit of images that also takes the form of a representation of Rome wherein the presentation of the self as a homosexual is practically impossible: "He is very preoccupied by his homosexuality and lives it in the manner of an Italian in the fifties. In the street, without realizing sometimes or simply to annoy him, I take his hand or I put my arm around his shoulder. He gets angry but he also laughs, startled and amused by what he deems a very bold behavior." The offscreen voice as figuring a manner of being invisible…How can you construct your sexuality and your desire in a culture that keeps gay and lesbian cultures in a state of invisibility? How can we construct a representation of ourselves as homosexuals in a culture that offers only representations that exclude us – in this case, heterosexual representations? If identities are built up on the basis of a culture and a memory, how can you project yourself in a way of being and build a homosexual identity, when this culture and this memory are not constituted in popular culture?

MEANWHILE, UNTIL THINGS GET BETTER
Keep an eye out for images – or fragments of images – apt to affect us. Commercial: A child in the middle of a church choir takes a drink of Pepsi and throws off his drab uniform…Cut to children playing soccer. Cut to Berlusconi giving a speech…Freeze frame. Cut back to Rome: A wall with *rivoluzione* written on it. The offscreen voice resumes its story. Long static shot of the wall, then of two abandoned chairs at the foot of a building. Cut to a fighter plane taking off. For a few moments we follow the plane in flight. Cut to three men in front of a door. A sequence of stock footage shots. An invitation to edit or simply record the stream of mediatized images aired on any television network? The heterogeneity of the registers to which the images belong and the apparent lack of connection between many of them and the story that the narrator is constructing seem to function as an invitation to choose images, to associate images in our own way – those that affect us…Rome, open city. The reduplication of the situation facing people who lack representations of their own way of being, thinking, and

acting. Make a picture through words and build up a desire on the basis of frag-
ments of pictures that the dominant culture affords us: From the picture of the
choir, retain only the lingering memory of a proximity of bodies and breathing at
a time when schools were not yet mixed...from the picture of sports, retain only
the nimble movements and the curve of a leg...from the picture of Berlusconi,
retain nothing at all...from the picture of the toothbrush, retain only that it should-
n't be shared...from the picture of a woman's face, retain only the sensuality of
the gesture of bringing the vanilla ice-cream with strawberry syrup to her lips,
and zap quickly (before the heterosexual model is imposed). The construction
of the image of desire requires editing. Focalize on (content yourself with) a few
fragments of the body, some facial features, attitudes, gestures, and so on,
picked out of the stream of representations addressed solely to heterosexual TV
viewers. An aesthetics of existence founded on the principle of *making do*.

Offscreen voice: "He's very meticulous: now I'm putting on the condom; now
I'm going to blow you a little. It's really weird but ultimately it's quite reassuring
and considerate. It's his way of being polite..." Cut to commercial insert: a man
brushing his teeth and proudly displaying a toothbrush that seems to satisfy him
immensely. Are we to read this insert as an attempt to provide the viewer with
some elements (some features) that could contribute to the slow composing of
a portrait (the militancy)? Is there some sort of self-assurance in the bearing of
the man the narrator is talking about? A smile like this? A way of expressing his
pride that looks like this man showing off his toothbrush? Meanwhile, "He's proud
of his car and his pizzeria"...Cut to a street in Rome, and then a few architec-
tural features... "He's also proud of his big penis and his vacation last year in
Sitges." Is there something specifically Roman about these sources of pride?
A collective pride (proud of Rome, proud of its architecture) that would rub off
on the private sphere (his big penis and his vacation)?...A class pride (the vaca-
tion in Sitges)? To wit, the integration of values and models that almost everyone
shares. Values and models of success and of the presentation of the self that
may pertain more to Roman culture than to gay culture. To images of gas mask
practice sessions in case of chemical warfare during the Gulf War: "With his
somewhat feminine gracefulness and his chubby, immature face, his whole being
seems to emanate submission and guilt. All of a sudden I feel scared of resem-
bling him one day..." Are we dealing with a disjunction (the incompatibility bet-
ween the televised picture and the portrait)? With a random juxtaposition?
With a staging of the practically obscene distance (indifference) separating the
thousands of lives threatened by armed conflict and the narrator's petty concerns

about his private little future?

At times there seem to be many possible constructions of meaning (the open-ended montage), at others the film brings the two narrative lines together (the stream of silent media images and the voice-over) to the point of conflating the two. "He insisted on inviting me to a restaurant..." Cut to commercial image of a woman bringing a spoonful of ice-cream to her lips (a cliché of sensuality)... Cut to a fleeting image of the celebration of a mass (the turn-off). The lines separate. Cut to pictures of stretchers being evacuated by an ambulance... "Bruno's studio is tiny. There are framed photos of black athletes covering the walls. Some of them, I think, were Bruno's lovers." Cut to advertising picture of a young black man doing breakdance figures (the embodiment of desire). The lines draw together again as if to indicate the modes of construction of a desire (a montage based on a taste for certain types of physical effort, certain movements, certain postures, certain skin colors, etc.) "...Then comes the struggle between bodies." To wit, a series of intimate behaviors produced by a mediatized culture. A question to end with: If collective, social behaviors seem to increasingly reproduce deterritorialized models, if Baskin Robbins conviviality is gaining ground on the unique conviviality of Roman plazas (the four-scoop portion for two versus tables of large parties in *Fellini's Roma*), if Rome can now be seen as a city that lacks places that could serve as backdrops for being-together (the decline of the public space), is there still a specifically Roman tradition of the culture of intimacy? "Bruno, like a lot of Romans I've known, really loves making love and he does it well. In each and every gesture you can feel his concern for others and for their pleasure – a precious sense of courtesy derived from the beginning of time and from this city..." The articulation of a sexuality and a desire built up from images sampled from advertising, sports, and clips (mediatized culture) with a way of being inherited from the art of love (from Ovid to Umberto Tozzi). In the event, Vincent Dieutre's film seems to confirm an observation: that of the invisibility of the self as a homosexual in contemporary mass culture and in the public sphere. To wit, the feeling of having no place. The construction of a self-image as the point at issue.

How is it possible to represent oneself and to construct an image for oneself out of the given cultural stock (the mainstream cultural supply)? 1992. *It Wasn't Love* (Sadie Benning): Withdraw into your room with your Fisher Price PXL 2000 camera. Film pictures that date to your formative years: the movies, variety shows, and documentaries about American society that were shown on TV...Film the

street from the window of your room or your car, retrieve bits of super 8 movies from your childhood, film yourself making up a story while playing with a miniature car, film yourself making up characters, dressing up in different outfits, striking male poses, and playing your teenage heroes – heroes from Hollywood, punk, jazz, or rock culture – and then piece it all together to form a montage of highly pixelized black-and-white video pictures. Consider a twenty-minute narrative. Twenty minutes to invent and recount in voiceover a road movie, love story. Two teenagers running away to a Hollywood they'll never reach. Two brash teenagers acting deliberately provocative (close-up of the word "fuck" written on a clenched fist and addressed to us), stealing and robbing like gangsters from some film noir ("I stole this car," "Let's go to Detroit. On the way, we'll rob some liquor stores"), showing off ("She said: 'Get in the car, we're going to Hollywood'"), smoking like men, and ending their adventure in a parking lot: "We didn't make it to Detroit, much less Hollywood. Instead we pulled into a fried chicken parking lot and made out...It wasn't love, but it was something." Rapid Jonas Mekas–style jump cutting between bits of pictures from mainstream culture... bits that left a mark on a young girl discovering her desire for chicks. Bits from sound tracks and from her favorite hits to punctuate (link) it all. For the time being, while waiting for images, use music to awaken sensuality. To the picture of Sadie and her girlfriend's faces, Billie Holiday: "You go to my head, and you linger like a haunting refrain." A voice that moves me. A voice that speaks to me. Or take a microphone and imitate the attitude of one of my favorite singers, in order to appropriate his old song and the words that express so well what I'm feeling: "I found my thrill, on Blueberry Hill...On Blueberry Hill, when I found you...The moon stood still, on Blueberry Hill...It lingered until, my dream came true." Take the male subject's place. Conjugate the song in the feminine gender without changing the lyrics and the figure to whom they're addressed. Jump cut to a road movie episode (the dream coming true). Slip a bit of fantasy into the rifts (the interstices) in heterosexual culture that seem to correspond to my desires, if only for a moment.

Run away from norms and imposed figures of love. Build up your own body of love and your own identity by subverting fragments of heterosexual culture and reappropriating them (two bad seeds doing their own movie). Somewhere in the middle of the road movie, the title from a film: *The Bad Seed*. Close-up of a little girl screaming: "He ran away from me, so I hit him with my shoe again. But he kept on crying and making a noise and I was afraid someone would hear him, so I kept on hitting him, mother." Insert-shot of variety show host: "Now, there's

a little ray of sunshine!" Jump cut back to *The Bad Seed*: violins, the seated mother slowly turns around: "Rhoda, come here to me." Cut. The girl walks over to her mother…Sadie cuts the sound, and plays Prince over the visuals: "I need your love, baby…" The mother takes her daughter's face in her hands…"That's all I'm living for…" Squeezes her arms while peering into her eyes…"I don't want to pressure you, baby…" They fall into each other's arms. Lap dissolve: The mother lowers her eyes. The girl tilts her head affectionately and caresses her mother's cheeks…"But all I ever wanted to do…I wanna be your lover…" The mother lifts her eyes, intrigued…"I wanna be the only one that makes you come …running." The child's caresses become more and more insistent, on the face, the neck…"I wanna be your love." When the daughter can be seen speaking again (the film sound track is still turned off): "I wanna turn you on, turn you out…" Instinctively and violently, the mother pushes her away and gets up (the taboo) …"All night long make you shout…" They throw themselves into each other's arms again…The mother hugging her daughter tightly against her body…"I wanna be the only one you come for…" The girl moves behind her mother…cheek to cheek, eyes closed, they exchange a few caresses with looks that suggest some form of ecstasy (a fragment of mainstream culture that seems to address me)…"I wanna be your mother and your sister too" (the confusion of subjects and sentiments)…"There ain't no other that can do the things I'll do to you": eyes shut, the mother tightly hugs her daughter, with a look on her face that could be seen as an expression of desire or carnal pleasure…(the dream come true). We can see from the picture (the sound track's still turned off) that she's whispering something to her daughter: "And I get discouraged, cuz you treat me just like a child" (switching roles). End of the song…back to the violins…Sadie turns the sound track back on: "I want to play the way we used to, mommy" (the return to reality). Cut to close-up of Sadie's eye. Offscreen voice resumes the story of the two chicks and their love affair: "I got nervous, she got sexy." *The Bad Seed* line is conflated with the road movie. Fiction of a desire (the mother figure) and a headtrip (the road movie with the chick) that become reality for the time of the sequence. Cut.

Devise ways of editing and mixing in which singular experiences (lived time) mingle with voices, phrases, information, movies, songs, and ambiances that run through and silence the anonymous (the mainstream cultural representation of experience). Sample (divert) fragments of love discourse in a hit sung by androgynous voices (switching identities) that affect us and shape us (the sound track of desire), and transpose them onto a film scene in which a mother admonishes

and then consoles her daughter (the picture of her desire), in order to build up your own body of love. Turn off the sound track of norms (the consoling words) and turn on (project) that of your desires (the words that will make her give in). Sample attitudes and situations – even clearly masculine ones – that you can identify with from television culture (a scene of gangsters settling scores in a shootout), dress up like a guy, smoke a big cigar, draw some figures with a cane (the headtrip) and then use it to pretend you're settling your own scores (do a remake of the scene). The female remake of situations thought of in masculine terms as a subversion of the spectacular scheme of structuring the imaginary. Stop integrating the models offered by the society of the spectacle, but reenact them – without conviction – in order to appropriate a world in which I have not yet found a place for myself. The headtrip versus the effectuation. Fiction versus experience. And if it isn't for real, that's because, in any event, all the work of constructing, producing, and distributing images that would at last speak to me directly, without the mediation of transvestitism, is still to come. The makeup and the subjection of the feminine subject to spectacular, masculine roles as acknowledgments of the impossibility of conceiving lesbian modes of representation in feminine terms.

Meanwhile, if we are lacking images, if they leave us out or impose behaviors upon us that don't correspond to our sexuality: cut the sound of mainstream culture, turn up the sound of your own voice (speak your mind in diary form), turn up the sound of the songs that constructed our affect when we were teenagers, and tack them onto images that we can appropriate at last (diverting and mixing). In the event, Sadie Benning does not produce new images or images that are different; she proposes a model of reappropriating images that leave us out and a model of constructing desire. Editing and mixing as a formulation.

If there are no images of the self, and if there are still no images to gain recognition for ourselves: At least gain access to visibility, for the time of a song, the time to let yourself go to the melancholic atmosphere of a melody and lyrics that you play again and again, alone in your room and in your culture…To the sound of "My Funny Valentine," Sadie's thumb and index finger meet to form a circle where she places her eye and then her lips…Lips that close lovingly over her thumb…The movement becomes sensual and slow…"Is your figure less than Greek…Is your mouth a little weak when you open it to speak…" A mouth that is sucking her thumb…"Baby, don't change one hair for me…Stay my funny Valentine." To wit, the realization of the fantasized regression constructed in the

sequence from *The Bad Seed*. The end in the form of a slow pan over tatooed skin on which we can read: "It wasn't love, but it was something."

to be continued…